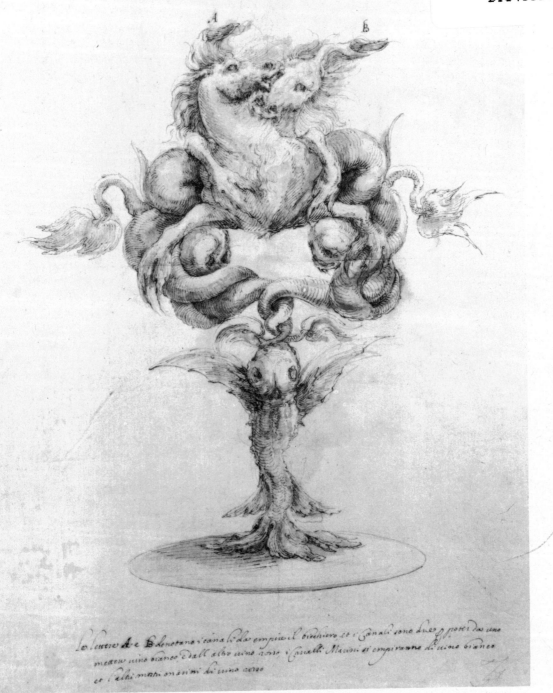

A B

Le lettere A e B denotano i canali da empire il bicchiero et i Canali sone due p poter da uno
mettere vino bianco e dall altro vino nero i Canali Mezoni si empiranno di vino bianco
et l'altri metti ordinarii di vino rosso

CHRISTIE'S REVIEW
OF THE SEASON 1975

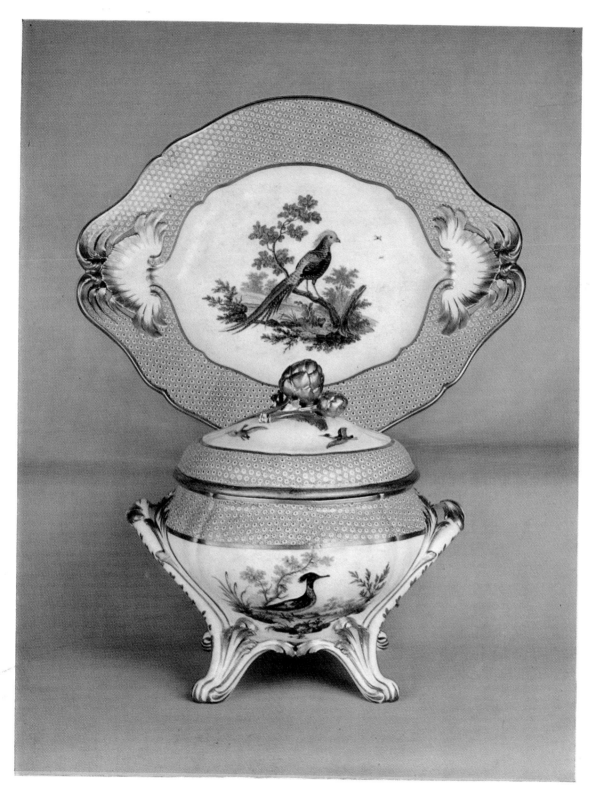

Sèvres ornithological service for dinner and dessert
Each piece with blue interlaced L marks enclosing the date variously for 1780, 1784, 1786, 1787, 1788, and with painters' marks for Roset, Dutanda, Taillandier, Massy, and other unidentified hands, the gilding by Vincent, Chavaux, Leguay and Prévost
Sold 30.6.75 for £33,600 ($77,280)
From the collection of Edmund de Rothschild, Esq., TD

CHRISTIE'S REVIEW OF THE SEASON 1975

Edited by John Herbert

HUTCHINSON OF LONDON

HUTCHINSON & CO (Publishers) LTD
3 Fitzroy Square, London W1

London Melbourne Sydney Auckland
Wellington Johannesburg and agencies
throughout the world

First published 1975

The illustration on the front of the jacket is reproduced by courtesy of
Roy Miles Fine Paintings, London

Endpapers:
STEFANO DELLA BELLA: Designs for fanciful ewers for red and white wine,
both inscribed by the artist
$12\frac{7}{8} \times 9\frac{3}{8}$ in. (32.8 × 23.8 cm.) and $14\frac{1}{4} \times 10\frac{1}{8}$ in. (36.1 × 25.8 cm.)
Sold 18.3.75 for £4200 ($10,080) and £5040 ($12,096) respectively
From a series of designs for table ornaments dedicated by the artist to
Prince Mattias de'Medici in 1629 (see article page 74)

© Christie, Manson & Woods, 1975

This book was designed and produced for
Christie, Manson & Woods by Hutchinson Benham Ltd
It was set in 'Monotype' Baskerville 12 on 15 point,
printed in England by The Anchor Press Ltd
and bound by Wm Brendon & Son Ltd, both of Tiptree, Essex

ISBN 0 09 125670 4

CONTENTS

The Hon. David Bathurst, Impressionist and Contemporary picture Director, selling Kitaj's *Synchromy with FB – General of Hot Desire* for a record price of £28,350 ($68,040) in a sale of Contemporary pictures in December which aroused tremendous interest

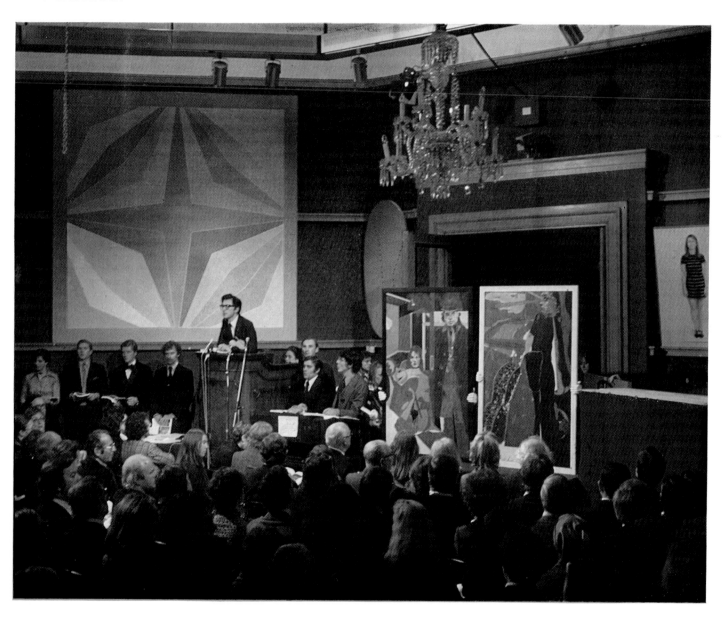

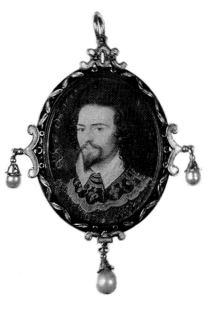

Above: NICHOLAS HILLIARD:
George Clifford, 3rd Earl of Cumberland
1½ in. (3.8 cm.) high
Sold 22.10.74 for £19,950 ($47,880)

Below: NICHOLAS HILLIARD:
A Lady at the Court of Queen Elizabeth I
2 in. (5.1 cm.) high
Sold 22.10.74 for £17,850 ($42,840)

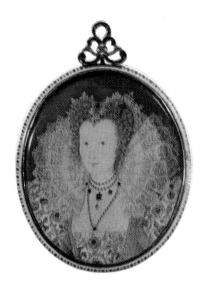

Antique sapphire and
diamond pendant, set with
a cushion-shaped sapphire
of 51.98 ct.
Sold 21.11.74 at the
Hôtel Richemond,
Geneva, for £34,160
(Sw. fr. 220,000)

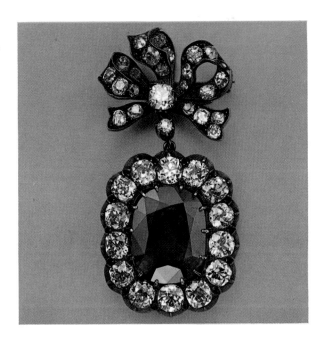

Mr John Floyd, the Chairman, selling a Louis XVI black lacquer and ebony bureau plat and cartonnier by Martin Carlin for £157,750 ($362,825). Sales of French furniture totalled £3,800,000 ($8,740,000)

Foreword

JOHN FLOYD

The reassuring comment on the 1974–75 season, as the following pages show, is that in virtually every department auction results have been extremely satisfactory. Outstanding prices were achieved in spite of tremors from the international monetary situation and our sales totalled £33,730,000 ($77,579,000).

Last autumn certain sections of the market were not as buoyant as previously, but since then there has been a good recovery and prices now compare favourably with the corresponding period last year. There is obviously not so much money about for the potential 'six-figure lot'. More than ever quality and condition are of prime importance, while it must also be remembered that if a picture has been offered to dealers and museums all over the world before being put up for auction its saleability will be prejudiced whatever the economic climate. In addition some vendors undoubtedly expect their property to appreciate too quickly.

The illustrations which follow give a cross-section of the most important sales, not only in London, but also in Geneva, Rome, Amsterdam, Sydney and Montreal, and demonstrate the strength of the international art market bearing in mind the world-wide economic decline. I would like to say a word about each of the main departments.

Pictures

In the Old Master field the highest price paid was £147,000 ($338,100) for a Pieter de Hooch courtyard scene, while a *Frozen River Landscape* by Van Goyen sold for a record £63,000 ($144,900) having sold for £47,250 ($113,400) in 1972. Canaletto's study of *The Old Horse Guards and the Banqueting Hall from St. James's Park* went for £105,000 ($241,000). There was an unusually large number of Venetian views during the season. Five by Canaletto sold for prices ranging from £69,300 ($159,390) to £30,400 ($70,035) and a Bellotto of *The Piazza della Santissima Annunziata, Florence* made £42,000 ($96,600).

The market for English pictures, depending as it does to a large extent on English buyers, has been somewhat quieter. However, the stability of prices is exemplified by the following. The Usher Gallery, Lincoln, paid a record £57,750 ($138,600) for *The Burton Hunt*, by John E. Ferneley, compared with £2,310 in 1948; Arthur Devis's

LUCAS VAN
VALKENBORGH:
Spring
Signed with
initials and dated
1595 and inscribed
with the signs of
the Zodiac of
Aries, Taurus and
Gemini
$48\frac{1}{2} \times 73\frac{1}{2}$ in.
(123·2 × 186.5 cm.)
Sold 29.11.74 for
£19,950 ($47,880)

picture of the Clavey Family made £39,990 ($95,760) and James Pollard's *The Royal Mail Coaches for the North Leaving Islington*, £36,750 ($84,525).

Among Impressionists, Degas' *Après le Bain* from a Chicago collection made £141,750 ($340,200) and a Modigliani portrait of *Huguette* from the same source sold for a record £126,000 ($302,400). Bonnard's *Vase de Fleurs* from the collection formed by Jerome Hill was sold on behalf of the Camargo Foundation, New York, for £86,100 ($206,640), also a record, while in the summer a small Degas pastel *Scène de Ballet* went for £94,500 ($217,350). There were two sales of Contemporary pictures, Kitaj's *Synchromy with FB – General of Hot Desire* making a record £28,350 ($68,040).

Furniture

French furniture sold particularly well, many of the most important pieces going to buyers abroad. A Louis XVI bureau plat and cartonnier by Martin Carlin sold for £157,750 ($362,825), a Louis XVI black lacquer and ebony commode by J. Baumhauer made £115,500 ($265,650) and a Louis XVI secretaire by J. H. Riesener £47,250 ($113,400). We also held a successful sale of French furniture and works of art in Geneva which included an Imperial Russian secretaire made originally for Catherine the Great by David Roentgen, which sold for £19,607 (Sw. fr. 120,000).

‶Actually I'm selling it at Christies to invest in the real thing...❜

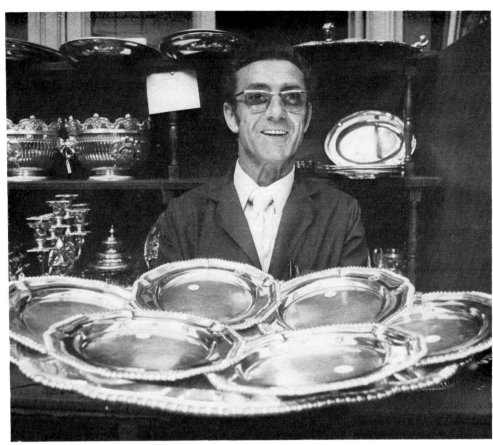

(*left*) By kind permission of Mark Boxer

(*right*) Part of a Victorian dinner service which sold for £26,000 ($57,200) From the collection of The Lord Barnard, TD

A Louis XIV Boulle commode made £16,339 (Sw. fr. 100,000), while the travelling secretaire made by Roentgen for Tsar Paul I achieved £11,437 (Sw. fr. 70,000).

Silver

In London, silver prices have been firm throughout the year. Perhaps the most remarkable price was the £26,000 ($57,200) paid for a Victorian dinner-service, while a pair of George III candelabra made £14,500 ($31,900) and a pair of Regency two-handled wine coolers, £13,000 ($28,600); all three lots came from the collection of Lord Barnard. In an earlier sale a Queen Anne wine-cistern and wine-fountain from the collection of the Marquess of Linlithgow sold for £19,000 ($43,700). The Geneva office mounted a sale of Continental silver which brought a record total for any silver sale anywhere of £420,225 (Sw. fr. 2,563,350); a Louis XV tureen from the famous Orloff service sold for £103,333 (Sw. fr. 620,000) while a Louis XIV silver-gilt mirror, believed to be part of the Duke of York's wedding present to Anne Hyde, made £50,000 (Sw. fr. 300,000).

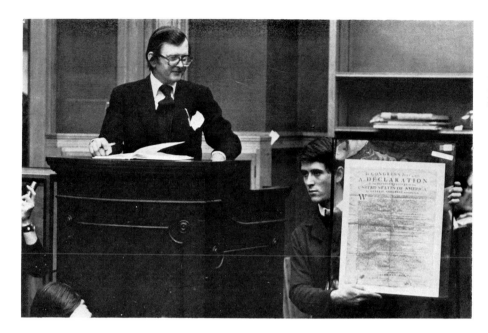

William Spowers, the Director in charge of our Book Department, auctioning for £40,000 ($92,000) one of the two recorded copies in private hands of
The Declaration of Independence

Jewellery

Our jewellery sales in London and Geneva totalled over £7,000,000 ($16,100,000), more than that sold by any other saleroom, irrespective of where their sales took place. Those in Geneva totalled £4,950,000 (Sw. fr. 30,690,000), an emerald and diamond necklace selling for £166,667 (Sw. fr. 1,000,000). Coloured stones as in former years continued to appreciate, a pair of sapphire and diamond ear-clips achieving £91,667 (Sw. fr. 550,000), while a sapphire and diamond ring made £75,000 (Sw. fr. 450,000). In London the jewellery total was a record £2,059,000 ($4,941,000) – a 73.16 carat sapphire and diamond brooch sold for £160,000 ($384,000), an emerald and diamond brooch pendant made £85,000 ($204,000), while two emerald and diamond necklaces made £55,000 ($126,500) and £42,000 ($96,600) respectively.

Books, manuscripts and autograph letters

There were a number of notable sales of Books, Manuscripts and Autograph Letters. The final session of the Mostyn Library brought the total for the six sales to £205,245 ($472,000); the Scott Library and other Books of Navigation achieved £130,000 ($300,000); while the Library of the late Siegfried Sassoon sold for £107,919 ($248,000). The Mildmay-White collection of Autograph Letters made £39,000 ($89,700). In another sale, one of the two copies of the Declaration of Independence in private hands made £40,000 ($92,000).

Anthony du Boulay
Director in charge of
the Porcelain
Department, selling
the early Ming dish,
discovered by a
Christie's expert in
Cornwall, for £17,850
($41,055)

Porcelain

Chinese porcelain prices have recovered to a large extent from the recession last autumn and are now back to a healthy level. A 15th-century blue and white jar achieved £75,600 ($173,880), an 18th-century armorial service sold for £57,645 ($139,348), a 14th-century under-glaze red bowl made £44,120 ($105,840), which in 1933 fetched only £36, and a Ming blue and white dish, which had been discovered by one of our experts in Cornwall, went for £17,850 ($41,055). Continental porcelain sales in London and Geneva included the magnificent Sèvres ornithological service from the collection of Edmund de Rothschild, which sold for £33,600 ($77,280), and a documentary Meissen gold-mounted snuff-box which achieved £15,225 ($36,540).

Wine

Undoubtedly one of the most historic sales not only of the season but also of Christie's 208-year history was the sale of 6000 cases of first growth claret from the Châteaux of Lafite and Mouton-Rothschild which sold for £438,222 ($1,008,000), a case of 1945 Lafite selling for £600 ($1380). The sale brought 310 buyers from all parts of the world. The wine department's total of £1,600,000 ($3,680,000) is not only a new record but a remarkable achievement considering that prices have eased considerably over the past year. The total was accomplished by holding far more sales and selling a far greater volume of wine. In addition to the Lafite/Mouton-Rothschild sale there was a two-day sale for the London Wine Company which totalled £188,000 ($414,000).

Of the other departments it is reassuring to note that the sales totals of clocks and watches, glass, art nouveau, objects of art and vertu, icons, coins and medals, arms and armour, modern sporting guns, photographica and models all surpassed those of the previous season.

Other developments during the year included the acquisition of Debenham Coe which is now operating as Christie's South Kensington. Here we offer a swift service for the sale of pictures, furniture and other works of art in the lower price range and this development has proved most successful. Examples of the works of art sold and prices achieved are given in a special section of this Review.

In Rome we now have a permanent saleroom in the splendid Palazzo Massimo Lancellotti where regular sales are planned. Of the sales already held one of the most successful was of Continental silver where outstanding prices were realized including £17,600 (L. 27,000,000) for a pair of 18th-century Italian candelabra and £12,400 (L. 19,000,000) for an 18th-century pear-shaped chocolate pot.

Finally it is with much regret that I record the death of Cyril Connolly about whose service to Christie's David Bathurst writes later in this Review. I know also that everyone will be sad to learn of the retirement of Mr Ridley Leadbeater after nearly 30 years' service with the Firm, for most of which time he was Front Counter manager. His daily greeting and assistance to all those who come to Christie's will be sorely missed.

Mr Ridley Leadbeater retired at the end of the season after nearly thirty years' service as Front Counter Manager

A wealth tax and our national heritage

SIR ANTONY HORNBY
Chairman of the National Art-Collections Fund

Christie's have done me the honour of asking me, as Chairman of the National Art-Collections Fund, to write a contribution to their Annual Review. The Fund and the Firm have close connections. Sir Alec Martin, who was Chairman of the Firm, was a member of the Fund for over half a century, and its Honorary Secretary from 1924 until his death in 1971. The Firm has always loyally supported us, and I would like to give three examples of its generosity. In 1967 Christie's gave us the entire proceeds of its Bi-Centenary Exhibition. Last year, in aid of the Fund, it arranged an extremely successful series of lectures, which were given in King Street by the directors of the principal London museums. And to crown all, Christie's has covenanted to give the Fund an annual four-figure subscription which far exceeds that of any other of our corporate members, and which, after tax has been recovered, is the equivalent in value of over six hundred single subscriptions. How I wish that other firms could be persuaded to follow their example!

It is in the nature of things that works of art should appear at Christie's, which we want to help the nation to secure, and which we regret to see coming up for sale. In the present plight of this country we are deeply concerned with the catastrophic effects that the proposed annual wealth tax on 'chattels' would have on our national heritage. We believe that the evidence against its imposition given before the Select Committee of the House of Commons by a number of experts was convincing and difficult to refute, but rigid Socialist doctrine may well disregard it, in which case we predict a flood of sales which may be beneficial to the salerooms in the short run, but which will result in this country being denuded of a vast amount of treasures. Our Fund is simply not equipped to deal with a flood of this kind, though it can cope with orderly normal disposals due to deaths and other acts of God. When the Minister for the Arts announced that he wished to add to the number of members of the Reviewing Committee on the Export of Works of Art, I was apprehensive that this was a sign that he himself expected that their services would be strained if a wealth tax were imposed, notwithstanding anything he had said previously to the contrary.

But what is also of great concern to the Fund and to the Firm is the effect of such a tax on the private collector. It is the private collector who has been the mainstay of

our National Collections. More than half of the pictures in the National Gallery were private gifts. The Wallace Collection and the Courtauld Collection were outright gifts to the Nation. The Burrell Collection was given to Glasgow, the Davies Collection to Cardiff, Apsley House and its contents by the Duke of Wellington to London, the Jones Collection to the Victoria and Albert Museum. What a crassly stupid thing it would be to discourage the collector, great and small; for many are small, comparatively poor, knowledgeable experts who may have unwittingly become 'wealthy', and who would only be able to pay their tax by selling something from their treasured collection. When you consider that they conserve their possessions, secure them, insure them, lend them, show them to anyone interested, there is surely a case for tax concessions rather than taxes!

Against the uncertain political and economic background in the world today I find it enormously encouraging that the Arts continue to flourish as they do. I do not believe for an instant that speculation and investment have been the main cause of this, but that there is a flame of genuine love of Art that cannot easily be extinguished. It is of paramount importance for the Nation, for the Fund and for the London art market that the private collector should not be eliminated.

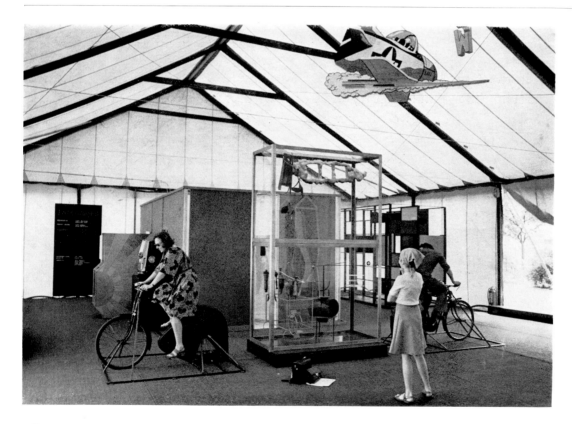

'Tate Games', an exhibition demanding the participation of visitors and related to the permanent exhibition in the Tate Gallery (see Roland Penrose's article opposite)

The crisis of the museum

ROLAND PENROSE

At the present time museums and art galleries are assailed by problems which could not have occurred to those who first founded them some two hundred years ago. Their aim then was not only to preserve and present to the public the riches of our civilization and its predecessors but also to overawe visitors by the classical grandeur of an edifice which reflected the affluence of its founder. In fact many museums are seriously prejudiced by the zeal with which their patrons forced on them an architecture which was bound to alienate the vast majority of those to whom their influence would have been a benefit. We find revolutionary poets, such as Apollinaire in the first decades of the twentieth century, declaring that 'all museums should be destroyed because they paralyse the imagination', and this was not facetious. The deadly pomposity of 19th-century philanthropy often defeated its own enlightened purpose.

But the essential function of a museum, even above its use as a treasure-house of the past, is to appeal to the imagination. We have a universal and natural museum in the sky at night with its mythical population of beasts and ancient heroes. The fact that the night sky allows us to see much further than we see by day suggests an analogy with an ideal museum which through the imagination opens great vistas into time and space. The difficulty in achieving this is traceable to the ambiguity we find in the meaning of the word itself. In the *Concise Oxford Dictionary* we find: 'Museum . . . n. Building used for storing & exhibition of objects illustrating antiquities, natural history, art, etc. . . . [L, f. Gk *mouseion* seat of the Muses (*Mousa*)].' The contradiction in terms is obvious, the derived meaning being practical, and its origin imaginative. The problem which now faces us is how and to what degree can we combine the two.

The first museum about which we know little except that it was destroyed by fire was founded in Alexandria by Ptolemy, who was himself an astronomer and who assembled his collection for the purpose of study. It seems unlikely that there was then a divorce between science and the muses. In recent years various efforts have been made by those who are conscious of the danger, to prevent our museums becoming no more than emporiums of past history, in fact mausoleums. There was a clever subterfuge devised by the director of the Stedelijk Museum in Amsterdam who, when he found that local people in the streets turned away at the entrance, intimidated by its

flight of marble steps, opened up a hole in a sidewall with a temporary door and wooden staircase. This more modest approach at once drew in the public in large numbers. Experiments of this kind are applauded by us all but, the more accessible the museum becomes and the greater the interest shown by the public, the more difficult it becomes to avoid overcrowding to a degree when the muses themselves die of suffocation.

But this is not the only menace brought about by present demands. The first half of this century witnessed a revolution in taste and style which outstripped the judgement of those in charge of buying for museums. The result was that they neglected disastrously artists who have now risen to fame and in consequence their works have become unobtainable except at prices beyond the means of nearly all buyers. We now smart from the lack of works by Cézanne, Matisse, Picasso, Brancusi and a score of other artists who are inadequately represented in our museums because no one in a position to act was sufficiently enlightened at the time. The shame now felt at this lack of foresight often leads to a spate of buying of young and immature artists in a panic that this could happen again. This brings with it inevitable overcrowding of exhibits in galleries which are already hard up for space.

I have no desire to discourage patronage of the young – to keep pace with revolutionary developments in the arts should always be our purpose. Recently, however, there has been much emphasis placed on the more ephemeral qualities which have their place in art but which tend to lack the concentration of emotion which gave great value to the 'easel' painting. These new creations of artists, conceptual, kinetic, minimal or spacial, are difficult to show by traditional methods. Often they are more alive and understandable as films and there is no doubt that adequate facilities for film programmes should be incorporated into museums. In order to give these tendencies their due at a time when both space and funds are rare, I have a suggestion: we should, I believe, think in terms of a separation between the rumpus area given over to experiments where the happenings and celebrations of contemporary artists can be enjoyed to their full, and the more static collection of works that have proved their value either as outstanding works of great merit or as a well-chosen record of the preoccupations and idiosyncrasies of a given period. Certain museums which have begun late to build up a collection of 20th-century art, such as the National Gallery in Canberra, have adopted the policy of buying only key works to cover long periods and, given adequate financial backing, this can still be done. If fifty years ago we had begun to concentrate in the same way, the Tate Gallery could have become the greatest collection of 20th-century art in the world, providing a mirror of current thought and achievements by the presentation of a well-balanced choice of the many tendencies that have evolved.

Fundació Joan Miró
Barcelona, sculpture
gallery at the opening
of the Miró exhibition
May 1975. An example
of unity between
interior and exterior

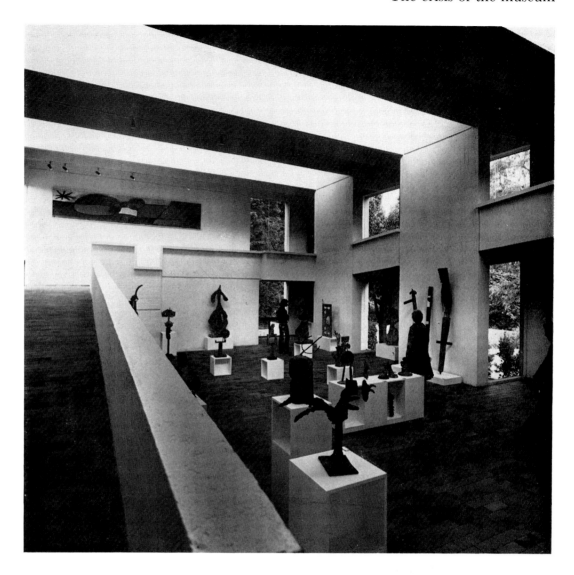

But this separation could only be successful if attention is given to the active development of a more experimental temple of the muses, readily accessible to the public and capable of fostering the immediate production of young artists. In such a place the most arbitrary forms of expression could find their place. Dada activities, Surrealist, Futurist, Vorticist, Expressionist and Abstract art would have found themselves at home in such an atmosphere and would not have had to wait in exile until they had become monuments of the past.

I feel sure that this can still be done. The Museum of Modern Art of New York is an example of how private endeavour on the part of a small group of enthusiasts can succeed in building up a splendid collection and keeping contact with the younger

generation of artists by a continuous programme of activities which also attracts a very large public. But as private patronage diminishes it is now the duty of the state to evolve a system by which youthful visionary talent is given its place – a place which would not be crowded out nor conflict with the formation of a more permanent collection.

This separation, which could be complimentary to both parts and could even exist under the same roof, would not interfere with the more static need to preserve the achievements of the past and it would encourage contemporary talent without inflicting on a gallery the embarrassment of purchasing works of art which it is for ever forbidden to exchange or sell. The evolution of museum collections would become a natural process. It would start with a period of encouragement of the turbulence and inventiveness of youth, prolonged when necessary by a period for the consideration and digestion of their work. From this harvest a winnowing would be made in due course which would result in a considered choice of works that would give lasting enrichment to the imagination.

If this were to be achieved it would relieve our national and provincial galleries, already lamentably overcrowded with minor works, of the embarrassment they now suffer from collecting works of art for eternity and too soon. It would also help to establish a continuity in our appreciation of the arts. It would encourage those who wished to understand better the violent changes and mysterious, often contradictory, manifestations which spring from a fundamental contact between the arts and life. It is a problem that has economic and social, as well as spiritual, overtones.

The crisis that our museums and art galleries present looks for an urgent solution. It grows in importance with the present increase in attendance at museums in general and the growing interest in the arts which can only result in chaos in the present unresolved relationship between the museums, the artists and the public. There have been great advances in the architectural concept of museums. The isolated top-lit gallery cut off from all contacts with the exterior has given way to a more open spacial conception where the outside world can be seen side-by-side with paintings and sculpture. The tomb-like silence of guarded uniformed wardens asleep in their chairs is now broken by parties of eager children and students; also with the advent of an experimental area the participation of visitors can become a reality. But the essential factor if art is to be given the place it deserves in life and in the museum is the creative artist. The museum is the mediator between artist and public and its aim should be to fuse the two to such a degree that it could ideally become superfluous. To quote from Willem Sandberg's recent Herbert Read lecture at the I.C.A.: 'The red thread of genius leads the way, let us show the story of creativity . . . let us not seal off the museums from life; open the museums!'

OLD MASTER
PICTURES

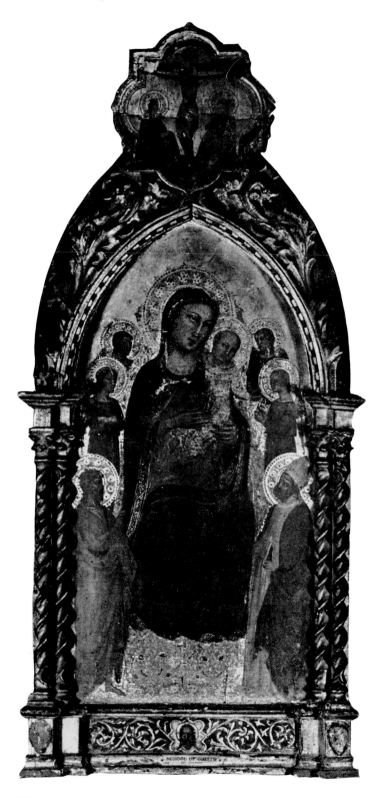

LORENZO DI BICCI: *The Madonna and Child with Saints and Angels*
On panel, arched top, in a carved wood frame decorated with the head of Christ and surmounted with a panel of the Crucifixion
23 × 12 in. (58.5 × 30.5 cm.)
Sold 27.6.75 for £15,750 ($36,225)
From the collection of Elizabeth Seton College, Yonkers, New York

PIERRE BINOIT: *Basket of Peaches and Plums, a Vase of Carnations, a Bowl of Blackberries*
Signed with initials and dated 1615, on panel
$17\frac{1}{2} \times 24$ in.
(44.45 × 60.96 cm.)
Sold 29.11.74 for £19,950 ($47,880)
From the collection of
Mrs R. H. J. Gladstone

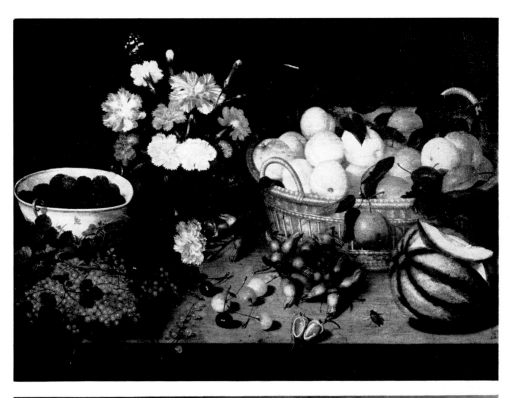

BALTHASAR VAN DER AST: *Peaches, Grapes and Other Fruit in a Late Ming Blue and White Dish*
Signed and dated 1625, on panel
$17\frac{1}{2} \times 24$ in. (44.5 × 60.9 cm.)
Sold 29.11.74 for £23,100 ($53,130)
From the collection of
Sir Christopher R. P. Beauchamp, Bt

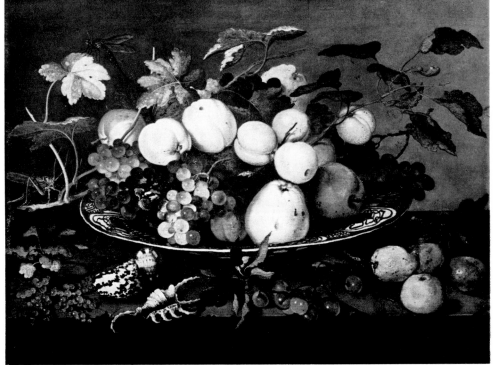

'The Mystic Marriage of Saint Catherine' by Parmigianino

WILLIAM MOSTYN-OWEN

There is perhaps a certain irony in the fact that one of the most frequently represented female saints in Italian painting, Saint Catherine of Alexandria, should have been removed from the Catholic Church Calendar in 1969, due to the uncertain historical basis of her life; and this in spite of the fact that she was second only to Saint Mary Magdalen in popular veneration.

The earliest surviving account of her life dates from the 9th century and is thought to have its roots in the story of Hypatia, a pagan philosopher of Alexandria who died in 415. According to the Golden Legend she was of royal birth, was extremely erudite and was converted to Christianity by a desert hermit. In a vision she underwent a mystic marriage with Christ. The Emperor Maximilian, having tried unsuccessfully to undermine her faith in argument, called in fifty philosophers who seem to have been equally unsuccessful – even more so, as the unfortunate men were then burnt at the stake. The Emperor then thought up a special instrument of torture for her consisting of four wheels covered with iron spikes to which she was bound; but a heaven-sent thunderbolt destroyed it before it could harm her, so recourse was had to more normal methods and she was beheaded.

During the 14th century a different version of the story became popular: Catherine's teacher, the hermit, gave her an image of the Virgin and Child. Her prayers caused the Infant to turn his face towards her, and later to place a ring on her finger. This was the most widely represented image of her and was that used by Parmigianino in his painting, which is possibly the one described by Vasari in his life of the artist as having been painted for a friend in Bologna with whom he was lodging at the time.

Born in Parma in 1503 and trained there by his two uncles, Parmigianino spent the years from 1524 to 1527 in Rome. From then until 1531 he spent most of the time in Bologna. He then returned to Parma and died near there in 1540. A dating from the Bologna years would tie in with a description of the picture in an inventory of c. 1700 of the collection in Palazzo Borghese in Campo Marzio, Rome, where it is described as '*Sposalizio di S. Caterina del Parmigianino ultima sua maniera*'. It had already been included in an inventory of the same palace made in 1693 where it was numbered 397, which corresponds to the same number inscribed in the lower left corner of the

FRANCESCO
MAZZOLA, IL
PARMIGIANINO:
The Mystic Marriage of Saint Catherine
On panel
$29 \times 22\frac{1}{4}$ in.
$(73.7 \times 56.4$ cm.$)$
Sold after the sale on
29.11.74 by private
treaty to the Trustees
of the National
Gallery
From the collection
of the Countess of
Normanton

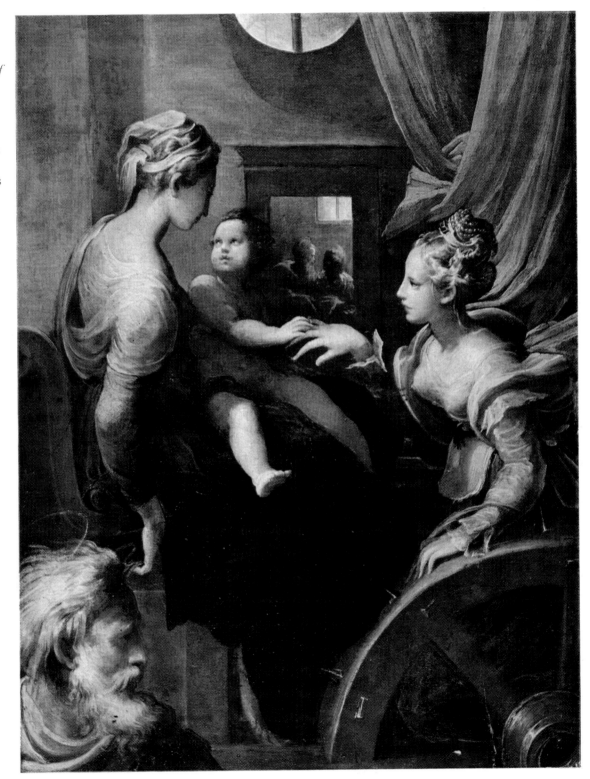

face of the picture. It was still to be found in a Borghese inventory of c. 1790, but was bought by the precocious English collector William Young Ottley in 1799 or 1800, when he was only 19 or 20 years old, and was Lot 45 in his sale at Christie's on 16th May, 1801. By 1814 it was in the collection of William Morland, MP and reappears at Christie's as Lot 102 in the Sir F. Morland sale on 19th May, 1832, when bought by Seguier for the 2nd Earl of Normanton. It made its third (and presumably final) visit to Christie's on 29th November, 1974, when offered as Lot 40 on behalf of the Countess of Normanton. Having narrowly failed to reach its reserve, it was acquired immediately after the sale by the National Gallery.

In the catalogue of the 1801 Ottley sale, there appears the following note on the painting: 'This picture undoubtedly ranks *the highest* of the few Catalogue Pictures of this celebrated painter. . . . The lovers of art must lament that so few pictures of this rare master exist, he having dedicated the greater Portion of his short life to Drawing and Alchymy.' Parmigianino's interest in alchemy is also discussed by Vasari in his life of the artist, where he wrote:

In the end, having his mind still set on his alchemy, like every other man who has once grown crazed over it, and changing from a dainty and gentle person into an almost savage man with long and unkempt beard and locks, a creature quite different from his other self, Francesco went from bad to worse, became melancholy and eccentric, and was assailed by a grievous fever and a cruel flux, which in a few days caused him to pass to a better life. And in this way he found an end to the troubles of this world, which was never known to him save as a place full of annoyances and cares. . . . Francesco delighted to play on the lute, and had a hand and a genius so well suited to it that he was no less excellent in this than in painting. It is certain that if he had not worked by caprice, and had lain aside the follies of the alchemists, he would have been without a doubt one of the rarest and most excellent painters of our age. I do not deny that working at moments of fever-heat, and when one feels inclined, may be the best plan. But I do blame a man for working little or not at all, and for wasting all his time over cogitations, seeing that the wish to arrive by trickery at a goal to which one cannot attain, often brings it about that one loses what one knows in seeking after that which it is not given to us to know.

In 1968 a small portrait, from the reserves of the Parma Gallery, painted in oil on paper, was cleaned and recognized as a self-portrait by Parmigianino from these last years. He has shown himself with the 'long and unkempt beard and locks' and wearing a battered floppy red hat. Significantly, the back of the portrait bears a pen drawing by the artist of various figures, one of them almost certainly a preliminary study for the kneeling Saint Catherine.

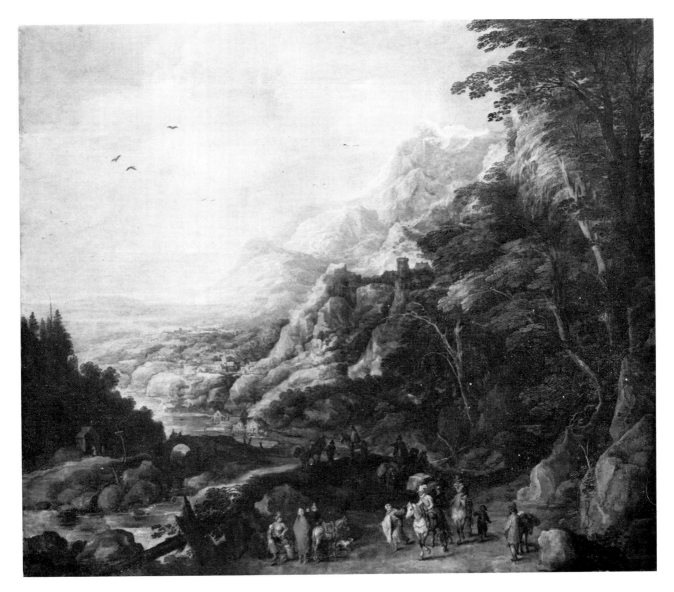

JOOS DE MOMPER: *Extensive Mountainous Landscape*
$72\frac{1}{2} \times 87$ in. (184.5×221 cm.)
Sold 27.6.75 for £29,400 ($67,620)
From the collection of Major Hubert Holden

JAN BRUEGHEL THE ELDER: *Wooded River Landscape*
Signed and dated 1619, on copper
16 × 23½ in. (40.6 × 59.7 cm.)
Sold 29.11.74 for £23,100 ($70,600)

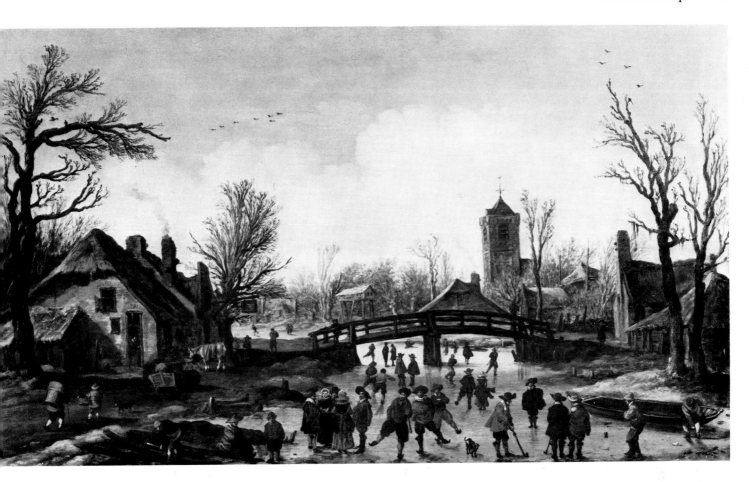

AN VAN GOYEN: *Frozen River Landscape*
igned and dated 1625, on panel
4¾ × 25½ in. (37.5 × 64.8 cm.)
old 27.6.75 for £63,000 ($144,900)
old 1972 for £47,250 ($113,400)
Record auction price for a work by this artist

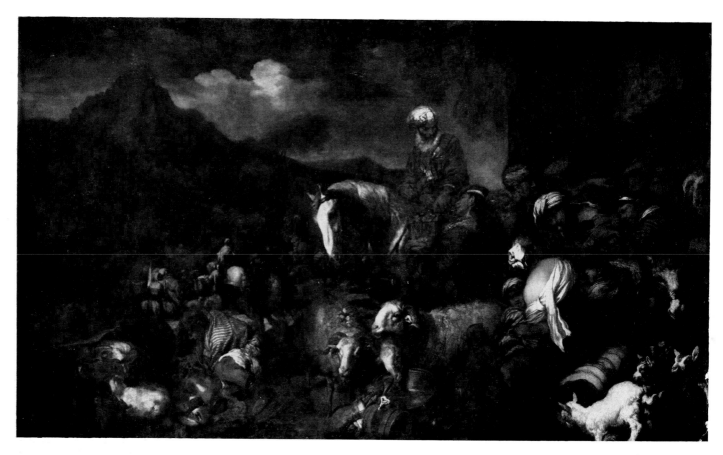

GIOVANNI BENEDETTO CASTIGLIONE, IL GRECHETTO: *Abraham's Departure for the Land of Canaan*
Inscribed
$55\frac{1}{2} \times 91$ in. (140.9 × 231.4 cm.)
Sold 27.6.75 for £26,250 ($60,375) on behalf of the Trustees of the Bedford Estates

DAVID TENIERS THE YOUNGER: *Gipsy Encampment*
Signed with monogram, on panel
$20\frac{1}{2} \times 33$ in. $(52 \times 83.8$ cm.$)$
Sold 29.11.74 for £25,200 ($60,480) on behalf of the Trustees of Raby Settled Estate

Additions to the work of Jean Barbault

WILLIAM MOSTYN-OWEN

It is rare that an 18th-century artist of the quality of Jean Barbault should have virtually disappeared into oblivion for over a century. Many of his works were reattributed to Goya, Zurbarán or his fellow Frenchman Subleyras. His 'rediscovery' is largely due to Madame Picault who published a detailed account of his career in 1951. Thanks to the subsequent research of other scholars, culminating in the catalogue by Nathalie Volle and Pierre Rosenberg of an exhibition held at Beauvais, Angers and Valence in the winter of 1974–75, we now have a clear picture of his life and work.

Born near Beauvais in 1718, Barbault went to Rome in 1747 having been a pupil in Paris of Jean Restout. He was made a *Pensionnaire* of the French Academy in 1749 largely as a result of a remarkable series of figure studies which he had painted in 1748.

Every year the pupils of the Academy used to take part in the Roman Carnival in the form of an elaborate Masquerade. Those of 1735 and 1738 had been particularly successful, but 1748 was to be the crowning year when the then director of the Academy, Jean-François de Troy, entrusted Joseph Vien with designing the costumes for a *Mascarade à l'Orientale*. Vien's drawings were later published in an album under the title *Caravane du Sultan à la Mecque, Mascarade donnée à Rome par Messieurs les Pensionnaires de l'Académie de France et leurs Amis au Carnaval de l'année 1748*. At the same time, de Troy commissioned Barbault, then a promising student, to paint 20 pictures based on Vien's drawings, representing various figures from the procession. In 1751 he produced, amongst numerous other works, another series entitled *Les Costumes d'Italie*. But then things began to go wrong for the *Pensionnaire* Barbault: in 1752 he got seriously into debt, and in 1753 he married, which was strictly against the rules of the Academy and led to his expulsion. During the remaining years of his life he continued to live in Rome with his wife and two surviving children (three others having died in infancy) and died there in 1762. But by then he was already almost forgotten. His figure studies for the Masquerade were offered as the work of de Troy himself in the Jean-François de Troy sale in Paris on 9th April, 1764, and subsequently reappeared in the Jean de Julienne sale on 30th March, 1767. By 1967 nine of them had been rediscovered, and the two offered on 11th April have only recently

come to light. For one, representing the *Sultane Blanche*, the model was a fellow-student named Beblon, and this was sold for £4410 ($10,143). For the other, entitled *Eunuque Noir*, which sold for £8610 ($19,803), the model was the painter Jean-François Martin, whose conduct was so bad that he was never made a member of the Academy. However, he produced the only painting of the whole Masquerade group (now in a private collection in Geneva) seen crossing the Piazza del Popolo.

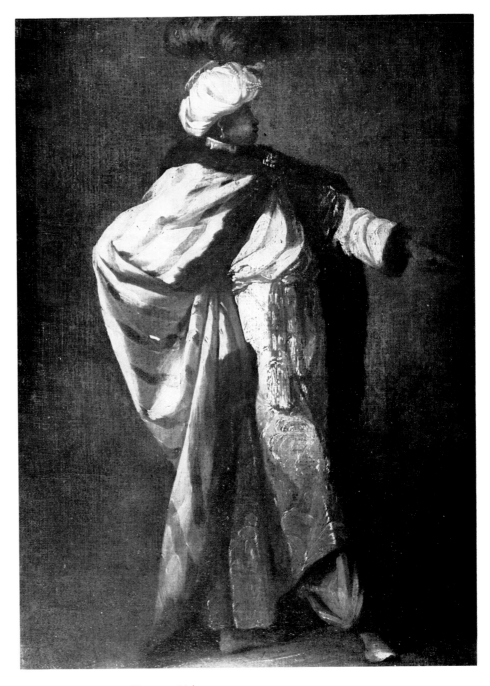

JEAN BARBAULT: *Eunuque Noir*
Inscribed on the stretcher
$24\frac{1}{2} \times 17\frac{1}{2}$ in. (62.2 × 44.5 cm.)
Sold 11.4.75 for £8610 ($19,803)

BARTOLOME-ESTEBAN
MURILLO: *Saint Catherine*
65 × 43½ in. (165 × 110.4 cm.)
Sold 29.11.74 for £17,850
($42,840) on behalf of the
Trustees of the Raby Settled
Estate

JEAN-ANTOINE
WATTEAU:
La Vraie Gaieté
On panel
$9 \times 6\frac{3}{4}$ in.
$(22.9 \times 17.2$ cm.)
Sold after the sale on
29.11.74 for £15,000
($34,500) to the
Musée de
Valenciennes
From the collection
of Lady Anne
Tennant

GIOVANNI BATTISTA
TIEPOLO:
The Flight into Egypt
22 × 16 in.
(55.5 × 41 cm.)
Sold 11.4.75 for
£37,800 ($86,940)

PIETER DE HOOCH:
The Soap Bubbles
Bears signature, on
panel
23 × 19½ in.
(58.4 × 49.5 cm.)
Sold 27.6.75 for
£147,000 ($338,100)
From the collection
of the late Major-
General Sir Harold
A. Wernher, Bt,
GCVO, TD, sold by
order of the
Executors
Record auction price
for a work by this
artist

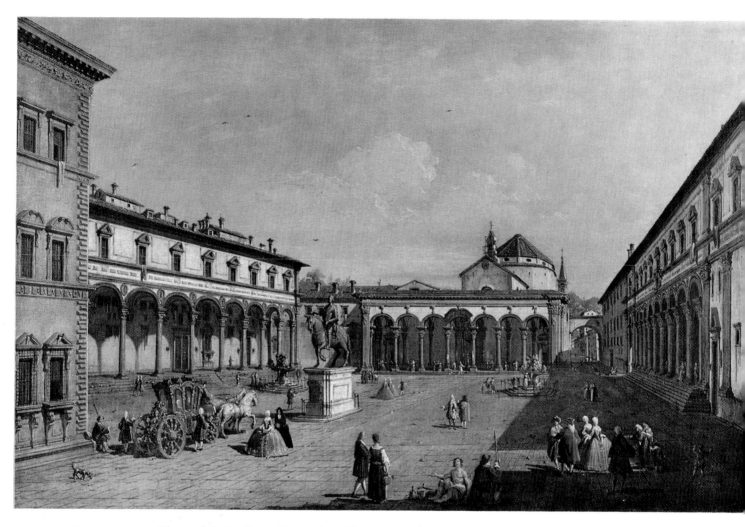

BERNARDO BELLOTTO: *Piazza della Santissima Annunziata, Florence*
22 × 33¾ in. (55.9 × 85.8 cm.)
Sold 27.6.75 for £42,000 ($96,600)
Sold on behalf of the Trustees of the late Mrs R. M. Cumberlege-Ware

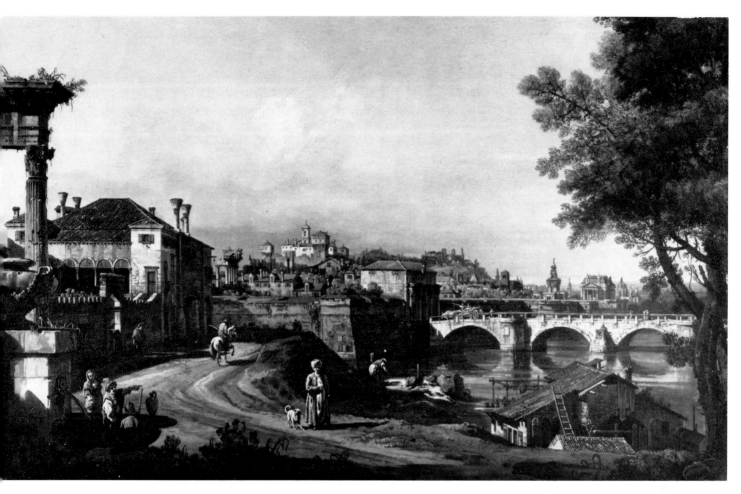

BERNARDO BELLOTTO: *Capriccio with a Town on a River*
18½ × 30½ in. (46.5 × 77.5 cm.)
Sold 29.11.74 for £29,400 ($70,600)

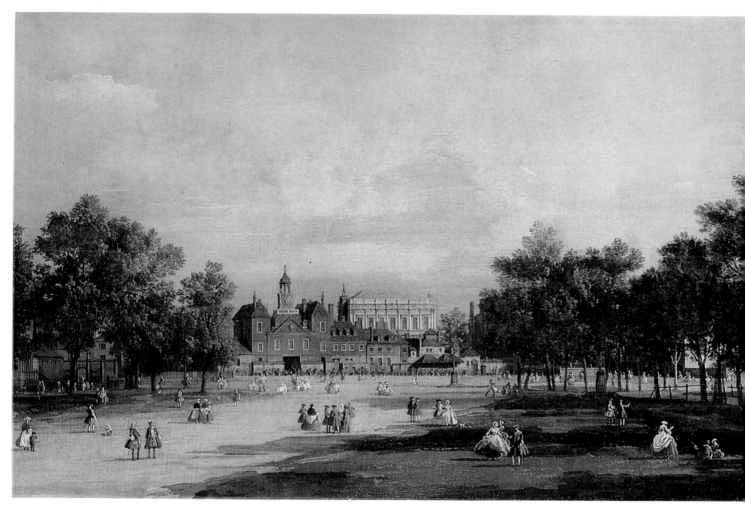

GIOVANNI ANTONIO CANAL, IL CANALETTO: *The Old Horse Guards and the Banqueting Hall from Saint James's Park*
$18\frac{1}{2} \times 30$ in. (46.9 × 76.2 cm.)
Sold 27.6.75 for £105,000 ($241,500)
Sold on behalf of the Executors of the late Sir Robert Wilmot, Bt

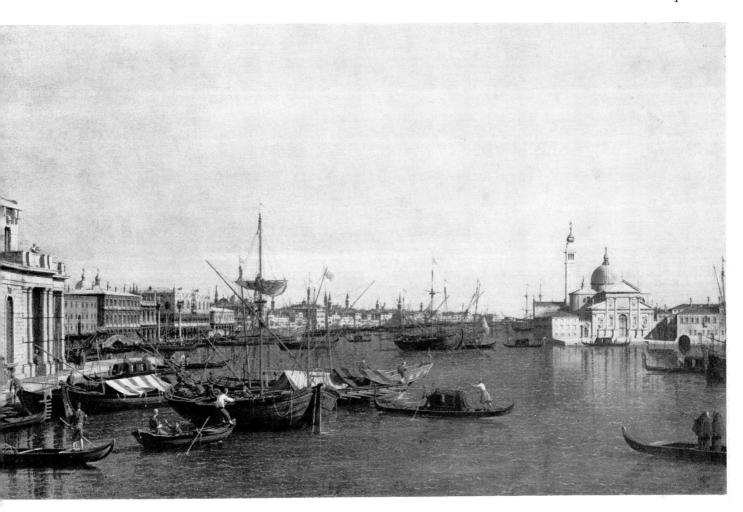

GIOVANNI ANTONIO CANAL, IL CANALETTO: *The Bacino di San Marco, Venice*
23 × 36½ in. (58.4 × 92.7 cm.)
Sold 27.6.75 for £35,700 ($82,110)
From the collection of the late Major A. F. Clarke-Jervoise, DL, JP

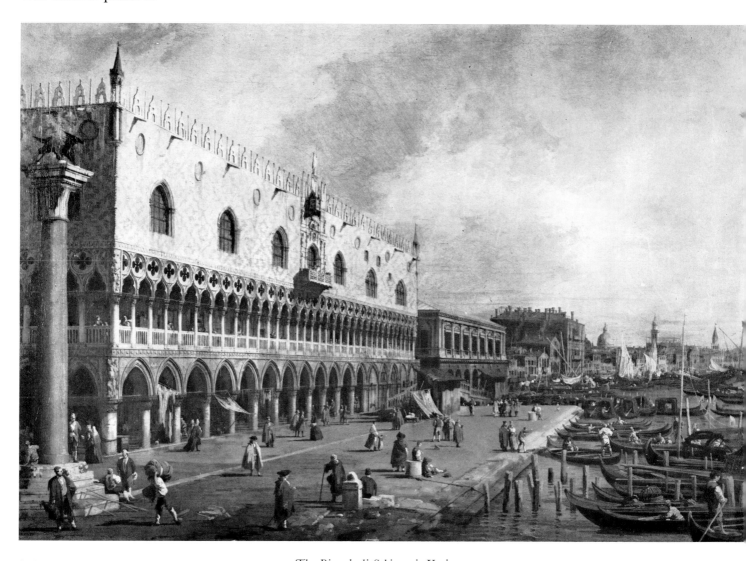

GIOVANNI ANTONIO CANAL, IL CANALETTO: *The Riva degli Schiavoni, Venice*
$22\frac{3}{4} \times 33\frac{1}{2}$ in. $(58 \times 85$ cm.$)$
Sold 11.4.75 for £69,300 ($159,390)

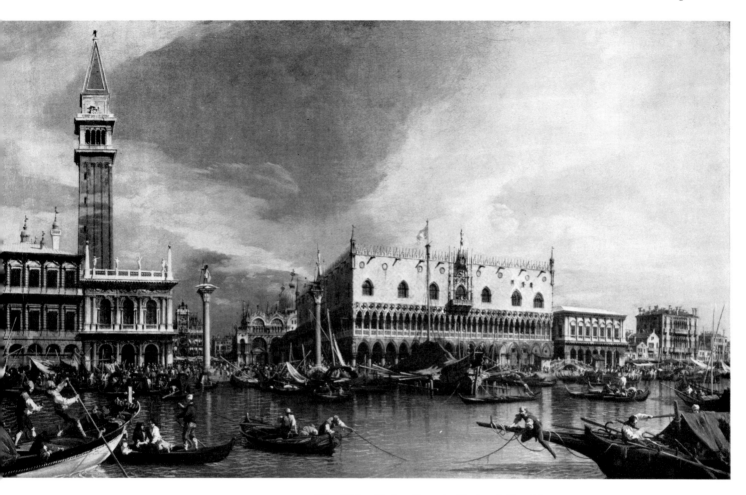

GIOVANNI ANTONIO CANAL, IL CANALETTO: *The Molo, Venice, from the Bacino di San Marco*
27×44 in. $(68.6 \times 111.8$ cm.)
Sold 27.6.75 for £52,500 ($120,750)
From the collection of Sir Norman Watson, Bt

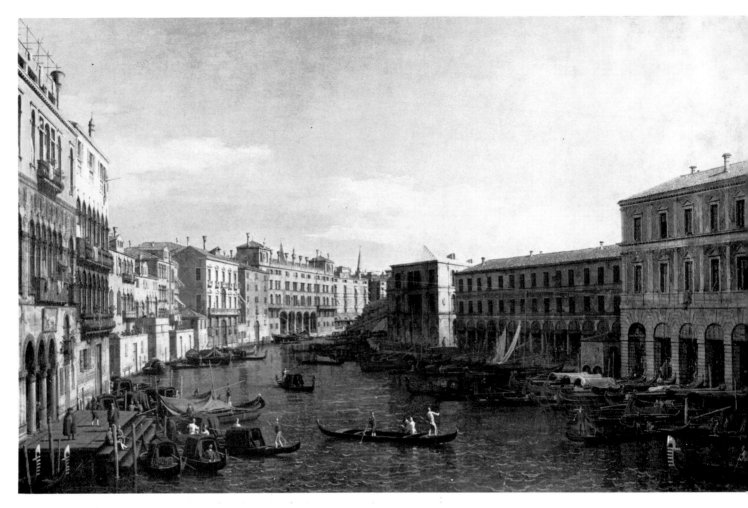

GIOVANNI ANTONIO CANAL, IL CANALETTO: *View on the Grand Canal, Venice*
$23 \times 36\frac{1}{2}$ in. (58.4×92.7 cm.)
Sold 27.6.75 for £30,450 ($70,035)
From the collection of the late Major A. F. Clarke-Jervoise, DL, JP

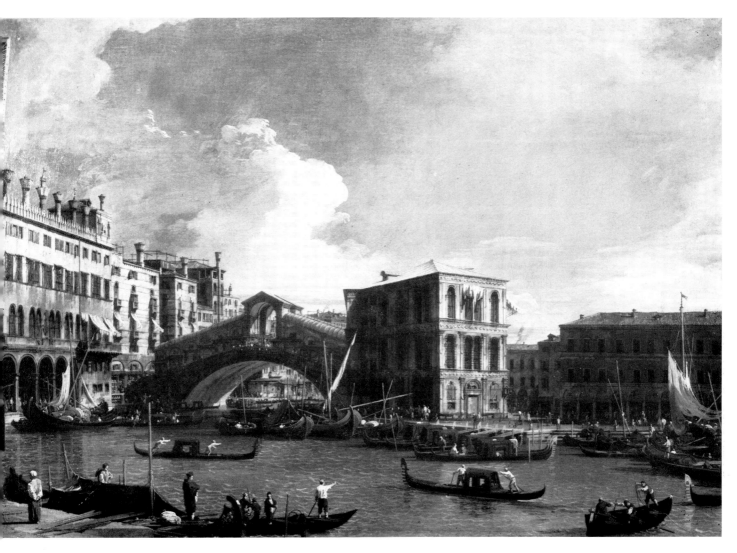

GIOVANNI ANTONIO CANAL, IL CANALETTO: *The Rialto Bridge, Venice*
$22\frac{3}{4} \times 33\frac{1}{2}$ in. (58×85 cm.)
Sold 11.4.75 for £68,250 ($156,975)

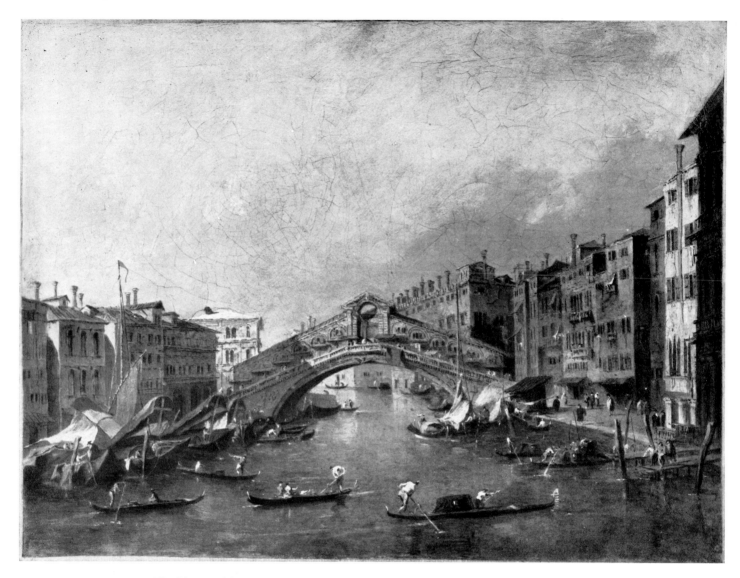

FRANCESCO GUARDI: *The Rialto Bridge, Venice*
$14\frac{1}{4} \times 19\frac{1}{2}$ in. (36.1×49.5 cm.)
Sold 11.4.75 for £27,300 ($62,790)
From the collection of The Hon. Michael Astor

FRANCESCO
GUARDI: *Quay on the
Venetian Lagoon*
Signed with initials
and inscribed with
the date 1781 on the
reverse, on panel
8 × 6¼ in.
(20.3 × 17.1 cm.)
Sold 29.11.74 for
£15,750 ($37,800)
From the collection
of the late Sir David
Ross, KBE, sold by
order of the
beneficiaries

LOUIS GAUFFIER:
*Two Views of Vallombrosa,
Tuscany*
From a set of four, all signed,
two dated 1797, and one
inscribed 'Florence'
$32\frac{1}{2} \times 45$ in. (82.5 × 114 cm.)
Sold 13.12.74 for £19,950
($45,885)
From the collection of The
Right Reverend Abbot and
Chapter of Glenstal Abbey,
Co. Limerick

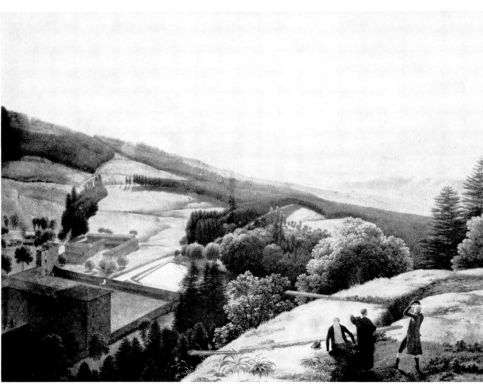

ENGLISH AND CONTINENTAL PICTURES

ANGLO-
NETHERLANDISH
SCHOOL,
c. 1495–1500:
The Archangel Gabriel
Inscribed with the
coat of arms of
Westminster Abbey
And *The Virgin
Annunciate*
Inscribed with the
coat of arms of Abbot
George Fascet
On panel, in the
original frames
9 × 33 in.
(17.8 × 83.6 cm.)
Wings of an altarpiece
Sold 20.6.75 for
£16,800 ($38,640)
Sold on behalf of the
Trustees of the 5th
Earl of Mount
Edgcumbe

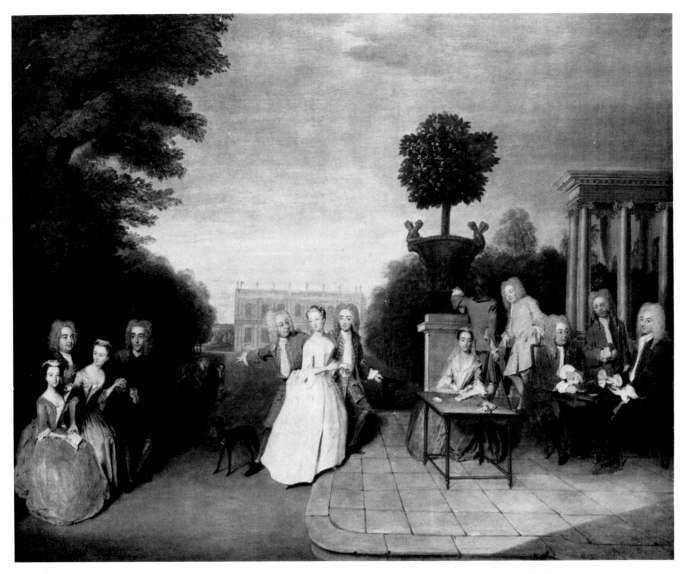

PHILIPPE MERCIER: *Party on a Terrace*, traditionally said to be at Shotover House, near Oxford
Signed and dated 1725
40½ × 49 in. (102.8 × 124.3 cm.)
Sold 22.11.74 for £30,450 ($73,100)
Record auction price for a work by this artist

The sitters are said to include Baron Schutz, his wife and Colonel Johann Schutz. The Schutz brothers were second cousins to George II, and held various Court appointments both in England and Hanover. Soon after the arrival in 1728 of Prince Frederick from Hanover, Colonel Johann Schutz was appointed the Groom of the Bedchamber while Mercier became a Gentleman of the Bedchamber. As the painting seems to have associations with Shotover, it is reasonable to assume that 'Baron Schutz' is Augustus Schutz, who in 1717 married Penelope Madam, the ward and heiress of General James Tyrell, owner at this date of Shotover House

51

Dr Clayton and his school

John Clayton (1709–73) was educated at Manchester Grammar School. He was a fellow townsman and close friend of John Byrom the poet, whose son Edward is seated cross-legged on the steps in the picture opposite. At Oxford he knew John and Charles Wesley. Leaving Oxford in 1732, he was ordained deacon at Chester. His first cure was at Sacred Trinity Chapel in Salford, where he was visited by Wesley, who preached from his pulpit on several occasions. He was a high churchman and a strong Jacobite. When the Young Pretender reached Manchester in 1745, Clayton publicly advocated the Prince's claims and offered prayers in the Collegiate Church for the Stuarts. When the Pretender was passing through Salford, it is said that he was met by Clayton, who fell on his knees and invoked divine blessing on his head.

Clayton conducted an academy at Salford for many years, drawing his pupils from wealthy Jacobite and Tory families. He so attached himself to his pupils that after his death they formed themselves into a society called the Cyprianites. At their first meeting they resolved to erect a monument to their master's memory, which still stands in Manchester Cathedral.

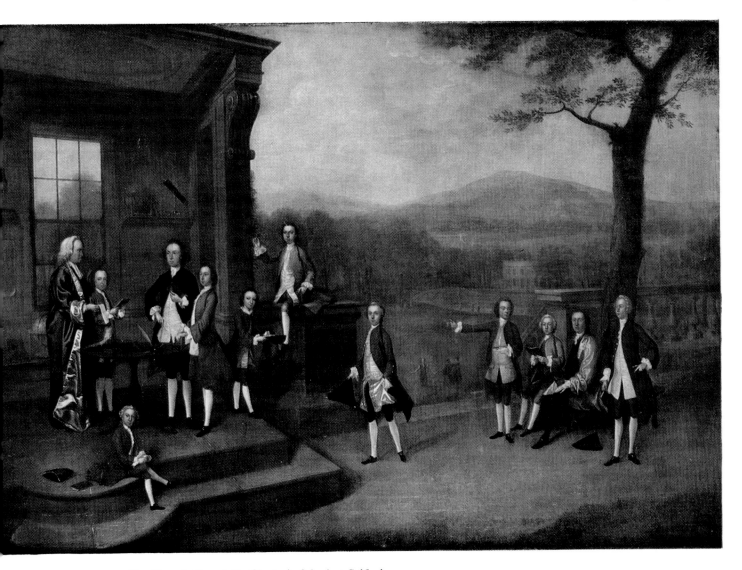

ARTHUR DEVIS: *Breaking-up Day at Dr Clayton's School at Salford*
Inscribed on an old label on the reverse
48 × 69 in. (121.8 × 175.1 cm.)
Sold 21.3.75 for £25,200 ($60,480)
Sold on behalf of the Governors of the Manchester Grammar School
The picture can be dated c. 1738

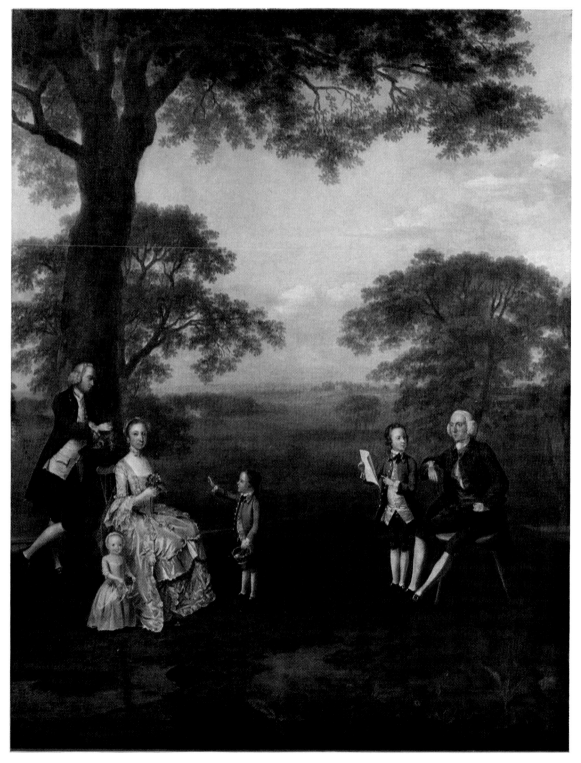

ARTHUR DEVIS: *The Clavey Family in Their Garden at Hampstead* Signed and dated 1754
49 × 39 in.
(124.4 × 99.6 cm.)
Sold 21.3.75 for
£39,900 ($95,760)

JOSEPH WRIGHT OF DERBY: *Portrait of Francis Burdett of Foremark*
Inscribed, in rococo style giltwood frame 50 × 40 in. (127 × 101.6 cm.)
One of a set of six sold 20.6.75 for a total of £59,325 ($136,447)

The six portraits of members of the Markeaton Hunt were sent for sale by Major E. P. G. Miller-Mundy, MC. They were painted for Francis Noel Clarke Mundy and are recorded in the artist's accounts among portraits c. 1762–65. Wright charged 12 gns. for each portrait. Francis Clarke Mundy succeeded to Markeaton in 1762 and the series must have been completed soon afterwards

GEORGE ROMNEY: *Portrait of Sir Robert Shore Milnes, Bt*
49 × 39 in. (124.5 × 99.5 cm.)
Sold 22.11.74 for £13,650 ($32,760)

THOMAS GAINSBOROUGH, RA: *Portrait of James
8th Earl of Abercorn*
Inscribed
87 × 55 in. (220.9 × 139.6 cm.)
Sold 20.6.75 for £18,900 ($43,470)
From the collection of the Marquess of Hamilton
Engraved by John Dean in mezzotint. Painted in 1778

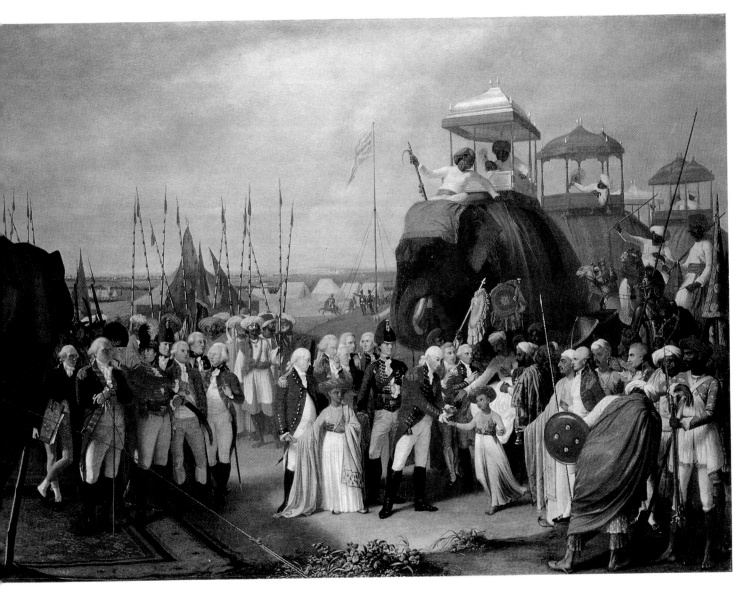

ROBERT HOME: *Lord Cornwallis Receiving Tipu Saib's Sons as Hostages, Seringapatam, 25 February, 1792*
58 × 78 in. (147.2 × 198 cm.)
Sold 20.6.75 for £27,300 ($62,790)
From the collection of the United Service and Royal Aero Club

In the *Madras Gazette*, Robert Home (1752–1834) is recorded as accompanying Lord Cornwallis on his campaign against Tipu Sultan, and making numerous sketches. On 7th October, 1794, the *Madras Hircarrah* advertised that subscriptions would be received by Mr Sharp for an engraving of a picture of the Reception of the Mysorean Hostage Princes by Marquis Cornwallis. The painting was to be sent to Europe to be engraved in the following January. On 28th February, 1795, the *Madras Gazette* announced that the same picture might be viewed at the artist's room in the Fort, and would be dispatched by the first fleet. It subsequently reached England safely and was exhibited at the Royal Academy in 1797

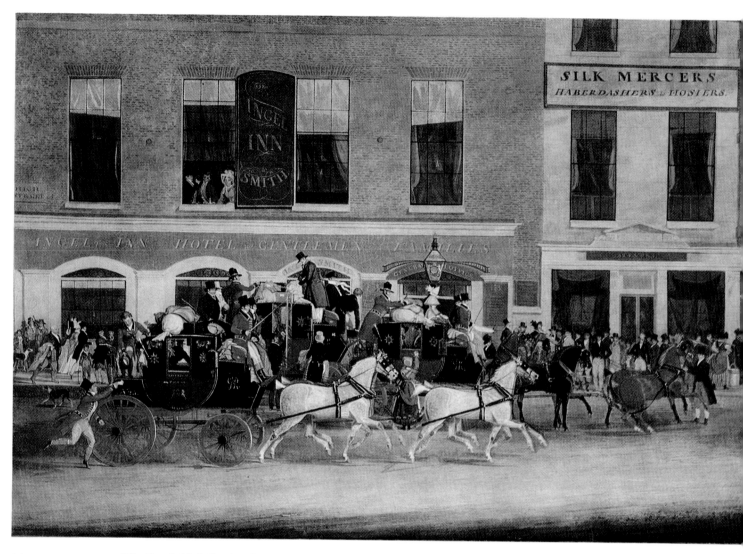

JAMES POLLARD: *The Royal Mail Coaches for the North Leaving the Angel Inn, Islington*
Signed and dated 1827
41 × 58 in. (104.1 × 147.2 cm.)
Sold 20.6.75 for £36,750 ($84,525)

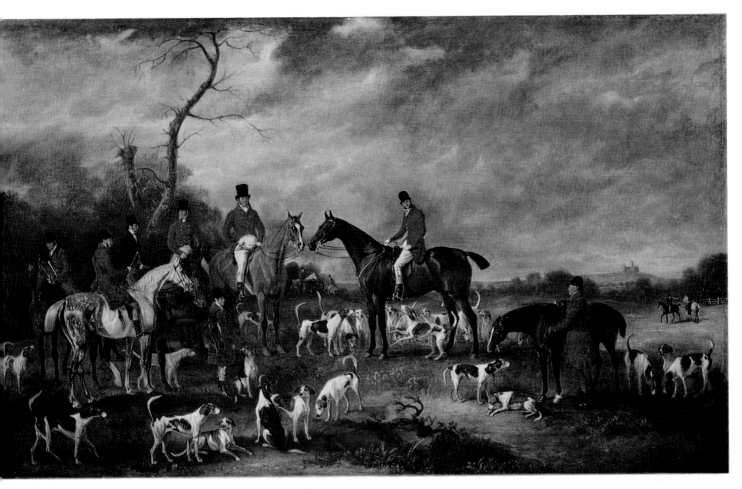

JOHN E. FERNELEY, SEN: *The Burton Hunt*
Signed and dated Melton-Mowbray 1830
60 × 97 in. (152.3 × 246.3 cm.)
Sold 22.11.74 for £57,750 ($138,600)
Sold at Christie's in 1948 for 2200 gns.
Record auction price for a work by this artist
Purchased by the Sandars Charitable Trust and the
Heslam Trust for the Usher Gallery, Lincoln

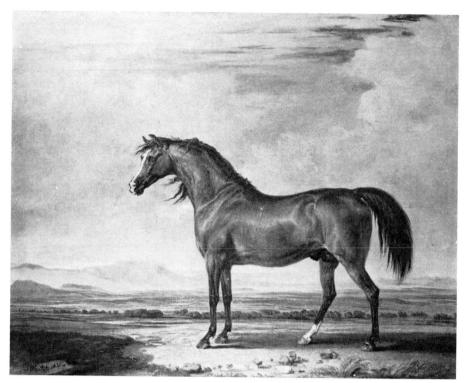

JAMES WARD, RA: '*Mameluke*'
Signed with initials and dated 1830
44 × 55½ in. (111.5 × 141 cm.)
Sold 21.3.75 for £29,400 ($70,560)
From the collection of Mrs D. Wells

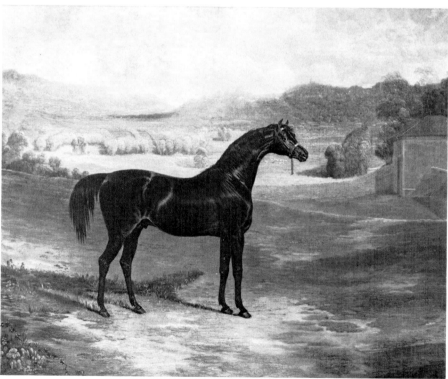

JOHN FREDERICK HERRING, SEN:
'*Jack Spigot*'
Signed, inscribed and dated 1824
40 × 50 in. (101.6 × 126.9 cm.)
Sold 21.3.75 for £14,700 ($35,280)
From the collection of Lord Bolton

SIR EDWIN LANDSEER, RA:
Mr Van Amburgh, the Lion Tamer
68 × 93 in. (172.7 × 236.2 cm.)
Sold 25.7.75 for £8400 ($18,480)
From the collection of the Duke
of Wellington, MVO, OBE, MC
Painted for the 1st Duke of
Wellington; thence by descent

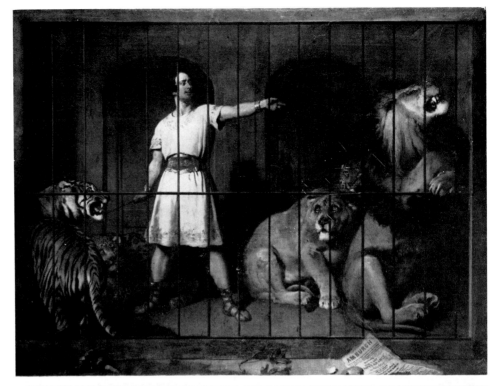

SIR JOHN EVERETT MILLAIS,
Bt, PRA: *Leisure Hours*
Portrait of Anne and Marion
Pender, daughters of Sir John
Pender
Signed with monogram and
dated 1864
33½ × 45½ in. (85.1 × 115.5 cm.)
Sold 25.7.75 for £4410 ($9702)

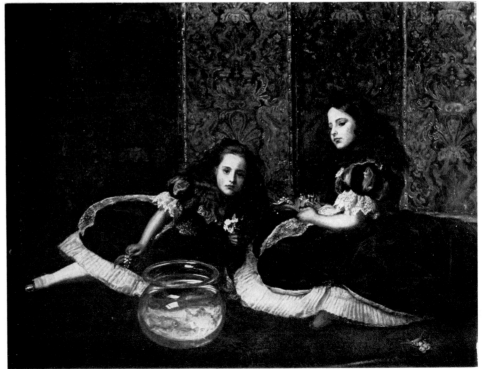

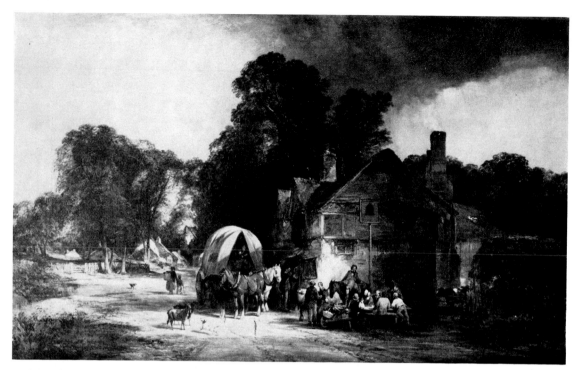

EDWARD CHARLES
WILLIAMS and
WILLIAM SHAYER:
Woody Landscape
Shaped top
30 × 50 in.
(76.2 × 127 cm.)
Sold 25.4.75 for
£4410 ($10,143)
From the collection
of Major-General
J. M. S. Pasley,
CB, CBE, MVO

THOMAS BROOKS:
The Captured Truant
Signed and dated
1854
28 × 46 in.
(71 × 116.8 cm.)
Sold 24.1.75 for
£2625 ($6300)

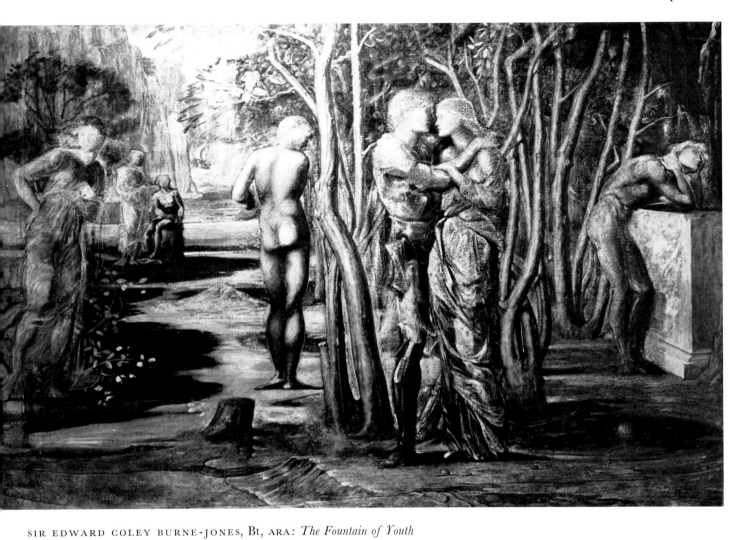

SIR EDWARD COLEY BURNE-JONES, Bt, ARA: *The Fountain of Youth*
Grisaille, unfinished
72 × 110 in. (182.8 × 279.3 cm.)
Sold 24.1.75 for £8400 ($20,160)
Sir Philip Burne-Jones, Bt, Sale of the Remaining Works of Sir Edward Burne-Jones, Bt, Christie's 5th June, 1919 (260 gns.)

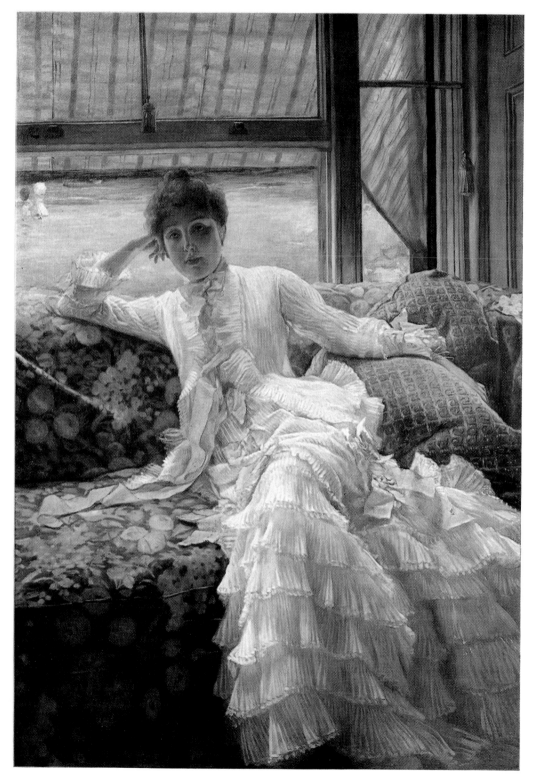

JACQUES JOSEPH TISSOT:
Seaside
Signed
$34 \times 23\frac{1}{2}$ in. (86.3×59.6 cm.)
Sold 25.7.75 for £11,550
($25,410)

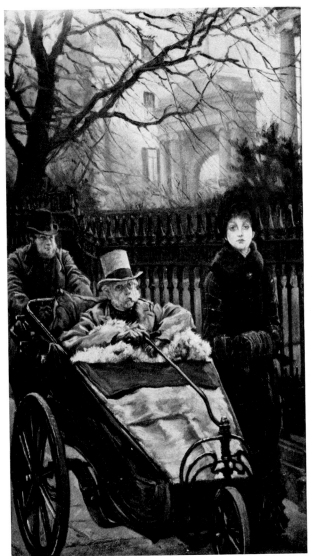

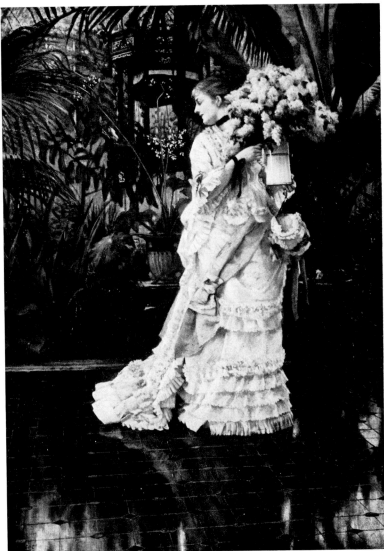

JACQUES JOSEPH TISSOT: *The Convalescent*
Signed, on panel
13 × 8 in. (34.3 × 20.3 cm.)
Sold 25.4.75 for £6825 ($15,697)
From the collection of Mrs Harry Blake-Tyler

JACQUES JOSEPH TISSOT: *The Bunch of Lilacs*
Signed
20 × 14 in. (50.8 × 35.5 cm.)
Sold 25.7.75 for £7350 ($16,170)

Frith at Homburg, 1869

To us the subject illustrated opposite may seem harmless enough – a waiter lighting a cigarette for a pretty young lady – but Frith's contemporaries thought it very shocking. Young ladies did not smoke in those days, least of all in public, and the Victorian spectator would at once have assumed that this young lady's manners and morals left much to be desired.

Frith based the picture on a scene he observed in the gardens of the Casino at Bad Homburg, a favourite Victorian spa, which he visited in 1869. While there he also began painting his large picture *The Salon d'Or at Homburg*, exhibited with great success at the Royal Academy in 1871, and now in the Rhode Island School of Design, Providence, U.S.A. The lady smoking was exhibited in 1870, and provoked a furore. Frith wrote ruefully in his autobiography, 'I think Hogarth would have made a picture of such an incident, with the addition, perhaps, of matter unpresentable to the present age. It might have adorned our National Gallery, whilst I was mercilessly attacked for painting such a subject at all.'

Frith was obviously well aware of the deadening influence of Victorian morality on painting. But there was also a strong prejudice against these so-called 'modern life' subjects. Frith's great panoramas – *Derby Day*, *Ramsgate Sands*, *The Railway Station* – were enormously popular with the public, but coolly received in artistic circles. Most cultured Victorians thought their own age hopelessly vulgar and unpicturesque. Modern life painting was not accepted in the normal canons of art, and critics almost invariably attacked it on the grounds that such prosaic, literal facts simply could not be suitable material for art. Frith however, persevered, fortunately for us, as his modern life pictures are a unique visual record of Victorian society.

WILLIAM POWELL
FRITH, RA:
At Homburg, 1869
Signed and dated
1870
Sold 18.10.74 for
£3570 ($8570)
From the collection
of Dr B. W. Rhodes

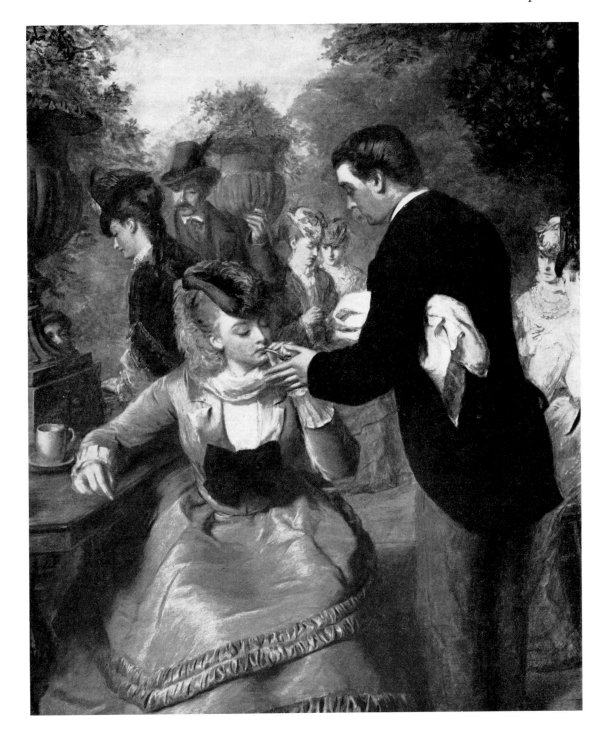

Middle Eastern interest

One important new development of this season has been the arrival of Middle Eastern buyers in the saleroom. This was reflected in the dramatically high price paid for this large and colourful work, which depicts Ibrahim Pasha (1789–1848), the ruler of Egypt, and a famous military commander, being greeted on his arrival in the Lebanon in 1831 by the Emir Bechir, the head of the Government. Ibrahim Pasha was a famous military commander and won many victories over the Ottoman armies, liberating Syria and Adaria from Turkish rule.

Apart from being the only known portrait of Emir Bechir it was an important moment in Lebanese history as during the visit the alliance between Egypt, Syria and Lebanon was consecrated.

The picture was sold at Christie's in 1969 for only £2940 ($7350).

As a result of the sale of this picture, a portrait of Ibrahim Pasha as an old man, by F. Goupil, came in for sale, and was sold on 9th May (Lot 65) for £1050 ($2415).

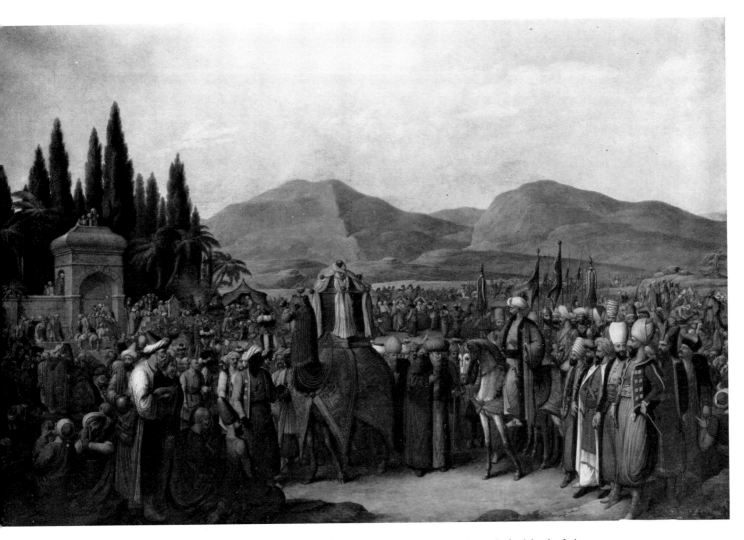

GEORG EMMANUEL OPIZ: *Emir Bechir Greeting Ibrahim Pasha upon His Triumphant Arrival in the Lebanon*
Signed
66 × 100 in. (167.5 × 254 cm.)
Sold 21.2.75 for £22,050 ($53,900)

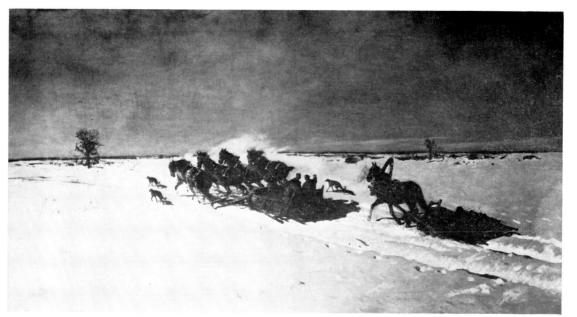

JOZEF CHELMONSKI:
*Extensive Winter
Landscape*
Signed and dated
1877
30 × 57 in.
(76.2 × 144.7 cm.)
Sold 21.2.75 for
£3570 ($8550)

CHARLES
LEICKERT:
Winter Landscape
Signed
$27\frac{1}{2} \times 39\frac{1}{2}$ in.
(69.8 × 100.3 cm.)
Sold 1.11.74 for
£3885 ($9320)
From the collection
of the late Miss Mary
von Oostveen

FREDERICK MARINUS
KRUSEMAN:
Wooded River Landscape
Signed and dated 1869
$19\frac{1}{2} \times 27$ in.
(49.5 × 68.6 cm.)
Sold 9.5.75 for £4725
($10,867)

GUGLIELMO CIARDI:
*The Harbour of Malmocco
near Venice*
Signed
$15\frac{1}{4} \times 23\frac{1}{4}$ in. (39 × 59 cm.)
Sold 9.5.75 for £5250
($12,075)

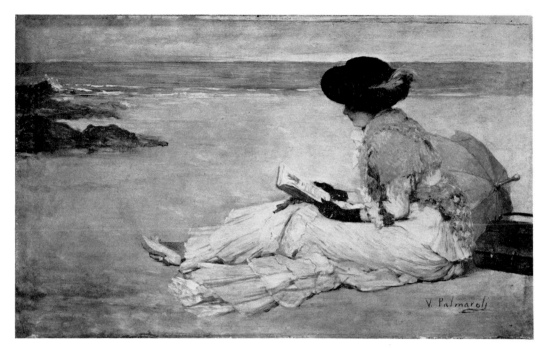

VINCENTI PALMAROLI:
Girl Reading on a Beach
Signed, on panel
7 × 12 in. (17.7 × 30.5 cm.)
Sold 1.11.74 for £2835
($6800)

GERARD PORTIELJE:
Figures Quarrelling over Cards
Signed and dated Anvers
1888, on panel
19½ × 26 in. (49.5 × 66 cm.)
Sold 9.5.75 for £5040
($11,592)

OLD MASTER AND ENGLISH DRAWINGS AND WATERCOLOURS

Drawings by Stefano della Bella

The most remarkable event in the field of Old Master drawings last year was the sale of 241 drawings by Stefano della Bella (1610–64), the Florentine artist. Stefano was one of the most inventive and prolific draughtsmen of his time and there are other substantial collections of drawings by him – in the Uffizi, the Louvre and

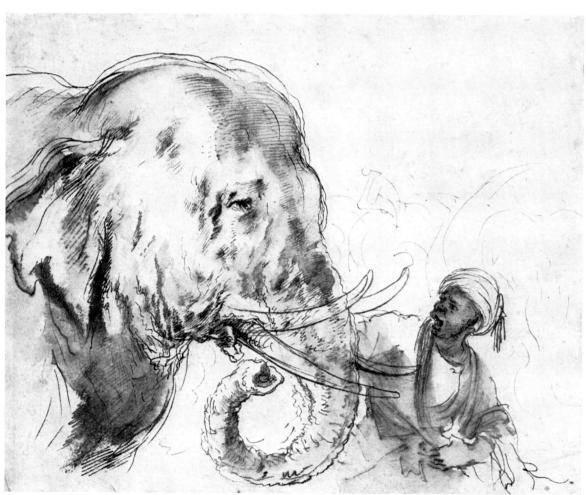

at Windsor – but those we sold, which come from an album assembled by the late 18th-century calligrapher Thomas Tomkins, had never been studied and were thus published for the first time in our catalogue.

The most spectacular feature of the collection was a series of 25 drawings for table decorations, which Stefano dedicated in 1629 at the age of 19 to one of his most influential patrons, Prince Mattias de'Medici. Unique in his known œuvre, these drawings for fanciful vases and tazze, urns and ewers are devised as if they were designs for glass, but their extraordinary complexity suggests that they were not intended for practical application (see endpapers). Nonetheless they offer fascinating evidence of the extravagance of Medici court taste which Stefano satisfied with his boundless inventive resource. But even Stefano was reluctant to waste ideas and it is not surprising that he was to draw on some of the motifs first developed in the Tomkins drawings for the series of cartouche designs etched in Paris in 1646.

The album also included a notable group of drawings of birds and animals, studies of elephants (facing page), camels (right), lions and of hounds, observed with Stefano's characteristic delicacy and wit. Many of them were deployed in etchings of the 1640s. Similarly, several of the finest of the equally extensive collection of figure studies (above right) were used for the series of large etchings of the Port of Leghorn, which Stefano published in 1655. Like the decorative and animal drawings, these studies form a coherent group. Their high quality explains why Stefano's art was so perfectly consonant with Tomkins' own fastidious sense of line.

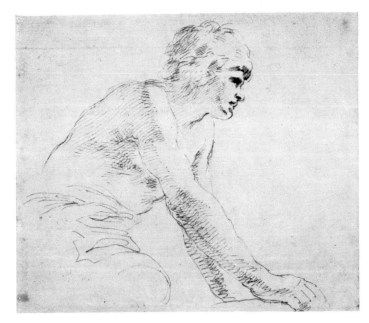

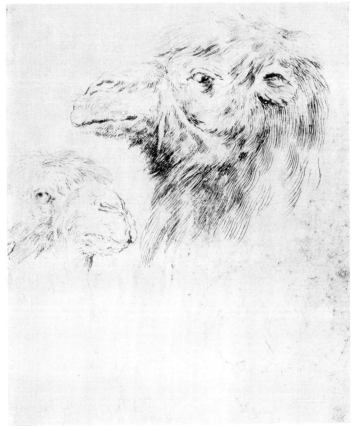

FRANCESCO MARIA
MAZZOLA, IL
PARMIGIANINO:
*The Adoration of the
Shepherds*
Black chalk
heightened with white
$9 \times 6\frac{1}{2}$ in.
(22.8×16.4 cm.)
Sold 8.7.75 for £5775
($13,282)
No related picture
survives, but this
unusually intimate
composition drawing
can be dated c. 1522,
as the reverse was
used for studies of
putti for the frescoes
at Fontanellato begun
in that year

Top left: PAOLO CALIARI, IL VERONESE: *Studies of Cybele, Groups of Putti and Venus Admonishing Cupid*
Numbered 25, and inscribed by Sir Joshua Reynolds on the reverse, pen and brown ink, brown wash
$5 \times 4\frac{1}{4}$ in. (12.7 × 10.9 cm.)
Sold 19.3.75 for £1890 ($4536)
Studies for Veronese's now much damaged frescoes in Palazzo Trevisan at Murano, executed in 1556–57

Top right: AURELIO LUINI: *Studies for an Overdoor of the Decollation of a Male Saint*
With subsidiary studies of heads and an arm (recto)
Black chalk, pen and brown ink, brown wash heightened with white on green preparation
$10 \times 7\frac{7}{8}$ in. (25.3 × 19.9 cm.)
Sold 19.3.75 for £1155 ($2772)

Bottom left: BARTHOLOMAEUS SPRANGER: *Adam and Eve*
Inscribed '. . . Spranger fecit'
Pen and brown ink, brown wash heightened with white
$9\frac{1}{2} \times 7$ in. (23.9 × 17.7 cm.)
Sold 8.7.75 for £1575 ($3622)

Bottom right: FEDERIGO ZUCCARO: *Group of Three Old Men*
Black chalk, pen and brown ink
$9\frac{7}{8} \times 7$ in. (25.1 × 17.6 cm.)
Sold 8.7.75 for £1155 ($2656)

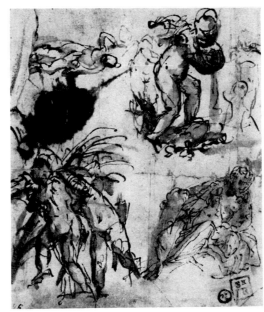

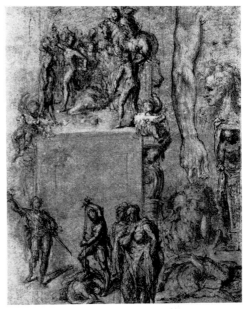

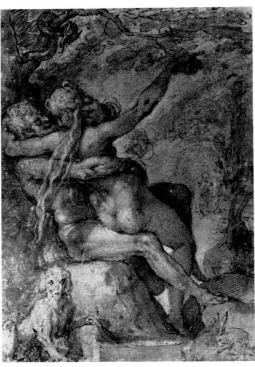

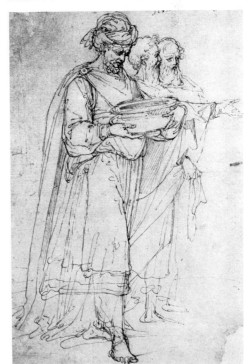

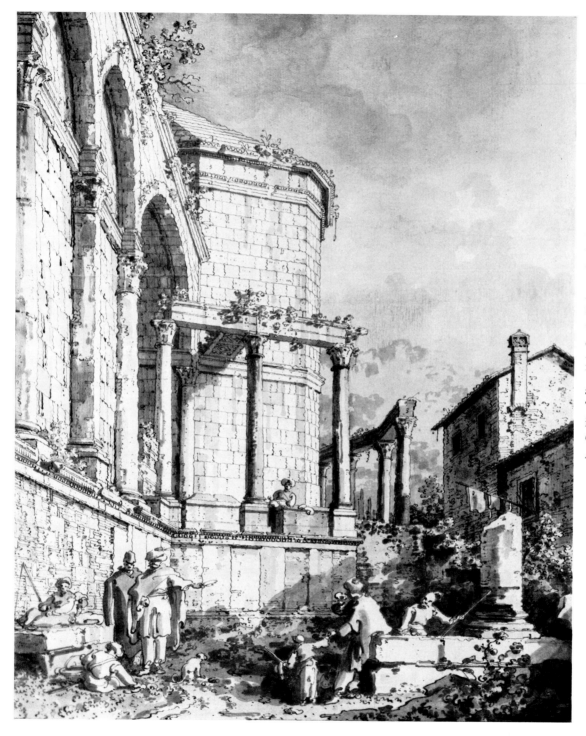

GIOVANNI CANAL,
IL CANALETTO:
*The Mausoleum of
Diocletian at Spalato*
Black chalk, pen and
brown ink, grey wash
16¾ × 13⅝ in.
(42.5 × 34.6 cm.)
Sold 19.3.75 for
£10,500 ($25,200)
Based on the view of
the Mausoleum
engraved for Robert
Adam's *Ruins of the
Palace of the Emperor
Diocletian at Spalato,*
1764
Adam visited
Spalato in 1757 and
the preparatory
drawings for his
publication were in
Venice between 1757
and 1760.
The present drawing
is the only evidence of
Canaletto's interest in
Adam's project

MARCO RICCI: *Two Horsemen Disturbing Geese and a Child on Their Arrival at a Farm*
Bodycolour on leather
$12\frac{3}{8} \times 18\frac{1}{8}$ in. (31.4×46 cm.)
Sold 26.11.74 for £6825 ($16,380)
From the collection of Sir Christopher Beauchamp, Bt
This and the companion illustrated below belong to a series of five gouaches formerly in the collection at Langley Park, Norfolk, and may have been purchased during his residence in Venice by George Proctor who purchased the house in 1742

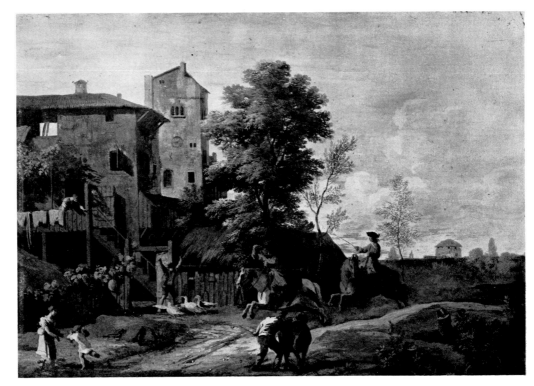

MARCO RICCI: *Washerwomen and a Horseman in a Yard with Two Columns near a Domed Church*
Bodycolour on leather
$12\frac{3}{8} \times 18\frac{1}{8}$ in. (31.4×46 cm.)
Sold 26.11.74 for £7350 ($17,640)
From the collection of Sir Christopher Beauchamp, Bt
A related drawing and a similar gouache from the collection of Consul Smith are at Windsor

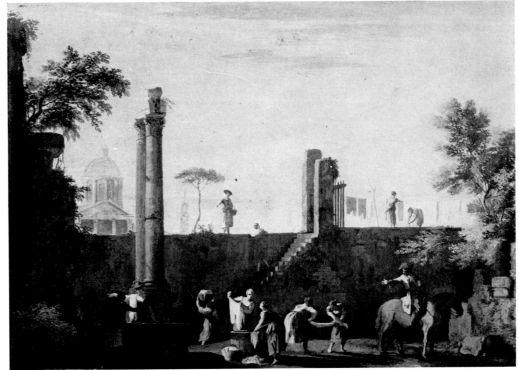

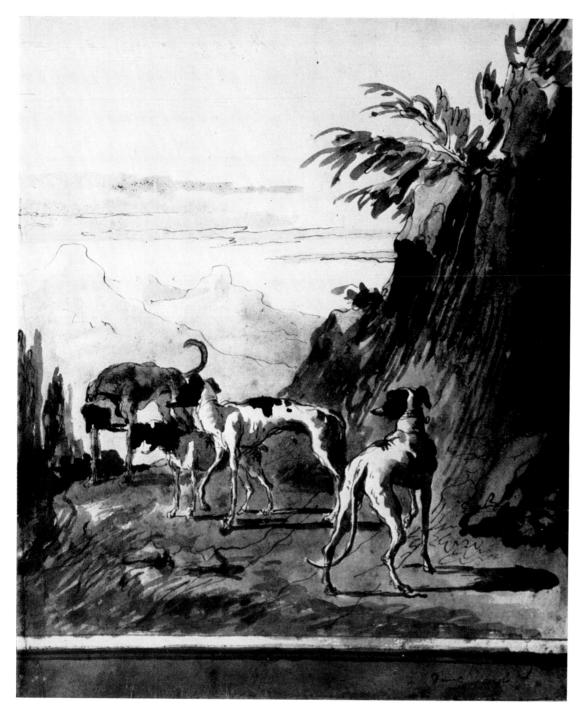

GIOVANNI
DOMENICO
TIEPOLO: *Four
Greyhounds on a Path*
Signed, pen and grey
ink, grey wash
$9\frac{1}{4} \times 7\frac{5}{8}$ in.
(23.5 × 19.4 cm.)
Sold 8.7.75 for £2730
($6279)
One of a group of
studies of dogs in
landscape settings
which have been
associated with
Domenico's work in
the Villa Tiepolo-
Duodo at Zianigo

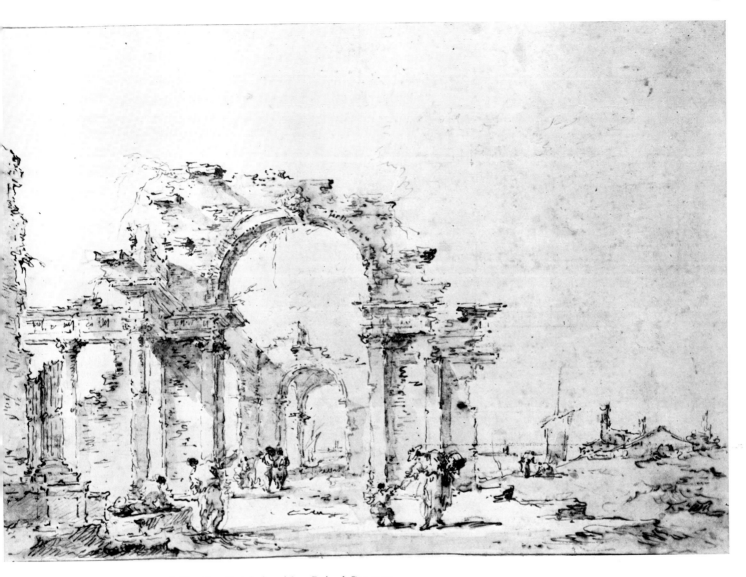

FRANCESCO GUARDI: *A Venetian Capriccio with a Ruined Gateway*
Black chalk, pen and brown ink, brown wash
$10\frac{3}{4} \times 15\frac{1}{8}$ in. (27.4×38.4 cm.)
Sold 19.3.75 for £8925 ($20,527)
Closely related to a picture formerly in the Mannheim Collection, Paris

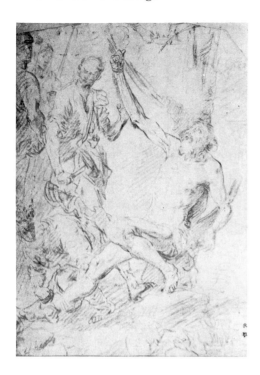

Left: GIUSEPPE DE RIBERA, LO SPAGNOLETTO: *The Martyrdom of Saint Bartholomew*
Red chalk, $10\frac{1}{8} \times 7\frac{5}{8}$ in. (25.8 × 19.3 cm.)
Sold 8.7.75 for £1260 ($2898)
Formerly in the collections of Sir Peter Lely, Jonathan Richardson, Sen., and John Barnard

Below left: GAETANO GANDOLFI: *Portrait of a Little Girl*
Black, red and white chalk on buff paper
$11\frac{1}{2} \times 8$ in. (29.4 × 20.3 cm.)
Sold 26.11.74 for £840 ($2016)
From the collection of Princess Lee Radziwill

Below centre: SCHOOL OF HAARLEM C. 1630: *Cloaked Gentleman, Seen from Behind, with a Lady*
Black and white chalk on grey paper, $13\frac{1}{4} \times 8$ in. (33.8 × 20.2 cm.)
Sold 8.7.75 for £1680 ($3864)
From the collection of Monsieur Paul Philippson, MBE

Below right: BARTOLOME ESTEBAN MURILLO: *The Immaculate Conception*
Inscribed 'Bartolome Murillo f.' and numbered 46
Pen and brown ink, brown wash, $12\frac{1}{2} \times 8\frac{3}{4}$ in. (31.8 × 22.3 cm.)
Sold 19.3.75 for £1575 ($3780)
From the collection of P. G. Palumbo, Esq
A preliminary study for the picture formerly in the Lansdowne Collection at Bowood

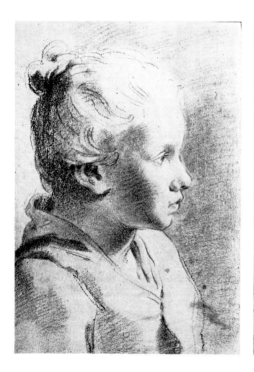

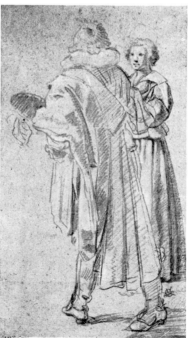

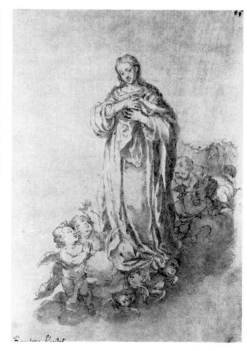

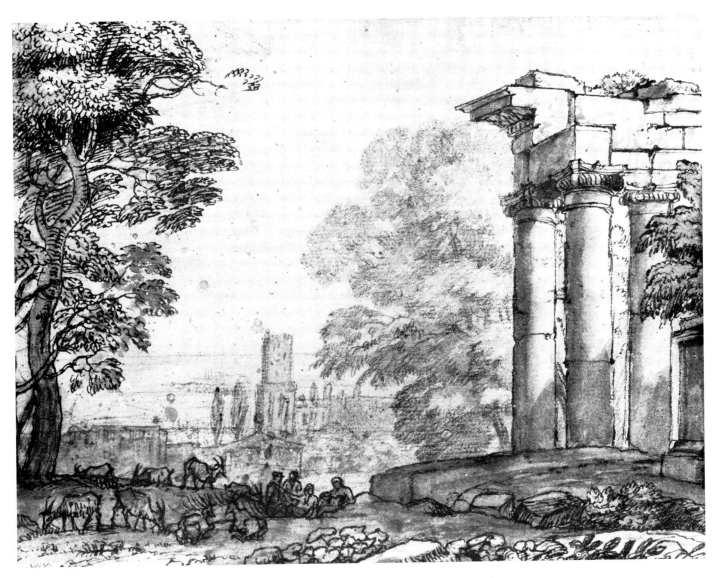

CLAUDE GELLEE, LE LORRAIN: *Landscape with a Ruined Portico, Trees and Pastoral Figures*
Black chalk, pen and brown ink, brown wash heightened with white on pink preparation
8 × 10½ in. (20.2 × 26.7 cm.)
Sold 8.7.75 for £9450 ($21,735)
Formerly in the collection of John Barnard
This characteristic capriccio is datable c. 1650–55. The buildings recall the Temple of Saturn in the Roman Forum and the
Torre de Milizie

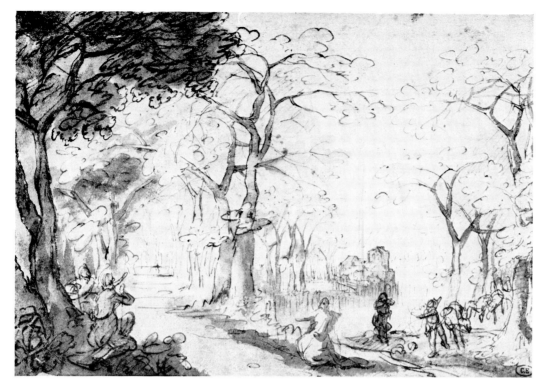

DAVID VINCKEBOONS:
Road by a Lake, with Elijah Mocked
Black chalk, pen and brown ink and watercolour
$7\frac{3}{4} \times 11\frac{1}{2}$ in.
(19.7 × 29.3 cm.)
Sold 8.7.75 for £1680
($3864)

JAN WELLENS DE COCK:
Extensive Estuary Landscape with Saint Christopher
Pen and brown ink, brown wash heightened with white on blue preparation
$11\frac{3}{8} \times 17\frac{1}{8}$ in.
(29 × 43.4 cm.)
Sold 26.11.74 for £2100
($5040)
A related drawing is in the Louvre and landscapes which probably belong to the same series are at Darmstadt and in the Uffizi

ESAIAS VAN DE
VELDE: *Peasants on a
River Bank Opposite a
Farm*
Signed and dated
1629
Black chalk, grey wash
$7\frac{5}{8} \times 12\frac{3}{8}$ in.
(19.3 × 31.4 cm.)
Sold 8.7.75 for £3675
($8452)

SIR PETER PAUL
RUBENS: *The Miracle
of the Lame Man
Healed by Saint Peter
and Saint John*
Pen and brown ink,
brown wash
heightened with white
and oil paint on
paper partly prepared
with red chalk
$9\frac{7}{8} \times 15\frac{1}{4}$ in.
(24.9 × 38.6 cm.)
Sold 8.7.75 for £3675
($8452)
From the collection
of H. L. Constant,
Esq, of Cape Town,
S. Africa
Based on
Parmigianino's
etching after
Raphael's tapestry
design, this drawing
was probably
executed c. 1602.
It was sold at
Christie's in 1902 for
15 gns. and in 1934
for 14 gns.

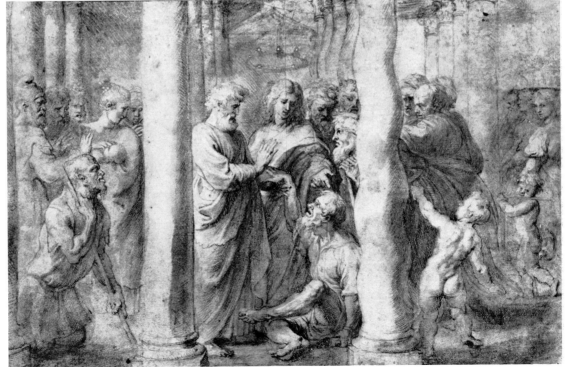

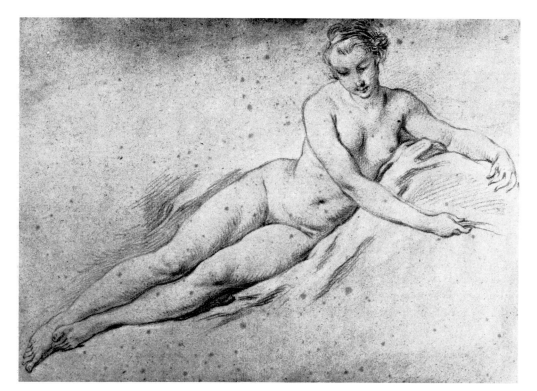

FRANÇOIS BOUCHER:
Reclining Female Nude
Red chalk and traces of white
chalk on light brown paper
$12 \times 16\frac{5}{8}$ in. (30.5 × 42.2 cm.)
Sold 8.7.75 for £3570 ($8211)
From the collection of
Anthony Freire Marreco, Esq
An unrecorded study for
Boucher's *Death of Adonis*
Previously known from an
offset in an American
collection

GABRIEL JACQUES DE
SAINT-AUBIN: *The Marriage
of Merope and Polyphonte*
Signed, black and red chalk
heightened with white on buff
paper
$13\frac{1}{4} \times 19\frac{7}{8}$ in. (33.8 × 50.5 cm.)
Sold 19.3.75 for £6825
($16,380)
An illustration to Voltaire's
tragedy, *Mérope*, first
performed in 1743

Hogarth gave full rein to his satyrical humour in this drawing, commissioned by Joshua Kirby, for his *Dr Brook Taylor's Method of Perspective Made Easy Both in Theory and Practice*, published in 1754. The drawing passed through the collections of Samuel Ireland, William Esdaile, H. P. Standly, and Dr Percy and was sold in these rooms in 1840, 1845 and again in 1890 for sums between £1. 2s. and 10 gns.

Similarly, Hogarth's drawing of *Hudibras Beating Sidrophel* (see illustration page 88), engraved for Samuel Butler's *Poem of Hudibras*, 1725, plate VIII, has been in several distinguished collections. It passed through our rooms in 1831 and 1845, being sold for 11½ and 9½ gns.

WILLIAM HOGARTH: *Frontispiece to Joshua Kirby's 'Dr Brook Taylor's Method of Perspective Made Easy'*
Pen and grey and brown ink, grey and pale brown wash
8¾ × 6⅝ in. (21.2 × 16.8 cm.)
Sold 17.6.75 for £2940 ($6762)
From the collection of Mrs M. A. Steele

WILLIAM HOGARTH:
Hudibras Beating Sidrophel
Pen and brown ink, grey
wash
$9\frac{1}{8} \times 13\frac{1}{8}$ in.
(23.2 × 33.4 cm.)
Sold 17.6.75 for £3990
($9177)
From the collection of
Mrs M. A. Steele
Engraved by the artist as
Plate VIII for Samuel
Butler, *Poem of Hudibras*,
1725

THOMAS ROWLANDSON:
Greenwich
Inscribed on the reverse
'Cabbage – 1, Mustard
P – 3', pen and grey ink
and watercolour
Sold 17.6.75 for £1995
($4588)

THOMAS WRIGHT: *View of Stoke Gifford* and *Plan of Swan Grove Walks at Badminton* from an album entitled *Sketches and Designs of Planting*
Pencil, pen and brown ink
Sold 5.11.74 for £3150 ($7560)

Thomas Wright (1711–86), architect and astronomer, was one of the most influential garden designers of the mid-18th century. This previously unrecorded album was evidently intended as a treatise on garden design and contains drawings relating to several of Wright's most important projects and to four gardens, Chew Hill, Wrest, Cassiobury and Phoenix Park, Dublin, with which his connection is otherwise undocumented

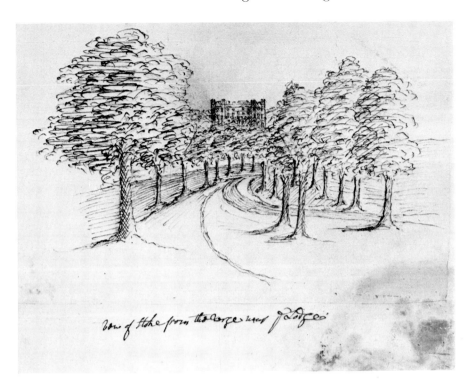

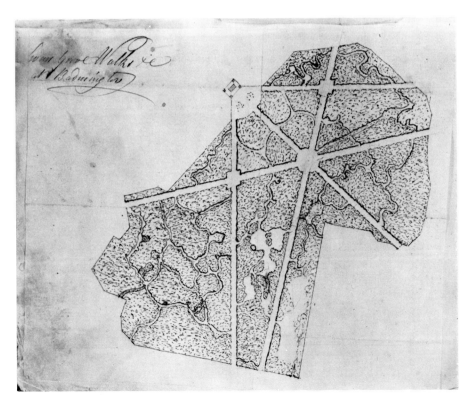

JOHN ROBERT COZENS: *The Lake of Nemi*
Signed, inscribed on the reverse, and dated 1790, pencil and watercolour
$14\frac{1}{2} \times 21$ in. (37×53.4 cm.)
Sold 4.3.75 for £8925 ($21,420)

THOMAS GIRTIN: *Caervarvon Castle from the East, with Fishing Boats and Figures in the Foreground*
Signed and dated 1800, pencil and watercolour
12 × 20 in. (30.5 × 50.8 cm.)
Sold 4.3.75 for £6090 ($14,616)

RICHARD PARKES BONINGTON: *Le Pont Royal, Paris*
Pencil and watercolour
$5\frac{5}{8} \times 9\frac{1}{2}$ in. (14.3 × 24 cm.)
Sold 17.6.75 for £11,550 ($26,565)
From the collection of Peter Dangar Esq, of Armidale, New South Wales

This drawing was lithographed by J. D. Harding for *Subjects from the Works of the late R. P. Bonington*, 1830. It was formerly in the collection of H. A. J. Monro of Novar and dates from the last two years of Bonington's life, 1827–28, when he was living in Paris

JOSEPH MALLORD WILLIAM TURNER, RA: *Boston*
Watercolour heightened with white
$11\frac{3}{8} \times 16\frac{5}{8}$ in. (29 × 42.2 cm.)
Sold 5.11.74 for £16,800 ($40,320)
From the collection of Mrs J. V. Fisher
Sold at Christie's in 1895 for 290 gns
Engraved for T. Jeavons, *Picturesque Views in England and Wales*, Vol. II, 1838

JOHN NIXON: *Francis Grose on Howth Heath with a View of Ireland's Eye and Lambay*
Inscribed, watercolour
$7\frac{3}{8} \times 10\frac{1}{4}$ in. (19.6 × 26 cm.)
Sold 5.11.74 for £388.50
($922)
Sold on behalf of the Governor and Directors of the French Hospital of La Providence

DAVID COX: *Boulogne*
Pencil and watercolour
$5\frac{3}{4} \times 8\frac{3}{4}$ in. (15 × 22.2 cm.)
Sold 5.11.74 for £3150
($7560)

HENRY EDRIDGE, ARA: *Lady Elizabeth and Lady Charlotte Bingham, Daughters of the 2nd Earl of Lucan*
Signed and dated 1803, pencil and watercolour
$12\frac{3}{4} \times 9\frac{1}{4}$ in. (32.4 × 23.5 cm.)
Sold 17.6.75 for £735 ($1690)

GEORGE JOHN PINWELL: *In a Garden (at Cookham)*
Signed with initials, water and bodycolour
$7\frac{1}{2} \times 5\frac{5}{8}$ in. (19.1 × 14 cm.)
Sold 15.10.74 for £787.50 ($1890)

CLARKSON STANFIELD, RA:
Caen
Watercolour
$8\frac{3}{4} \times 11\frac{7}{8}$ in. (22.2 × 30.2 cm.)
Sold 17.6.75 for £945 ($2173)

MYLES BIRKET FOSTER:
Returning from Market
Signed with monogram
Watercolour heightened with
white
$9\frac{3}{4} \times 13\frac{3}{4}$ in. (24.8 × 35 cm.)
Sold 20.5.75 for £1470
($3381)
From the collection of the late
F. I. Edwards, Esq

OLD MASTER
AND
MODERN PRINTS

ALBRECHT DÜRER: *The Passion* (B., M., Holl. 3–18)
Engravings, two of the set of sixteen plates
Sold 4.12.74 for £7350 ($17,640)

ALBRECHT DÜRER:
Hercules or *The Effects of Jealousy*
(B. 73; M., Holl. 63)
Engraving, a fine
Meder II A impression
Sold 4.12.74 for £2940
($7060)

ALBRECHT DÜRER:
*The Assumption and
Coronation of the Virgin*
(B. 94; M., Holl. 206)
Woodcut, a fine
impression before the
text of 1511
Sold 4.12.74 for £1260
($3024)

ALBRECHT DÜRER:
*The Virgin Surrounded by
Many Angels*
(B. 101; M., Holl. 211)
Woodcut, a very fine
Meder A impression
Sold 2.7.75 for £1890
($4347)

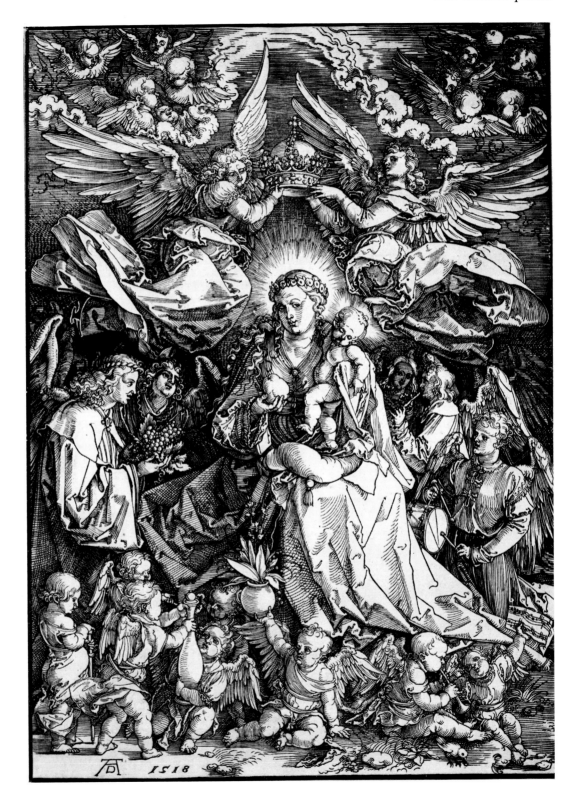

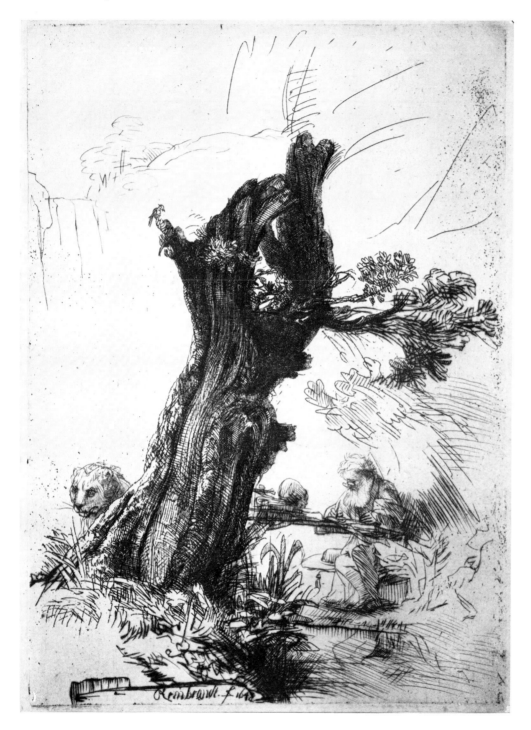

REMBRANDT HARMENSZ.
VAN RIJN: *Saint Jerome Beside
a Pollard Willow*
Etching and drypoint, second
(final) state
Sold 2.7.75 for £2940 ($6762)

REMBRANDT
HARMENSZ. VAN
RIJN: *Medea* or *The*
Marriage of Jason and
Creusa
(B., Holl. 112; H. 235)
Etching, fourth state
(of five)
Sold 4.12.74 for
£2100 ($5040)

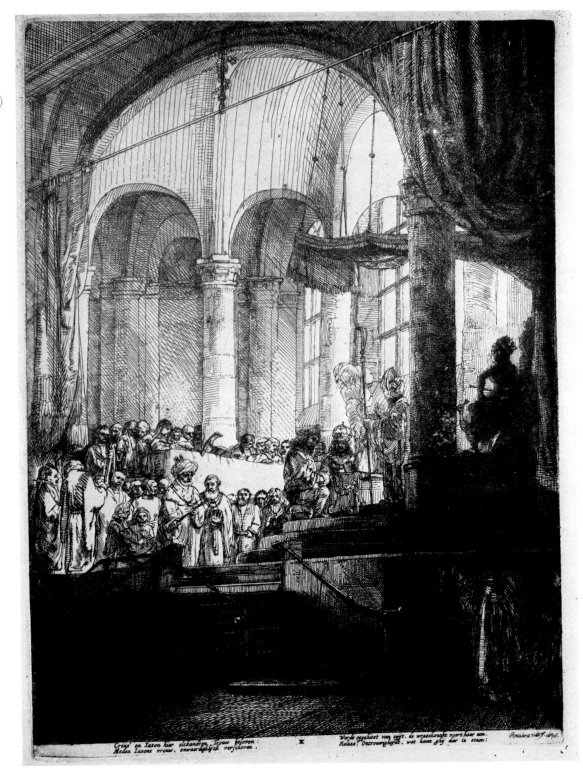

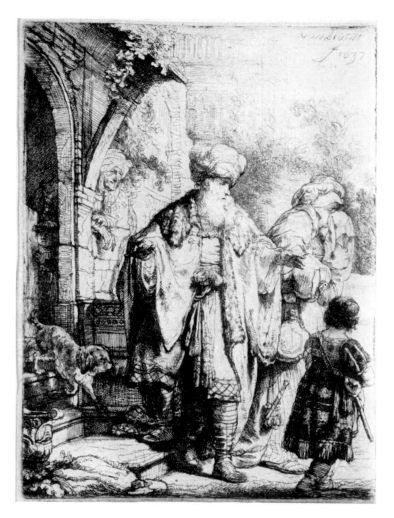

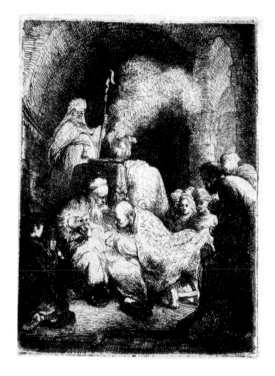

REMBRANDT HARMENSZ. VAN RIJN:
The Circumcision (B., Holl. 48; H. 19)
Etching, only state
Sold 4.12.74 for £630 ($1512)

REMBRANDT HARMENSZ. VAN RIJN:
Abraham Casting out Hagar and Ishmael (B., Holl. 30; H. 149)
Etching, only state
Sold 4.12.74 for £1365 ($3276)

ADRIAEN VAN
OSTADE: *The Painter*
(B., Holl. 32)
Etching, ninth state
(of twelve)
Sold 4.12.74 for £399
($958)

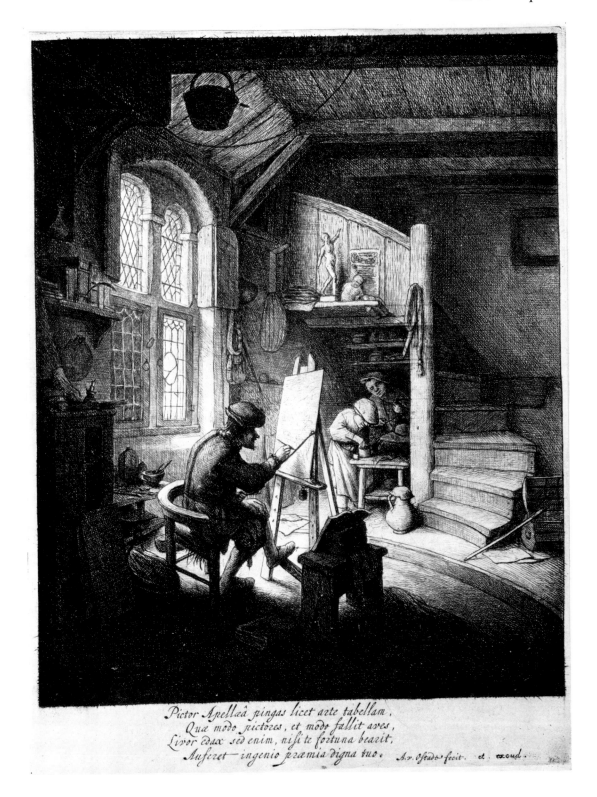

Pictor Apellaâ pingas licet arte tabellam,
Qua modo pictores, et modo fallit aves,
Livor edax sed enim, nisi te fortuna bearit,
Auferet — ingenio præmia digna tuo. A.v. ostade fecit. et excud.

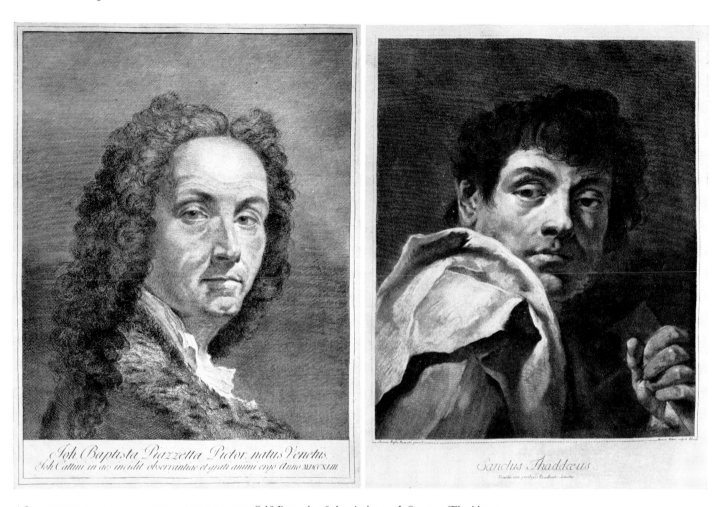

After GIOVANNI BATTISTA PIAZZETTA: *Self-Portrait of the Artist* and *Sanctus Thaddaeus*
From a volume incorporating two sets of engravings by Marco Pitteri and others
Sold 2.7.75 for £3150 ($7245)

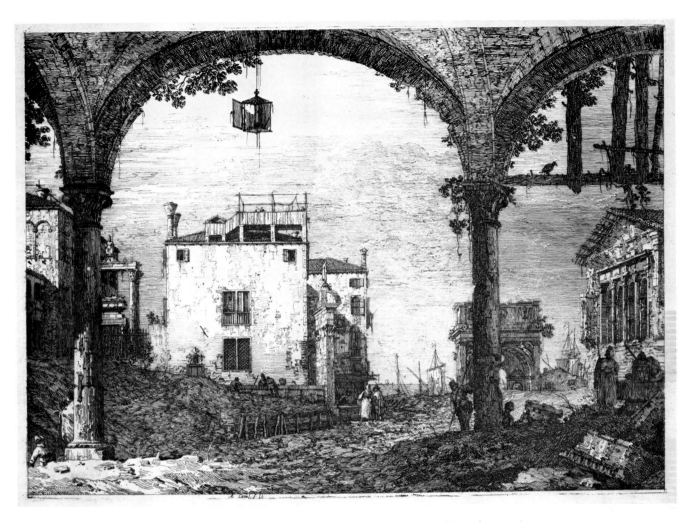

GIOVANNI ANTONIO CANAL, IL CANALETTO: *The Portico with the Lantern* (Bromberg 10)
Etching, second state (of three)
Sold 25.3.75 for £1155 ($2772)

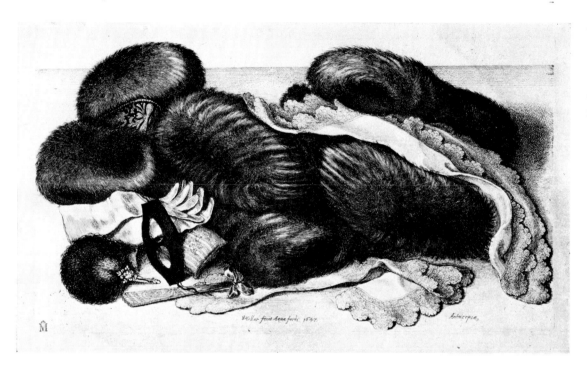

WENZEL HOLLAR:
Muffs and Finery
(P. 1951)
Etching
Sold 2.7.75 for
£997.50 ($2294)

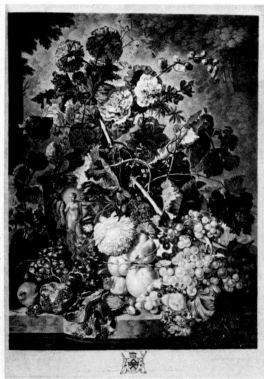 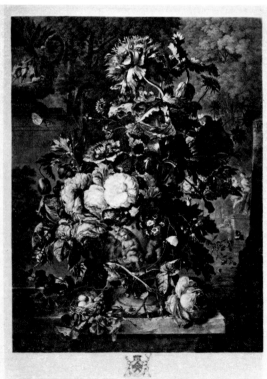

RICHARD EARLOM:
*Still Life with Flowers
and Fruit* and *Still Life
with Flowers and a
Bird's Nest*
After Jan van
Huysum, published
by J. Boydell, 25th
June, 1778, and 1st
September, 1781
Mezzotints
Sold 30.7.75 for £924
($2033)
Sold on behalf of the
Estate of the late
Mrs Marguerite
P. Wolf

JOHANN LUDWIG
ABERLI: *La Ville de Berne
du Côté du Nord*
One of nine views in
Switzerland
Coloured etchings
Sold 20.5.75 for £3780
($8694)

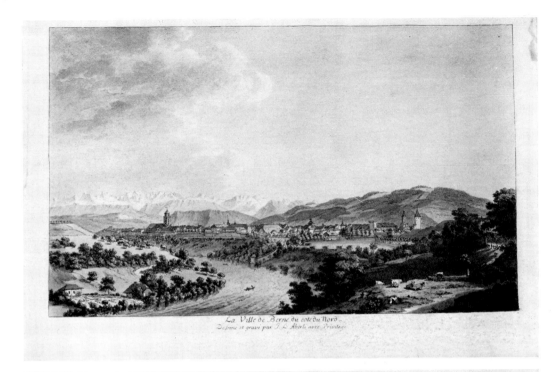

THOMAS AND WILLIAM
DANIELL, RA: *Mausoleum
of Kausim Solemanke at
Chunar Gur*
From *Oriental Scenery*: Part
IV (Abbey, Travel II, 420
nos. 76–100)
Coloured aquatints, 1801–03,
title and set of 24 plates
Sold 20.5.75 for £1155
($2656)
From the collection of the
Thomas Coram Foundation

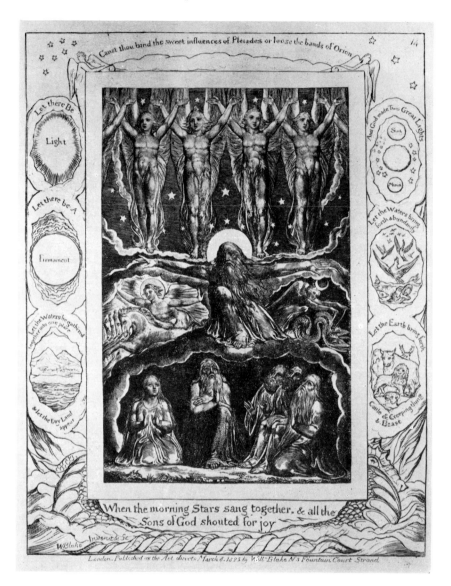

WILLIAM BLAKE: *When the morning Stars sang together . . .*
From Illustrations of the Book of Job, the engraved title and set of 21
plates, after removal of the word 'Proof'
Sold 29.10.74 for £2520 ($6048)

GEORGE RICHMOND, RA:
The Fatal Bellman
Engraving, 1827, printed on vellum, with
the word 'Proof' in the lower margin
Sold 25.3.75 for £493.50 ($1184)
From the collection of Anton Lock, Esq

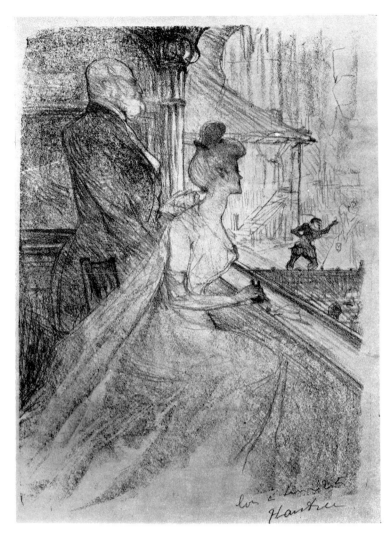

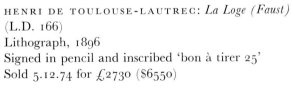

HENRI DE TOULOUSE-LAUTREC: *La Loge (Faust)*
(L.D. 166)
Lithograph, 1896
Signed in pencil and inscribed 'bon à tirer 25'
Sold 5.12.74 for £2730 ($6550)

JAMES ABBOTT MCNEILL WHISTLER: *The Toilet*
(Way 6)
Lithotint, 1878, first state
Signed with the butterfly monogram, one of about
twelve impressions of this state
Sold 2.7.75 for £651 ($1497)

GEORGES ROUAULT:
Amazone, from
illustrations to
André Suarès, *Cirque*
(Bellini 71–8)
Aquatints, 1930–38
The set of eight
completed plates
printed in colours
Sold 2.7.75 for £2940
($6762)

GEORGES ROUAULT: *Nu de Profil*, from *Les Fleurs du Mal*, Roger Lacourier, 1945 (Bellini 119–20)
Aquatints, 1936–38
The set of 12 printed in colours
Sold 2.7.75 for £3990 ($9177)

ERNST LUDWIG KIRCHNER: *Selbstbildnis mit Erna* (Dube 634)
Woodcut, 1933, on Japan, first state (of two)
Signed in ink and inscribed 'Eigendruck', dedicated to 'Herrn
G. Schiefler Dez 33 freundlichkeit von EL Kirchner'
Sold 5.12.74 for £1470 ($3528)

EMIL NOLDE: *Tingel-Tangel II*
(Schiefler 26)
Lithograph, 1907, printed in black, blue
and mauve on thick Chine, 1915
(second state)
Signed in pencil, inscribed 'Auflage Nr. 3'
(of twelve)
Sold 5.12.74 for £1890 ($4536)

CHRISTOPHER RICHARD WYNNE NEVINSON, ARA:
Swooping down on a Taube
Lithograph, 1917
Signed in pencil, numbered 101
Sold 29.10.74 for £147 ($353)

Below right: EDWARD GORDON CRAIG:
Twelve Etchings, Florence, 1907
Complete with folded printed leaf and 12 mounted etchings, each
signed with initials in pencil on the tab, number 13 of 30 copies
Initialled in ink on the justification, contained in the original cloth
portfolio
Sold 25.3.75 for £630 ($1512)

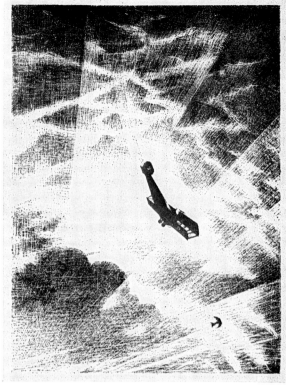

GEORGE GROSZ:
Friedrichstrasse
Lithograph, 1917
Signed in pencil
Numbered 8
Sold 5.12.75 for £472.50
($1134)

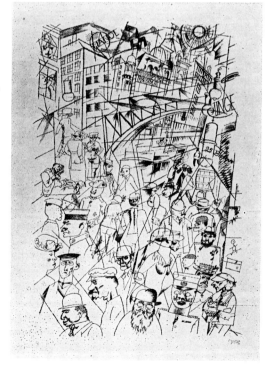

PAUL KLEE: *Pflanzen Nachts im Regen*
(Kornfeld 57)
Etching on zinc, 1913, only state
Signed and titled 'Regen Nachts' in
pencil, inscribed
One of very few impressions
Sold 2.7.75 for £1050 ($2415)

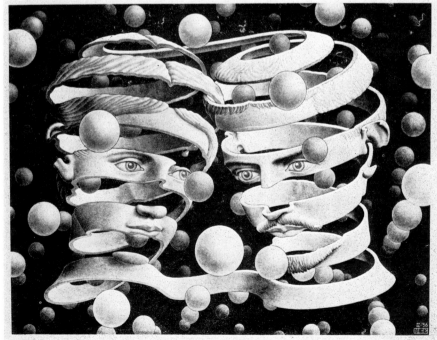

MAURITS CORNELIS ESCHER: *Bond of
Union* (Oldbourne 46; Locher 212)
Lithograph, 1956
Signed in pencil and numbered 17/52 II
Sold 2.7.75 for £682.50 ($1569)

IMPRESSIONIST,
NINETEENTH- AND
TWENTIETH-CENTURY
PICTURES
AND SCULPTURE

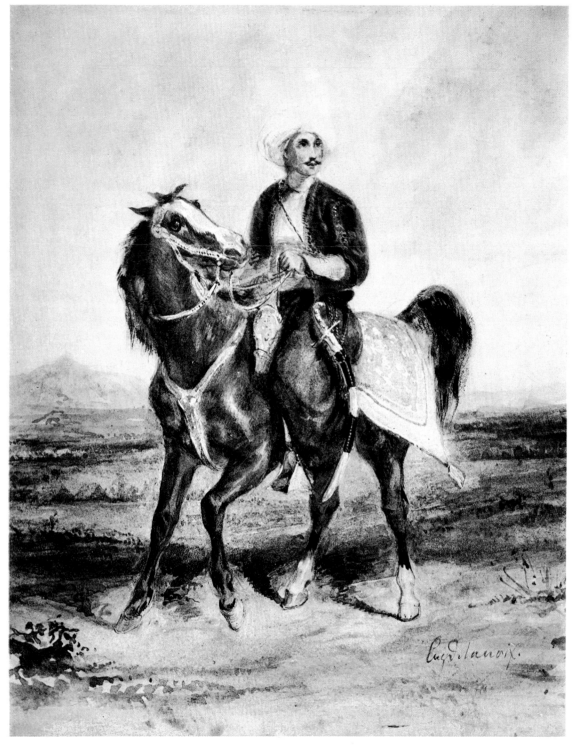

EUGENE
DELACROIX:
Cavalier Turc
Signed, watercolour
Painted c. 1825
$10\frac{1}{4} \times 8\frac{1}{4}$ in.
(26 × 21 cm.)
Sold 15.4.75 for
£18,900 ($45,360)
From the collection
of the B. E. Bensinger
Family

HONORE DAUMIER:
Les Deux Confrères
Signed, watercolour with
pen and black ink
$11\frac{1}{4} \times 8\frac{1}{4}$ in.
$(28.5 \times 21$ cm.)
From the collection of
the B. E. Bensinger
Family

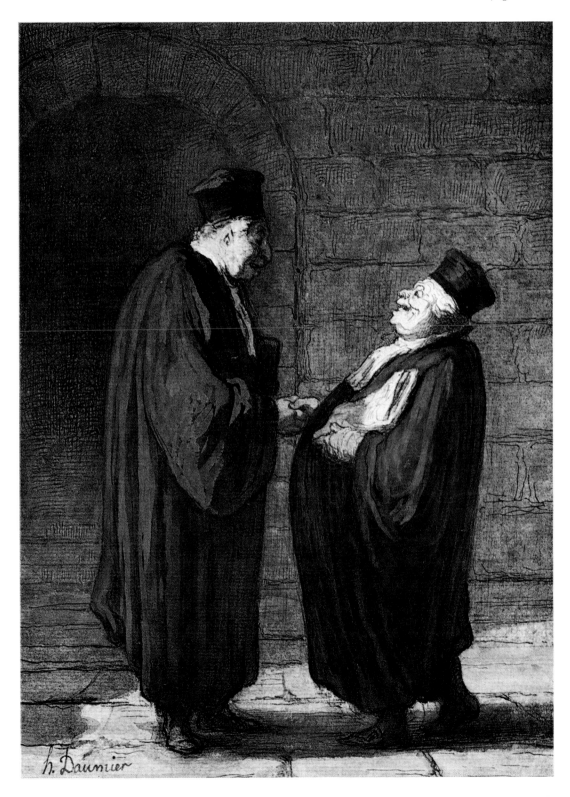

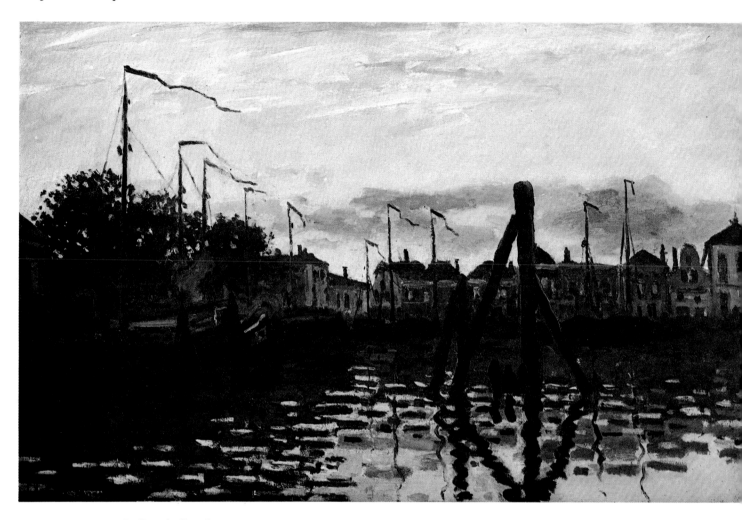

CLAUDE MONET: *Le Port de Zaandam*
Signed
18½×29 in. (47×73.6 cm.)
Sold 3.12.74 for £84,000 ($201,600)
Painted in 1871 during the artist's visit to Holland. The houses stand on the western part of the Hoogendijk, which forms the western boundary of the port of Zaandam

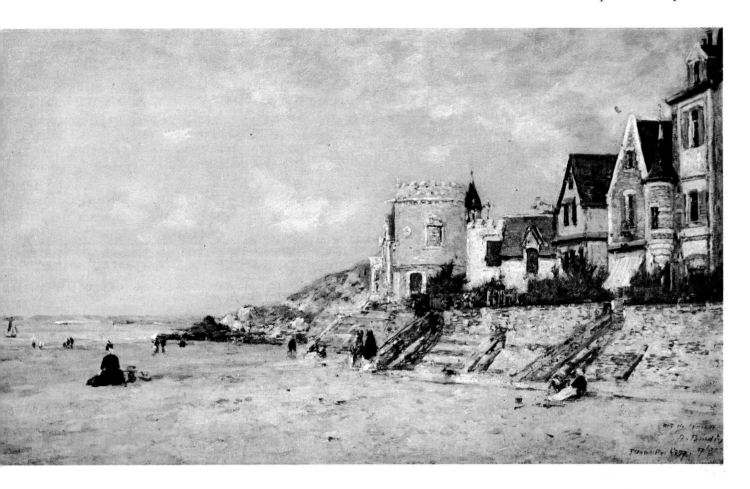

EUGENE BOUDIN: *La Tour Malakoff et le Rivage à Trouville*
Signed, indistinctly inscribed and dated Trouville 7bre 1877, on panel
13 × 22½ in. (33 × 57 cm.)
Sold 15.4.75 for £27,300 ($65,520)
From the collection of the B. E. Bensinger Family

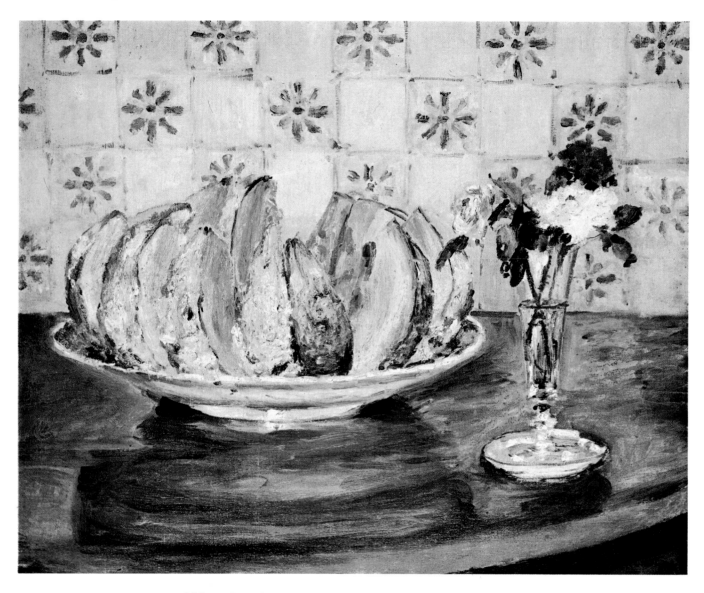

PIERRE AUGUSTE RENOIR: *Melon et Vase de Fleurs*
Signed, painted c. 1872
$21\frac{1}{2} \times 25\frac{1}{2}$ in. (55×65 cm.)
Sold 3.12.74 for £42,000 ($100,800)

PIERRE AUGUSTE
RENOIR: *Pivoines*
Signed, painted in
1878
$23\frac{1}{4} \times 19\frac{1}{2}$ in.
$(59 \times 49.5$ cm.$)$
Sold 15.4.75 for
£84,500 ($202,800)
From the collection
of the B. E. Bensinger
Family

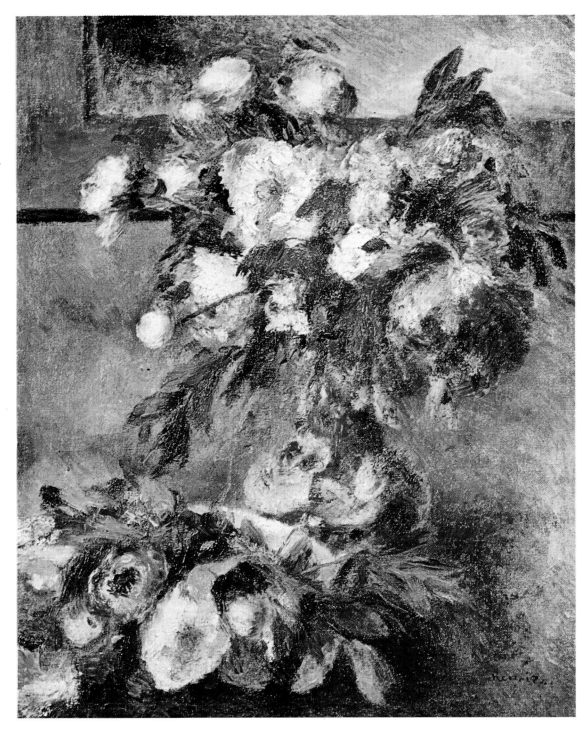

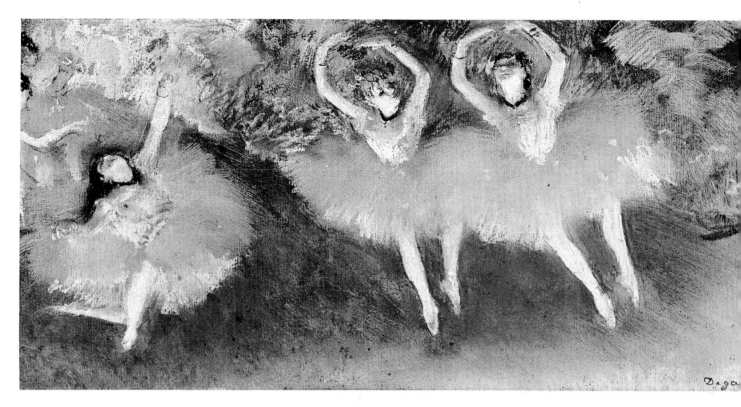

EDGAR DEGAS: *Scène de Ballet*
Signed, pastel over monotype (Janis 4; second state)
$8\frac{3}{4} \times 16\frac{3}{4}$ in. (22×42.5 cm.)
Sold 1.7.75 for £94,500 ($217,350)
From the collection of Mr and Mrs Moorhead C. Kennedy

EDGAR DEGAS:
Après le Bain
Signed and dated '85
Pastel
25 × 20 in.
(63.5 × 51 cm.)
Sold 15.4.75 for
£141,750 ($340,000)
From the collection
of the B. E. Bensinger
Family

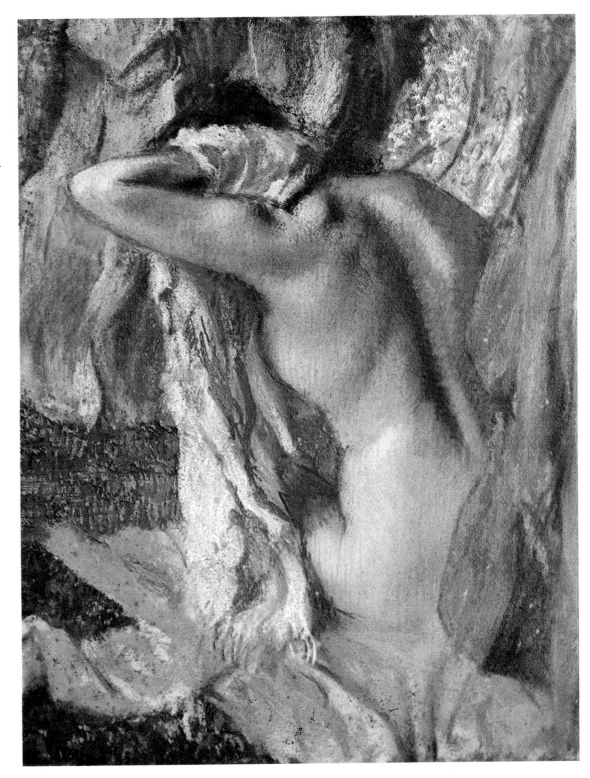

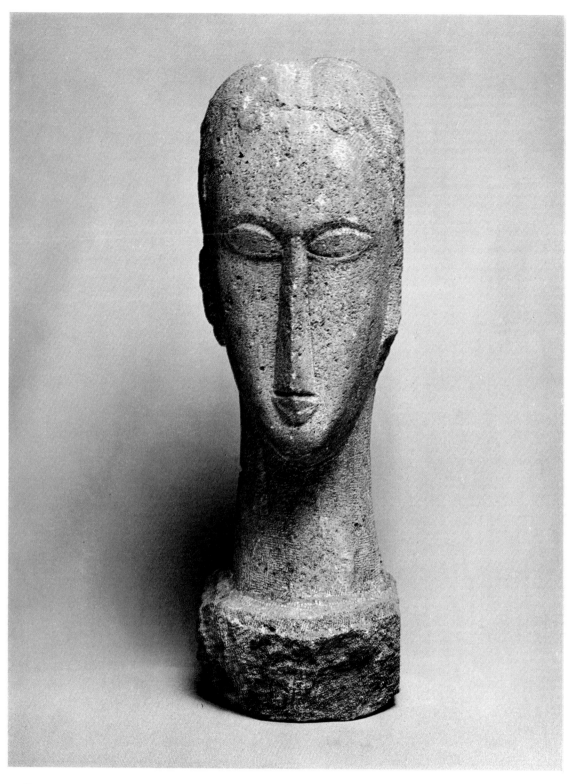

AMEDEO
MODIGLIANI:
Tête de Femme
Stone, executed in
1911–12
19½ in. (49 cm.) high
(including base)
Sold 15.4.75 for
£44,100 ($105,840)

AMEDEO MODIGLIANI:
Fillette sur une Chaise: Huguette
Signed, painted in 1918
36 × 23¾ in. (91.5 × 60 cm.)
Sold 15.4.75 for £126,000
($302,400)
From the collection of
the B. E. Bensinger Family
Record auction price for a work by
this artist

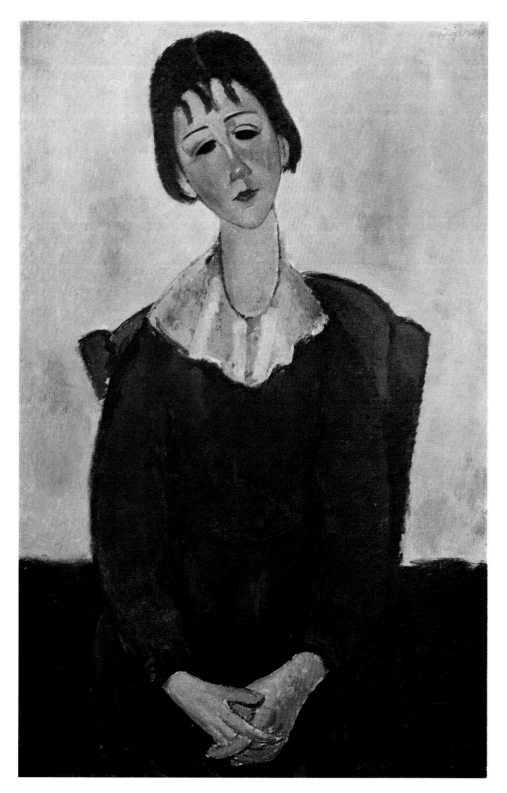

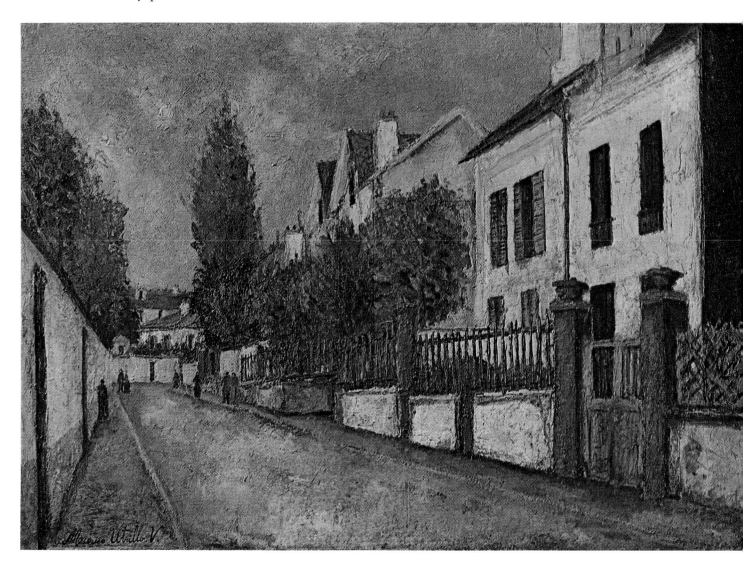

MAURICE UTRILLO: *Rue à Sannois*
Signed, on panel, painted c. 1911
$19\frac{3}{4} \times 28\frac{1}{2}$ in. (50×72 cm.)
Sold 15.4.75 for £27,300 ($65,520)

PIERRE BONNARD: *Vase de Fleurs*
Signed, painted in the summer of 1933
$39\frac{1}{4} \times 19$ in. (99.5 × 48.5 cm.)
Sold 2.12.74 for £86,100 ($206,640)
From the collection of Jerome Hill, sold by order of
The Camargo Foundation
Record auction price for a work by this artist

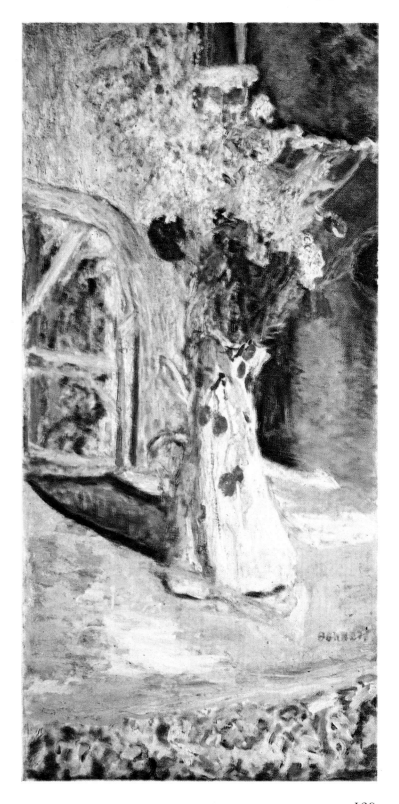

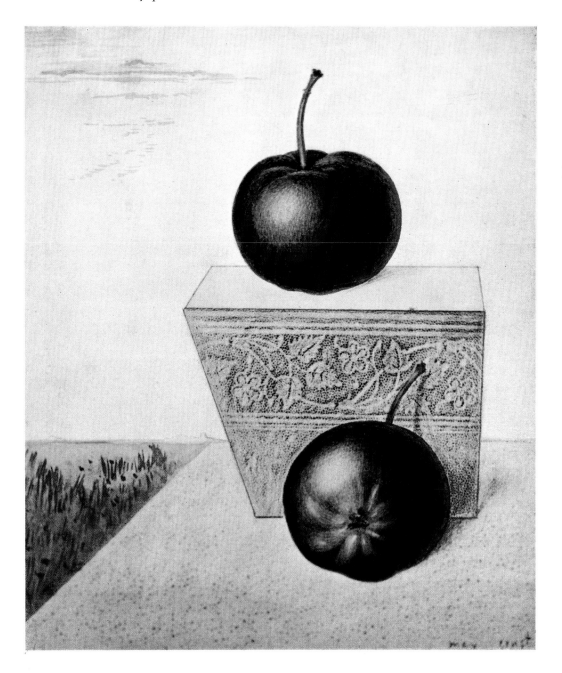

MAX ERNST:
Pommes Visibles
Signed, watercolour and
pencil frottage, executed
c. 1924
$6 \times 5\frac{1}{2}$ in. (15×14 cm.)
Sold 15.4.75 for £12,600
($30,240)
From the collection of the
B. E. Bensinger Family

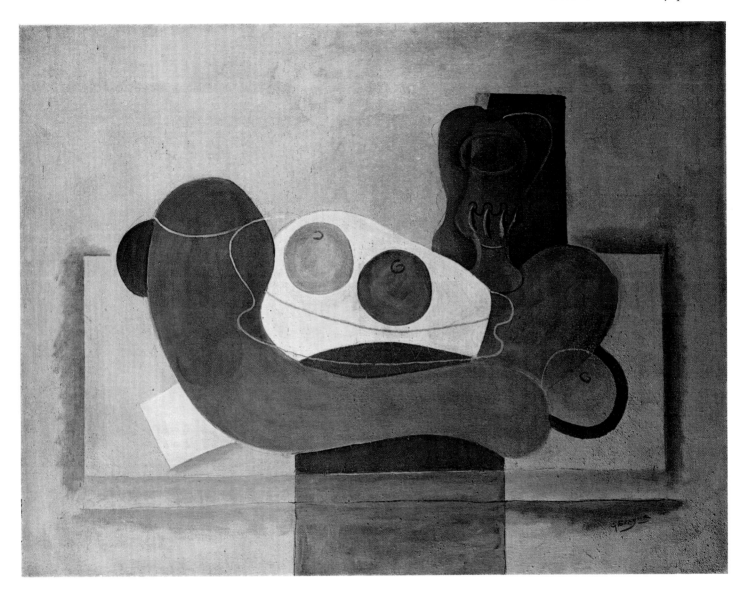

GEORGES BRAQUE: *Les Pommes Grises*
Signed, painted in 1933
35 × 46 in. (89 × 117 cm.)
Sold 3.12.74 for £63,000 ($151,200)

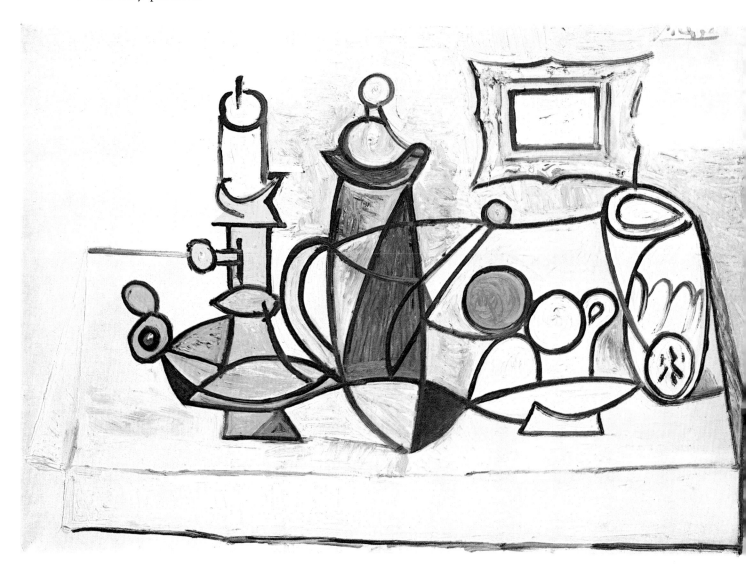

PABLO PICASSO: *Nature Morte au Chandelier*
Signed and on the reverse dated 6 Avril 44
$26\frac{1}{4} \times 37\frac{1}{4}$ in. (67×94.5 cm.)
Sold 2.12.74 for £73,500 ($176,400)
From the collection of Jerome Hill, sold by order of The Camargo Foundation

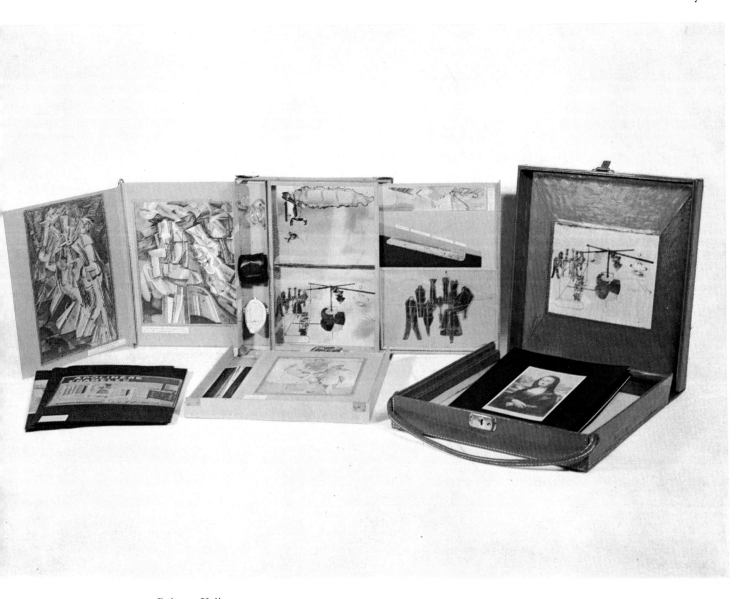

MARCEL DUCHAMP: *Boîte en Valise*
Signed, dated New York 1943
16 × 15 × 4 in. (41 × 38 × 10 cm.)
Sold 1.7.75 for £6825 ($15,699)
From the collection of Mr D. R. A. Wierdsma of New York

Nearly two hundred years separate this Louis XVI bureau plat and cartonnier by Martin Carlin and other important pieces of French furniture from the Contemporary Pictures by Vasarely, Appel, Arman, Tápies and others in the background exemplifying part of the fascinating cross-section of works of art sold during a single week

Contemporary art sales

JÖRG-MICHAEL BERTZ

There is a good precedent to selling pictures by contemporary or living artists at Christie's. When James Christie started as an auctioneer in the 18th century, paintings by his contemporaries, Reynolds, Gainsborough and others, were frequently put under the hammer at his Great Rooms in Pall Mall.

On 3rd December 1974, however, Christie's held their first sale in London devoted entirely to contemporary art, an occasion which caused considerable excitement inside and outside the firm. When the shipping crates were opened a few days before the view and the large canvases were hung on the walls, more hands than usual were required. Long before the auction took place, there were discussions as to how pictures painted in such bright colours and often with such unusual materials would look in the rooms where Titian's *Death of Actaeon* was sold for £1,680,000 ($4,065,000); *Juan de Pareja* by Velazquez for £2,310,000 ($5,544,000) and Claude Monet's *La Terrasse à Sainte Adresse* fetched £588,000 ($1,411,200). To everybody's surprise the contemporary pictures, which usually hang in sparsely furnished private houses or in white painted galleries, made a perfect complement to the French furniture which was on view at the same time. Collectors who had consigned their pictures to Christie's for sale were pleased with the hanging arrangements and visitors and potential buyers were attracted by the combination of past and present.

On entering the saleroom on the evening of the sale, one was confronted with an enormous canvas by Frank Stella, *Abra Variation, No. 3*, from the Protractor Series (see illustration page 6). To the side of the audience was a 'Veil' painting by Morris Louis and hanging opposite a blue 'Anthropométrie' by Yves Klein together with two pictures by Cy Twombly painted in 1960 and 1963 respectively. At the back of the saleroom there were paintings by photo-realist artists such as Douglas T. Bond, Malcolm Morley and Ron Kleemann and beneath were Andy Warhol's famous silkscreen set of ten portraits of Marilyn Monroe.

The sale went well, bringing outstanding prices for two pictures by R. B. Kitaj. *Synchromy with FB – General of Hot Desire* (see illustration page 136), a diptych which had been included in a major exhibition of Kitaj's work touring on the Continent in 1970, fetched £28,350 ($68,040) – a world record – with *Randolph Bourne in Irving*

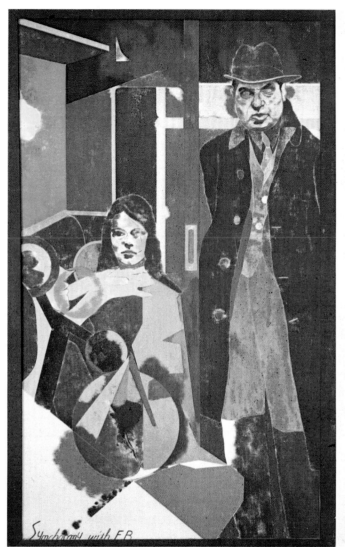

Place (facing page) by the same artist following at £20,475 ($49,140). Collectors of contemporary art who had never attended an auction before were quick to accept this new method of buying.

Christie's next sale of contemporary art took place on 1st July, 1975, together with a sale of Impressionist and modern paintings. The catalogue included examples by several of the same artists as in the first sale, but with a greater emphasis on European rather than American painters with a view to testing the market for these outside galleries and art-fairs. A high percentage of these, both abstract and figurative works, were sold for good prices including a group of early paintings by Vasarely, collages by Christo (see illustration page 138) and objects by Arman.

Opposite: RONALD B. KITAJ: *Synchromy with FB – General of Hot Desire*
Inscribed, diptych
Painted c. 1968
60 × 72 in.
(152.5 × 183 cm.)
Sold 3.12.74 for
£28,350 ($68,040)
Record auction price for a work by this artist

RONALD B. KITAJ: *Randolph Bourne in Irving Place*
Signed on the reverse
Oil and collage on canvas, painted in 1963–64
60 × 60 in.
(152.5 × 152.5 cm.)
Sold 3.12.74 for
£20,475 ($49,140)

Judging from sales to date, it seems that London is gradually emerging as the centre of the contemporary art market, as indeed it is already for other categories. The London auctions certainly attract increasing interest from buyers and sellers of European and American art since 1945. The simplicity of tax-free importation from abroad coupled with our ability to pay overseas vendors in the currency of their choice make King Street a natural gathering point for future contemporary sales.

It is a new concept to hold complete sales solely devoted to contemporary art. However, in the manner of the now well-established Impressionist sales, these new auctions

CHRISTO: *Valley Curtain*
Signed, inscribed and dated 1970, collage, coloured chalks and pencil
$27\frac{1}{2} \times 21\frac{3}{4}$ in. (70 × 55 cm.)
Sold 1.7.75 for £2100 ($4830)

will provide a pivotal function in establishing an open broad-based market for a field that might otherwise have gained a reputation for being monopolized by an international group of contemporary art-fair enthusiasts. Regular sales provide a yard-stick for valuations both for insurance purposes and as a guide for assessing likely future sale values. They give confidence to collectors by demonstrating that there clearly is a popular market for living painters. Perhaps most important of all, they provide both an exhibition and a market-place where interested newcomers can observe, enquire, make comparative judgments and perhaps finally participate in a field that has to many seemed perplexing and highly specialized. Collectors, museums and dealers all benefit from such auctions not only as vendors or buyers but also in the manner of participants in a convention or seminar where views on artists, prices, and current market trends can be exchanged. One really gets the feel of the contemporary art market at these sales.

Since the war, there has been an enormous exchange of contemporary art between the two continents. More exhibitions than ever are held all over the world and internationally linked galleries and art-fairs in Europe promote new art. In Europe

there are today nearly as many collections of American contemporary art as in the United States and vice versa. Our offices all over the world bring together these scattered works to London and, similarly, the buyers converge on London for these sales. Artists and critics frequently attend and consequently contemporary sales, more so perhaps than any other saleroom category, are living events, as much part of the making of modern art history as an artist's one-man exhibition.

From now on we shall be holding regular sales in this field.

JOSEF ALBERS:
Study for 'Earthern I'
Signed with initial
and dated '55, signed
again, inscribed and
dated again on the
reverse, on board
24 × 24 in.
(61 × 61 cm.)
Sold 3.12.74 for
£8610 ($20,660)

TOM WESSELMANN: *Great American Nude, No. 9*
Signed and dated '61, inscribed on the reverse, oil and collage on panel
$48\frac{1}{4} \times 48\frac{1}{4}$ in. (122.5 × 122.5 cm.)
Sold 3.12.74 for £8190 ($19,700)

WILLEM DE KOONING: *Abstraction*
Signed, on board, painted c. 1949–50
$14\frac{1}{2} \times 18\frac{1}{4}$ in. (37×46.5 cm.)
Sold 3.12.74 for £13,650 ($32,760)
From the collection of Jerome Hill, sold by order of The Camargo Foundation

ANTONI TÁPIES:
Noire et Craie sur Carton
Signed on the reverse, on
board
$29\frac{1}{2} \times 41\frac{1}{2}$ in. (75×105 cm.)
Sold 1.7.75 for £5040
($11,592)

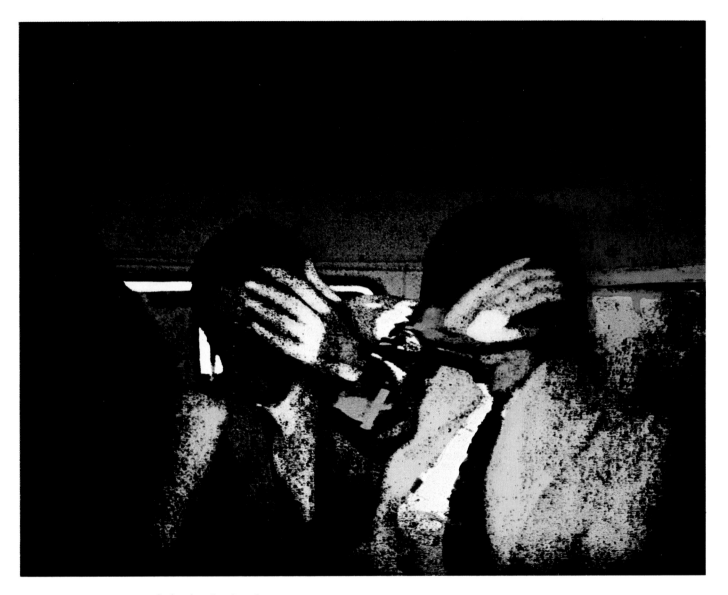

RICHARD HAMILTON: *Swingeing London, 67*
Enamel and silkscreen on canvas, painted in 1968–69
$26\frac{1}{2} \times 33\frac{1}{2}$ in. (67.5×85 cm.)
Sold 3.12.74 for £11,550 ($27,720)

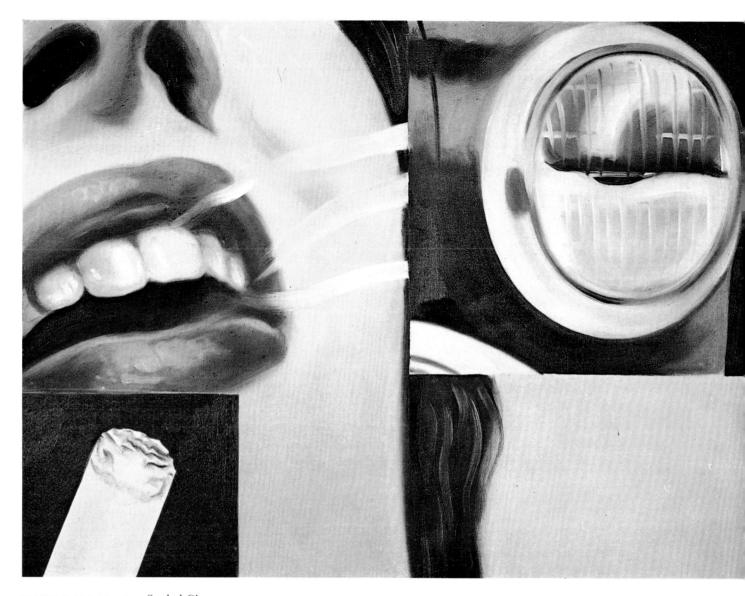

JAMES ROSENQUIST: *Smoked Glass*
Signed, inscribed and dated 1962 on the reverse
24 × 32 in. (60 × 80 cm.)
Sold 3.12.74 for £5250 ($12,600)
From the collection of Mr Helmut Klinker of Bochum, Germany

KENNETH NOLAND: *A Memory for Gonzalez*
Signed and dated 1963 on the reverse, inscribed on the stretcher
45 × 45 in. (114 × 114 cm.)
Sold 1.7.75 for £9450 ($21,735)

WILSHIRE BOULEVARD, LOS ANGELES

DAVID HOCKNEY: *Wilshire Boulevard, Los Angeles*
Signed, inscribed and dated
March 1964 on the stretcher
Acrylic on canvas
36 × 24 in. (91 × 61 cm.)
Sold 3.12.74 for £8925 ($21,430)

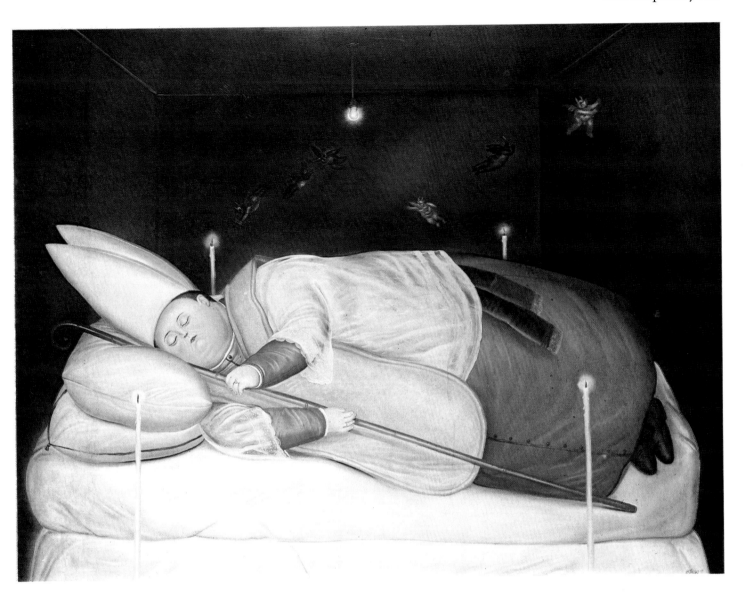

FERNANDO BOTERO: *Siesta del Cardenal*
Signed and dated '71
56½ × 73 in. (143.5 × 185.5 cm.)
Sold 15.4.75 for £9975 ($23,940)

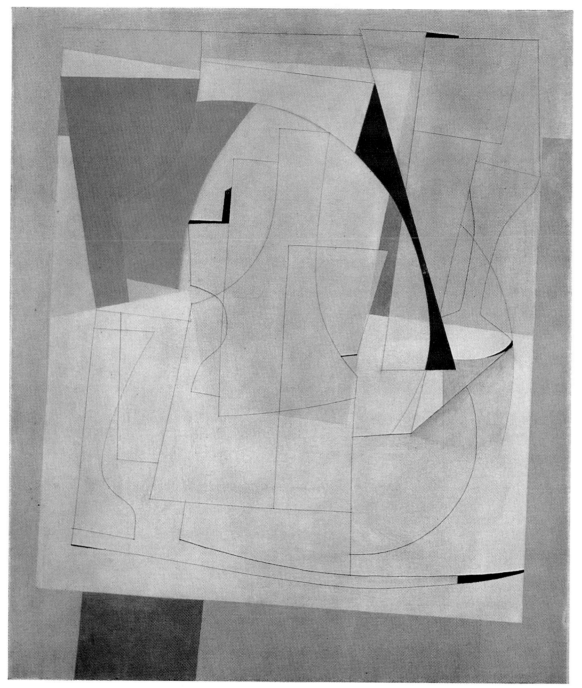

BEN NICHOLSON,
OM: *Nov. 52 (Looking Glass)*
Signed and inscribed on the overflap of the canvas
$30\frac{3}{4} \times 26\frac{1}{4}$ in.
(78×66.6 cm.)
Sold 11.10.74 for
£24,150 ($57,960)
From the collection of Mrs Thorold Dickinson

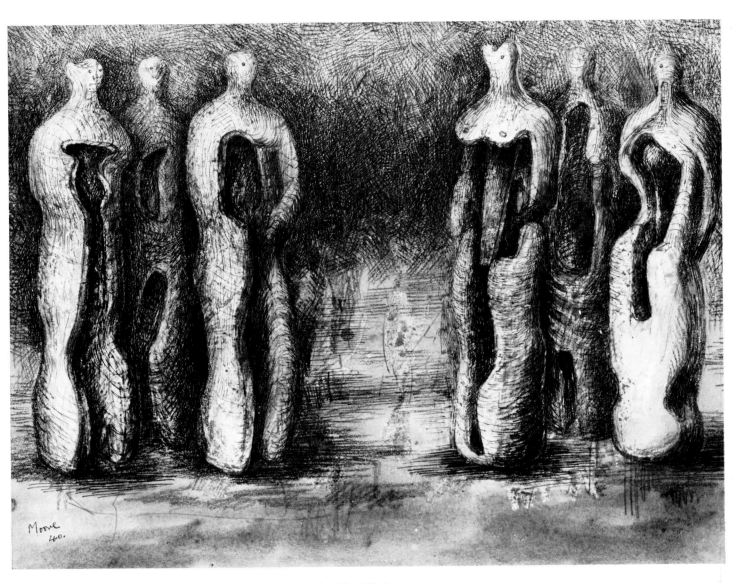

HENRY MOORE, OM, CH: *Standing Figures; Drawing for Wood Sculpture*
Signed and dated '40, watercolour, black and coloured chalks, pen and black ink and pencil
11 × 15 in. (28 × 38 cm.)
Sold 18.7.75 for £5775 ($12,705)
From the collection of the late F. R. S. Yorke, Esq, CBE, FRIBA

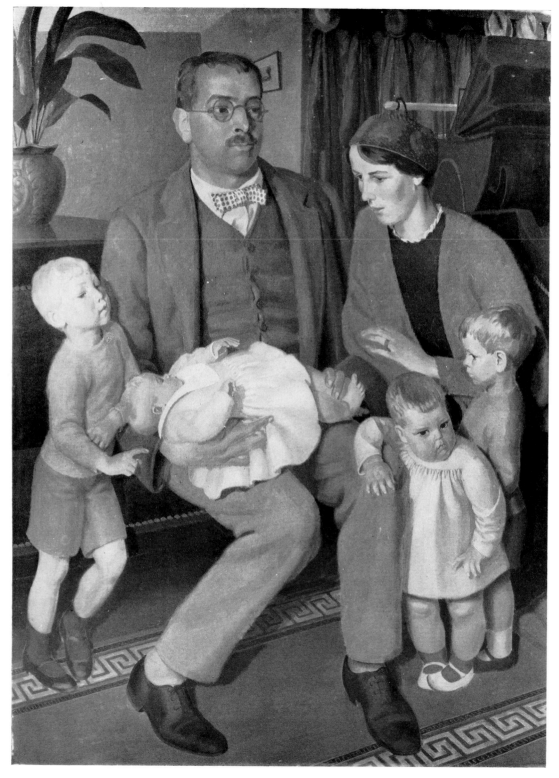

HENRY LAMB, RA:
*George Kennedy and
Family*
Painted in 1921
44 × 32 in.
(111.8 × 81.3 cm.)
Sold 11.10.74 for £1365
($3276)
Sold on behalf of George
Behrend, Esq, from the
collection of Mr and
Mrs J. L. Behrend

GWEN JOHN:
Girl Holding a Rose
Painted c. 1922
$18 \times 14\frac{1}{2}$ in.
(45.7 × 36.8 cm.)
Sold 11.10.74 for
£3885 ($9234)
From the collection
of Sidney Gilliat, Esq

SIR STANLEY SPENCER, RA: *Priory Farm, Leonard Stanley*
20 × 30 in. (50.8 × 76.2 cm.)
Sold 28.2.75 for £7140 ($17,136)

SIR STANLEY SPENCER, RA:
Hilda and I at Burghclere
$30\frac{1}{2} \times 20\frac{1}{2}$ in. $(77.5 \times 52$ cm.)
Sold 28.2.75 for £12,600 ($30,246)
From the collection of
Mr and Mrs G. J. ff. Chance

FRANCES HODGKINS: *Two Sisters*
Signed, on canvas laid down on board
$25 \times 25\frac{3}{4}$ in. $(63.5 \times 65.4$ cm.)
Sold 18.7.75 for £2205 ($4851)
Record auction price for
a work by this artist

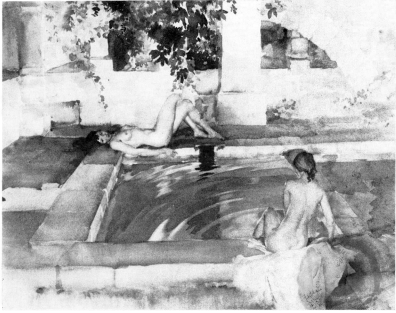

SIR WILLIAM RUSSELL FLINT, RA: *Gleaming Limbs and Cool Waters*
Signed, signed again and inscribed on the
reverse, watercolour
$19\frac{1}{4} \times 26\frac{1}{4}$ in. $(49 \times 66.6$ cm.)
Sold 18.7.75 for £4515 ($9933)

Opposite: LUCIAN FREUD: *Girl Holding a Towel*
Painted in 1967
$19\frac{1}{4} \times 19\frac{1}{4}$ in. $(49 \times 49$ cm.)
Sold 28.2.75 for £13,250 ($32,506)
From the collection of Miss A. M. Bull

EDWARD SEAGO: *The 'Centaur'
and 'Spinaway' at Pin Mill*
Signed and dated 1971
Inscribed on the reverse, on
board
16 × 24 in. (40.7 × 61 cm.)
Sold 18.7.75 for £3360 ($7392)
Record auction price for
a work by this artist

DUNCAN GRANT:
Provençal Landscape
Signed and dated '29
28½ × 35¾ in. (72.3 × 90.5 cm.)
Sold 18.7.75 for £1470 ($3234)
Record auction price for
a work by this artist

JOHN PETER RUSSELL: *Belle-Ile en Mer*
Signed and dated 1904
$23\frac{5}{8} \times 28\frac{3}{4}$ in. (60 × 73 cm.)
Sold 13.3.75 for £5000 ($A 9000)
Sold at the Southern Cross Hotel,
Melbourne

JOHN PERCEVAL: *Arthur Boyd Pottery Shop*
Signed and dated '48
$32\frac{1}{4} \times 36\frac{5}{8}$ in. (82 × 93 cm.)
Sold 13.3.75 for £8888 ($A 16,000)
From the collection of Mesdames Nancy
and Pamela Buchdahl
Sold at the Southern Cross Hotel,
Melbourne

FREDERICK
MCCUBBIN: *Hauling
Timber, Macedon
Heights*
Signed and dated
31 × 55 in.
(78.7 × 139.7 cm.)
Sold 2.10.74 at the
Wentworth Hotel,
Sydney, for £22,472
($A 40,000)
Record auction price
for a work by this
artist

SIDNEY NOLAN:
African Elephant
Signed and dated '63
On board
48 × 60 in.
(121.9 × 152.4 cm.)
Sold 2.10.74 at the
Wentworth Hotel,
Sydney, for £8708
($A 15,000)

CORNELIUS KRIEGHOFF: *An Indian Squaw*
signed
× 11 in. (34 × 28 cm.)
d 7.3.75 for £4200 ($1080)

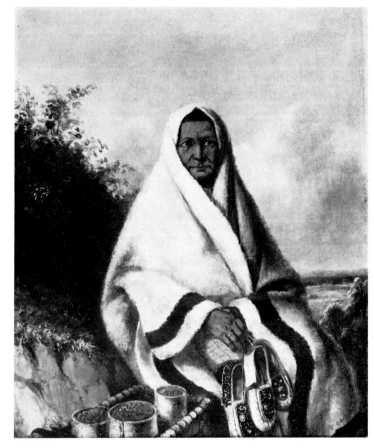

FREDERIC REMINGTON, ANA: *The Winchester*
signed
× 28½ in. (29.2 × 72.4 cm.)
d 8.11.74 for £9200 ($21,344)

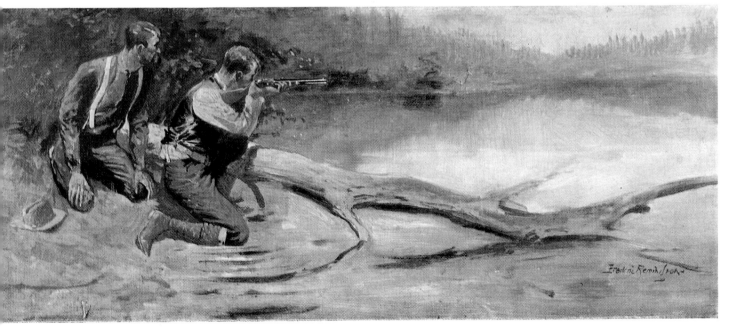

CHARLES
BURCHFIELD, NA:
Boulevard
Signed and dated 1917
Gouache
$19 \times 21\frac{1}{2}$ in.
(48.2 × 54.6 cm.)
Sold 7.3.75 for £2835
($6804)

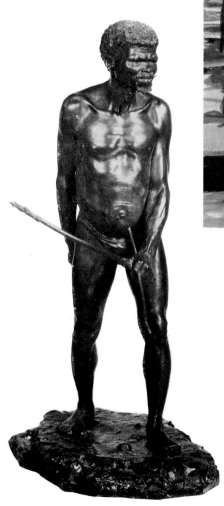

ANTON VAN WOUW:
Bushman Hunting
Signed, stamped 'G. Nisini, fuse
Roma' and dated 1902, bronze
$19\frac{1}{4}$ in. (49.5 cm.) high
Sold 8.11.74 for £2520 ($6050)

Opposite: NICHOLAS CHEVALIER:
*Maori War Dance: The Friendly Maoris
Before the Duke of Edinburgh at Auckland,
New Zealand, May 1869*
Signed and dated 1869
Watercolour
$5\frac{1}{2} \times 15\frac{1}{2}$ in. (14 × 39.4 cm.)
Sold 8.11.74 for £1575 ($3654)
From the collection of the late Lady
Patricia Ramsay, sold by order of the
Executors

SIR THOMAS
LIVINGSTONE
MITCHELL: *Dance of
Natives on First
Hearing the Report of a
Pistol*
Watercolour
7 × 10 in.
(17.5 × 25.5 cm.)
Also a preliminary
sketch of the subject
together with the
print
Sold 7.11.74 for £840
($2016)

NICHOLAS CHEVALIER:
*The Duke of Edinburgh's
Interview with the Mikado in
the Summerhouse of the
Palace Garden at Yeddo,
4th September 1869*
Signed, inscribed and
dated 4 Sept. '69
Watercolour
$5\frac{1}{4} \times 8$ in. (13.2 × 20.3 cm.)
Sold 8.11.74 for £630
($1512)
From the collection of
the late Lady Patricia
Ramsay, sold by order
of the Executors
Purchased on behalf of
the New Zealand
Government for the
National Art Gallery,
Wellington

CORNELIS SPRINGER: *Canal Scene, Oudewater*
Signed and dated 1876, certified on a label by the artist on the reverse, on panel
$22\frac{1}{2} \times 28\frac{3}{4}$ in. (57×73 cm.)
Sold 22.10.74 at the Singer Museum, Laren, for £16,667 (H. fl. 100,000)

Opposite: ANGLO-CHINESE SCHOOL, 19th century: *Panoramic View of Canton Seen from the Harbour*
Watercolour and gouache
24×47 in. (61×119.5 cm.)
Sold 7.3.75 for £1260 ($3024)

JOHANNES HENDRIK WEISSENBRUCH: *Extensive Landscape with a Cottage by a Canal*
Signed and dated '97
$28 \times 39\frac{5}{8}$ in. (71×100.5 cm.)
Sold 18.3.75 at the Singer Museum, Laren, for £9549 (H. fl. 55,000)

Saxon guild flagon
20⅛ in. (51 cm.) high
By Hans Reichardt
Dor the Elder
Bayreuth, first half
17th century
Sold 19.3.75 at the
Singer Museum,
Laren, for £2256
(H. fl. 13,000)

A 16th-century Dutch mortar

The March sale at the Singer Museum in Laren (N.H.) contained some notable metalwork of which the most outstanding example was the bronze mortar inscribed *M Clemens van Zutfen* (*sic*) and dated 1582 (see illustration opposite).

The date is written in the Roman classical manner. This and the foliage decoration entwining two medallion portraits in profile speak clearly of the Netherlandish High Renaissance and of the revived interest in classical motifs.

Clemens of Zutphen is assumed to have been the master responsible for casting this piece but there is apparently no record of such a bronze-caster in Zutphen nor elsewhere in the Netherlands, and apparently there is no other known work by him.

The production of bronze mortars only became fairly common in the Netherlands by the first half of the 17th century; this piece, dated 1582, is therefore, on grounds of date alone, something of a rarity. At the time, bronze was in great demand as an alloy crucial for maintaining the Dutch war effort against their traditional Spanish rulers. It can therefore be assumed that this mortar was an important commission. There is no physical evidence that it was ever used, and its weight, its imposing inscription, fashionable decoration and unusual shape confirm that it was indeed made solely for the purpose of display.

The circumstances of the commission will probably always remain a mystery, as will the identity of Clemens. However, this mortar remains as a further reminder that the aesthetic impetus was maintained during the early years of the war for Dutch independence: in this case to the extent that vitally needed bronze could be used to elevate an everyday tool into an object to be admired.

Large two-handled
bronze mortar
The rim inscribed
M CLEMENS VAN
ZUTFEN MDLXXXII
9 in. (23 cm.) high
Dutch, 16th century
Sold 19.3.75 at the
Singer Museum,
Laren, for £3125
(H. fl. 18,000)

Set of 4 silver table-candlesticks
8¼ in. (21 cm.) high
By Peter Schemmekes, Zutphen, 1756
Sold 23.10.74 at the Singer Museum, Laren, for £3333
(H. fl. 20,000)

Silver table-bell
4⅞ in. (12.5 cm.) high
Amsterdam, 1751
Sold 23.10.74 at the Singer Museum, Laren, for £917
(H. fl. 5500)

JEWELLERY

Mr John Floyd, Chairman, taking a jewellery sale in Geneva
which totalled £2,304,000 (Sw. fr. 14,287,000). The total
amount of jewellery sold in Geneva during the year was nearly
£5,000,000 (Sw. fr. 30,000,000) while sales in London achieved
a new record of £2,059,000 ($4,735,700). More jewellery was
sold by Christie's during the year than by any other auction house
anywhere in the world

Right: Pair of sapphire and diamond ear-clips, each set with a pear-shaped sapphire weighing 29.76 ct. together, surrounded by fine navette and pear-shaped diamonds of 21.20 ct.
By Harry Winston
Sold 1.5.75 at the Hôtel Richemond, Geneva, for £91,667 (Sw. fr. 550,000)

Below left: Sapphire and diamond brooch, the sapphire weighing 73.16 ct.
Sold 12.3.75 for £160,000 ($384,000)

Below right: The Golden Pelican Diamond
An unmounted rectangular-cut diamond of fancy brown colouring weighing 63.93 ct. Named after the Pelikaanstraat of Antwerp, the famous diamond centre where the stone was cut by its owners, E. Sévery and M. Ginsburg. The diamond was exhibited in Canada and Switzerland and, in 1958, at the Diamond Pavilion at the World Fair in Brussels
Sold 21.11.74 for £23,595 (Sw. fr. 150,000)

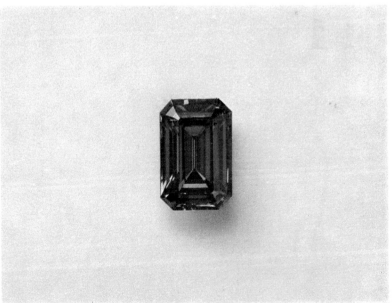

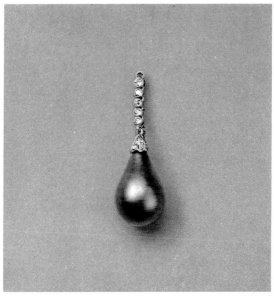

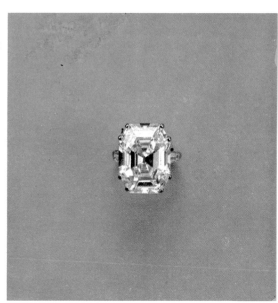

Left:
Black pearl and diamond pendant
Sold 21.11.74 for £6536
(Sw. fr. 40,000)
Right:
Diamond ring, set with a diamond of 16.32 ct.
Signed by Van Cleef & Arpels
Sold 21.11.74 for £100,931
(Sw. fr. 650,000)

Below: Ruby and diamond pendant brooch, with a cushion-shaped ruby of 4.96 ct. and a drop-shaped diamond of 7.20 ct.
Sold 1.5.75 for £43,333 (Sw. fr. 260,000)

Below: Emerald and diamond brooch pendant, the emerald weighing c. 8.71 ct.
Sold 12.3.75 for £85,000 ($204,000)

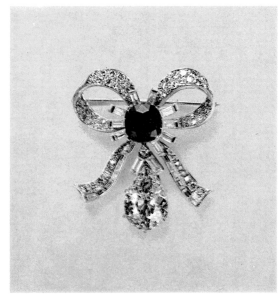

Above:
Navette-cut diamond ring, of 20.95 ct., flanked by shield-shaped diamonds
Signed by Harry Winston
Sold 1.5.75 for £50,000
(Sw. fr. 300,000)

All except *right* sold at the Hôtel Richemond, Geneva

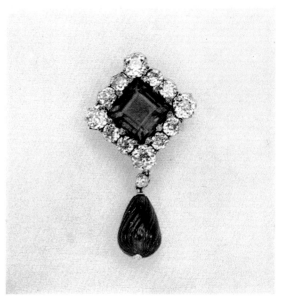

Antique emerald and
diamond necklace
£30,000 ($72,000)

Centre: Victorian
emerald and diamond
pendant
Weight of emerald
c. 4.15 ct.
£34,000 ($81,600)

Bottom left: Diamond
and pearl brooch
£2600 ($6240)

Bottom centre:
Victorian emerald
and diamond brooch
£30,000 ($72,000)

Bottom right: Sapphire
and diamond brooch
pendant
Weight of sapphire
c. 11.19 ct.
£21,000 ($50,400)

All sold 27.11.74
All except necklace
from the collection of
the Mildmay-White
Family Trust

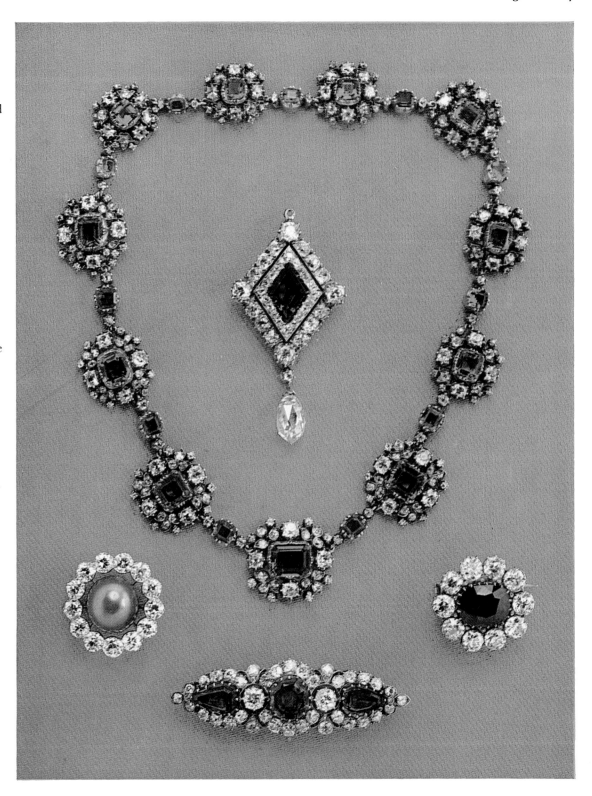

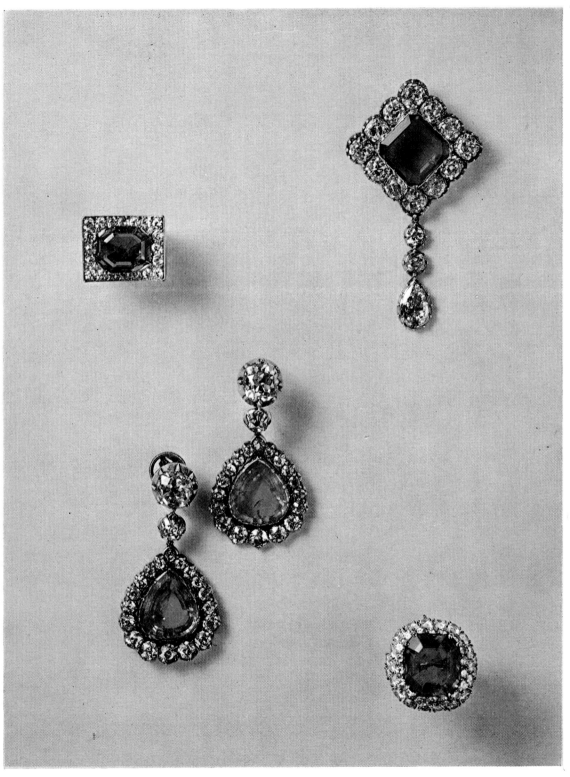

Emerald and
diamond ring, set
with a rectangular-
cut emerald of 7.38 ct.
Signed by Cartier
£30,000
(Sw. fr. 180,000)

Antique emerald and
diamond pendant
brooch, set with a
square-cut emerald
of 8.02 ct.
£23,333
(Sw. fr. 140,000)

Pair of antique
emerald and diamond
ear-pendants, the
two emeralds
weighing 25.06 ct.
£25,000
(Sw. fr. 150,000)

Emerald and
diamond ring, set
with a rectangular-cut
emerald of 15.75 ct.
£50,000
(Sw. fr. 300,000)

All sold 1.5.75 at the
Hôtel Richemond,
Geneva

rald and
ond necklace
ed by
Cleef & Arpels
1.5.75 at the
l Richemond,
eva, for £155,667
fr. 1,000,000)

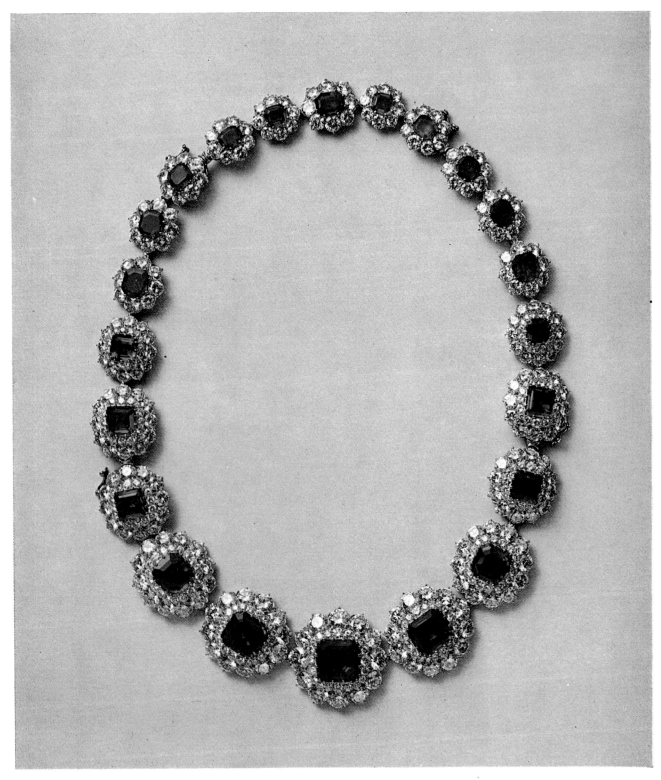

Jewellery

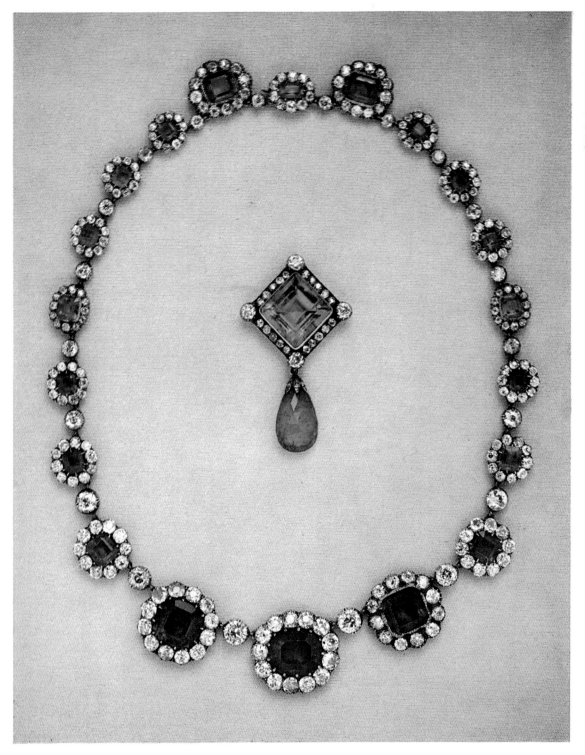

Emerald and
diamond necklace
Sold 11.6.75 for
£42,000 ($96,600)

Emerald and
diamond brooch
pendant
Sold for £12,000
($27,600)

Emerald and
diamond necklace
Sold 11.6.75 for
£55,000 ($126,500)

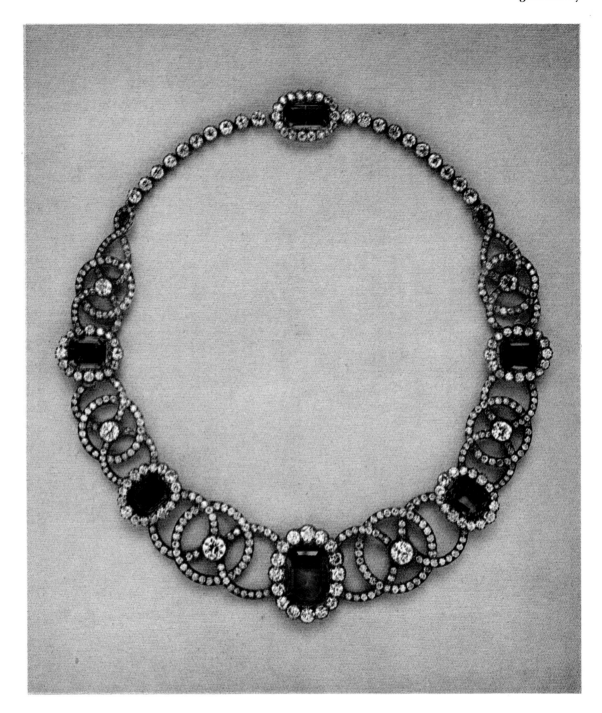

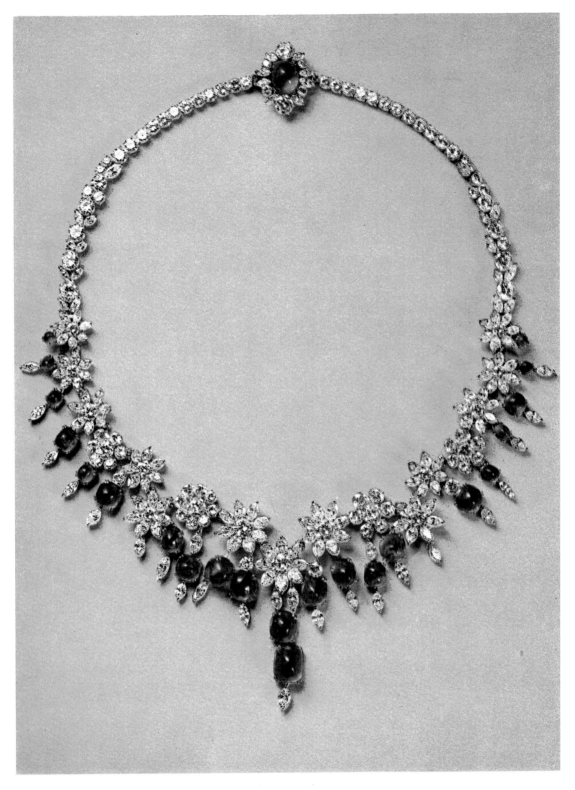

Cabochon emerald
and diamond
necklace
Sold 21.11.74 at the
Hôtel Richemond,
Geneva, for £54,261
(Sw. fr. 360,000)

Emerald and
diamond necklace
with a rectangular-cut
emerald of 10.79 ct.
Signed by
Harry Winston
£62,111
(Sw. fr. 400,000)

Emerald and
diamond ring,
set with an almost
square-cut emerald
of 7.66 ct.
By Harry Winston
£54,261
(Sw. fr. 360,000)

Pair of emerald and
diamond ear-
pendants, the two
emeralds weighing
5.07 ct. and 4.90 ct.
By Harry Winston
£40,732
(Sw. fr. 260,000)

All sold 21.11.74 at
the Hôtel Richemond,
Geneva

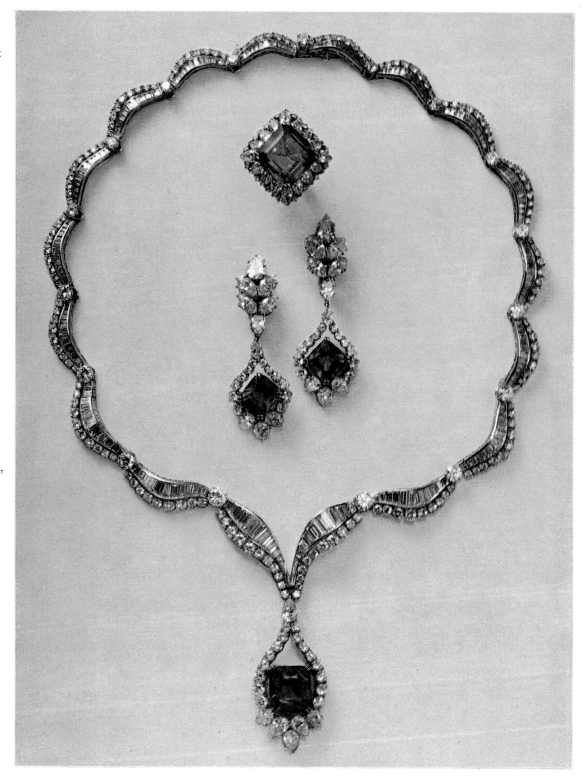

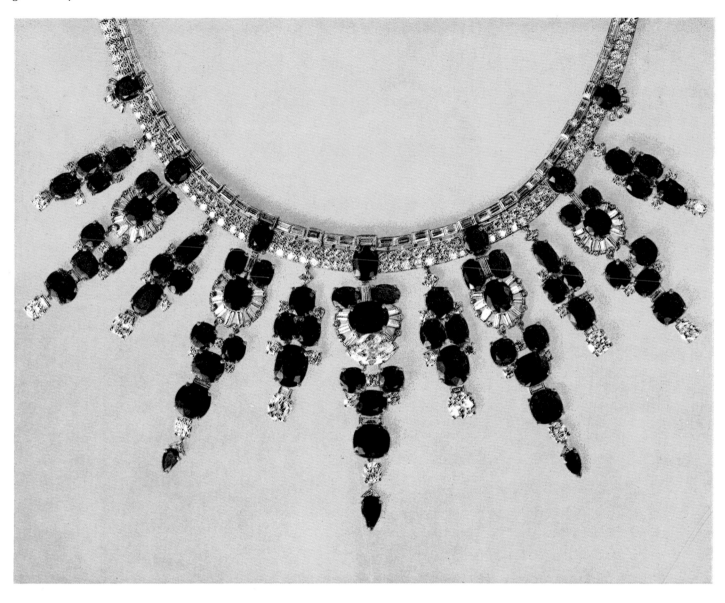

Ruby and diamond necklace
Mounted by Cartier
Sold 1.5.75 at the Hôtel Richemond, Geneva, for £53,333 (Sw. fr. 320,000)

Ruby and diamond
ring, set with a
cushion-shaped ruby
on a baguette and
circular-cut diamond
mount
By Gübelin
£21,667
(Sw. fr. 120,000)

Ruby and diamond
bracelet, formed of
nine curved sections
invisibly set with
calibre rubies
rectangular-cut
diamond borders
Signed by
Van Cleef & Arpels
£15,000
(Sw. fr. 90,000)

Ruby and diamond
brooch, shaped as a
leaf, invisibly set with
calibre rubies and
circular-cut diamonds
Signed by
Van Cleef & Arpels
£9167
(Sw. fr. 55,000)

All sold 1.5.75 at the
Hôtel Richemond,
Geneva

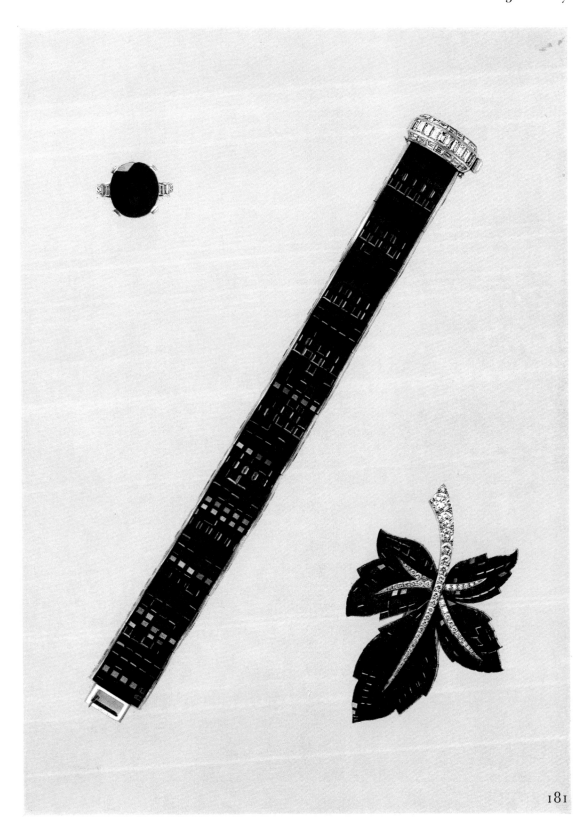

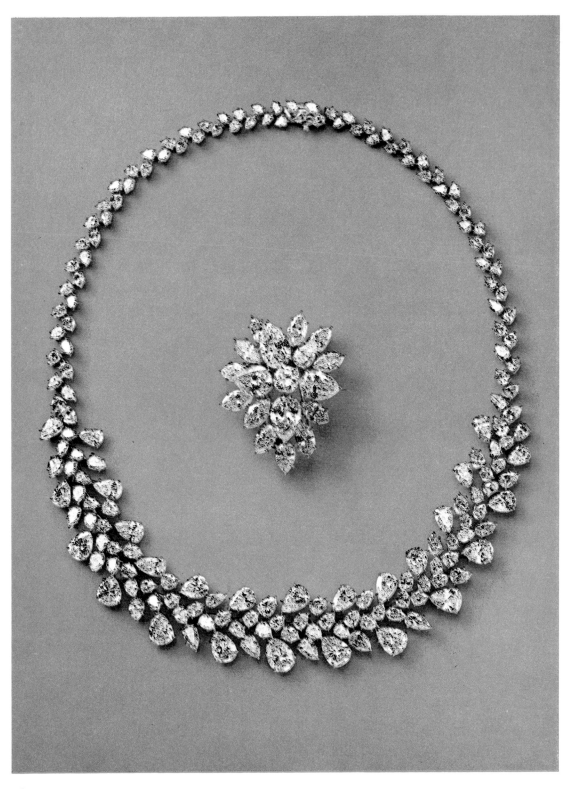

Diamond necklace
By Harry Winston
Sold 21.11.74 at the
Hôtel Richemond,
Geneva, for £23,595
(Sw. fr. 150,000)

Diamond brooch
Sold 21.11.74 at the
Hôtel Richemond,
Geneva, for £19,608
(Sw. fr. 120,000)

Pair of sapphire and diamond ear-pendants, the drop-shaped sapphires each weighing 7.62 ct. By Cusi
£15,000
(Sw. fr. 90,000)

Sapphire and diamond bracelet
By Cusi
£15,000
(Sw. fr. 90,000)

Sapphire and diamond ring, the sapphire weighing 17.28 ct.
£50,000
(Sw. fr 300,000)

Sapphire and diamond ring, the sapphire weighing 28.47 ct.
By Cusi
£75,000
(Sw. fr. 450,000)

All sold 1.5.75 at the Hôtel Richemond, Geneva

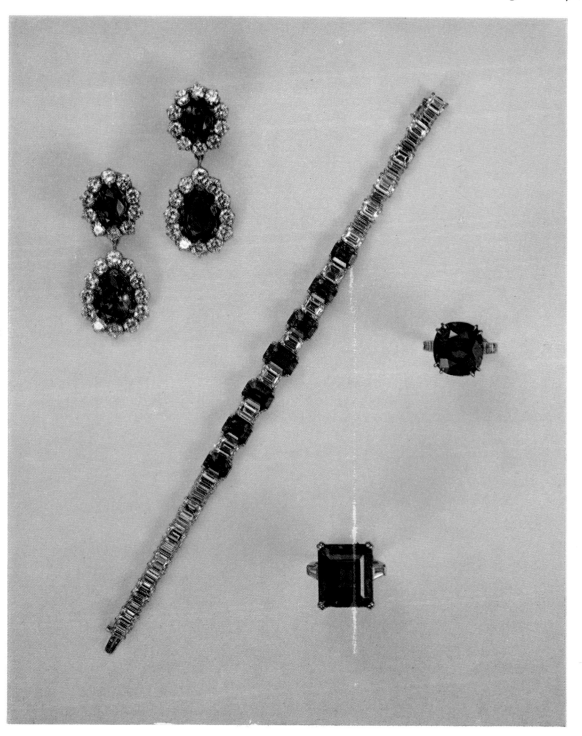

Antique diamond and pearl stomacher brooch
Sold 1.5.75 at the Hôtel Richemond, Geneva, for £10,000
(Sw. fr. 60,000)
This brooch was part of the jewels of Catherine the Great of
Russia. It was sold at Christie's, London, as part of the Russian
Crown Jewels on 16th March, 1927 (Lot 99) for £350

Antique diamond tiara
The three panels are detachable for use as brooches
Sold 12.3.75 for £4400 ($10,560)
From the collection of Lady Nabarro

Diamond necklace
forming a tiara
Sold 11.6.75 for
£40,000 ($92,000)
The 28 diamonds
formed two pendants
of the diamond comb
of the French Crown
Jewels and were
purchased by a
member of the present
owner's family in
1887. A painting in
the Royal Collection
by E. M. Ward
shows Empress
Eugénie wearing the
comb

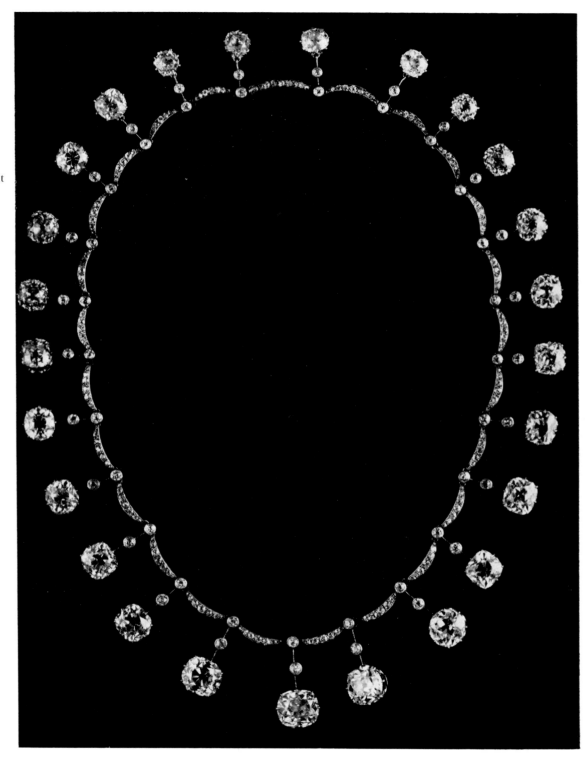

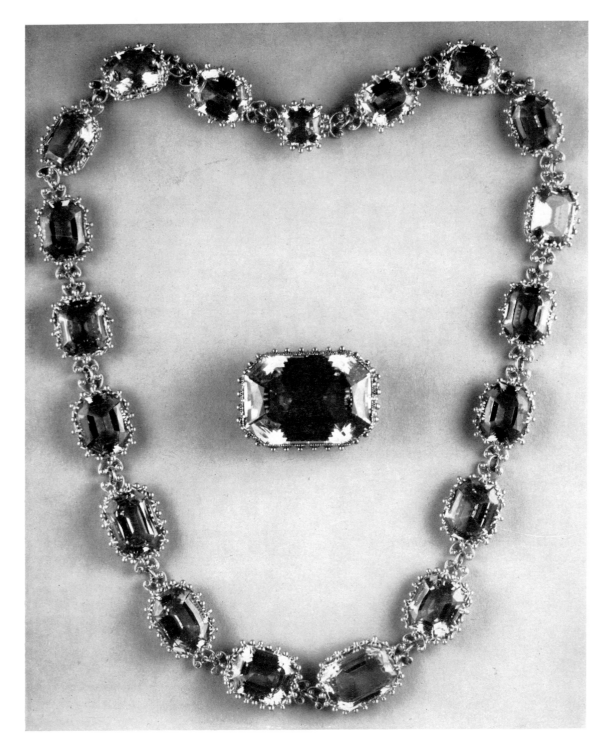

Topaz necklace
Sold 11.6.75 for
£7500 ($17,250)

Cut-cornered oblong
precious topaz
weighing c. 82.45 ct.
Set in a gold beaded
mount as a
single-stone brooch
Sold 11.6.75 for
£4400 ($10,120)

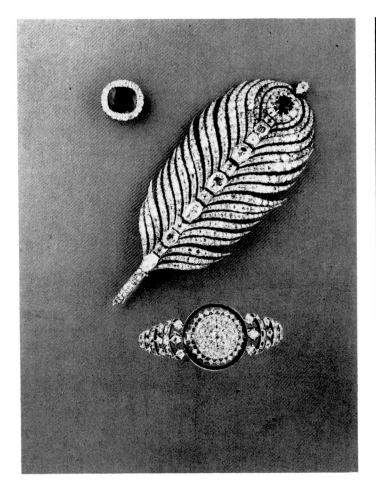

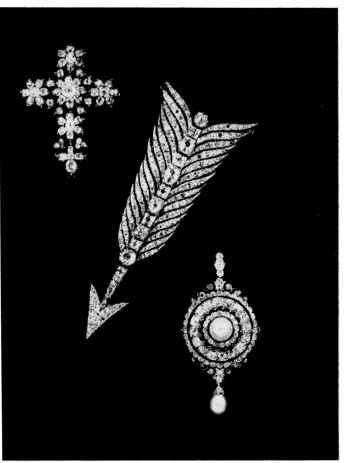

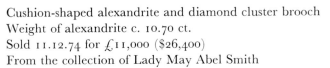

Cushion-shaped alexandrite and diamond cluster brooch
Weight of alexandrite c. 10.70 ct.
Sold 11.12.74 for £11,000 ($26,400)
From the collection of Lady May Abel Smith

Antique diamond and sapphire brooch
Sold 11.12.74 for £3600 ($8640)
From the collection of Sir Christopher R. P. Beauchamp, Bt

Antique diamond bracelet
The central diamond cluster is detachable for use as a brooch
Sold 11.12.74 for £480 ($1152)
From the collection of Sir Christopher R. P. Beauchamp, Bt

Antique diamond pendant cross
Sold 11.12.74 for £1600 ($3840)
From the collection of Sir Christopher R. P. Beauchamp, Bt

Antique diamond arrow brooch
Sold 11.12.74 for £1300 ($3120)
From the collection of Sir Christopher R. P. Beauchamp, Bt

Antique diamond and pearl brooch pendant
Sold 11.12.74 for £1000 ($2400)

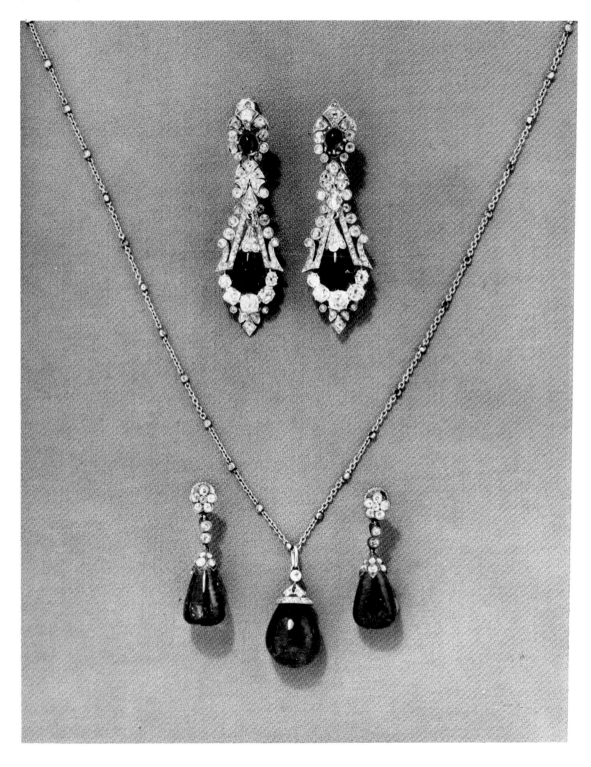

Pair of antique
emerald and diamond
pendant earrings
Sold 27.11.74 for
£6500 ($15,600)

Pair of cabochon
emerald and diamond
pendant earrings and
a pear-shaped
cabochon emerald
pendant on a
diamond and
platinum neckchain
Sold 27.11.74 for
£5500 ($13,200)
From the collection
of P. J. Stent, Esq

Pair of diamond pendant
earrings
Sold 11.6.75 for £14,000
($32,200)

Victorian diamond and pearl
necklace
Sold 11.6.75 for £2100
($4830)

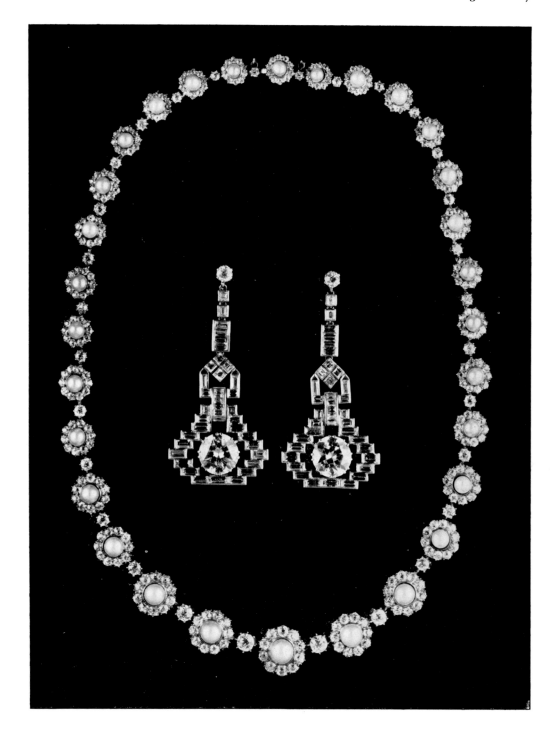

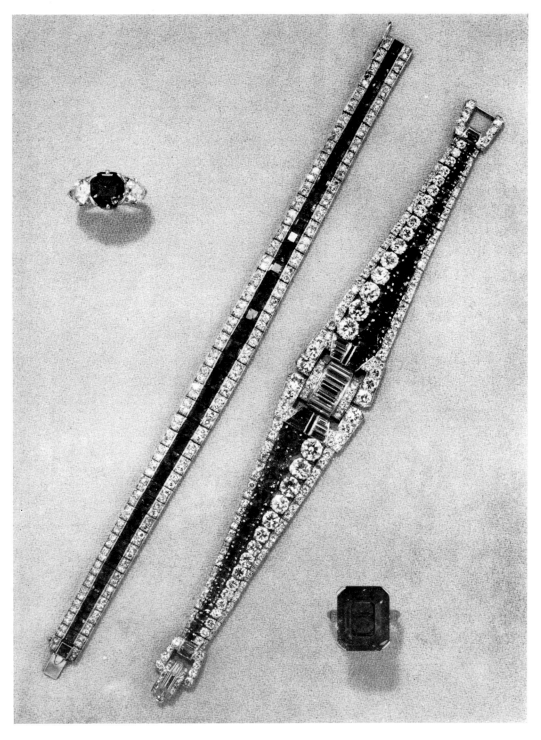

Emerald and diamond
ring, the emerald weighing
2.67 ct
£13,000 ($31,200)
From the collection of
The Countess of
Clanwilliam

Emerald and diamond
three-row tapered line
bracelet
£2000 ($4800)

Emerald and diamond
bracelet
£5200 ($12,480)

Rectangular sapphire
single-stone ring, the
sapphire weighing 25.96 ct.
£24,000 ($57,600)

All sold 2.10.74

Diamond and pearl
bracelet
£1800 ($4320)

Diamond brooch
£1500 ($3600)

Diamond brooch
£2400 ($5760)

All sold 12.3.75
All from the collection
of H.R.H. Princess
Alice, Duchess of
Gloucester,
CI, GCVD, GBE

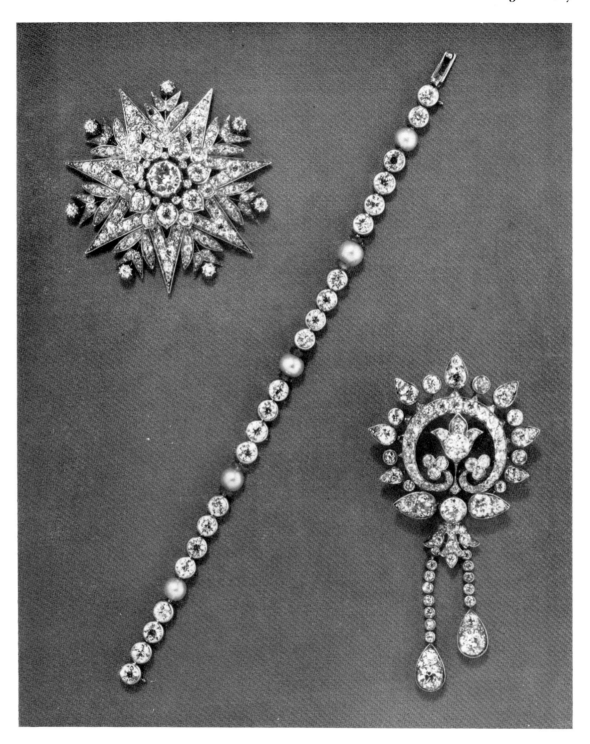

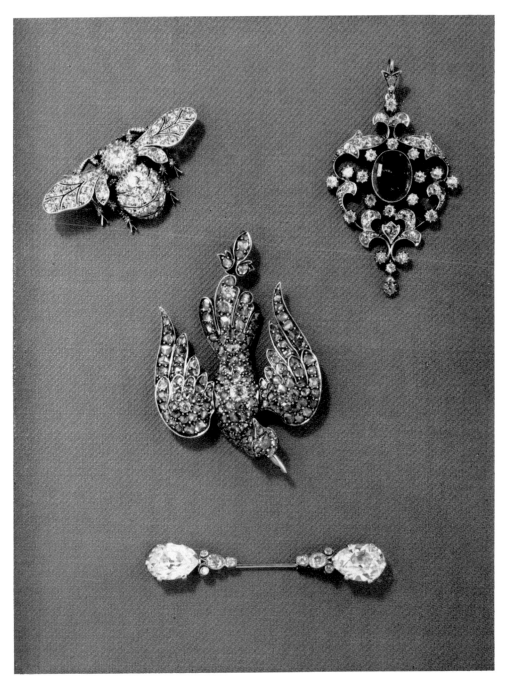

Victorian diamond bee brooch
£900 ($2160)

Antique emerald and diamond brooch pendant
£850 ($2040)

Antique diamond dove brooch pendant
£580 ($1392)

The above three from the collection of the late Mrs F. Mott

Important diamond sûreté pin
Weight of pear-shaped diamonds c. 6.43 and 6.38 ct.
£10,000 ($24,000)

From the collection of the late The Dowager Marchioness of Zetland

All sold 11.12.74

SILVER

Two great Royal silver sales

ARTHUR GRIMWADE

George IV's taste and patronage as the most prominent art-loving sovereign after Charles I is widely recognized in English art history, but his acquisition of a group of Continental examples of goldsmiths' work and a few early English pieces, still of course in the Crown Collection, is of relatively minor interest to his pictures and furniture. What has, however, hitherto passed unnoticed is that his taste in this sphere was shared very extensively by two of his younger brothers, Frederick Duke of York and Augustus Duke of Sussex, both of whom amassed remarkable groups of silver, both functional and display items, made for them by the leading English exponents of the day, and also earlier pieces, English or foreign, acquired from whatever sources were then available. Such were their activities as plate collectors that when they died, York in 1827 and Sussex, the last of the 'wicked uncles', in 1843, the sales entrusted by their executors to James Christie II in the first case, and his sons James and George and the Manson brothers in the second, each lasted four days.

How early in life the brothers developed their taste for plate it is impossible to determine, but it may well have been due in part to the enthusiasm and salesmanship of John Bridge, Philip Rundell's partner, the nephew of the sheep farmer Bridge of Dorset with whom George III, on his rides on his Weymouth holidays, had cultivated a pastoral acquaintanceship, to which happy accident Rundell and Bridge owed their appointment as Crown Goldsmiths. Be that as it may, the taste for collecting antique plate had already begun before the end of the 18th century, as is evidenced by the account in her diary by the Swiss girl Sophie von la Roche for 15th September, 1786 (*Sophie in London*, edited by Clare Williams, 1933). On that day she was taken to see the establishment of Jefferys and Jones, the then Crown Goldsmiths, in Cockspur Street and wrote ecstatically: 'We visited Messrs Jeffries' silver store . . . whose stock must be worth millions. I have never seen silver moulded into such noble, charming, simple forms . . . with the added pleasure of comparing the works of previous generations with up-to-date modern creations. These antique pieces, so Mr. Jeffries said, often find a purchaser more readily than the modern. This is because the English are fond of constructing whole portions of their country houses . . . in old Gothic style, and so are glad to purchase any accessions dating from the same or a similar period.'

A
CATALOGUE
OF THE WHOLE OF
THE MAGNIFICENT SILVER AND SILVER GILT
PLATE,
OF HIS ROYAL HIGHNESS,
THE DUKE OF YORK,
DECEASED;
Which (By order of the Executors,)
Will be Sold by Auction,
BY MR. CHRISTIE,
AT HIS GREAT ROOM,
NO. 8, KING STREET, ST. JAMES'S SQUARE,
On MONDAY, MARCH the 19th, 1827,
And Three following Days,
AT ONE O'CLOCK PRECISELY.

CATALOGUE
OF THE
TRULY MAGNIFICENT COLLECTION
OF ANCIENT AND MODERN
SILVER, SILVER GILT, AND GOLD
PLATE,
OF
HIS LATE ROYAL HIGHNESS
THE DUKE OF SUSSEX, K.G.,
AMOUNTING TO UPWARDS OF
FORTY THOUSAND OUNCES;
WHICH (BY ORDER OF THE EXECUTORS),
Will be Sold by Auction, by
Messrs. CHRISTIE & MANSON,
At their Great Room,
8, KING STREET, ST. JAMES'S SQUARE,
On THURSDAY, JUNE 22nd, 1843; on FRIDAY, JUNE 23rd;
on MONDAY, JUNE 26th; and on TUESDAY, JUNE 27th;
AT ONE O'CLOCK PRECISELY.
May be publicly viewed two days preceding, and Catalogues had, gratis, at
Messrs. CHRISTIE and MANSON's Offices, 8, King Street, St. James's Square.

The sales of the two brothers were remarkably similar in size and result, although their content in its relationship of relatively new and functional plate to obvious collector's pieces was markedly different. The York sale comprised 433 lots of which only 47 were categorized as 'Ancient' or 'Valuable Cabinet Vessels', the whole weighing a total of 45,153 ounces, painstakingly totalled up by the sales clerk of the day, and the total sum realized was £22,438. The Sussex sale sixteen years later amounted to 695 lots, of which over half appear to have been collector's pieces, but as many of these were small the total weight was less – 38,986 ounces – and the result roughly proportionate at £20,750. It will be noticed that the average price per ounce for the York sale was approximately 10s. and the Sussex figure only a trifle above this, but both sales contained a small admixture of plate, ormolu pieces and plate chests so these figures are broad indications only of the market of the day.

Both sales, it seems, were entirely without reserve and indeed a newspaper report of the first day of the York sale (W. Roberts, *Memorials of Christie's*) states so. After summarizing 'a short speech made by Mr. Christie' before the sale commenced, in which he eulogized the departed Duke 'warmly applauded by the company', the report continues: 'The chief purchasers, we understand, were silversmiths and persons

commissioned by gentlemen. The general opinion was that the articles did not bring near so much as they were worth intrinsically and certainly not as much as they cost, especially the massive silver-gilt plate. A magnificent cistern, 18½ in. in diameter, weighing 811 ozs., said by Mr. Christie to have cost his Royal Highness £1500 was sold for only 11/- an ounce.' This tour-de-force chased with Roman galley battle scenes reappeared in the sale of Lady Molesworth at King Street in 1888 when its price sank still further to 7s. 4d. per ounce (£295). It was then said to bear the hall-marks for 1785 but, since the York Catalogue stated that the piece was 'finely executed by Mr. Lewis' who can be identified as Kensington Lewis, the fashionable retailing goldsmith of St James's Street, it is clear that the date letter 'k' for 1825 was misread for the similar mark for 1785 (see John Culme, 'Kensington Lewis, A Nineteenth Century Businessman' in *The Connoisseur*, September 1975). The present whereabouts of this weighty piece of Royal extravagance is unknown to me.

Another item also stated to have been 'made' by Lewis was the remarkable gilt Hercules candelabrum bearing the maker's mark of Edward Farrell, 1824, weighing 1144 ounces, which reappeared at King Street in 1967 (see illustration on facing page). This the newspapers reported 'was knocked down for 6/- an ounce after Mr. Christie had dwelt a considerable time at that bidding. There was a murmur ran round the room of "How cheap" when the hammer fell. Mr. Christie said that the candelabrum was purchased by the late owner for the new Palace, which it pleased Providence that he was never to inhabit.' On its reappearance eight years ago as the property of Sir Clive Milnes Coates, in whose family it had remained since the York sale, this remarkable piece fared better than the cistern in 1888, since it realized £4800, being acquired by the American collector the late E. Ruxton Love, at a multiple of 14 over its 1827 price of £343.

Equally elaborate pieces, also by Farrell of 1824 and originally attributed to Lewis, are a pair of ewers chased with classical battle scenes and the arms of France. These, after the York sale (when, sold separately, each was pompously called 'A Grand Praefericulum') passed into another Royal Collection, that of the Duke of Cambridge, and reappeared at King Street on his death in 1904, when they advanced in price only to £418 from the figure of £279 in 1827, and returned again in an American collection in 1962 to realize £1900. With them on this occasion were two of an original set of four circular dishes with the supposed monogram and crown of Queen Anne, but again made by Farrell in 1825, which had been sold piecemeal in 1827 at around £65 each and as a pair in 1962 fetched £460.

In the third day's sale the most interesting lot to have been subsequently identified was 'A pair of very handsome fronts of Silver Dogs for burning wood . . . bearing the initials of King William' which were bought by John Bridge acting for George IV

The Hercules
Candelabrum
35 in. (85 cm.) high
By Edward Farrell
1824

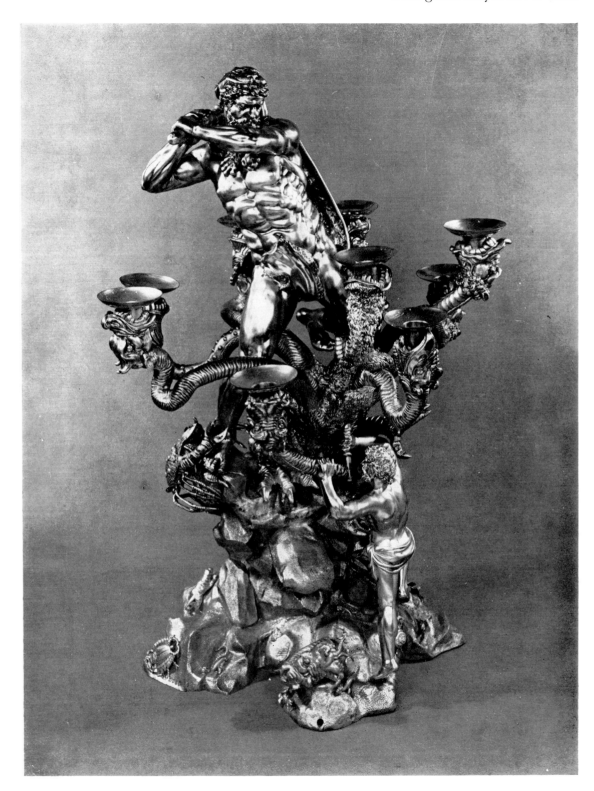

Silver-gilt bowl and cover
8 in. (20.3 cm.) wide
By Philip Rollos, 1710

for £118 8s. and are still in the Royal Collection. These, it was suggested by Mr Oman in the catalogue of the Royal Silver shown at the Victoria and Albert Museum in 1954, seem to have formed part of the silver furniture presented to William III by the City of London. Had they perhaps been given to Frederick Augustus by his father or how had he acquired them? Possibly from the sale of Royal plate in 1808 supposed to have been melted down by Rundell and Bridge to provide new plate for the Princess of Wales's establishment at Kensington Palace but known to have been sold to various clients. Also in the Royal Collection from the York sale is lot 47 of the fourth day's sale, 'A superb set of toilette plate which was formerly the property of Queen Anne' bought by Bridge for £500. This service, also shown in 1954, is in fact of a composite nature, the eight earliest pieces bearing a Britannia Standard maker's mark possibly that of Isaac Liger after 1696, while three other pieces are hallmarked for 1708.

Perhaps the loveliest of the pieces which have been identified on reappearance is the gilt oval bowl and cover with the arms and cypher of Queen Anne by Philip Rollos, 1710, sold in the Brownlow Collection in 1963 and now in an American private collection (see illustration above). Its identity is made certain both from the 1827 description, 'A beautiful oval sugar bason and cover with gadrooned edges; the bowl of the vessel enriched with scrollwork in relief: weight 35 ozs. 5 dwts. N.B. this was formerly the property of Her Majesty, Queen Anne', and from the fact that when it reappeared twelve years ago its weight proved to be 35 ounces 4 dwts. In 1827 its modest price was 18s. per ounce or £31 14s. 6d. In 1963 the winning bid was £3800.

Wine cistern
35 in. (85 cm.) wide
By James and Elizabeth Bland
1794

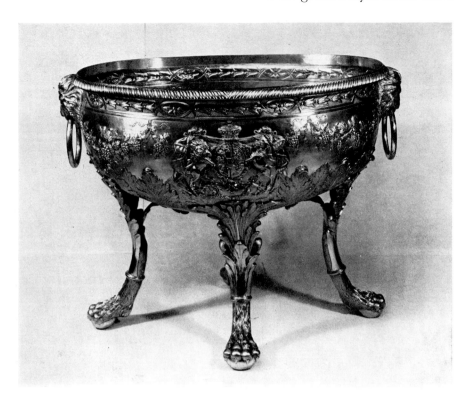

More could be said of other reappearances from the York sale but it is time to consider that of his brother Sussex in 1843. As already mentioned, this showed a far greater preponderance of collector's pieces than that of the Duke of York and indeed Sussex was an omnivorous collector in many fields as is shown by the sales which followed the Silver Collection in June and July of that year. One day of Portraits, Miniatures and Engravings; five days of Rings, Seals, Snuff Boxes and Fowling Pieces; one day of Clocks, Chronometers and Watches; three of Furniture, Porcelain, Bronzes and Statuary, and as a tailpiece 'The Unrivalled Collection of Pipes, Havannah, Cigars and Manilla Cheroots' lasting three days!

From the identification of pieces that has so far proved possible, and indeed from the catalogue itself, it seems that York's liking for the elaborate baroque style of large decorative pieces was not particularly shared by his younger brother and that the latter's taste was more eclectic. His largest piece was a wine cistern now known to be by James and Elizabeth Bland, 1794, weighing 1177 ounces, sold in 1843 for 5s. 9d. per ounce (£338) which reappeared at King Street in the collection of Sir Edward Hussey Packe in 1947 and returned again in Mr L. T. Locan's collection in 1962 when it sold for £3400 (see illustration above). It seems that, like York, Sussex may have made purchases from Rundell and Bridge of the Royal plate dispersed in 1808 since

Pair of Charles II firedogs
18 in. (46 cm.) high
c. 1670, maker's mark G.C.

the sale included the pair of firedogs with Crown and cypher of Charles II, wrongly thought in 1843 to be that of his father, then bought by Garrard's for £123, which can be identified with the pair offered in the Brownlow Collection in 1963 when the same firm rebought them for £8800 (see illustration above). Apart from the description, the identity is confirmed by the fact that in 1843 they were sold 'with branches for two lights each projecting in front' being then termed 'Sideboard Stands' and the Brownlow firedogs had been pierced at the fronts with two holes through which branches had obviously been attached.

Several other items of Royal association may be mentioned, suggesting that, rather like the late Queen Mary, Sussex was considerably interested in objects which had family connections. The first are two gilt salvers engraved with the Exchequer Seal of William and Mary, one of 1687 which after selling for £102 in 1843 returned to King Street in 1929 to realize £558 and the other a heavier copy by David Willaume, 1726, which curiously only fetched £73 in the Sussex sale and is now part of the Schiller Bequest of the Inner Temple. Another item which is almost certainly a further example of 'Seal Plate' was 'A Superb Chalice and Cover, surmounted by the fleur de lys and engraved with the royal arms and the cypher of William and Mary 25 in. high from the Lansdowne Collection, 146 ozs. 10 dwts.' which sold for £87 and reappeared in 1917, when its significance was still apparently unrecognized, realizing £452. I am ignorant of its present location. Twenty lots later in the sale appeared 'The Superb Irish Cup, with angles forming harp handles, on either side is inlaid a large medallion

of George II, enthroned'. This medallion, as the cup's reappearance in 1920 established, is a representation of the Great Seal of Ireland, and the cup, by Samuel Walker of Dublin, c. 1750, is no less than 20 inches high and weighs 198 ounces. Surprisingly it advanced from £108 in 1843 to only £183 in 1920. Where is it now?

The final Royal piece to recall is the wonderful Culloden tankard, now one of the treasures of the National Army Museum, with its engraved view of the battle and the flight of Prince Charlie from the scene. This appeared as lot 566 in the Sussex sale, 'A Noble Tankard' – a fitting adjective indeed – 'Supported on lions, with a lion on the cover' etc., and was bought by the firm of Town and Emanuel. After that all was silence until it reappeared in 1968 to be sold for the Countess of Breadalbane for £12,000 ($28,800) to a private collector and was subsequently acquired for its final resting place in Chelsea.

One of the earliest identifiable pieces of English silver in the Sussex Collection was the Elizabethan standing salt of 1584 engraved with the inscription 'The Gift of the Cittie for ever, Thomas Varham' which then cost Town and Emanuel £100. This imposing example 11½ in. high and weighing over 31 ozs. reappeared from an anonymous source at King Street in 1895, being bought for £485 by the leading dealer Durlacher, and was acquired soon after by the great J. Pierpont Morgan to be subsequently sold in his son's sale in 1947 in New York. It is, one presumes, still in America.

These then are a few of the pieces which Augustus, Duke of Sussex, that liberally minded Royal patron of the arts and sciences, brought together in the early days of silver collecting in this country. But there are many more tantalizing entries in the catalogue which remain to be identified. Where or what, for instance, is 'A Superb and very elegant Tea urn 2 feet high, chased with masks, medallions and terminal ornaments in the beautiful taste of Paul l'Emery' (the first reference to Lamerie, I believe, in print after his death in 1751); or 'The Irish Gold [sc. gilt] Inkstand of William III in a plain oblong dish engraved with the arms and cypher of King William'; or rather more exotically 'A Superb Coffee Pot of solid gold of fine Indian work, with figures of Vishnu, the handle formed of a superb piece of steatite, with two jewelled ornaments suspended by a chain; this splendid gold cup originally belonged to the King of Candy, the gold weighs about 41 ozs.' One is baffled, as one reads, by the lack of information which, had they been then understood, the mention of the marks would instantly convey. But perhaps, after all, the real fascination to us today is the delightful game of hide and seek the pieces of these two great Royal Collections play with us as we turn the time-worn pages of their catalogues in our archives, and from time to time succeed in connecting the charming descriptions of that day with an actual example before our eyes.

Left: Pair of James II parcel-gilt beakers
3⅛ in. (7.9 cm.) high
1688, maker's mark RS mullet below
Sold 27.11.74 for £2000 ($4800)
From the collection of the
Mildmay-White Family Trust

Below: Elizabeth I silver-gilt mounted tigerware jug
10 in. (25.5 cm.) high
By Thomas Mathew, Barnstaple, c. 1580
Sold 21.5.75 for £1800 ($4140)
From the collection of G. S. Sanders, Esq

Below: Commonwealth cylindrical tankard
6 in. (15.2 cm.) high
By James Plummer, York, 1648
Sold 21.5.75 for £7800 ($17,940)
From the collection of G. S. Sanders, Esq

William and Mary tankard and cover
6¼ in. (15.9 cm.) high
By Augustin Float, Gateshead, c. 1690
Sold 27.11.74 for £5600 ($13,440)

William and Mary two-handled porringer and cover
6½ in. (16.5 cm.) high
1689, maker's mark PR in cypher
Sold 27.11.74 for £2600 ($6240)

One of a pair of Queen Anne
silver-gilt salvers
11½ in. (29.3 cm.) diam.
By Philip Rollos, 1705
Sold 25.6.75 for £9000 ($20,700)
From the collection of
Palladio Stiftung

Queen Anne silver-
gilt octagonal castor
8¾ in. (22.2 cm.) high
By Jacob Margas
1713
Sold 25.6.75 for
£6200 ($14,260)

Queen Anne
silver-gilt Great Seal
cup and cover
Maker's mark only
probably a variation
of that of
Philip Rollos
Sold 26.3.75 for
£3000 ($7200)
From the collection of
Mrs R. L. Cameron

Queen Anne wine
fountain and wine
cistern
27½ in. (69.9 cm.)
high and 27¼ in.
(69.2 cm.) long
respectively
By William Lukin
1707
Sold 25.6.75 for
£19,000 ($43,700)
Sold on behalf of the
Trustees of The Most
Hon. The 3rd
Marquess of
Linlithgow, MC

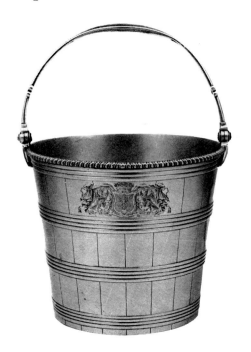

Left: One of a pair of George III wine-coolers
7 in. (17.8 cm.) high
By Thomas Heming, 1766
Sold 25.6.75 for £5200 ($11,960)

Below left: George II vase-shaped coffee-pot
11 in. (28 cm.) high
By James Schruber, 1749
Sold 25.6.75 for £3900 ($8970)
From the collection of Sir Ian Walker-Okeover, Bt, DSO

Below right: George II two-handled vase-shaped cup and cover
11¾ in. (30 cm.) high
By George Wickes, c. 1735
Sold 26.3.75 for £3500 ($8400)
From the collection of
Maj.-Gen. Sir George Burns, KCVO, CB, DSO, OBE, MC

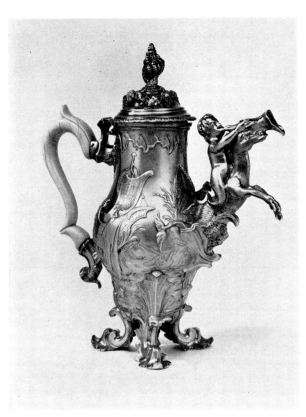

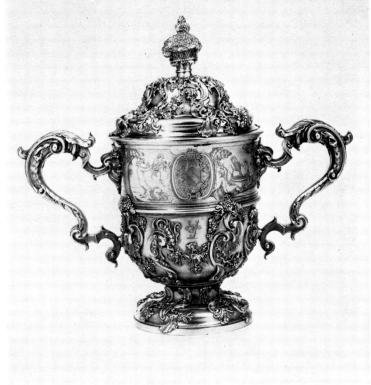

One of a pair of
Victorian wine-coolers
12 in. (30.5 cm.) high
By Mortimer and Hunt
1842
Sold 27.11.74 for £3600
($8640)
From the collection of
the late Captain
W. S. Mitford
Sold with these was the
original pencil and
watercolour design and
an alternative
preparatory sketch

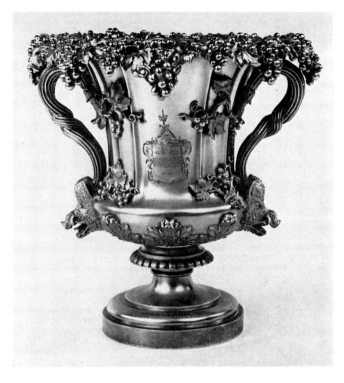

One of a set of nine George III
silver-gilt oval dessert-dishes
Six 11¾ in. (29.8 cm.) long
Two 13 in. (33 cm.) long
One 14¾ in. (37.5 cm.) long
By Thomas Pitts
1771 and 1772
Sold 15.7.75 for £2600
($5720)
From the collection of
The Earl of Radnor

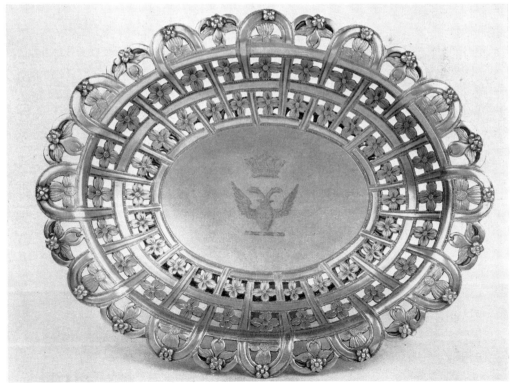

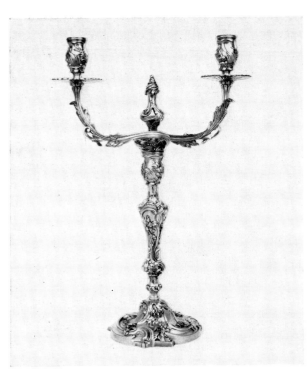

One of a pair of George III two-light candelabra
19¼ in. (49 cm.) high
By William Tuite, 1764
Sold 21.5.75 for £3400 ($7820)

Below left: One of a pair of Regency four-light candelabra
28¾ in. (73 cm.) high
By Paul Storr, 1810
Sold 29.4.75 at the Hôtel Richemond, Geneva, for £7000
(Sw. fr. 42,000)

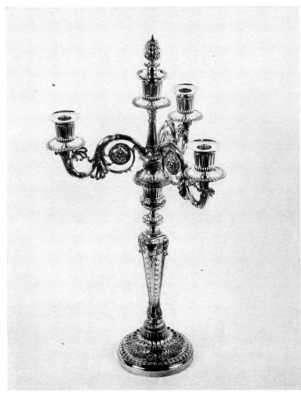

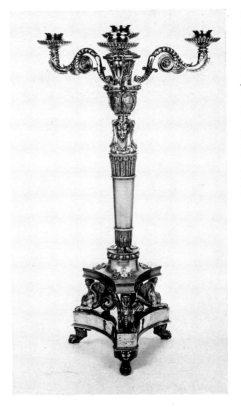

One of a pair of
George III candelabra
34½ in. (87.6 cm.) high
By Benjamin and
James Smith, 1806
The nozzles 1809
Sold 15.7.75 for
£14,500 ($31,900)
From the collection of
The Lord Barnard, TD
Removed from
Raby Castle

Two of a set of six Regency silver-gilt
wine-coasters
$5\frac{1}{4}$ in. (13.2 cm.) diam.
By Paul Storr, 1814
Sold 25.6.75 for £10,500 ($24,150)
Sold on behalf of the Trustees of the
Lonsdale Settled Estates

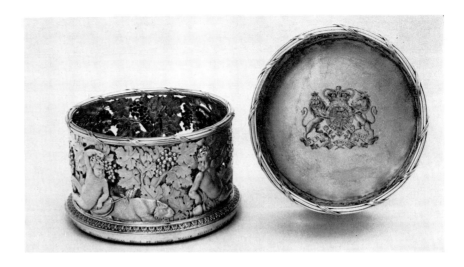

Regency large two-handled tea-urn
16 in. (40.6 cm.) high
By Paul Storr, 1813
Sold 26.2.75 for £2700 ($6480)
From the collection of
Sir Ian Macdonald of Sleat, Bt

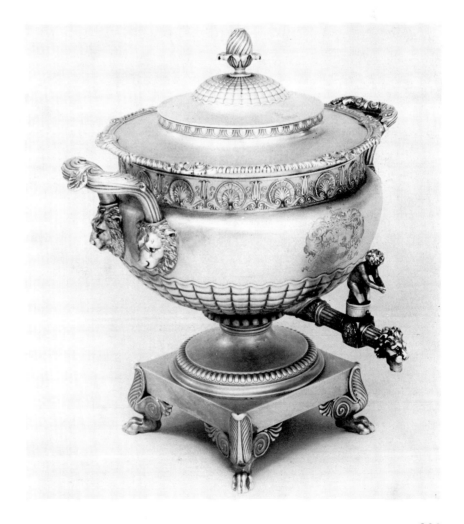

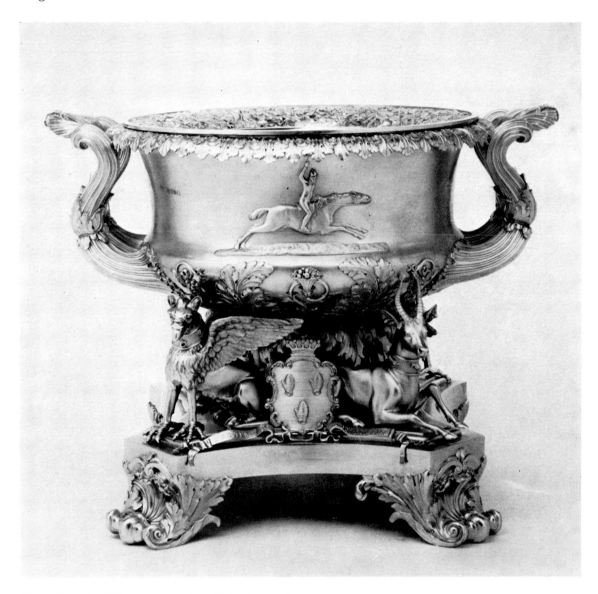

One of a pair of Regency two-handled wine-coolers
10⅞ in. (27.7 cm.) high
By Paul Storr, 1817
Sold 15.7.75 for £13,000 ($28,600)
From the collection of The Lord Barnard, TD
Removed from Raby Castle

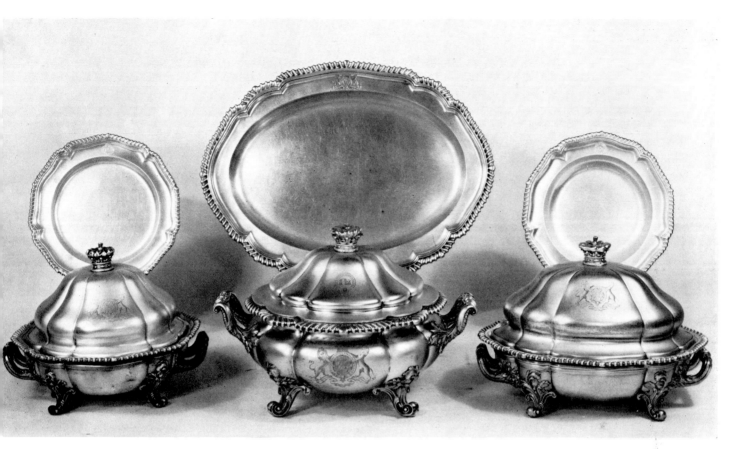

Victorian dinner-service, comprising 101 pieces
By J. Mortimer and J. S. Hunt, 1842
Sold 15.7.75 for £26,000 ($57,200)
From the collection of The Lord Barnard, TD
Removed from Raby Castle

A private sale of Royal plate

CHRISTOPHER PONTER

Many visitors to the Victoria & Albert Museum in recent years will have wondered at the unique pair of silver-gilt caddinets (illustrated opposite) which were on loan from the Lonsdale Collection. Indeed, it was only when they were exhibited in Stockholm in 1958 that Charles Oman embarked on research which revealed the true nature and status of these pieces which had long been regarded as inkstands (*Burlington Magazine*, December 1958). Introduced into England in very limited numbers from France, these caddinets (or cadenas) were used for containing the table utensils of royalty and other high nobility, and the earliest Inventory of Royal plate in the Jewel House, dated 19th March, 1687, shows there were then 'Five Cadenatts guilt' weighing 425 ozs. However, the only known public occasion on which these caddinets appeared was the Coronation banquet of William and Mary on 11th April, 1689, and it is of particular interest that the caddinet of 1688–89 by Anthony Nelme carries a variant of the Royal Arms. Here the second supporter is not the Scottish unicorn, but the Tudor dragon, and may be explained by some hesitancy on the part of the engraver to prejudice the decision (which came on Coronation Day) of the Scottish Convention Parliament to accept the new Sovereigns. One other example of this variant appears on the cruet jug also in the Lonsdale Collection.

When the Trustees of the Lonsdale Settled Estates approached Christie's to advise on the most appropriate method of selling these articles, it was a matter of careful judgment to decide whether it was better to seek a spectacular price at auction or to seek to persuade one of the public collections to enter into a private treaty sale.

As the caddinets had been conditionally exempted from Estate Duty in the past, the Trustees were advised to take advantage of the tax rebate available in private treaty negotiations. It was thought appropriate that these articles, if possible, should re-join the various items of Royal plate at present on display with the Royal regalia in the Jewel House of the Tower of London, and thus negotiations were commenced, and successfully concluded, with the Secretary of State for the Environment, utilizing his powers under the Historic Buildings and Ancient Monuments Act.

We at Christie's are proud that we have thus been instrumental in ensuring that these unique examples of Royal plate remain part of the national heritage.

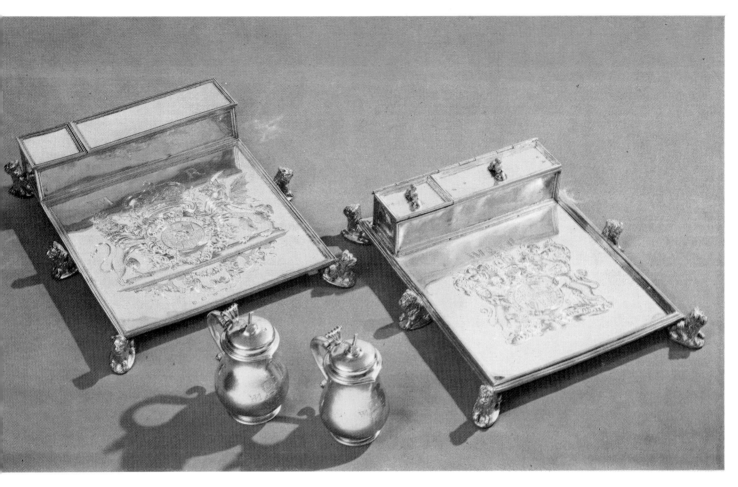

Pair of 17th-century silver-gilt caddinets for which a private sale was negotiated on behalf of the Trustees of the Lonsdale Settled Estates. The caddinets, which are a unique example of Royal plate, are now on display in the Jewellery House of the Tower of London

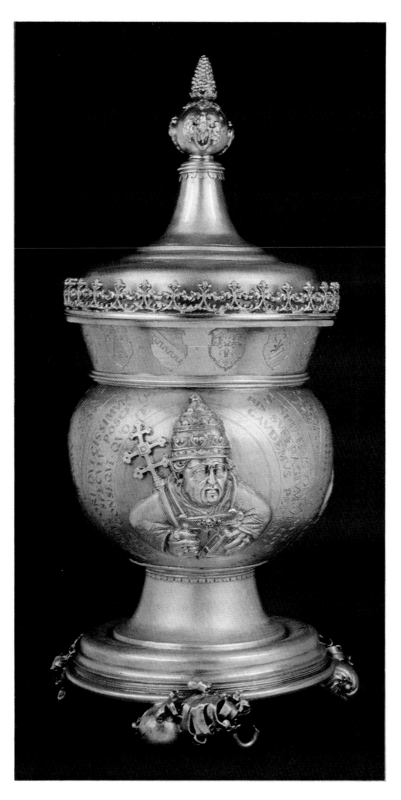

The 'Martinus Napf'

This rare silver-gilt cup made in Münster in the second half of the 16th century is known as 'Martinus Napf' and the cup comes from the Convent of St Martin, Münster, Westphalia. The lip is engraved with the coat-of-arms of the Prior, Deacon and Canons resident in the Convent in 1597, while on the bowl of the cup there are plaques of St Paul, patron saint of the Archbishopric of Münster, St Martin, patron saint of the Convent, and St Gregory. It is not possible to attribute with certainty the maker of the cup but it is most probably the work of either Joachim Schrewe or Johann Schouw who are known to have worked in Münster during the late 16th century.

The archives of the Chapter of St Martin mention the cup's existence in 1754, 1758 and 1784. It was thought mistakenly that the cup had been melted down in 1811, only to reappear after an absence of over 150 years at Christie's sale in Geneva. It is now in the Münster Museum.

Highly important and rare silver-gilt standing cup and cover
13 in. (33 cm.) high
By Joachim Schrewe or Johann Schouw, Münster, second half 16th century
Sold 29.4.75 at the Hôtel Richemond, Geneva, for £20,000 (Sw. fr. 120,000)

German parcel-gilt
cylindrical flagon
12⅝ in. (33 cm.) high
Probably Lübeck or
Königsberg, c. 1580
Sold 19.11.74 at the
Hôtel Richemond,
Geneva, for £5719
(Sw. fr. 35,000)

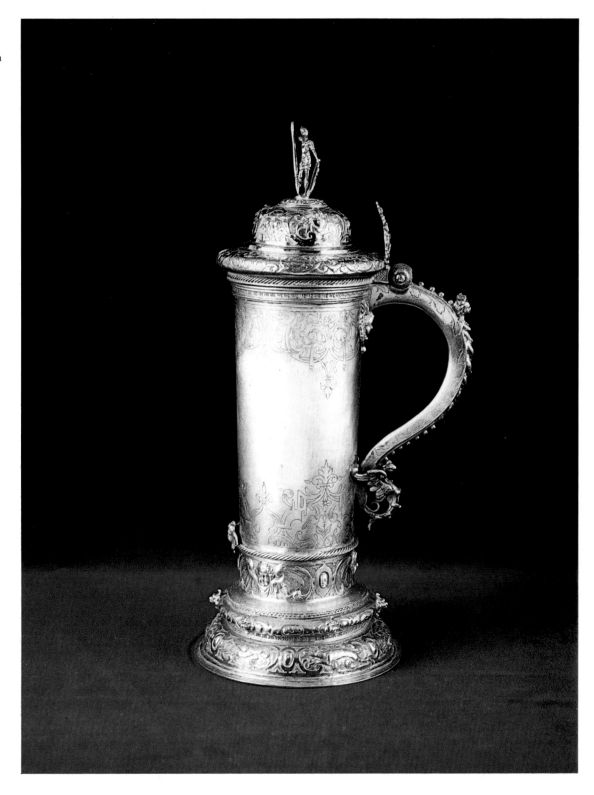

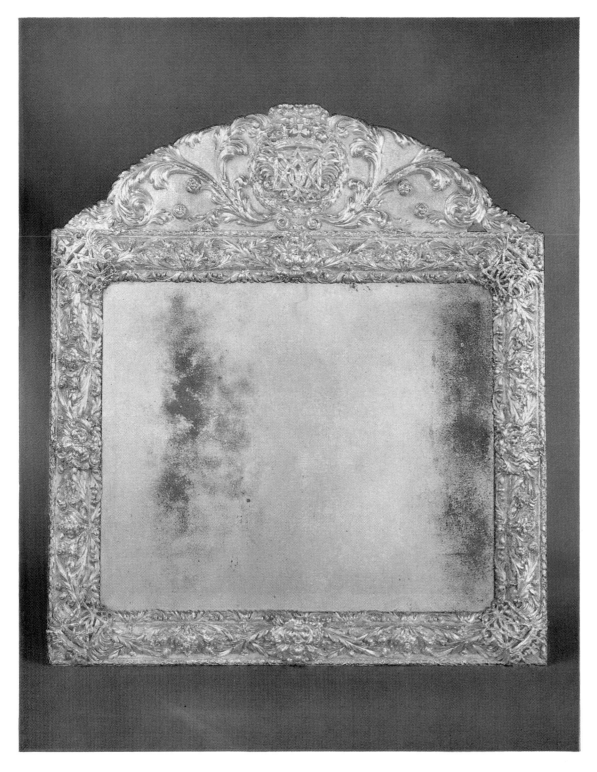

Louis XIV silver-gilt
toilet-mirror
$22 \times 20\frac{1}{8}$ in.
(56×51 cm.)
Paris, 1660, maker's
mark indistinct,
possibly a fleur de lys
and crown, struck
twice with two date
letters
Sold 29.4.75 at the
Hôtel Richemond,
Geneva, for £50,000
(Sw. fr. 300,000)
See also foot of
facing page

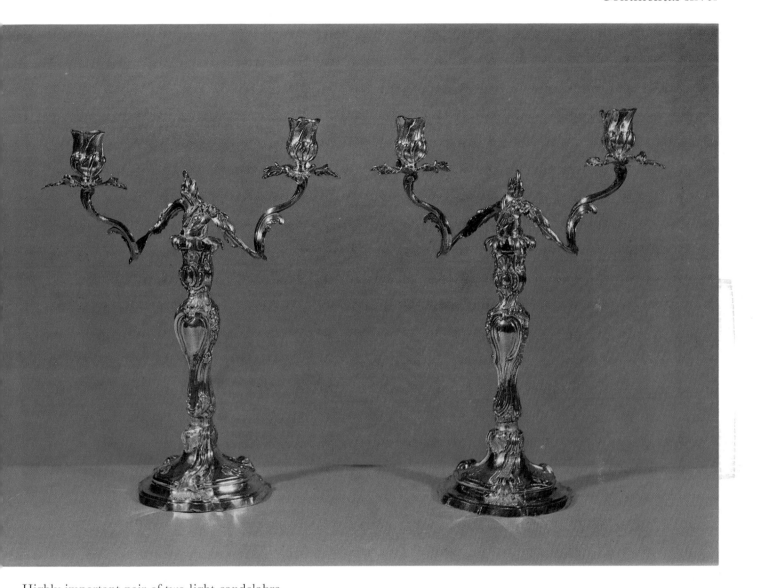

Highly important pair of two-light candelabra
14⅝ in. (37 cm.) high
Turin, c. 1780
Sold 14.3.75 at the Palazzo Massimo Lancelotti, Rome, for £17,612 (L. 27,000,000)

The Louis XIV silver-gilt mirror (opposite) appears to have been made for James, Duke of York, later James II, as part of his wedding present to Anne Hyde. The mirror has a frame boldly embossed with baroque foliage, which is much finer than the similar foliage of a comparable London-made toilet service of the Charles I period. It is not surprising that the Duke of York should have turned to a Parisian goldsmith for his wife's toilet service. The London goldsmiths were not likely to have had one in stock, nor had they been called upon to supply anything so luxurious in the preceding years of the Commonwealth

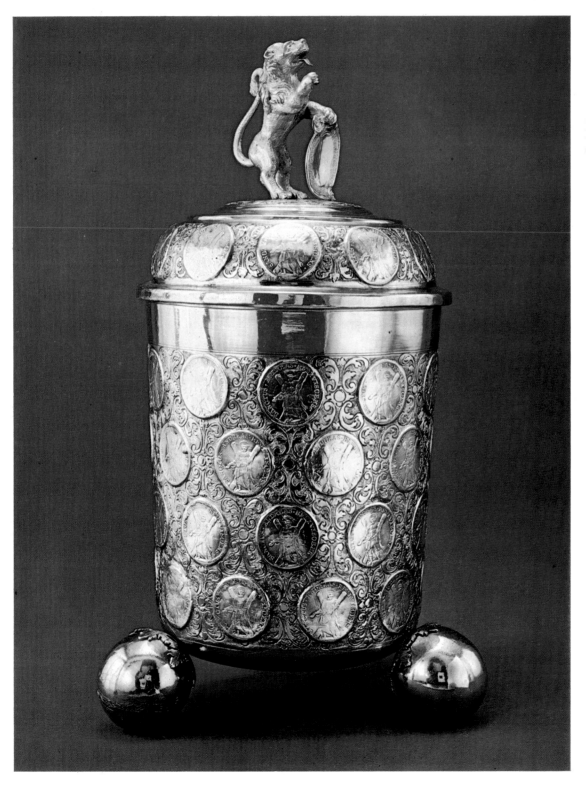

German large parcel-gilt beaker and cover
9 in. (23 cm.) high
Leipzig, c. 1711
Maker's mark perhaps that of F. C. Stevens
Sold 19.11.74 at the Hôtel Richemond, Geneva, for £3595 (Sw. fr. 22,000)

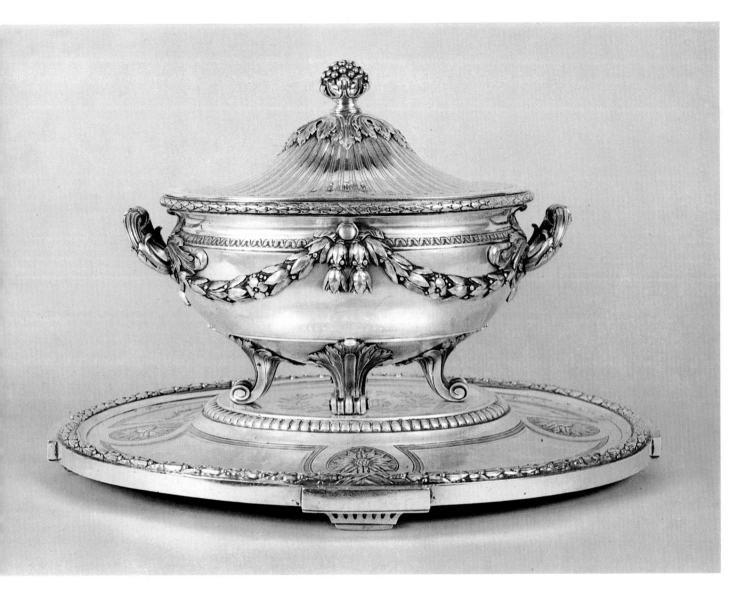

Louis XVI soup-tureen, cover and stand
Tureen 12⅝ in. (32 cm.) long, stand 20⅞ in. (53 cm.) long
By Robert-Joseph Auguste, Paris, 1779 and 1780
The arms are those of the Dukes of Cadaval, Portugal
Sold 19.11.74 at the Hôtel Richemond, Geneva, for £15,523 (Sw. fr. 95,000)

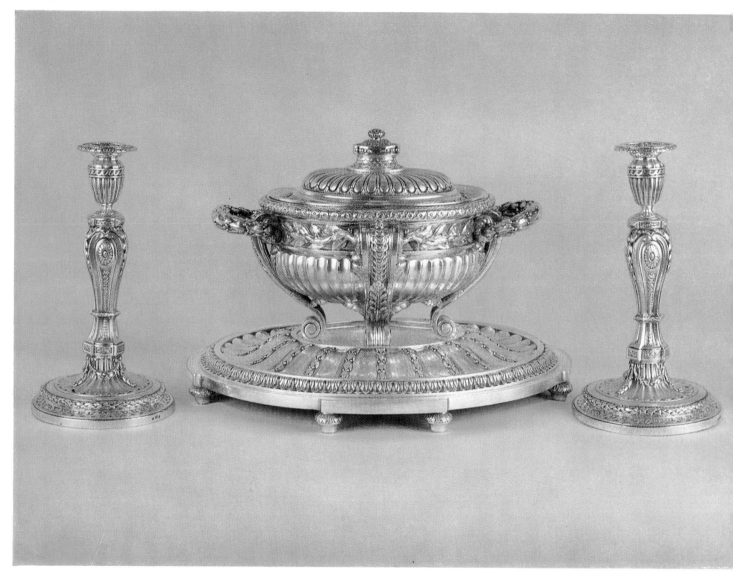

Louis XV soup-tureen and stand from the Orloff service
13⅛ in. (33.5 cm.) high, stand 19⅝ in. (50 cm.) wide
By Jacques Nicolas Roettiers, Paris, 1770, with the
poinçons of Julien Alaterre and St Petersburg counter
marks for 1784 with assay mark of Nikofor Moschtjalkin
Sold 29.4.75 at the Hôtel Richemond, Geneva, for
£103,333 (Sw. fr. 620,000)

Pair of Louis XV table-candlesticks
12⅝ in. (32 cm.) high
By Julien Nicolas Roettiers, Paris, 1771 and 1772, with
the poinçons of Julien Alaterre and St Petersburg counter
marks for 1784 with assay mark of Nikofor Moschtjalkin
Sold 29.4.75 at the Hôtel Richemond, Geneva, for
£23,333 (Sw. fr. 140,000)

The Orloff service

This Louis XV soup-tureen – strictly known as a *pot à oille* and used for a soupy stew popular at the time – and the pair of candlesticks are from the service of 3000 pieces made by Jacques Roettiers and his son Jacques Nicolas, the most fashionable of the Parisian silversmiths during the second half of the 18th century.

The service was originally made for Catherine the Great, but by the time it was completed she decided to present it to Count Gregory Orloff, who had become her lover and remained so for ten years. Orloff and his brothers played an important part in deposing Catherine's husband, Peter III, and it is thought that Peter's assassination by Alexei Orloff was designed to enable the Empress to marry Gregory. She declined to do so, however, and to appease Gregory's fits of temper she gave him expensive presents. One of these was the vast silver service which since then has always been known as the Orloff service.

Ironically Gregory hardly had time to enjoy Catherine's gesture. By 1776 the Tzarina had tired of him and he left Russia for Holland. Returning to his native country in 1782 he discovered that his place at Court had been taken by his friend Gregory Potemkin; filled with disillusionment he died the following year.

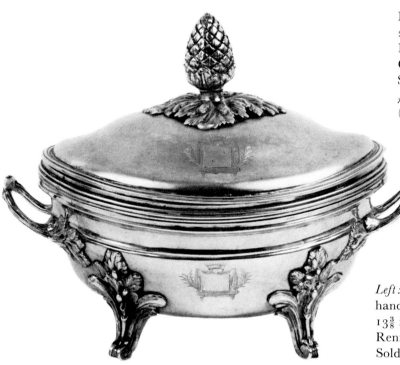

Louis XV egg-cup
2⅞ in. (7.3 cm.) high
By François-Thomas
Germain, Paris, 1762
Sold 29.4.75 for
£5000
(Sw. fr. 30,000)

Left : One of a pair of Louis XV two-
handled oval soup-tureens and covers
13⅜ in. (34 cm.) long
Rennes, 1772
Sold 29.4.75 for £10,833 (Sw. fr. 65,000)

Below : One of a pair of Louis XVI wine-coolers
8⅞ in. (22.5 cm.) high
By Robert-Joseph Auguste, Paris, 1779 and 1780
Sold 29.4.75 for £15,000 (Sw. fr. 90,000)

One of a pair of silver-gilt
sauceboats
Base 9⅞ in. (25 cm.) long
By J. B. C. Odiot, Paris
c. 1820
Sold 29.4.75 for £4333
(Sw. fr. 26,000)

All sold at the Hôtel
Richemond, Geneva

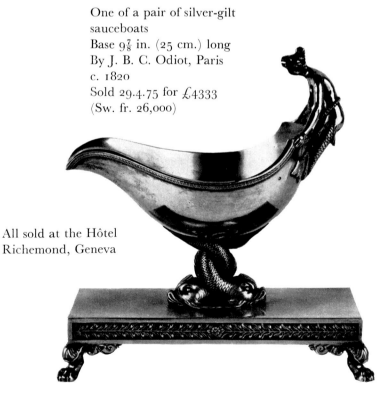

Pair of Louis XIV table-candlesticks
6¾ in. (17 cm.) high
By Jean Chabrol, Paris, 1711
Sold 29.4.75 at the Hôtel Richemond,
Geneva, for £6333 (Sw. fr. 38,000)

Pair of Louis XIV table-candlesticks
9 in. (22.9 cm.) high
Paris, 1710–11, maker's mark NOB
presumably for Nicolas Outrebon
Sold 27.11.74 for £4300 ($10,320)

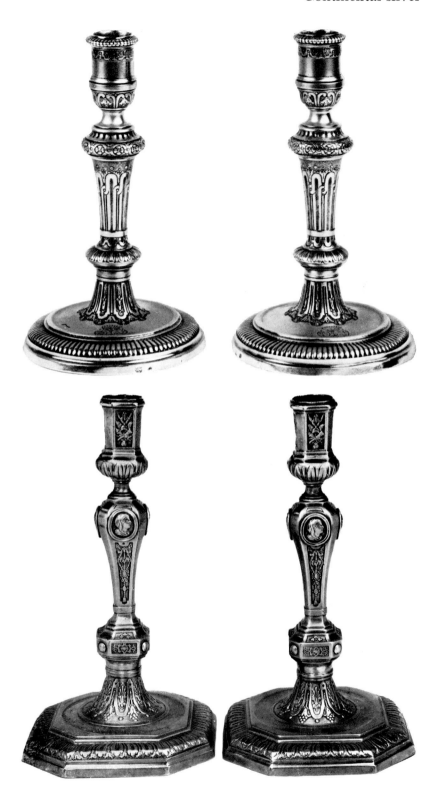

German parcel-gilt tankard and cover
7 in. (17.8 cm.) high
Augsburg, c. 1670, maker's mark SM
Sold 15.7.75 for £2300 ($5060)

Estonian parcel-gilt cylindrical tankard
8¼ in. (20 9 cm.) high
Dorpat, c. 1700, maker's mark CRL
Sold 26.3.75 for £2600 ($6240)

Pair of German parcel-gilt cylindrical tankards
and covers
9¼ in. (23.4 cm.) high
1660, Probably Hamburg, maker's mark HG
in script
Sold 25.6.75 for £5600 ($12,880)
From the collection of The Earl of Radnor

Pair of German silver-gilt mounted Kunckel-
glass pilgrim-bottles
14⅞ in. (37.8 cm.) high
Augsburg, c. 1700, maker's mark TD
Sold 25.6.75 for £7200 ($16,560)
From the collection of the late Maj.-Gen.
Sir Harold A. Wernher, Bt, GCVO, TD
Sold by order of the Executors

Silver-gilt ewer and basin
Ewer 10⅝ in. (27 cm.) high, dish 19⅝ in. (50 cm.) diam.
By one of the Peffenhauser family, Augsburg, c. 1720
Sold 29.4.75 at the Hôtel Richemond, Geneva, for £7500 (Sw. fr. 45,000)

Left: Vase-shaped
fluted coffee-pot
14¼ in. (36 cm.) high
Probably Ancona
c. 1770
Sold 14.3.75 at the
Palazzo Massimo
Lancellotti, Rome, for
£3913 (L. 6,000,000)

Right: Italian fluted
pear-shaped coffee-pot
10¼ in. (26 cm.) high
Genoa, 1770
Sold 11.11.74 at the
Grand Hotel, Rome,
for £3219
(L. 5,000,000)

Left: Chocolate-pot
11 in. (28 cm.) high
By Esajas Busch
Augsburg, c. 1730
Sold 29.4.75 at the
Hôtel Richemond,
Geneva, for £4000
(Sw. fr. 24,000)

Right: Pear-shaped
chocolate-pot
9⅞ in. (25 cm.) high
Turin, c. 1760
Sold 14.3.75 at the
Palazzo Massimo
Lancellotti, Rome, for
£12,394
(L. 19,000,000)

Dutch octagonal tobacco-box
5¼ in. (13.3 cm.) long
By Leendert Beekhuysen, Amsterdam, 1756
Sold 26.3.75 for £1200 ($2880)

Dutch spherical pomander
Unmarked, c. 1580
Sold 26.3.75 for £900 ($2160)

Norwegian cylindrical tankard
8⅞ in. (22.5 cm.) high
Kristiania (later Oslo), c. 1600, maker's mark a skull
Sold 29.4.75 at the Hôtel Richemond, Geneva, for
£8667 (Sw. fr. 52,000)

Russian silver-gilt charger
22 in. (56 cm.) diam.
By Iwan Sajezev, 1826
Sold 29.4.75 at the Hôtel
Richemond, Geneva, for
£3667 (Sw. fr. 22,000)

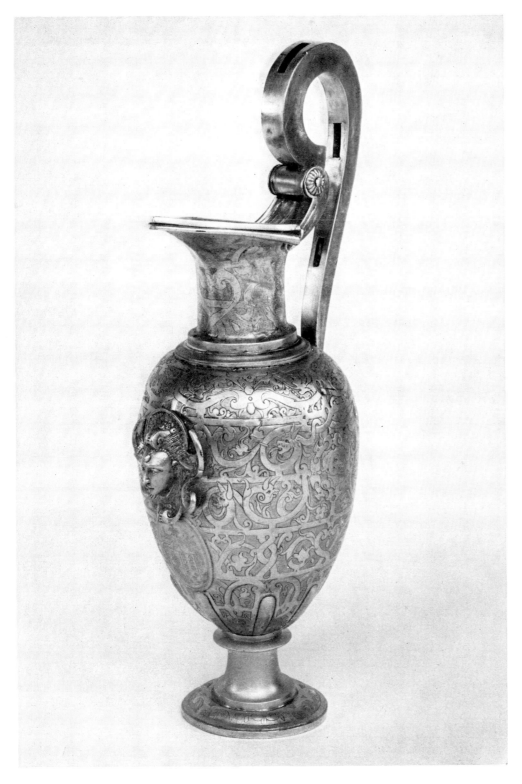

Spanish silver-gilt vase-shaped
ewer
16 in. (40.5 cm.) high
c.1600
Sold 19.11.75 at the Hôtel
Richemond, Geneva, for
£5484 (Sw. fr. 34,000)

OBJECTS OF ART AND VERTU, ICONS, COINS, ANTIQUITIES AND ETHNOGRAPHICA

Needlework portrait of *Charles I*
3½ in. (8.8 cm.) high
Believed to have been worked by the Princess
Elizabeth at Carisbrooke Castle during her
father Charles I's imprisonment there
Sold 24.6.75 for £924 ($2125)

Above, left to right:

SCANDINAVIAN SCHOOL: *A Lady*
¾ in. (1.9 cm.) high
In bezel of gold ring with split shoulders, c. 1775
Sold 24.6.75 for £89.25 ($205)

BERNARD LENS: *A Gentleman*
⅝ in. (1.7 cm.) high
In bezel of contemporary gold ring with sunburst reverse and
scrolling hoop
Sold 24.6.75 for £304.50 ($700)

Gold-mounted agate ring with intaglio of Brutus,
Cap of Liberty and two daggers
c. 1740
Sold with letter from Sir John Ramsden to his daughter-in-law
24.6.75 for £336 ($772)

SCHOOL OF ISABEY: *Napoleon I*
⅜ in. (0.8 cm.) high
In bezel of gold ring
Sold 24.6.75 for £178.50 ($410)

J. A. ARLAUD: *A Nobleman*, perhaps *The Duke of Marlborough*
½ in. (1.2 cm.) high
In bezel of gold ring with sunburst reverse
Sold 24.6.75 for £294 ($676)

Above: MRS ISABELLA BEETHAM:
Laura Montagu
On glass
$3\frac{1}{2}$ in. (8.9 cm.) high
Sold 1.10.74 for £199.50 ($479)

Top right: GIRARDUS VAN SPAENDONCK:
Basket of Flowers
Signed
$3\frac{1}{4}$ in. (8.3 cm.) diam.
In cover of gold-mounted tortoiseshell box
Paris, 1777, poinçons of J.-B. Fouache
Sold 18.12.74 for £1260 ($2898)
From the collection of the
Mildmay-White Family Trust

Bottom right: AUGUSTIN DUBOURG:
A Lady with Two Children
Signed
3 in. (7.5 cm.) diam.
Sold 18.3.75 for £546 ($1310)

Miniatures

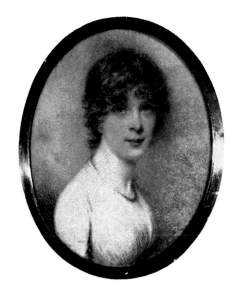

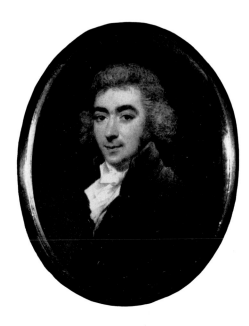

Top left: WILLIAM WOOD:
A Lady
2½ in. (6.4 cm.) high
Sold 24.6.75 for £609 ($1400)

Top right: HENRY EDRIDGE:
A Gentleman
Perhaps a self-portrait
2⅝ in. (6.8 cm.) high
Sold 18.3.75 for £357 ($856)
From the collection of
Mrs G. M. Theobald

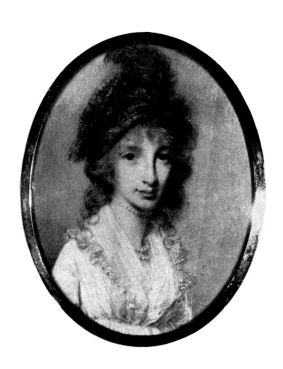

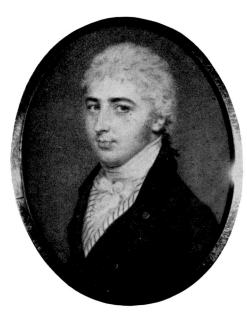

Bottom left: GEORGE
ENGLEHEART:
A Lady of the Urquhart Family
3 in. (7.6 cm.) high
Sold 22.10.74 for £1050
($2520)
From the collection of
Lt.-Col. H. N. Crawford

Bottom right: JOHN SMART:
A Gentleman
Signed with initials and dated
1800
2⅞ in. (7.2 cm.) high
Sold 24.6.75 for £1155
($2656)

WILLIAM GRIMALDI:
Lady Georgiana and
Lady Harriet Cavendish
Signed with initials
3¼ in. (8.2 cm.) high
Sold 22.10.74 for £840 ($2016)

LAWRENCE CROSSE: *A Lady*
Signed with monogram
13 in. (33 cm.) wide
Sold 18.3.75 for £1260 ($3024)
From the collection of
Mrs E. Longstaffe

PETER PAILLOU: *Sir Benjamin Thompson, Count von Rumford*
4¾ in. (12.2 cm.) high
Signed and dated 1790
Sold 18.12.74 for £504 ($1159)

Below left: GEORGE ENGLEHEART: *Master Lumley Skeffington*
7¼ in. (18.4 cm.) high
Sold 18.12.74 for £1680 ($3864)
From the collection of Major R. M. O. De La Hey

GEORGE ENGLEHEART: *Sir William Charles Farrell Skeffington, Bt*
7¼ in. (18.4 cm.) high
Sold 18.12.74 for £1555 ($2657)
From the collection of Major R. M. O. De La Hey

Russian large three-handled
enamelled silver vase
9½ in. (24.1 cm.) high
By Pavel Ovtchinnikov, Moscow
Sold 22.10.74 for £4830 ($11,592)

Russian silver-gilt and niello tea
service
By Andrie Postnikov, Moscow, 1873
Sold 22.10.74 for £2835 ($6804)
From the collection of
The Earl of Clanwilliam

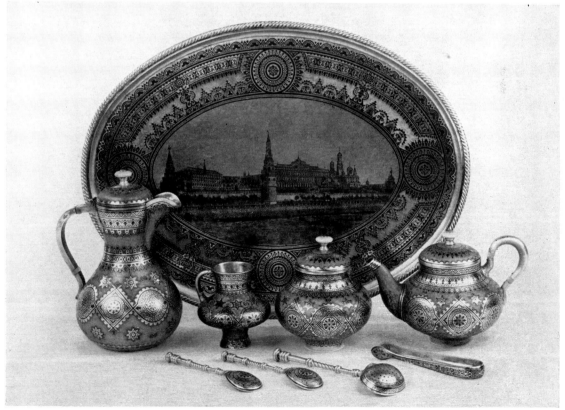

Above: Fabergé opal figure of a playful spaniel
1¾ in. (4.5 cm.) long
Sold 29.4.75 at the Hôtel Richemond, Geneva, for £2500 (Sw. fr. 15,000)

Above left: Russian silver-gilt hoof-shaped box with detachable cover
2 in. (5 cm.) wide
By Carl Fabergé, Moscow
Sold 24.6.75 for £945 ($2173)
From the collection of
Lady Elizabeth von Hofmannstal

Fabergé circular gold box in the Louis XVI style, the cover with an oval miniature of Empress Catherine the Great by Zehngraf
3¼ in. (8.2 cm.) diam.
Workmaster Michael Perchin
Sold 29.4.75 at the Hôtel Richemond, Geneva, for £6000 (Sw. fr. 36,000)

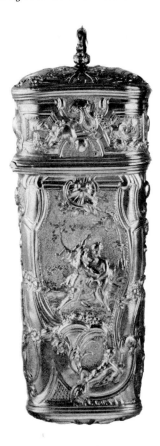

Left: George II gold-mounted
terrapin bonbonnière
3¼ in. (8.3 cm.) wide
c. 1730
Sold 18.3.75 for £3255 ($7812)

Swiss vari-coloured
gold vinaigrette
1¼ in. (3.1 cm.) wide
c. 1820
Sold 24.6.75 for £714
($1642)

Right: George II gold etui
4 in. (10 cm.) high
c. 1760
Sold 24.6.75 for £1470 ($3381)

Louis XV rectangular gold snuff-box
3⅛ in. (8 cm.) wide
By Henri Delobel, Paris, 1757–58
Poinçons of Eloy Brichard
Sold 18.3.75 for £18,900 ($45,760)

Swiss rectangular vari-coloured gold singing-bird box
3⅛ in. (7.9 cm.) wide
c. 1810, maker's mark FR for Frères Rochat
Sold 24.6.75 for £5775 ($13,282)

Below: Circular gold snuff-box
3 in. (7.7 cm.) diam.
By A. J. Strachan, 1807
Sold 24.6.75 for £3675 ($8452)

Russian rectangular silver-gilt table
snuff-box
4½ in. (11.5 cm.) wide
c. 1760
Sold 24.6.75 for £2100 ($4830)

JEAN BAPTISTE ISABEY:
Empress Marie-Louise
Signed
$1\frac{1}{4}$ in. (3.2 cm.) high
Sold 24.6.75 for £3150
($7245)

Louis XV oval enamelled
gold snuff-box
$2\frac{3}{4}$ in. (7 cm.) wide
By Charles Le Bastier
Paris, 1768
Sold 24.6.75 for £8925
($20,527)

George III enamelled gold
snuff-box with miniatures
by Richard Cosway
$3\frac{1}{2}$ in. (9 cm.) wide
By James Morriset, 1779
Sold 24.6.75 for £8400
($19,320)

Dresden rectangular
mother-of-pearl encrusted
gold snuff-box
$3\frac{1}{8}$ in. (8 cm.) wide
Perhaps by Baudesson
c. 1760
Sold 24.6.75 for £10,500
($24,150)

Fabergé purpurine seated cat
4⅞ in. (12.3 cm.) high
Sold 19.11.74 at the Hôtel Richemond,
Geneva, for £8170 (Sw. fr. 50,000)

Fabergé star-shaped clock
5¼ in. (13.2 cm.) high
Workmaster Michael Perchin
Sold 19.11.74 at the Hôtel Richemond, Geneva, for £7353
(Sw. fr. 45,000)

Antique gold mouse automaton
Probably by Henri Maillardet
c. 1810–15
Sold 20.11.74 at the Hôtel Richemond,
Geneva, for £13,072 (Sw. fr. 80,000)

Indian ivory chess-set
Kings 4¾ in. (12 cm.) high
Pawns 3¼ in. (8.2 cm.) high
Delhi, late 18th/early 19th century
Sold 24.6.75 for £1207.50 ($2777)

Icon of St George
slaying the dragon
12¼ in. (31.1 cm.) high
North Russian
c. 1600
Sold 5.3.75 for £3780
($9072)

Rare and important gilded silver triptych
26 in. (66 cm.) high, 35¾ in. (90.8 cm.) wide when extended
Kremlin Armoury Workshops, dated 1637
Sold 5.3.75 for £17,325 ($41,580)
Record auction price for an icon

The triptych above is decorated with sapphires, rubies, emeralds, river pearls, enamel, and twelve niello mountings, the central panel depicting the Vernicle, the outer silver shutters superbly engraved with illustrations of the miraculous origin and deeds of the icon of the Saviour, with an engraved donor's inscription: 'To this wonderful, most wonderful and most marvellous icon of the Vernicle, Matfej Timofevich Izmailov, according to his vow.' (Members of the Izmailov family are recorded in official posts at the court in Moscow during the 17th century.) Probably the most significant work of the Armoury Workshops ever to appear at auction and iconographically highly important, it is equal to the best contained within the State Armoury of the Moscow Kremlin. Now in the Metropolitan Museum of Art, New York

Icon of the Saviour
of the Unsleeping Eye
26 in. (66 cm.) high
Regional School of
Novgorod
16th century
Sold 5.3.75 for £5460
($13,104)

Icon of the Dormition
of the Virgin
27¾ in. (70.5 cm.) high
Central Russian
Probably Moscow
School, second half
16th century
Sold 5.3.75 for £6300
($15,120)

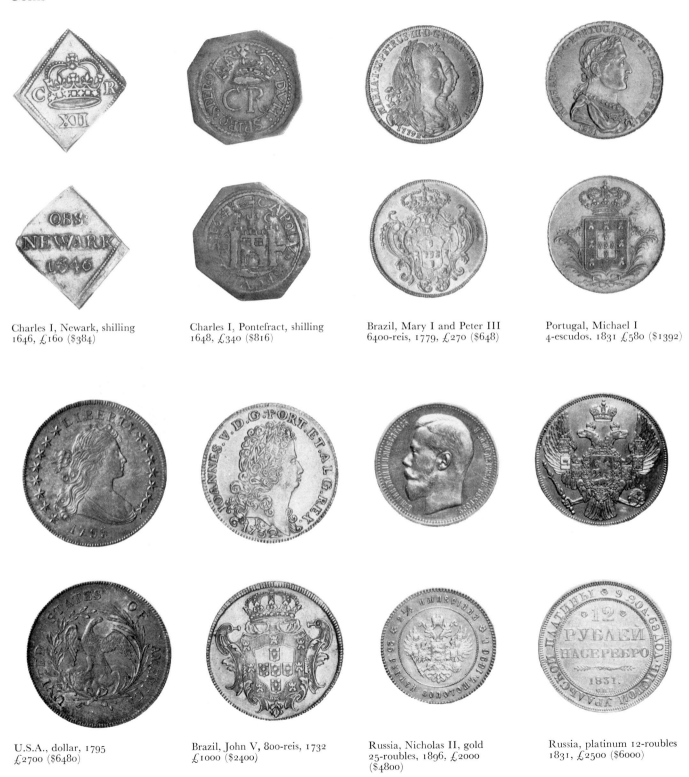

Charles I, Newark, shilling
1646, £160 ($384)

Charles I, Pontefract, shilling
1648, £340 ($816)

Brazil, Mary I and Peter III
6400-reis, 1779, £270 ($648)

Portugal, Michael I
4-escudos, 1831 £580 ($1392)

U.S.A., dollar, 1795
£2700 ($6480)

Brazil, John V, 800-reis, 1732
£1000 ($2400)

Russia, Nicholas II, gold
25-roubles, 1896, £2000
($4800)

Russia, platinum 12-roubles
1831, £2500 ($6000)

Macedon, Philip II
(359–336 B.C.), stater
£1200 ($2880)

Macedon, Alexander
III (336–323 B.C.)
stater, £1000 ($2400)

Faustina I (died
A.D. 141), aureus
£1250 ($3000)

Edward IV, second
reign (1471–83)
half-angel, £160 ($384)

Cnut, Cunetti, penny
£80 ($192)

Italy, Sub-Alpine
Republic, 20-francs
1801, £450 ($1080)

Switzerland, Geneva
1 small pistole of
35-florins, 1752, £520
($1248)

U.S.A., 2½-dollars
1831, £1050 ($2520)

Burma, Mindon Min
4-rupees, 1878, £300
($720)

Edward the Elder
(A.D. 899–924)
Beahred, penny, £125
($300)

Scotland, James V
bonnet piece, 1540
£1800 ($4320)

Mary, Queen of Scots
half-ryal or thirty-
shilling piece, 1555
£1300 ($3120)

Scotland, James III
1460–88, quarter-rider
£1100 ($2640)

George III, sovereign
1820, £260 ($624)

France, Louis XV
1-louis d'or, 1767
£360 ($864)

Russia, Order of St Alexander-Nevsky, a magnificent diamond-set badge and breast star awarded to General Sir Arthur Paget, GCB, KCVO, £9000 ($21,600)

Order of St Stanislaus, 1st class badge 1848, £650 ($1560)

Order of St George 4th class, c. 1850 £400 ($960)

Order of the White Eagle, star, c. 1870, £900 ($2160)

Late Assyrian 'Mosul Marble'
orthostat from the palace of
Assurnasirpal II (883–859 B.C.)
41¾ × 24 in. (160 × 61 cm.)
c. 879 B.C.
Sold 11.12.74 for £57,750 ($132,830)
From the collection of The
Rt. Hon. Viscount Gage, KCVO

The Northwest Palace at Nimrud
was excavated by Sir Henry Layard
in the 1840s. This relief was removed
from the site in the summer of 1853
by Hormuzd Rassam, Layard's local
assistant from Mosul, and shipped
direct to Lord Gage by way of
Scanderoon, present-day Alexandretta
A letter from Rassam to Layard
describing the transport arrangements
is preserved in the British Museum
The orthostats from Room I of the
Northwest Palace were carved in two
registers – the lower with a frieze of
griffin-headed genii standing on either
side of the Tree of Life and
pollinating it, the upper register with
kneeling genii engaged in the same
ceremony
Room I was part of an important
formal audience suite in the inner
courtyard of the Northwest Palace
but its exact function remains
uncertain. It was L-shaped and fitted
with pierced drainage slabs
suggesting that it may have been used
either for ordinary ablutions or those
connected with the cult, the latter
more likely in view of the nature of
the reliefs lining its walls

Antiquities

Campanian red-figured bell-krater
12¼ in. (31.2 cm.) high
350–320 B.C.
Sold 30.4.75 for £4830 ($11,109)
From Nostell Priory, sold on behalf of the
Trustees of the Nostell Estate

Attic black-figured amphora, Type B
16⅛ in. (41.1 cm.) high
c. 540 B.C.
Sold 30.4.75 for £7350 ($16,905)
From Nostell Priory, sold on behalf of the Trustees of the
Nostell Estate

252

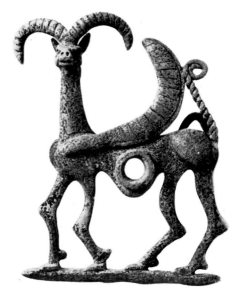

Left: Persian large bronze
cheekpiece
6½ in. (16.5 cm.) high
9th/7th century B.C.
Sold 30.4.75 for £2625 ($6037)
From the Bröckelschen Collection

Right: Persian bronze quiver plaque
23 in. (58.3 cm.) high
9th/8th century B.C.
Sold 30.4.75 for £3990 ($9177)
From the Bröckelschen Collection

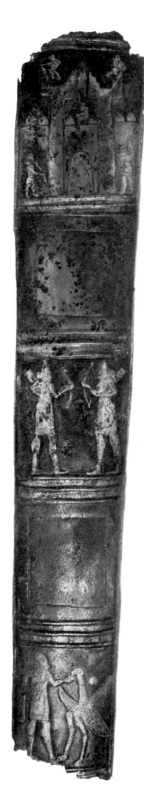

Left: Upper part of a Sassanian
hollow-cast bronze figure of a
dancing girl
10 in. (25.4 cm.) high
c. 7th century A.D.
Sold 11.12.74 for £3150 ($7245)

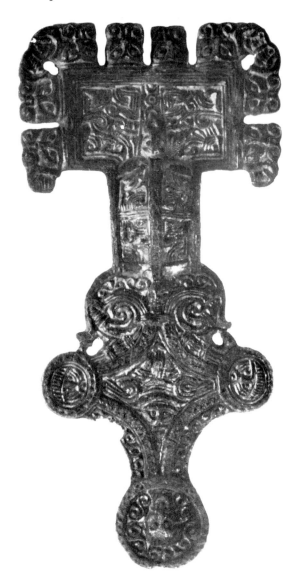

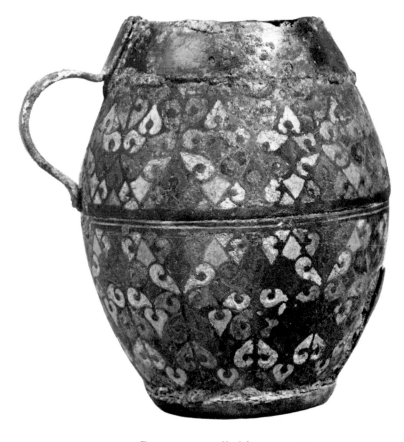

Roman enamelled bronze cup
4¼ in. (10.7 cm.) high
3rd century A.D.
Sold 16.7.75 for £2730 ($6006)
From the collection of The Earl of Selborne

Anglo-Saxon square-headed bronze brooch
5¾ in. (14.6 cm.) long
6th century A.D.
Sold 11.12.74 for £1260 ($2898)

Eskimo ivory toggle
3 in. (7.5 cm.) long
Sold 16.7.75 for £1365
($3003)

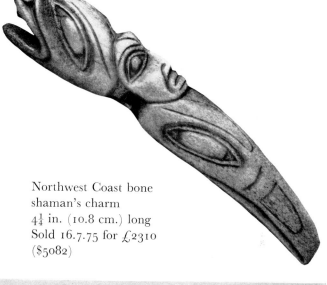

Northwest Coast bone
shaman's charm
4¼ in. (10.8 cm.) long
Sold 16.7.75 for £2310
($5082)

Two Hawaiian necklaces
lei niho palaoa
Upper pendant 4¼ in. (10.8 cm.)
long
Sold 16.7.75 for (top) £1575
($3465) and (bottom) £1680
($3696)

Eskimo ivory harness-ornament
3¼ in. (8.2 cm.) long
Sold 16.7.75 for £1155 ($2541)

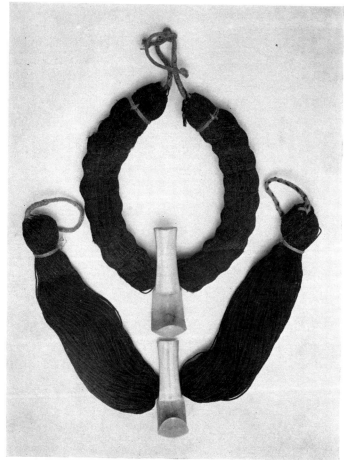

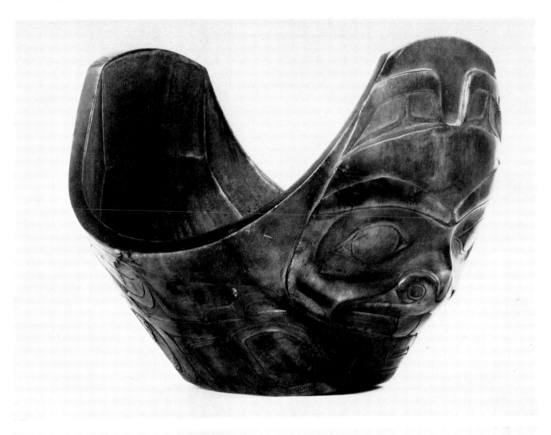

Haida horn
ceremonial oil-dish
7¼ in. (18.2 cm.) wide
Sold 16.7.75 for
£9450 ($20,790)

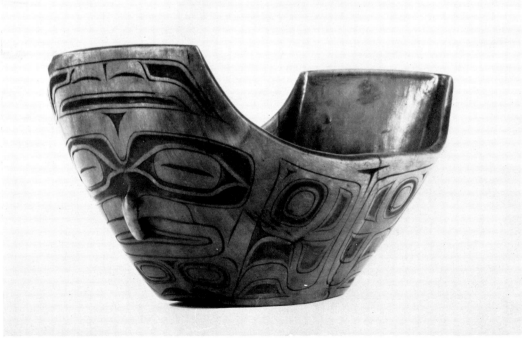

Haida horn
ceremonial oil-dish
7¾ in. (19.8 cm.) wide
Sold 16.7.75 for
£6825 ($15,015)

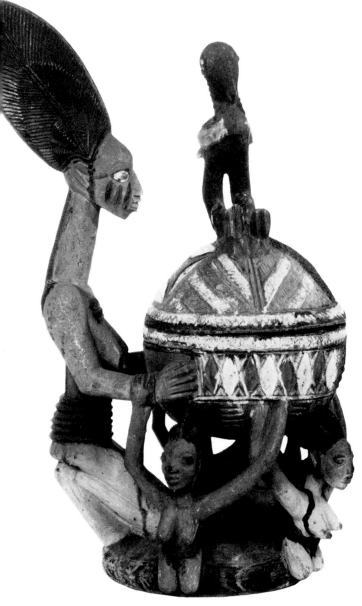

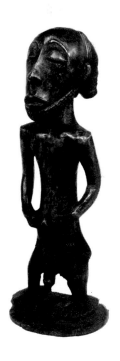

*: Yoruba wood bowl and cover
Olowe of Ise, Ekiti
.. (56 cm.) high
11.12.74 for £1365 ($3140)
the collection of Mrs L. Hinchliffe

Above: Ashanti gold hat, of green
leather applied with sheet gold
10½ in. (26.7 cm.) wide
Sold 11.12.74 for £2520 ($5796)

Taken by Lt F. Cowan, of the
Royal Welsh Fusiliers, from the
dressing-room of the Asantehene
Kofi Karikari, 'King Kofi', in
Kumasi, 1874.
Lt Cowan was amongst
the 6000 troops who
entered Kumasi on the night of
4th February, 1874, with Gen.
Sir Garnet Wolseley, who was
sent by the British Government
to stem the Ashanti expansion
which was disturbing the peoples
of the coast

Luba wood standing male figure
Kongolo region
11 in. (28 cm.) high
Sold 16.7.75 for £2100 ($4620)

257

Porcupine quillwork of North America

DENIS B. ALSFORD
Curator of Collections, Canadian Ethnology Service
National Museum of Man, Ottawa

Far left: Pair of moccasins
(Sioux type)
9 in. (23 cm.) long
Sold 7.5.75 at the Ritz Carlton
Hotel, Montreal, for £159 ($380)
From the Wilson Mellen Collection

Pair of moccasins (Sioux type)
Sold 7.5.75 at the Ritz Carlton
Hotel, Montreal, for £126 ($300)
From the Wilson Mellen Collection

The porcupine can hardly be described as the most attractive animal in North America but it provided the native North American with a good source of food as well as the raw materials for the production of a unique art form. After being captured and killed, the porcupine was de-quilled, the quills being graded, washed, flattened, trimmed (the barb removed), dyed and finally stored, for use later in transforming plain skin products into works of art.

The distribution of the porcupine covered most of Canada south of the tree line, and the mountainous regions of the eastern and western United States. But quillwork-decorated products were made outside of this area as far south as Oklahoma and all across the Plains, the quills being obtained by trade.

Porcupine quillwork was certainly being produced before settlement by Europeans, although the earliest archaeological evidence suggests no earlier than about the 13th century A.D. Today, the only survival that retains any real semblance of pre-contact tradition is found in the Northwest Territories where a handful of people produce loom-woven quillwork. Quillwork-decorated birchbark boxes still being made in the Georgian Bay–Manitoulin Island region are, and always have been, produced for the tourist trade.

Most museum collections of early Indian material culture give the impression that the Indians decorated almost all of their possessions, but this is probably not so. Early travellers' reports make little or no mention of decorative forms, but those examples

Skull cap (Malecite)
Sold 7.5.75 at the Ritz Carlton Hotel, Montreal, for
£335 ($800)
From the Wilson Mellen Collection

Right: Circular basket (Pomo)
5½ in. (14 cm.) diam.
Sold 7.5.75 at the Ritz Carlton Hotel, Montreal, for £293 ($700)
From the Wilson Mellen Collection

of 'savage' craftsmanship that did get taken back to Europe in the 18th century were inevitably decorative since such items had greater appeal to the souvenir hunter.

Thus arose the myth of a people who were colourful not only in manners and customs, but also visually. In fact it is far more likely that the Indians' everyday products were plain and practical. Porcupine quillwork cannot have been hardwearing and practical in a society that relied upon hunting, gathering and agriculture in a topography that is tough upon even the technologically advanced products of today's society. The Indians were as technologically advanced as was possible within the confines of their environment and available resources.

With a number of minor variations, five techniques of quillworking were used: wrapping of quills around a thong of leather or a strip of birchbark; sewing, by using sinew thread to attach the quills either in a single line or a broad band between two lines of sewing; netting, by joining alternate pairs of sinew elements with a quill; plaiting, by bending and weaving a quill around two threads; and weaving, on a simple bow loom using several sinew threads as the warp separated by birchbark sheds, with the quills forming the weft.

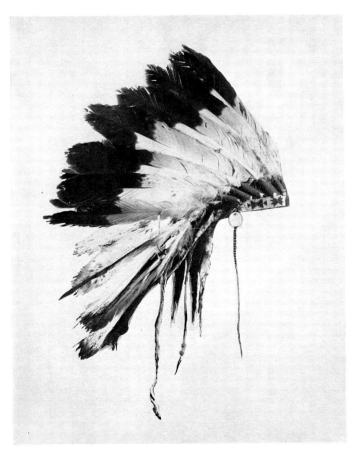

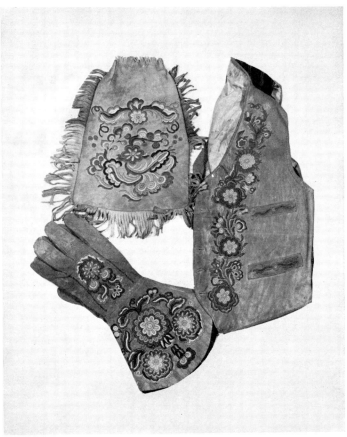

From these simple techniques, geometric, zoomorphic and anthropomorphic designs were produced with great subtlety and creativeness, in solid or outline forms, with certain designs distinctive for particular groups. The surfaces of clothing, bags, and other skin appurtenances, along with wooden items such as pipe stems, and club and knife handles, were decorated in one, or frequently several, techniques.

Centres of production arose in such widely scattered places as the Great Lakes region and the Northwest Athabaskan area. Of particular interest was the Red River Métis centre which produced some of the finest quillwork for the tourist trade between 1820 and 1850, only to be replaced, as was almost all of the quillwork, by beadwork. Not only was this the case with articles designed for both native use and the tourist trade, but the original intent and use of quillwork were destroyed in the process.

It may be argued that porcupine quillwork was no more than a craft, but the subtlety of the colour and the sheer beauty of the designs transform the craft into an art. The intricacy of the techniques, and the skill, patience and careful thought involved, demonstrated time and again that the work went beyond craftsmanship to

Above left: Feather bonnet (Plains Ojibway type) 24 in. (61 cm.) long Sold 7.5.75 at the Ritz Carlton Hotel, Montreal, for £837 ($2000) From the Wilson Mellen Collection

Opposite : Skin bag
(Cree–Metis)
15 in. (38 cm.) long
Sold 7.5.75 at the
Ritz Carlton Hotel,
Montreal, for £125
($300)
From the Wilson Mellen
Collection

Skin vest (Cree–Metis)
c. 34 in. (86 cm.)
chest size
Sold 7.5.75 at the
Ritz Carlton Hotel,
Montreal, for £176
($420)
From the Wilson Mellen
Collection

Skin gauntlets
(Cree–Metis)
16 in. (40.7 cm.) long
Sold 7.5.75 at the
Ritz Carlton Hotel,
Montreal, for £117
($280)
From the Wilson Mellen
Collection

Right : Man's skin shirt
(Blackfoot type)
Sold 7.5.75 at the Ritz Carlton
Hotel, Montreal, for £1087
($2600)
From the Wilson Mellen
Collection

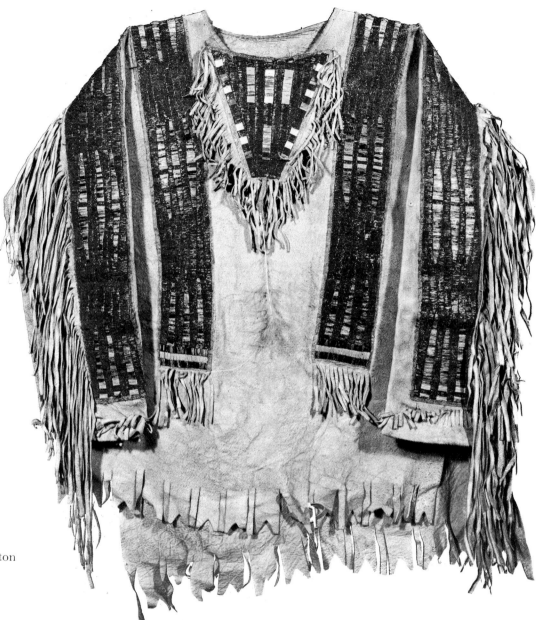

an inspired form of art motivated by religious practices, charged with prestige, and tinged with vanity.

In fact, religion was a prime source of inspiration as evidenced by the mythical thunderbird and underwater-panther designs of the Great Lakes region. Among the Prairie groups the work was performed in seclusion and the artist was painted, wore a special necklace as protection and said prayers before doing any quillwork. The

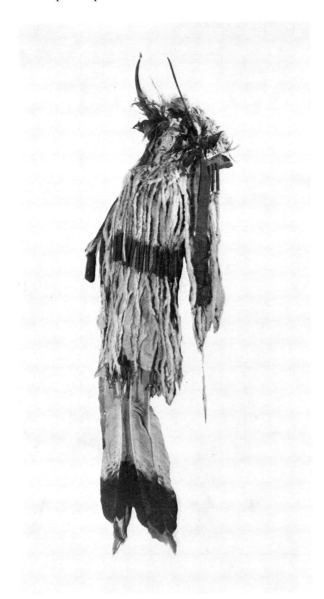

resultant products were used for religious and ceremonial purposes, and on occasions when prestige was of paramount importance. Only later, in the 19th century, did they become objects of trade, by which time the European intruder had introduced floral designs and the fur trade had flooded the market with beads to the point where the tradition has been lost in the mists of time.

In any event it can be said that porcupine quillwork decoration survived for about six to seven hundred years, apparently peaking in its aesthetic quality and productiveness in the 18th century before declining to the pressures of outside intrusive influences.

The remnants of its survival were apparent in the Christie's sale of 7th May, 1975, in Montreal, where the only porcupine quillwork available came from the Prairies and Northwest Territories regions around the turn of this century. These examples showed geometric designs and used dyed quills with aniline dyes that lack the subtle tones of traditional dyes.

Headdress (Blackfoot type)
Sold 7.5.75 at the Ritz Carlton Hotel, Montreal, for £1422 ($3400)
From the Wilson Mellen Collection

Right: Necklace (Sioux type) of brass and glass beads and 21 bear claws. 36 in. (91 cm.) long
Sold 7.5.75 at the Ritz Carlton Hotel, Montreal, for £314 ($750)
From the Wilson Mellen Collection

BOOKS AND
MANUSCRIPTS

Qur'an binding
$24\frac{3}{4} \times 19\frac{1}{8}$ in. $(63 \times 48.5$ cm.$)$
[Turkish, late 16th or early 17th century]
Sold 10.7.75 for £3000 ($6600)

Procession in a Palace Courtyard
Leaf from a Royal manuscript
of the *Shahjehan-Nameh*
$14\frac{3}{4} \times 8\frac{5}{8}$ in. (37.5 × 22 cm.)
[Mughal, mid-17th century]
Sold 10.7.75 for £13,500
($29,700)

This miniature reputedly was
presented to John Holwell, who
survived the Black Hole of
Calcutta and later became
Governor of Bengal.
It is the left side of a double-
page illustration from a later
volume of the *Shahjehan-Nameh*.
The dispute as to the identity of
the procession remains unresolved.
Other pages from the manuscript
are in the Musée Guimet, Paris,
the Institute for the Peoples of
Asia in Leningrad, and the
Bodleian Library, Oxford

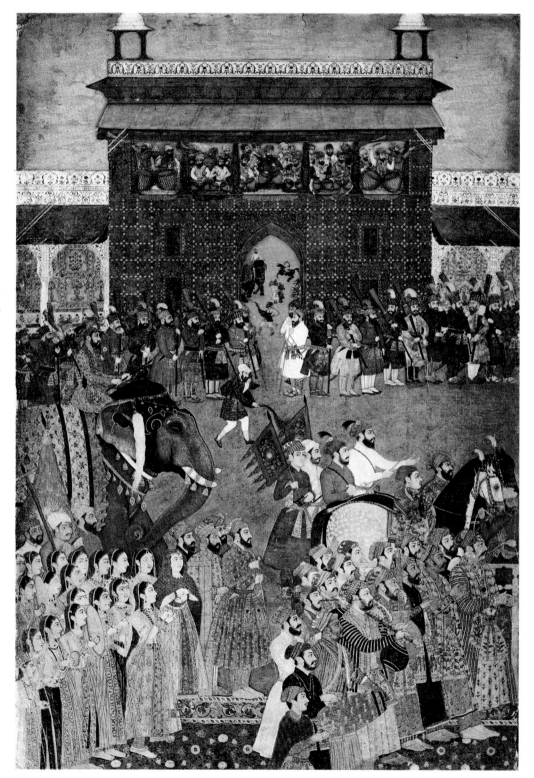

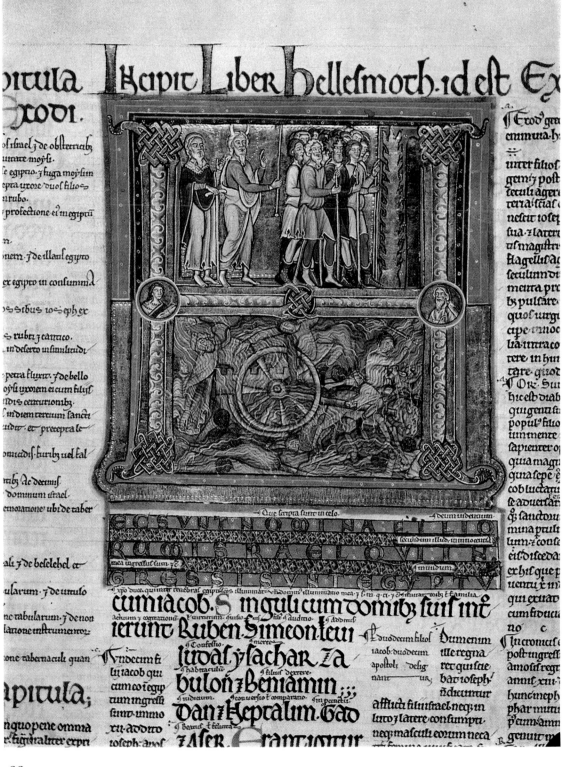

The Pentateuch with glosses in Latin
Illuminated
manuscript on vellum
8 illuminations
Large folio
[France, last quarter
12th century]
Sold 24.10.74 for
£9500 ($22,800)
From the Mostyn
Hall Library

JOHANN CHRISTOPH
DIETZSCH: One of 17
watercolour drawings
of flowers, on black
and dark brown
painted vellum, many
of them with
butterflies,
caterpillars, other
insects, etc.
Large folio
First half 18th
century
Sold 28.11.74 for
£5500 ($13,200)

TITUS MACCIUS
PLATUS:
Ex Plauti Comoediis XX
8vo, contemporary
brown morocco, gold-
tooled with a lozenge
and double rectangle
interlace
Bound for Jean
Grolier by Claude de
Picques, July 1522
Sold 9.10.74 for
£8500 ($20,400)
From the Mostyn
Hall Library

GEOFFREY CHAUCER: *The Works of Geoffrey Chaucer*
Limited to 425 copies, 87 woodcut illustrations after
Edward Burne-Jones, folio
Original blind-tooled pigskin after the design by Morris
by The Doves Bindery
Hammersmith, Kelmscott Press, 1896
Sold 28.5.75 for £5200 ($11,960)

JOHN GOWER: *Balades*, and other poems in French, English
and Latin
Manuscript on vellum
The only known manuscript from the collections of King
Henry VII and the Parliamentary general Lord Fairfax
[English, c. 1400]
Sold 2.7.75 for £10,500 ($24,150)
From the collection of The Countess of Sutherland

JOHN SPEED: *The Theatre of the Empire of Great Britaine*
67 double-page engraved maps
Large folio
1611–[1612]
Sold 5.12.74 for £5000 ($12,000)
From the Scott Library of Navigation and Marine Science Books

LT.-COL. CHARLES HAMILTON: *Representation of Shipping of All Classes & Nations Primitive Ancient and Modern*
240 original drawings in 3 vols.
Large 4to
[c. 1839]
Sold 5.12.74 for £2300 ($7680)
From the Scott Library of Navigation and Marine Science Books

Le Neptune François, ou Atlas Nouveau des Cartes Marines Levécs et Gravées par ordre exprès du Roy pour l'usage des Armées de Mer . . .
2 vols., 12 plates of flags, 23 plates of ships, 1 plate of winds and 77 maps, the majority double-page and all coloured in outline, large folio
Paris, 1693
Amsterdam, 1693
Amsterdam, 1700
Sold 2.7.75 for £4000 ($9200)

ISAAC WALTON: *The Compleat Angler . . .*
The second Edition, much enlarged
8vo, 1655
Sold 24.10.74 for £1100 ($2640)

Opposite, top right: T. PENNANT:
The Journey from Chester to London
Author's copy, large paper, extra
illustrated with over 80 drawings,
63 of them by Moses Griffith,
including the original drawings
for the work
3 vols., 4to, 1782
Sold 23.10.74 for £3400 ($8160)

Opposite, bottom right: JOHN
KEATS: A.L.S. [10th January,
1818] to John Taylor (his
publisher), referring to *Endymion*
1 p., 4to
Sold 2.4.75 for £2400 ($5520)

PERCY BYSSHE SHELLEY: A very long (12 pp.) A.L.S. (P.B.S.') to Thomas Love
Peacock from Montaiegre Près de Geneva, July 17. 1816, giving a detailed account
of his journey through Switzerland with Lord Byron ('as mad as the winds')
Sold 2.4.75 for £9800 ($22,540)
From the collection of the Mildmay-White Family Trust

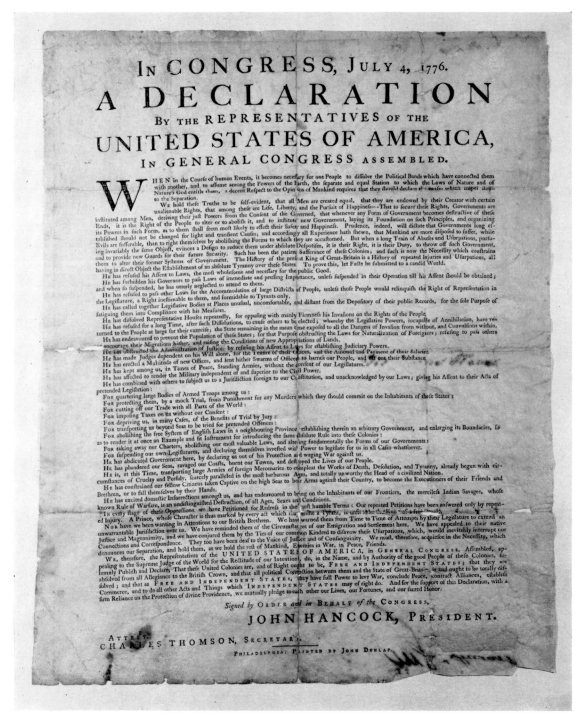

Connolly in King Street

DAVID BATHURST

Cyril Connolly had been a hero of mine ever since I read *The Unquiet Grave*. His *Enemies of Promise* confirmed my admiration. Indeed, one of these two books should surely qualify for inclusion in *The Modern Movement* if a new edition is published and Cyril himself wistfully expressed such a hope for *The Unquiet Grave* in his introduction to the 1971 University of Texas Exhibition, *Cyril Connolly's One Hundred Modern Books*. Nothing he subsequently wrote shook my belief in his heroic standing. It was, therefore, slightly in the manner of a Manchester United supporter asking George Best to tea that I wrote to him in April 1972 asking if he would lunch with me to discuss the possibility of his running a modern book section within Christie's book department.

Until then, with the exception of the Thomas Balston sale in 1968, Christie's had sold 20th-century books in general sales. Our rivals, Sotheby & Co, under the expertise of Anthony Hobson and the late 'Jake' Carter, monopolized the modern book sales. Cyril himself sold books from his library there. Although involved in modern paintings at Christie's, I had for a number of years been collecting 20th-century First Editions of my favourite authors (Cyril's, of course, being prominent) and I was therefore anxious that our firm should compete in this field. Rereading through *The Modern Movement* one evening, it struck me that Cyril's selection of the best literature from 1880–1950 would, in its first edition or manuscript form, be the dream book sale. A vision of the manuscript of Henry James' *Portrait of a Lady* (1881) followed by Yeats' *Mosada* (1886), the Gerrard printing of Joyce's *The Day of the Rabblement* (1901), a Grasset, Proust's *Du Côté de Chez Swann* (1913), *The Egoist*, T. S. Eliot's *Prufrock* (1917) and Spender's privately printed edition of Auden's Poems (1928), rose before my eyes, all collected together on Christie's shelves (rather than on those of the University of Texas at Austin) ready for the most distinguished sale of modern literature to be held. The only possible way to achieve a similar heady gathering seemed to be to ask Cyril to help. And by 'help' I really meant asking him to do it all himself.

I felt like a tongue-tied teenager when we met for lunch the first time in April 1972. I knew so little of the task I was about to ask him to undertake. Would he be insulted that I thought he might waste his time on such a footling job? Would he demand to

be paid a fortune? Would he insist on being immediately appointed head of the book department? If I had known him at all, these fantasies of impending embarrassment would never have arisen, but I had only met him briefly once at Somerhill and I had no idea what to expect. We went off to lunch at Pruniers – I remember wondering if he meant the front brim of his blue homburg to be turned up like a bookmaker's in a high wind – and, since he couldn't make up his mind between oysters mornay and salmon fishcakes, he had both.

I was delighted to have a letter from him a few days later saying, 'The more I think about it, the more the idea appeals to me as it gives me a chance to help other writers as well as myself and I also consider it an honour to be associated with Christie's for which I have always felt a great admiration though I once wrote an introduction to a Sotheby catalogue.' This seemed too good to be true; the honour, it seemed to me, was Christie's and it was, of course, typical of him that he immediately saw in his proposed role a chance to assist young writers by helping them raise money through sales of manuscripts and other autograph material. He was anxious that his close friend Anthony Hobson of Sotheby's should not be upset by his affiliation with Christie's and he therefore wrote to Hobson before any public announcement was made to ensure that there was no ill-feeling. He wrote later, 'They [Anthony Hobson and 'Jake' Carter] are very happy about a new live wire' in the modern literature field, although he rightly warned me, 'they have built up more good-will because of the greater importance they have given to book sales, particularly modern, which were inaugurated by Anthony Hobson. This is a handicap we can overcome by some judicious advertising and the best advertisement (of which I am fully conscious) is that we have a good sale. . . . I like my work and I only hope I can earn my keep.' His connection with Christie's was not immediately publicized because 'I wanted to wait till my C.B.E. went through before my association with Christie's was mentioned in the Press – it looks more reassuring – like John Carter's in "Another Place". Also I wanted to make sure I was capable of the work.'

Capable he clearly was, and enthusiastic too. The list of vendors in the first of the sales he organized, held on 4th April, 1973, included Barbara Bagenal (81 autograph letters from Leonard and Virginia Woolf), John Braine (original manuscript for *Room at the Top*), Sir Arthur Bryant (original manuscript of *The Great Duke*), Sir Henry D'Avigdor-Goldsmid (fine collection of Verlaine First Editions), Tom Driberg, Mrs Ian Fleming, Stephen Spender and under the title 'The Property of a Gentleman' 52 lots from his own library. He had quickly fallen victim to the two standard auctioneers' phobias. The 'Oh-God-there's-going-to-be-nothing-decent-in-the-sale' hang-up probably explains the inclusion of his own books. The second disease, 'Oh-God-no-one-is-going-to-come-and-buy-anything-at-the-sale', hit him worse. For two weeks

beforehand he was in a torment of apprehension lest the saleroom on the day should be deserted, with all his friends' property remaining ignominiously unsold. I do believe that, if this had occurred, he would have bid recklessly and in solitary splendour to avoid total disaster, ill though he could have afforded it. As it turned out, all went well, the buyers materialized and Cyril breathed again. 'It had all been worth it', he wrote in an entertaining piece entitled 'A Breeze in the Book Room' for *Christie's Review of the Season 1973*.

Why did Cyril join Christie's? Why did he bother? As he himself wrote in the same *Review of the Season* article, 'When asked to become a consultant on modern books I was tempted to refuse as too inexperienced until I suddenly envisaged my disappointment if the job were offered to someone else. . . . So as well me as another'; and further on, 'Perhaps one day in a more civilized climate the absurdly low prices for early editions of Yeats, Joyce, Eliot, or the productions of the Hogarth, Nonsuch and other private presses, or authors' manuscripts and typescripts over which they have long laboured and despaired, will seem of more interest than a Regency moustache-cup.' Shades here of the editor of *Horizon* encouraging the new young writers, but now in the more paternal role of trying to ensure that they are decently rewarded for their efforts.

Then there were his own finances which could usefully benefit from Christie's fees. Above all, however, I think it was the prospect of getting further involved in books – books for books' sake. 'They're only boards and paper', as he himself pointed out, but he was hooked on them. He derived as much pleasure from handling a rare book as a wine lover would a bottle of pre-phylloxera claret. He enormously enjoyed being surrounded by them, talking of their writers and their publishers, of the pain and dramas that accompanied their original production, their feel, their smell and most of all the anticipation of what he might find printed or (better still) inscribed inside.

He was only with us for two years but I know he enjoyed that short time. He was entirely responsible for the foundation of the now regular modern literature sales held at Christie's, and for that the firm and the good friends he made in the bookroom will always be grateful. I predominantly enjoyed listening to him. Throughout our all too short friendship I remained in awe of his erudition. Frankly, there were frequent moments when I didn't know who or what he was talking about and when he inscribed my First Edition of *The Evening Colonnade* 'with love from Cyril and two years' happy collaboration' I felt like an art student who had just secured Michelangelo's autograph. Heroes are normally best not met. But not so in this case. His visits to Christie's are likely to be the source of much boredom to my grandchildren.

The Siegfried Sassoon sale

DUDLEY MASSEY

On 4th June Christie's sold books, manuscripts and autograph letters from the library of Siegfried Sassoon for just over £100,000 ($230,000). It was one of the most exciting sales of modern first editions and manuscripts ever to have been held, and mainly consisted of Sassoon's own books and manuscripts, letters to him from contemporary writers and some presentation books from his contemporaries. The sale attracted a great deal of interest and the high prices were achieved principally because one dealer who had so often secured similar collections privately had to buy at auction against the fiercest competition.

The sale was unusual inasmuch as it clashed with the view held in some quarters that the papers of a 20th-century writer should be sold privately in bulk to an institutional library, probably an American one, which has happened so often during the past decade, achieved mostly by the zeal and alertness of an American book dealer. Criticism directed at the sale must surely have been allayed by the fact that one American dealer (the redoubtable El Dieff), presumably acting for a library, spent £85,000 ($195,500) at the sale and many of the groups of letters can now join the other side of the correspondence in the archive of a University Library.

Sassoon was an ardent book collector and his letters to Blunden referred to his 'finds' in country bookshops, from catalogues and the Farringdon Road, but this side of his collection was scarcely represented in the sale; there was a long run of first editions by the Dorset poet William Barnes, which included a copy of the rare *Orra, A Lapland Tale*, 1822, £300 ($690) and a copy of Christina Rossetti's *Verses*, 1847, her first book written between the ages of 12 and 16, £350 ($805).

The largest portion of the sale consisted of Sassoon's own writings, among them the original manuscript of *Counter-Attack* (albeit some of it was in typescript); this volume also contained six unpublished manuscript poems and at £2200 ($5060) it cannot be considered expensive as it contains some of Sassoon's most pungent war poetry. A proof copy bore a note by Eddie Marsh (who had seen the book through the press): 'This is the best stuff so far done on the war'. Sassoon's fame is established by his semi-autobiographical *Memoirs of a Fox-Hunting Man* and *An Infantry Officer*, the manuscripts of which sold for £3200 ($7360) and £3000 ($6900) respectively.

SIEGFRIED SASSOON:
*Memoirs of a
Fox-Hunting Man*
Autograph
manuscript, in ink
and pencil
3 vols. [1928]
Sold 4.6.75 for £3200
($7360)
From the library of
the late author

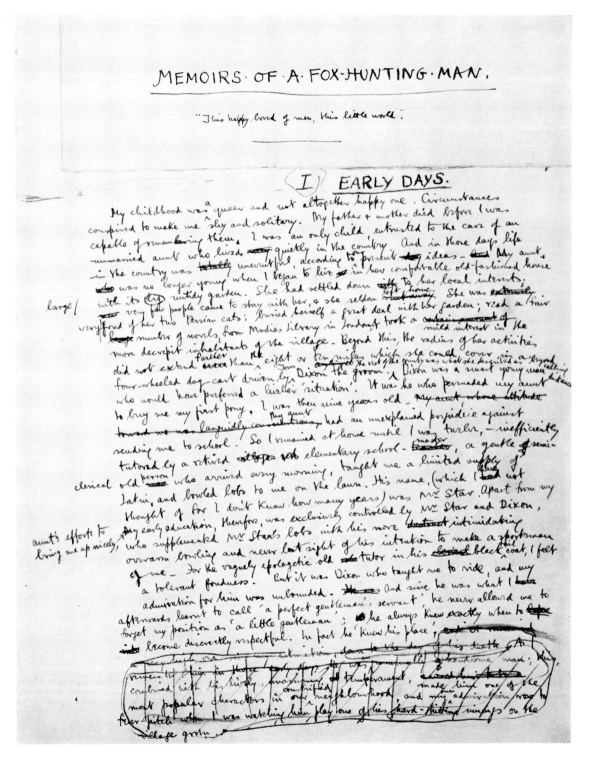

Included among an almost complete collection of his printed work were copies of his first book, *Poems*, 1906, one of 52 copies, £1300 ($2990), and the even rarer *Sonnets and Verses*, 1909, one of 5 extant copies of an edition of 50 (Sassoon destroyed all but 5), £1600 ($3680). These are extremely high prices for a poet who has not been avidly collected and there are comparatively few modern writers whose rarer works would make much more.

Sassoon's friends were well represented. 41 lots were devoted to Edmund Blunden, most being presentation copies to Sassoon and often containing long affectionate inscriptions; they totalled £3422 ($7870).

One of the most interesting items was a copy of Robert Graves's *Goodbye to All That*, 1929, heavily annotated by Blunden and Sassoon, with the most abrasive comments by both writers criticizing Graves's recollections of the war. This fascinating volume

POEMS.

"Our words and works, our thoughts and songs, turn thither,
Toward one great end, as waves that press and roll.
Though waves be spent and ebb like hopes that wither,
These shall subside not ere they find the goal."

SWINBURNE.

1906.

ORPHEUS
IN
DILŒRYUM.

. sang
Jocund and jubilant, with a sound
Of those gay, golden-vowelled madrigals
The shy thrush at mid-May
Flutes from wet orchards flushed with
the triumphing dawn.

W. E. HENLEY.

1908

SONNETS
AND
VERSES.

Non tanta cœlo societas nobiscum est, ut nostro fato mortalis sit
ille quoque siderum fulgor.

PLINY.

PRINTED FOR PRIVATE CIRCULATION.
1909.

sold for £2850 ($6550). An interesting footnote regarding this copy, which was an example of the first state containing Sassoon's poem printed without his permission, was that the sale included a manuscript copy of the suppressed poem, dated 1923, in Robert Graves's hand containing lines which were not printed – Graves wrote that he had taken a copy because it was 'a bloody good poem'.

The sale concluded with the correspondence of writers to Sassoon. Among these were a long series of over 600 letters and cards from Edmund Blunden spanning more than 40 years of friendship; 100 or so letters and cards from E. M. Forster, slightly mocking at times but praising his poems as being 'far beyond what any one from Betjeman to Byron could turn out'; and a fascinating series from Robert Graves, started during the First War and continuing until 1962. Graves praises and criticizes Sassoon's writings, stating, 'Your poems are damned good but horrific . . . don't send me any more corpse poems', and asks for critical advice on his poems while expecting the same help from Sassoon. Thomas Hardy writes accepting the dedication of *The Old Huntsman* and praises the poems in *Picture Show*; T. E. Lawrence compares Wilfred Owen's poems with Sassoon's, which latter have a 'peculiar heart-rending-ness'. These 17 letters were the most expensive lot in the sale at £4200 ($9660).

SIEGFRIED SASSOON: Ten watercolour caricatures, mostly of Osbert Sitwell, entitled *Holy Orders, The Brigade, Enoch Arden, Swiss Navy, The Halls, The Legitimate, Court of Appeal, Pantology, A Statesmanlike Utterance* and *E M.F[orster] disapproving of the Two Minutes' Silence*
Sold 4.6.75 for £260 ($598)
From the library of the late author

Edith and Osbert Sitwell's correspondence to him amounted to over 200 letters and cards and was aptly described as an exuberant and entertaining series. Edith highly praises Sassoon's poetry which 'cuts right down to the bone – the most rare and unusual thing in this muffled stiffled age'. There appears to have been a love-hate relationship between the three of them. Sassoon, who was a clever caricaturist, embellished many of her books with amusing drawings, and a delightful series of Osbert in various costumes appeared in the sale. Osbert Sitwell, on his side, wrote indignantly, 'This is the third grossly rude letter I have received from you in recent months . . . you cannot address a writer of my standing in the manner which you assume.'

As was to be expected, the sale contained Sassoon's copy of the first edition of Wilfred Owen's *Poems*, 1920, to which Sassoon wrote the introduction; and this copy was further enhanced by 15 other poems by Owen written in by Sassoon. They had been friends, as is known from Siegfried's *Journey*, and perhaps the seven letters written in 1917 and 1918 from Owen were the most memorable lot in the sale. Owen described his poetry as 'a dark star in the orbit where you [Sassoon] will blaze'. On 22nd September, 1918, writing from the Front, he adds a poignant postscript, giving his mother's address and writes, 'I know you would try to see her, if – I failed to see her again.' In the last letter, written on 10th October, he says that 'Counter-Attack frightened him much more than the real thing.' This must be one of the last letters written by Wilfred Owen, for on 4th November he was killed.

PORCELAIN
AND
GLASS

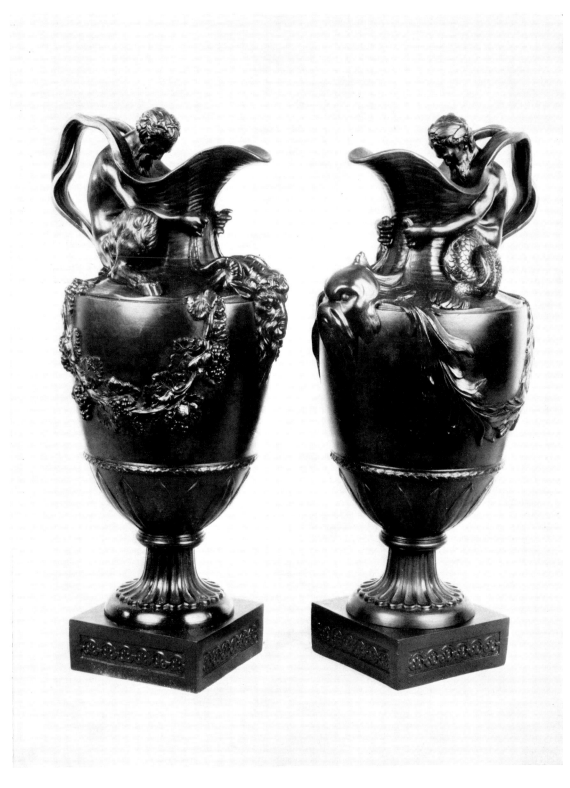

Pair of Wedgwood &
Bentley black basalt
wine and water ewers
Modelled by
John Flaxman
$16\frac{1}{4}$ in. (42 cm.) high
Wedgwood & Bentley
Etruria marks
Sold 27.5.75 for
£5460 ($12,558)
From the collection
of Hensleigh C.
Wedgwood, Esq,
FRSA

Longton Hall cauliflower
tureen, cover and leaf stand
Stand 10 in. (25.4 cm.) wide
Tureen $5\frac{1}{2}$ in. (14 cm.) wide
Sold 7.7.75 for £840 ($1848)
From the collection of
The Earl of Radnor

Worcester yellow-ground fluted
oval sauceboat
6 in. (15.2 cm.) wide
Sold 16.6.75 for £1680 ($3864)

Chelsea large fable-decorated sauceboat
8¾ in. (22.3 cm.) long
Red anchor mark
Sold 16.6.75 for £1680 ($3864)

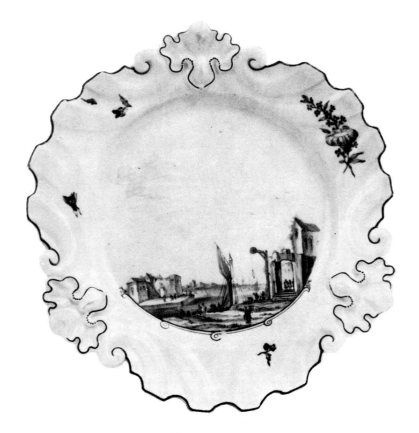

One of a pair of Chelsea dishes
Painted by Jeffreyes Hammett O'Neale
9 in. (23 cm.) diam.
Raised anchor period
Sold 16.6.75 for £3360 ($7728)

Chelsea figure of an ostler
5 in. (12.7 cm.) high
Red anchor mark at back
Sold 16.6.75 for £1575
($3622)

Chelsea acanthus-leaf teapot and cover
7 in. (17.7 cm) wide
Incised triangle mark
Sold 16.6.75 for £6090 ($14,007)

London Delft blue and white
tankard
Dated 1663
5¼ in. (13.3 cm.) high
Sold 2.6.75 for £2730 ($6279)
From the collection of
Pamela Lady Glenconner

London Delft blue
and white Royalist
mug of bell shape
Inscribed 'God Bless
King William &
Q. Mary'
3½ in. (9 cm.) high
Sold 2.6.75 for £735
($1690)

One of a pair of Bristol polychrome plates
13½ in. (34.3 cm.) diam.
Sold 2.6.75 for £892.50 ($2053)
From the collection of Mrs G. I. Cameron

Glasgow (Delftfield) oblong octagonal armorial dish
11½ in. (28.7 cm.) wide
Sold 2.6.75 for £546 ($1256)
From the collection of the late Mrs G. I. Cameron

Longton Hall
melon-tureen and
cover
$4\frac{1}{4}$ in. (11 cm.) high
Script B mark
Sold 28.4.75 for
£2625 ($6300)
From the Wilkinson
Collection

Far right: The
companion Longton
Hall melon-tureen
and cover
$4\frac{1}{4}$ in. (11 cm.) high
Script W mark
Sold 28.4.75 for
£2625 ($6300)

Pair of Lund's
Bristol vases
$6\frac{1}{4}$ in. (16 cm.) high
Sold 28.4.75 for
£1365 ($3276)
From the Wilkinson
Collection

Pair of Worcester
(Dr Wall) pink-scale
Giles-decorated
plates
9 in. (23 cm.) diam.
Sold 28.4.75 for
£3990 ($9576)
From the
Wilkinson Collection

Worcester (Dr Wall)
plate from the Duke
of Gloucester service
Finely painted in the
atelier of James Giles
9 in. (23 cm.) diam.
Gold crescent mark
Sold 28.4.75 for
£3150 ($7560)
From the
Wilkinson Collection

Documentary slipware press-moulded dish
By Samuel Malkin
14½ in. (36 cm.) diam.
Sold 18.11.74 for £8400 ($20,160)
From the collection of Mrs I. M. Morgan

Far left: Ralph Wood figure of the sailor's companion
8 in. (20.3 cm.) high
Sold 7.7.75 for £840 ($1932)

Left: Ralph Wood figure of a sailor
8 in. (20.3 cm.) high
Sold 7.7.75 for £840 ($1932)

Below left: Pair of Staffordshire coloured salt-glaze campana vases
6 in. (15.3 cm.) high
Sold 7.7.75 for £1575 ($3622)

Below right: Staffordshire salt-glaze figure of a bear
6 in. (15.3 cm.) high
Sold 7.7.75 for £1050 ($2415)

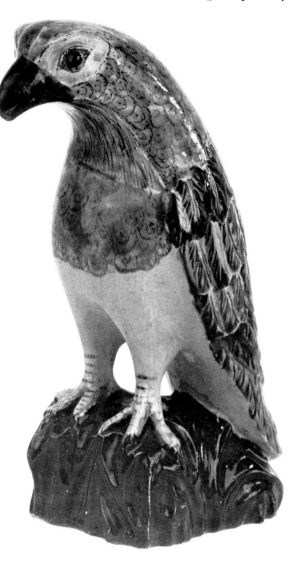

Astbury glazed redware Capture of Porto Bello
bell-shaped mug
$6\frac{1}{4}$ in. (16 cm.) high
Sold 7.7.75 for £1365 ($3139)

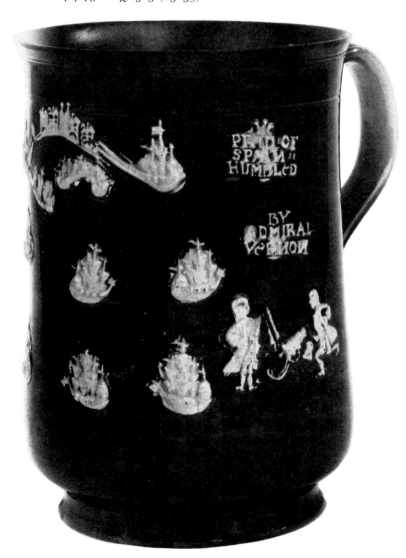

Coloured salt-glaze figure of a falcon
$6\frac{1}{2}$ in. (16.5 cm.) high
Sold 7.7.75 for £3360 ($7728)

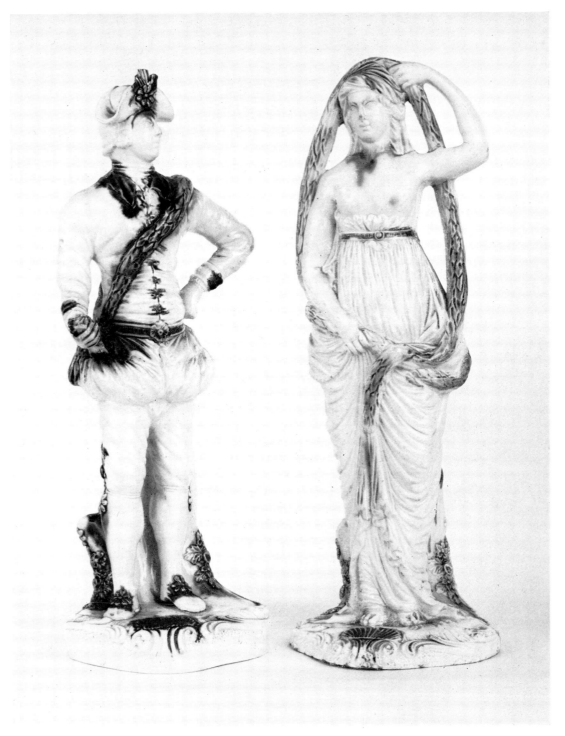

The Mackintosh pair of
Ralph Wood figures of
Hamlet and Ophelia
13 in. (33 cm.) high
Sold 7.7.75 for £2310
($5313)

Right: Du Paquier lobed dish
Painted in the Oriental style
$13\frac{1}{2}$ in. (34.3 cm.) diam.
Sold 30.6.75 for £3150 ($7245)

Nuremberg faïence Enghalskrug
Painted in colours by Bartholomaus Seuter in Augsburg
$8\frac{1}{2}$ in. (21.5 cm.) high
Sold 30.6.75 for £2600 ($5980)

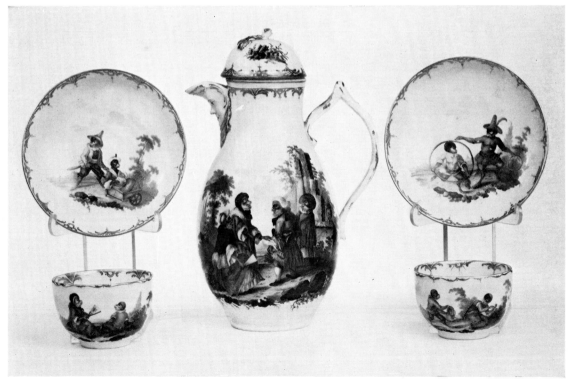

Fürstenberg part coffee- and tea-service
Sold 30.6.75 for £4410 ($10,143)
From the collection of The Earl of Radnor

Continental porcelain

Oval snuff-box
Painted in colours by
B. G. Häuer
2¾ in. (6 cm.) wide
Sold 30.4.75 at the
Hôtel Richemond, Geneva,
for £2667 (Sw. fr. 16,000)

Right: One of a
pair of Meissen
Hausmaler teacups
and saucers
Blue crossed swords
mark
Sold 24.3.75 for
£1785 ($4284)

One of a pair of armorial
cylindrical coffee-cups
and monogrammed saucers
Blue fish marks
Sold 30.4.75 at the
Hôtel Richemond, Geneva,
for £533 (Sw. fr. 3200)

Very rare black-ground
snuff-box
2¾ in. (7 cm.) wide
Sold 30.4.75 at the Hôtel
Richemond, Geneva, for
£1416 (Sw. fr. 8500)

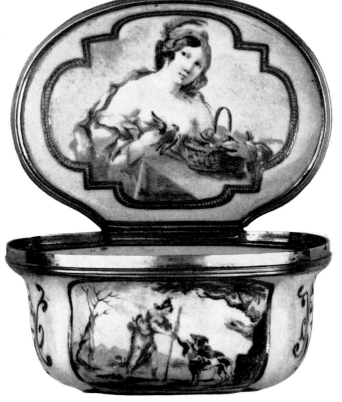

Right: Shaped oval
Doccia snuff-box
5⅛ in. (13 cm.) wide
Sold 30.4.75 at the
Hôtel Richemond,
Geneva, for £2833
(Sw. fr. 17,000)

Meissen armorial porcelain

HUGO MORLEY-FLETCHER

Pair of Meissen
armorial beakers
Blue crossed swords
marks
Sold 2.12.74 for
£2730 ($6550)

Meissen armorial
teabowl
Blue crossed swords
mark
Sold 2.12.74 for
£1365 ($3276)

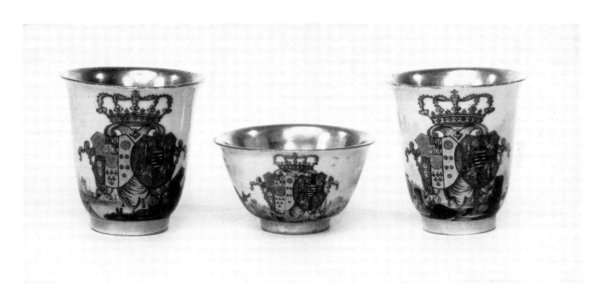

One of the great glories of the Meissen factory was the succession of armorial wares that were produced in the 1730s and 1740s for noble clients in Germany, Italy and France. Our sales in 1974–75 contained an interesting cross-section of these. The earliest piece was a plate (see illustration page 298) from the Sulkowski service of between 1735 and 1738 which brought £1000 (Sw. fr. 6000) in Geneva, while the most splendid was the dish (see illustration page 299) from the great Swan service modelled for Count Bruhl by Kändler and Eberlein which came from Sweden to sell for £2835 ($6804). This service dates from c. 1737, in which year Amalia, daughter of Augustus III, married Carlo di Borbone, King of Naples and the Two Sicilies. Her dowry included numerous cases of Meissen wares, among which was a tea and coffee service with *Allianzwappen* of the spouses. Two beakers and a teabowl from this service, without their saucers, appeared in our December sale and brought £4095 ($9826), a price justified by the Royal association and brilliant quality (see illustration above). In the same sale was a pair of plates made for Jean Paris de Montmartel, Comte de Sampigny, Marquis de Bounoy and his wife Mlle de Bethune. They married in 1746. These sold for £714 ($1642).

The star of the season, however, was a papal service (see illustration opposite) made for Tommaso Lambertini, who was elected Pope Benedict XIV in 1740 and died in 1758. Though this was a service well known to scholars of Meissen, no piece from it had until recently been available and none had appeared at auction. Therefore, it was no surprise when five Lots sold for £9817 ($23,560) with a single saucer bringing as much as £682 ($1637).

Our March sale contained two pairs of dishes from the Podewils service of the early 1740s which fetched £1995 ($4788) and £1785 ($4284) respectively.

These services, apart from representing the greatest achievement of the factory and being produced with the richest and most precise decoration, also served as some of the factory's models for more commercial productions and gave rise to the eventual stock patterns that were supplied to their ordinary clients. Indeed, without the showpiece products of this type many simpler pieces would not have come into being.

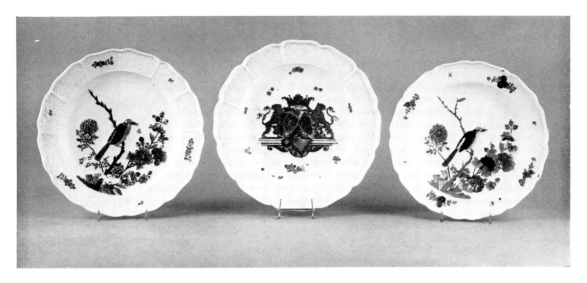

Plate with Sulkowski ozier border painted in the Kakiemon style
9 in. (23 cm.) diam.
Blue crossed swords mark
Sold 30.4.75 at the Hôtel Richemond, Geneva, for £750 (Sw. fr. 4500)

Armorial plate from the Sulkowski service
9½ in. (24 cm.) diam.
Blue crossed swords mark
Sold 30.4.75 at the Hôtel Richemond, Geneva, for £1000 (Sw. fr. 6000)

Plate in the Kakiemon style
Similar to the above left
8⅞ in. (22.5 cm.) diam.
Blue crossed swords mark
Sold 30.4.75 at the Hôtel Richemond, Geneva, for £800 (Sw. fr. 4800)

Meissen large circular dish from the
Swan service
16½ in. (42 cm.) diam.
Blue crossed swords mark
Sold 2.12.74 for £2835 ($6804)

Meissen armorial
tea-caddy and cover
bearing the arms of
Tommaso Lambertini,
Pope Benedict XIV
4¾ in. (12 cm.) high
Impressed 66, the
cover with gilt B
Sold 2.12.74 for
£1785 ($4284)

Meissen armorial
teapot and cover
6½ in. (16.5 cm.) wide
Blue crossed swords
mark
Sold 2.12.74 for
£2940 ($7060)

Frederick the Great's snuff-box?

The Meissen gold mounted snuff-box illustrated opposite is of exceptional interest because it combines historical importance with artistic distinction. Whilst commemorating a specific event it gives us explicit evidence of the style of a particular painter at Meissen.

Shortly after his accession in December 1740 Frederick the Great invaded Silesia and invested Neisse, the strongest border fortress. The siege was notable for Frederick's use of mortars (clearly to be seen on the cover and base of the present lot).

Seeing, however, that the continued bombardment of the city would so destroy it as to make it useless to him, Frederick lifted the siege and proceeded to defeat the Austrians at the battle of Mollwitz in the following April (it is to this event that the battle scene round the body of the box most probably refers). On 9th October of the same year a protocol was signed between Frederick and the Austrian commander whereby Silesia was ceded entirely to Prussia. It is probable, since Arithmetic is pointing with her index finger to the figure nine on the horn book that this is the event commemorated by this box. The protocol was confirmed by the Treaty of Breslau in the following year (11th June, 1742).

The third party to the agreement of 9th October and the Treaty of Breslau was John Carmichael, 3rd Earl of Hyndford, British Ambassador at Berlin at the time, who was invested by Frederick with the Order of the Thistle on 29th August, 1742. It is possible that this box was given to him by Frederick on this occasion, which would explain the presence of an English mount on the piece at so early a date after the manufacture of the box.

Two other signed pieces by the painter Johann Jacob Wagner are known, neither of them dated.

In 1868 Mr W. J. Lloyd acquired the box in the sale of George Hibbert's collection described as 'an old Dresden snuff-box painted with battle scenes' for the princely sum of 52 gns. It was the most expensive lot in the sale. For a century it remained in the family of the purchaser until one of our staff rediscovered it in 1968. Only then did it become apparent how very interesting a piece it was.

Documentary Meissen gold-mounted
circular snuff-box, commemorating the
First Silesian War
Signature J. Wagner
$3\frac{1}{8}$ in. (8 cm.) diam.
The gold mount English, c. 1750
Sold 2.12.74 for £15,225 ($36,540)
From the collection of David Loyd, Esq

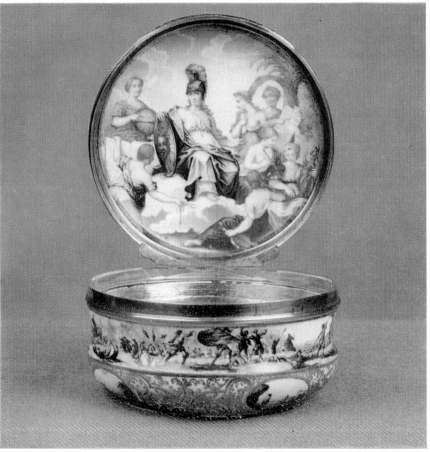

'The painter of the Grey Landscapes'

This Meissen snuff-box, which we sold in Geneva on 30th April for the record sum of £15,833 (Sw. fr. 95,000), affords an interesting contrast with the one that appeared in London in December (see page 300–1). Here was a piece with no documentary or historical associations but which depended on the quality of the painting and the excellence of the varicoloured gold mounts. We do not know the name of the painter responsible, who is generally called 'the painter of the Grey Landscapes', but he painted an almost identical box with views of Dresden and may well have worked on the Christie-Miller service.

Although it has been suggested that the subjects are views around Salzburg it is interesting to note that one of them, on the base, corresponds with an engraving *Prospect von Cirpressen in der Vingna del Card. Mont Alto* by Melchior Kussell in Johann Wilhelm Baur: *Iconographia begreift in sich Allerhand Meersehen von den Auctore nach den heben gezaichnet*, Augsburg, 1682, which also was used as a *Vorzeichnung* for the Christie-Miller service. Since subjects from the same work occur also on the Lambertini service (see page 299), this book was obviously available to the Meissen painters as a source of inspiration. It may well be that further source prints will one day be identified. In any case, they will add an interesting gloss to an already outstanding object.

Gold-mounted rectangular box
$3\frac{3}{8}$ in. (8.5 cm.) wide
Sold 30.4.75 at the Hôtel Richemond, Geneva, for £15,833 (Sw. fr. 95,000)
Record auction price for a Meissen snuff-box

Unrecorded early
Meissen chinoiserie
table ornament
Modelled by Johann
Gottlob Kirchner
19⅝ in. (50 cm.)
high
Sold 2.12.74 for
£6300 ($15,120)

Louis XV ormolu
and Meissen porcelain
jardinière
Swans modelled by
J. J. Kändler
19⅝ in. (50 cm.) high
13 in. (33 cm.) wide
Sold 30.4.75 at the
Hôtel Richemond,
Geneva, for £9333
(Sw. fr. 58,000)

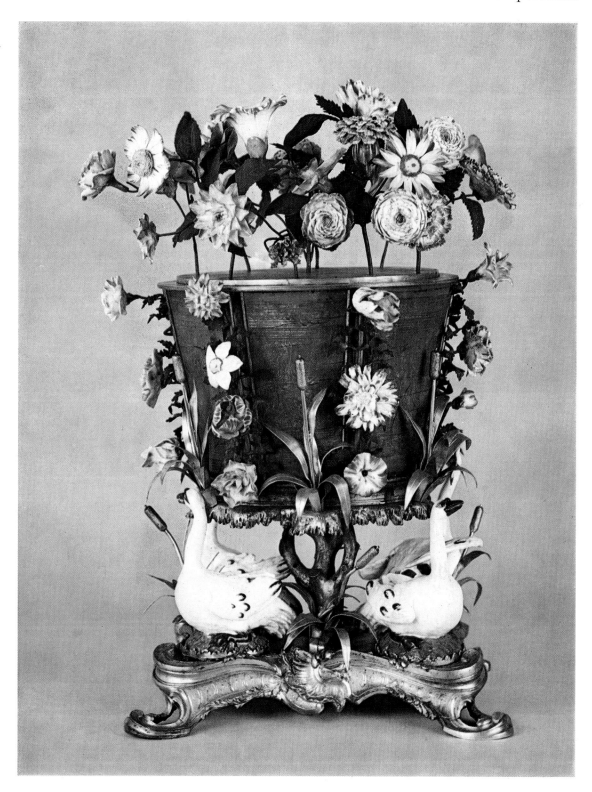

Left: Höchst faïence figure of a parrot with a cherry
Possibly modelled by J. F. Hess
15¾ in. (39 cm.) high
Sold 2.12.74 for £4725 ($11,340)
From the collection of the Hon. Mrs Mildmay-White

Right: Höchst faïence figure of a parrot
Painted by Johannes Zeschinger
15¾ in. (40 cm.) high
Sold 2.12.74 for £5775 ($13,860)
From the collection of the Hon. Mrs Mildmay-White

Crinoline group of 'Der Handkuss'
Modelled by J. J. Kändler
9 in. (23 cm.) wide
Sold 30.4.75 at the Hôtel
Richemond, Geneva, for £1200
(Sw. fr. 7200)

Left: Figure of Pulcinella
Modelled by J. J. Kändler
6⅛ in. (15.5 cm.) high
Sold 30.4.75 at the
Hôtel Richemond, Geneva,
for £5033 (Sw. fr. 32,000)

Right: Figure of Harlequin alarmed
Modelled by J. J. Kändler
6½ in. (16.5 cm.) high
Sold 30.4.75 at the Hôtel
Richemond, Geneva, for £3333
(Sw. fr. 20,000)

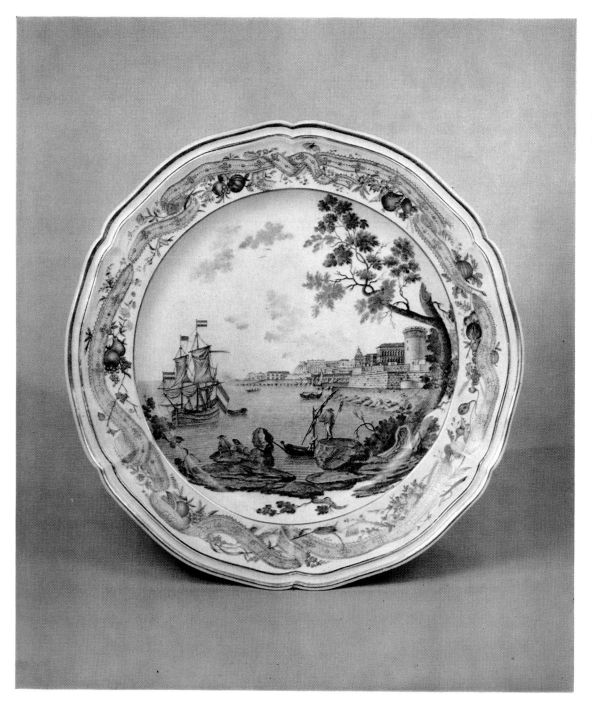

Capodimonte (Carlo III) hexafoil dish
Painted by
Giovanni Caselli
15¾ in. (40 cm.) diam.
Blue fleur-de-lys mark
Sold 30.6.75 for
£4830 ($11,109)

Tuscan albarello
11¾ in. (30 cm.) high
Last quarter 15th century
Sold 19.5.75 for £4200 ($9660)
From the collection of
the late Tom Virzi of New York

Faenza Berretino armorial dish of Casa Pirota type
11 3/8 in. (29 cm.) diam.
c. 1530
Sold 19.5.75 for £4725 ($10,867)

Urbino istoriato dish
Painted in the manner of Pseudopellipario
$10\frac{7}{8}$ in. (27.5 cm.) diam.
Sold 19.5.75 for £5040 ($11,592)

Saxon armorial blue dish engraved in diamond-point
Dated 1649
10¼ in. (26 cm.) diam.
Sold 22.4.75 for £1575 ($3780)

Lithyalin beaker
By Friedrich Egermann
Inscribed 'Andenke von Haydn'
and with the date 1849 below
4¼ in. (11 cm.) high
Sold 22.4.75 for £1785 ($4105)

Bristol London-
decorated
opaque-white
scent-bottle
3 in. (7.5 cm.) high
Sold 2.10.74 for
£892.50 ($2143)
From the collection
of Mrs F. E. Thurgood

Early Staffordshire baluster
cream-jug
2½ in. (7 cm.) high
Sold 22.4.75 for £577.50 ($1328)
From the collection of the late
The Hon. Edward Grenville Gore
Langton

Bristol opaque white decanter and stopper
11¼ in. (28.5 cm.) high
Sold 26.11.74 for £840 ($2016)
From the collection of Mrs Nancy Lancaster

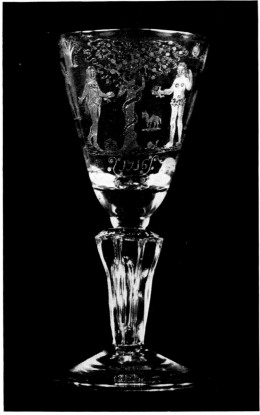

Above left: Engraved goblet
Inscribed 'God Bless King William and Queen Mary'
Dated 1689
6¾ in. (17 cm.) high
Sold 22.4.75 for £1680 ($3864)

Above centre: Engraved Nuremberg cylindrical beaker
In the manner of Georg Schwanhardt the Elder
6½ in. (16.5 cm.) high
Second half 17th century
Sold 22.4.75 for £1050 ($2415)

Above right: Opaque-twist wine-glass
the ogee bowl enamelled by Beilby
6 in. (16 cm.) high
Sold 2.10.74 for £504 ($1210)
From the collection of Mrs M. E. Laws

Left: Royalist goblet with the inscription 'God save King George'
Dated 1716
8¼ in. (21 cm.) high
Sold 2.10.74 for £2940 ($7056)
From the collections of the Misses E. M. C. and E. N. A. Atkinson
and Mrs M. K. Gedge

St Louis butterfly
and spray weight
3 in. (7.7 cm.) diam.
Sold 8.4.75 for
£2310 ($5313)

Clichy bouquet weight
2¾ in. (7 cm.) diam.
Sold 8.4.75 for £1995 ($4588)

Clichy bouquet weight
2¾ in. (7 cm.) diam.
Sold 8.4.75 for £2310 ($5313)

The Milkmaid
Documentary cameo two-handled vase
12 in. (30.5 cm.) high
Signed G. Woodall, the wood stand bearing
silver plaque inscribed 'Melbourne Tennis
Club Trophy, Presented by M. O'Shanassy,
Won by W. D. Coldman, May 25th, 1892'
Sold 3.6.75 for £8925 ($20,527)
From the collection of
Mr and Mrs John Coldham

Top left: Gallé intaglio-cut vase
5½ in. (14 cm.) high
Marked
Cristallerie de Gallé
Sold 18.11.74 at the Hôtel Richemond, Geneva, for £1307 (Sw. fr. 8000)

Top right: Gallé mould-brown oviform vase
9½ in. (24 cm.) high
Signed
Sold 18.11.74 at the Hôtel Richemond, Geneva, for £980 (Sw. fr. 6000)

Bottom left: Verre français overlay table-lamp
15¾ in. (40 cm.) high
Candy-stripe mark
Sold 27.1.75 for £252 ($580)

Bottom right: Daum double-overlay table-lamp and shade
17½ in. (44.5 cm.) high
Signed
Sold 27.1.75 for £735 ($1690)

Standard Tiffany bronze and
stained-glass geometric
standard-lamp
78¾ in. (200 cm.) high
Marked Tiffany Studios
New York
Sold 18.11.74 at the Hôtel
Richemond, Geneva, for
£4085 (Sw. fr. 25,000)

Pear-shaped vase
By Emile Decoeur
9½ in. (24 cm.) high
Sold 21.10.74 for
£861 ($2066)

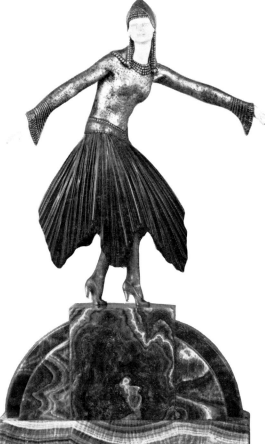

Bronze and ivory
figure of a dancer
By D. H. Chiparus
22⅞ in. (58 cm.) high
Signed
Sold 18.11.74 at the
Hôtel Richemond,
Geneva, for £882
(Sw. fr. 5400)

CHINESE CERAMICS
AND
WORKS OF ART

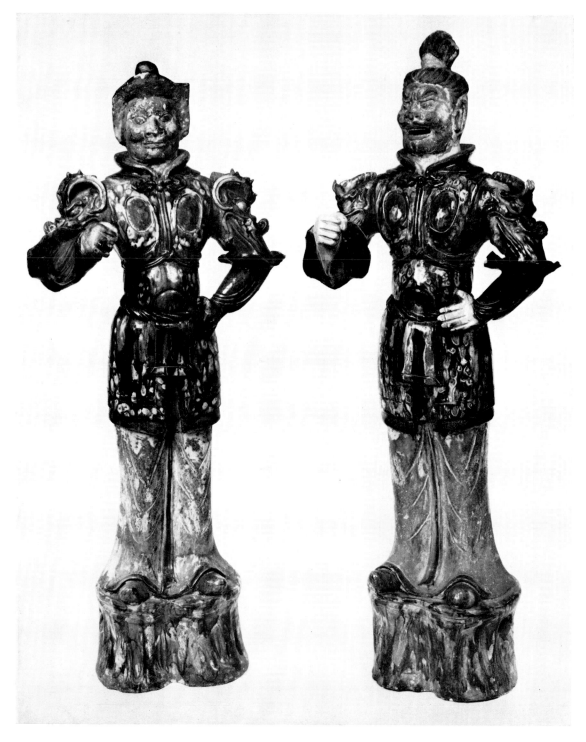

Large San Ts'ai
glazed buff pottery
figures of Lokapala
42½ in. (108 cm.) and
40½ in. (103.5 cm.)
high
T'ang Dynasty
Sold 12.5.75 for
£8190 ($18,837)

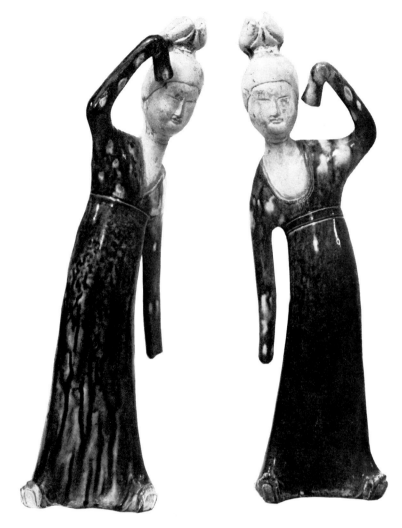

Pair of glazed buff pottery figures of dancing ladies
12 in. (30.5 cm.) high
T'ang Dynasty
Sold 26.11.74 for £5460 ($13,104)
Sold on behalf of the Estate of the late Gertrude C. Lee
of Westwood, Massachusetts

Late Ming Wu Ts'ai pear-shaped bottle
18½ in. (47 cm.) high
Wan Li horizontal six-character mark
below the rim and of the period
Sold 9.6.75 for £14,700 ($33,810)
From the collection of A. A. Ballard, Esq.

Right: Famille verte armorial dish
16½ in. (42 cm.) diam.
Late K'ang Hsi
Sold 23.6.75 for £1260 ($2898)
The arms are those of Compton. This dish is from a service made for Spencer Compton, second son of James, 3rd Earl of Northampton. Spencer Compton was born c. 1666. Speaker of the House of Commons in 1714 and 1722, he was, by stages, created Earl of Wilmington; in 1731 he became Lord President of the Council. He is generally regarded as having been the second 'Prime Minister' of Great Britain since he briefly succeeded Sir Robert Walpole in the equivalent of that office before his death in July 1743

Famille verte fluted pear-shaped wall fountain and domed cover
16 in. (41.5 cm.) high
K'ang Hsi
Sold 23.6.75 for £714 ($1642)

Garniture of five blue and white vases
19 in. (49 cm.) high
Chia Ching six-character marks within double circles but K'ang Hsi
Sold 23.6.75 for £2730 ($6279)
From the collection of Count R. H. van Limburg Stirum

Late Ming blue and white rectangular box and domed cover
10 in. (25 cm.) wide
Lung Ch'ing six-character mark within a double circle and
of the period
Sold 12.5.75 for £2940 ($6762)
From the collection of R. H. Newsholme, Esq

The 'H. C. Huth Hawthorn Jar'
9½ in. (24.5 cm.) high
K'ang Hsi
Sold 25.11.74 for £1785 ($4284)

From the collection of The Lord Astor
Once regarded as the finest of all blue and white
pieces, it held the auction record price (though
higher prices were paid privately)
until the recent boom in Ming blue and white,
and possibly still holds this record for the K'ang Hsi period.
In the sale of the H. C. Huth Collection in 1905 at
Christie's it realized £5900

Pair of famille verte
dishes
14 in. (35.5 cm.) diam
Leaf marks within
double circles
K'ang Hsi
Sold 7.10.74 for
£2310 ($5544)

Famille rose 'Aesop's
Fable' punch-bowl
14 in. (36.5 cm.) diam.
Ch'ien Lung
Sold 23.6.75 for
£1785 ($4105)

Underglaze red bowl
8½ in. (21.5 cm.)
diam.
late 14th century
Sold 26.11.74 for
£44,120 ($105,840)
The only recorded
example of this
type of decoration

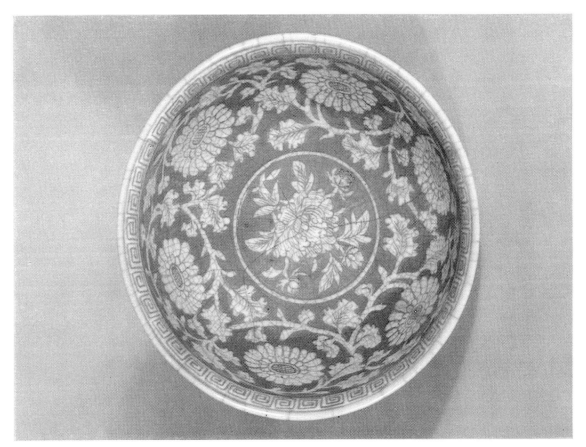

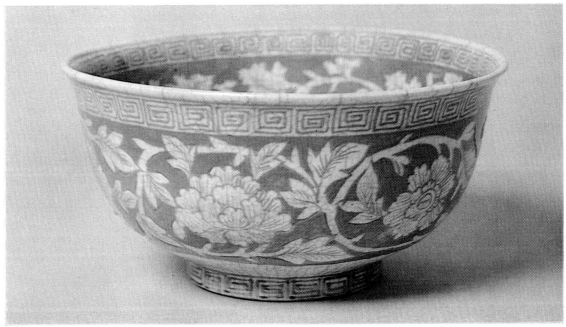

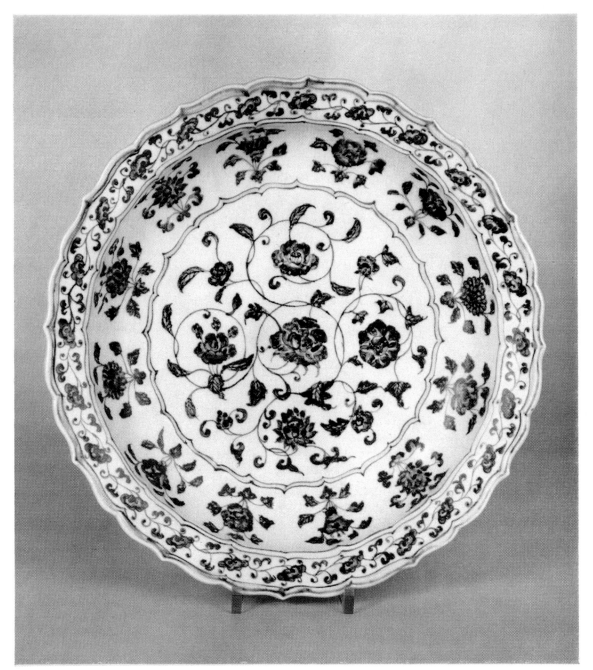

Early Ming blue and
white deep dish
15 in. (38 cm.) diam.
Yung Lo
Sold 12.5.75 for
£17,850 ($41,055)
From the collection
of A. E. Povey, Esq

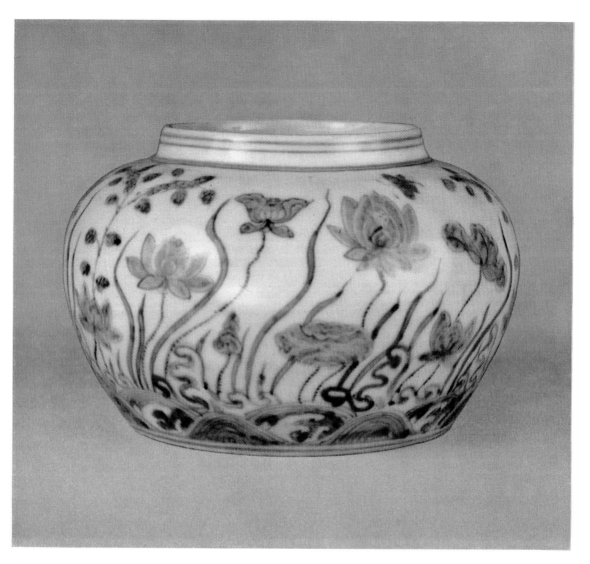

Blue and white broad globular jar (kuan)
6¼ in. (16 cm.) diam., 4 in. (10.3 cm.) high
15th century
The concave base painted with a Ch'êng Hua six-character mark within a double circle and of the period
Sold 9.6.75 for £75,600 ($173,880)

Coromandel lacquer twelve-leaf screen
Each leaf 96 × 18 in. (244 × 46 cm.)
K'ang Hsi
Sold 5.12.74 for £11,550 ($27,720)

Two massive famille
rose baluster vases
Both c. 52 in.
(132 cm.) high
Tao Kuang
Sold 7.10.74 for
£5460 ($13,100)
From the collection of
The Shaw Savill Line

Pair of famille rose
Mandarin baluster
vases and domed
covers, with seated
Buddhistic lion finials
52½ in. (134 cm.) high
Ch'ien Lung
Sold 28.7.75 for
£9975 ($21,945)
From the collection
of Edmund de
Rothschild, Esq, TD

Ku Yüeh Hsüan
pear-shaped vase
$6\frac{1}{4}$ in. (16 cm.) high
Blue enamel Ch'ien
Lung four-character
mark in a double
square and of the
period
Sold 12.5.75 for
£16,800 ($38,640)

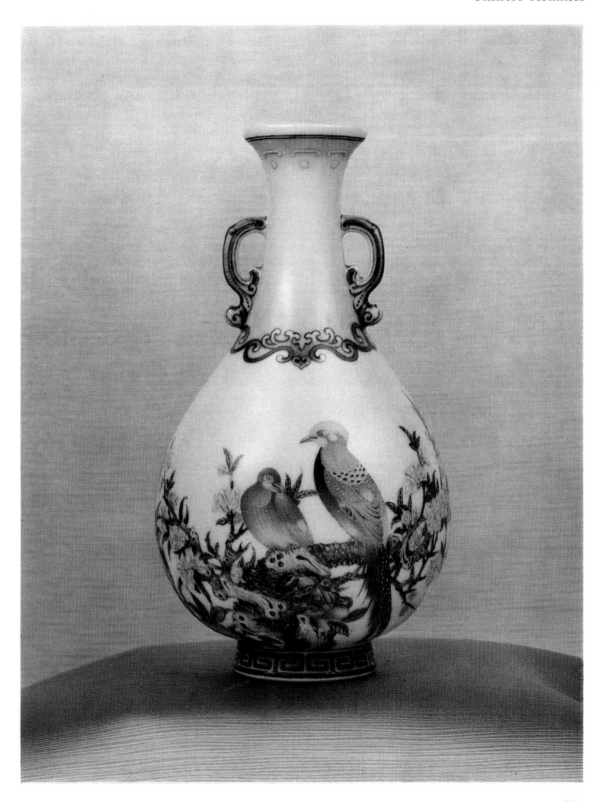

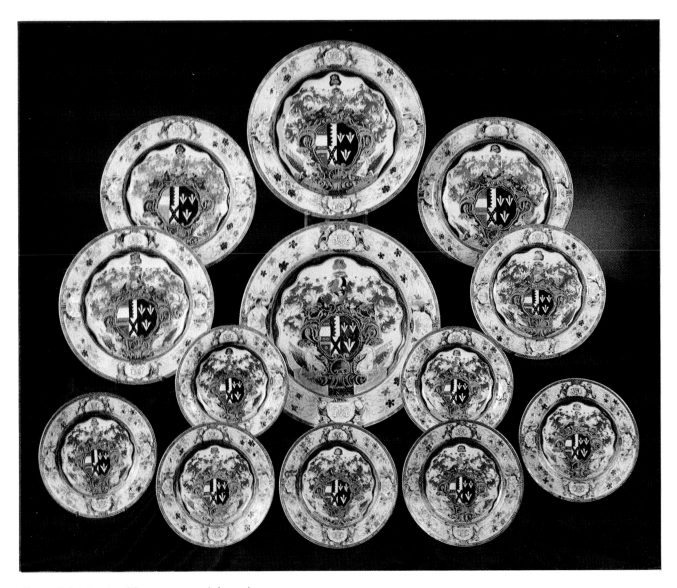

Part of the Leake Okeover armorial service
18th century
100 pieces sold 3.3.75 for a total of £57,645 ($138,348)
From the collection of Col. Sir Ian Walker-Okeover, Bt, DSO

The Leake Okeover service

During the 18th century there was an extensive trade between Canton and England in armorial dinner services. The practice was to send out a painting of the coat-of-arms to be copied on the porcelain. This trade had begun with blue and white and famille verte porcelain at the end of the 17th century and had grown to much larger proportions by the time that famille rose replaced famille verte in the 1720s.

The one-hundred-piece famille rose service sold on 3rd March in 20 lots for a total of £57,645 ($138,348) is believed to be unique in that the original painting from which it was copied is still in the possession of the vendor, Colonel Sir Ian Walker-Okeover, Bt, DSO. So too is the original bill dated 1739/40. The arms on this service are those of Sir Ian's forebear Leake Okeover (1702–65), a man of renowned extravagance even for his time. This service certainly reflects his taste. D. S. Howard in his recently published book *Chinese Armorial Porcelain* describes it as representing 'the solid grandeur of the West'.

It has no connection with Chinese sensibilities or Eastern criteria in ceramics but it does demonstrate the superb technical quality of the Chinese potters and painters and the efficiency of their highly specialized organization in which each painter is thought to have been responsible for only one colour or one type of motif.

Such was the strength of this trade, that when Meissen and other European factories began to compete with China during the 18th century, the Chinese dinner services remained available at a fraction of their competitors' price; hence their enormous popularity and success.

However, as the century progressed the European factories became more competitive by improving the technical quality of their wares and lowering their costs. The Chinese found it increasingly difficult to compete and even before the end of the century the quality of their wares had begun to deteriorate. The Chinese armorial trade did struggle on into the 19th century but had virtually ceased by the 1820s. Moreover, changing tastes caused the coat-of-arms to be reduced in size during the third quarter of the 18th century and so this service can be said to represent the 'golden age' of the trade when all the artistic and economic factors were in its favour.

Pair of blanc-de-chine figures mounted on deer
8½ in. (21 cm.) high
18th century
Sold 17.2.75 for £1365 ($3276)

Pair of cloisonné enamel
incense-burners and covers,
modelled as parrots
9½ in. (24 cm.) high
Ch'ien Lung/Chia Ch'ing
Sold 7.10.74 for £2100 ($5040)

Pair of famille rose figures of standing mules
10 in. (25 cm.) high
18th century
Sold 23.6.75 for £4410 ($10,143)

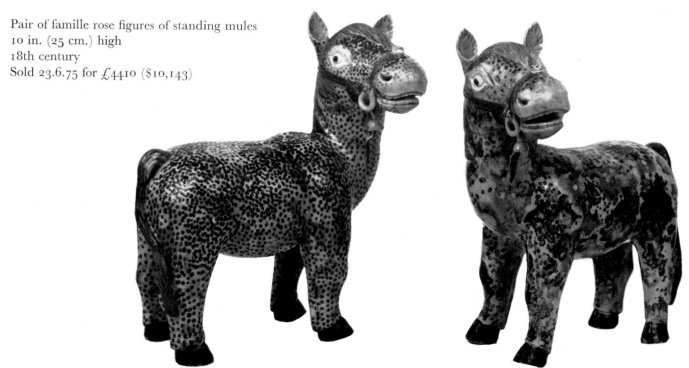

Red, green and blue lacquer shaped rectangular plaque
28 × 40 in.
(71.5 × 102 cm.)
Ch'ien Lung
Sold 9.6.75 for
£2730 ($6279)

Cloisonné enamel rectangular plaque depicting the Dagoba (Islamic tower) of the Winter Palace on the Ch'iung-hua
$17\frac{1}{2} × 30\frac{1}{2}$ in.
(44 × 77.5 cm.)
Signed Te-ch'êng chih
Late Ch'ien Lung
Sold 12.5.75 for
£2940 ($6762)

Mottled spinach-green
jade boulder
12 in. (30.5 cm.) high
11 in. (28 cm.) wide
K'ang Hsi
Sold 21.10.74 for
£8190 ($19,856)
From the collection
of The Lady
McCorquodale

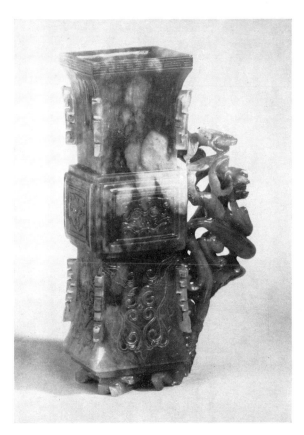

Mottled emerald jade vase
5⅛ in. (13 cm.) high
Sold 14.7.75 for £7350 ($16,170)

Unusual pale celadon jade carving of a
conch shell
8 in. (20 cm.) wide
K'ang Hsi
Sold 18.3.75 for £5040 ($11,592)

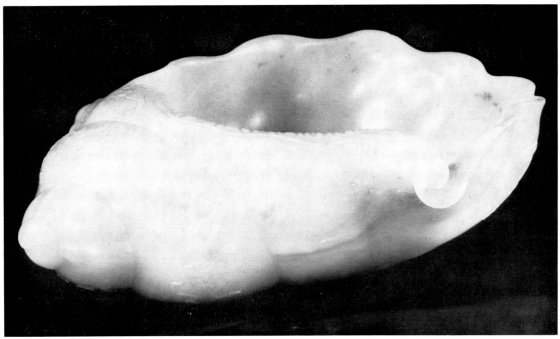

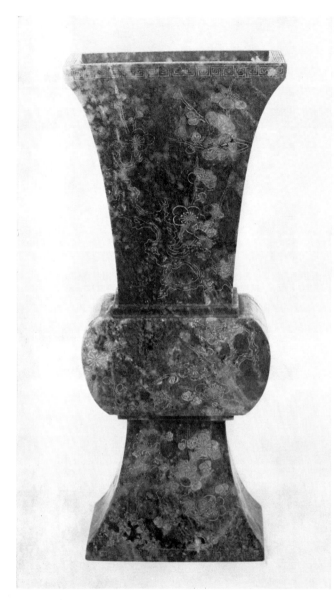

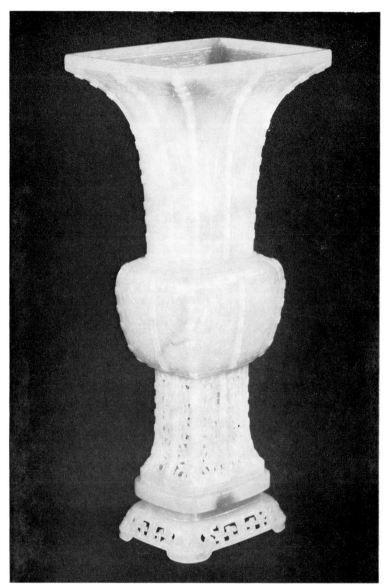

Lapis lazuli rectangular ku
10¾ in. (27.5 cm.) high
Ch'ien Lung
Sold 18.3.75 for £6825 ($15,697)
This piece was reputed to have been taken from the
Imperial Palace during the siege of Peking and was
the property of the Emperor Ch'ien Lung

One of a pair of translucent pale green jade ku-shaped beaker
vases and stands
10 in. (25.5 cm.) high
Ch'ien Lung
Sold 18.3.75 for £7350 ($17,640)

Unusual translucent pale celadon
jade ewer and domed cover
6⅛ in. (15.5 cm.) high
Sold 5.5.75 for £2520 ($5796)

White jade marriage bowl
9 × 6 in. (23 × 15 cm.) wide
18th century
Sold 21.10.74 for £8400 ($10,160)
From the collection of
The Lady McCorquodale

Pair of large mottled apple-green jade flat carvings
of phoenix
19 in. (48 cm.) high
Sold 21.10.74 for £7875 ($19,100)
From the collection of The Lady McCorquodale

Large pale celadon jade carving of a standing figure
of Kuan Yin
16 in. (41 cm.) high
18th century
Sold 21.10.74 for £5040 ($12,096)
From the collection of The Lady McCorquodale

From top to bottom left to right:

Hornbill (ho ting) bottle
£945 ($2268)

Transparent blue glass bottle
£378 ($907)

Opaque sky-blue glass bottle
£546 ($1310)

Opaque pale turquoise glass bottle
£199.50 ($479)

Famille rose moulded porcelain bottle
£42 ($101)

Opaque turquoise glass bottle
£336 ($805)

Beige jade bottle
£420 ($1008)

Opaque white glass bottle
£168 ($403)

Aragonite bottle
£99.75 ($239)

Centre bottle 3 in. (7.5 cm.) high
All sold 9.10.74

JAPANESE,
INDIAN, TIBETAN,
PERSIAN AND ISLAMIC
WORKS OF ART

Pair of Kakiemon
tigers
$9\frac{7}{8}$ in. (25 cm.) high
Late 17th century
Sold 18.2.75 for
£8190 ($19,656)

Two leaves of an eight-leaf screen
Each leaf $57\frac{7}{8} \times 26\frac{3}{8}$ in. (147×67 cm.)
Momoyama period
Leaves separated; originally a pair of four-leaf screens
Sold 18.2.75 for £3780 ($9072)
Presented to Dr L. H. Baekeland by the Emperor
Taisho in recognition of the first establishment of
the Japanese plastics industry

Six-leaf screen
Each leaf $64\frac{1}{8} \times 25\frac{5}{8}$ in. (163×60 cm.)
Early or middle Edo period
Sold 3.6.75 for £2310 ($5313)

Murasaki-odoshi dangaiye-do
1632–1868
Sold 29.10.74 for £12,600 ($30,240)
Record auction price for a Japanese
suit of armour

Kaga tosei-gusoku
Late 16th/early 17th century,
the mounting early 19th century
Sold 29.10.74 for £5040 ($12,096)

Lacquer tansu
$22\frac{7}{8} \times 14\frac{1}{8}$ in. (58 × 36 cm.)
19th century
Sold 17.12.74 for £1575
($3623)

One of a pair of lacquer
rectangular robe chests
$31\frac{7}{8} \times 20\frac{1}{8} \times 20\frac{7}{8}$ in.
(81 × 51 × 53 cm.)
Late Edo period
Sold 17.12.74 for £4200
($9660)

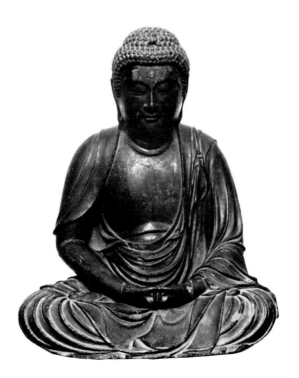

Gilt wood seated figure of Buddha
18⅞ in. (48 cm.) high
17th/18th century
Sold 3.6.75 for £1260 ($2898)
From the collection of Captain
Jack Simpson, RA

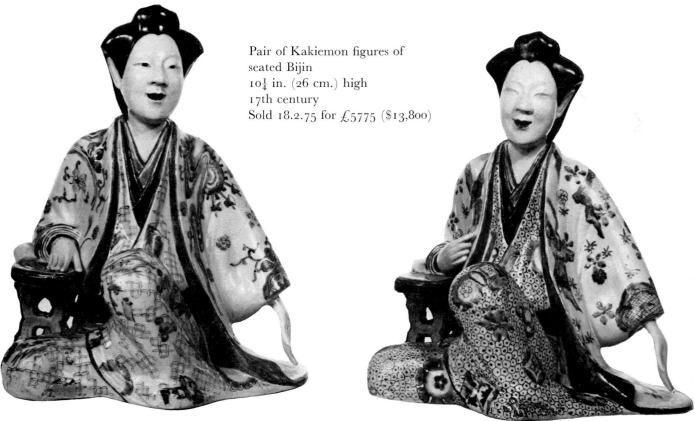

Pair of Kakiemon figures of
seated Bijin
10¼ in. (26 cm.) high
17th century
Sold 18.2.75 for £5775 ($13,800)

349

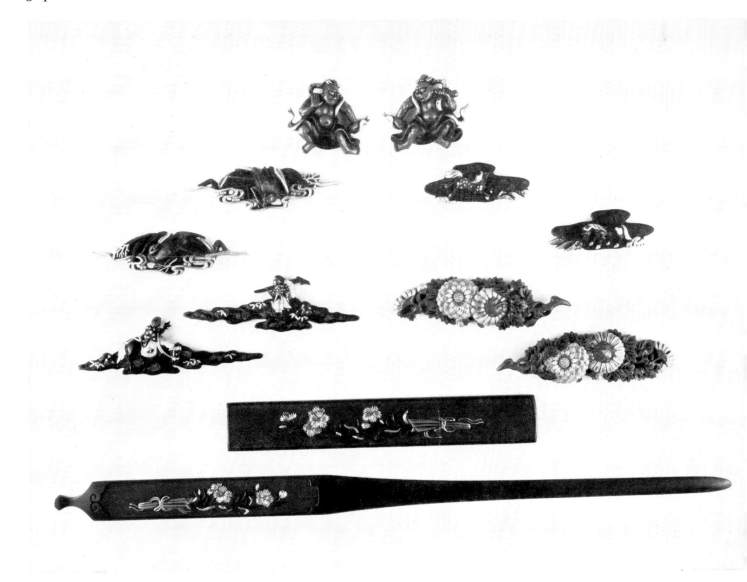

Matching kozuka and kogai by Tamagawa Yoshihisa
Sold 11.3.75 for £787.50 ($1890), and

Five pairs of menuki by various artists
Sold 11.3.75 for a total of £1722 ($4132)

The kozuka (lit. small handle) normally has a small steel blade and is then called kogatana (lit. small knife); it probably served much of the same purposes as a European pocket-knife. The kogai is a skewer-like implement of much earlier origin, and was generally used for dressing the hair, originally worn in a queue drawn up on top of the head. Occasionally divided lengthwise (wari-kogai), it then served as hashi or chopsticks. Kozuka and kogai were usually carried in a slot on each side of the scabbard of the wakizashi or short sword. Menuki are pairs of metal ornaments attached one on each side of the hilt. Originating as the heads of rivets securing the hilt to the tang, they later became purely decorative and are usually bound under the silk hilt-braid. Kogai, kozuka and menuki are together known as mitokoromono or 'objects of three places'

Daisho pair of
shakudo-nanako tsuba
$3\frac{1}{4}$ in. (8.25 cm.) and
3 in. (7.6 cm.)
Unsigned, probably
by Ormori Eisho
Sold 11.3.75 for
£2310 ($5544)

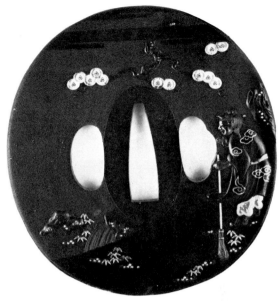

Daisho pair of
shakudo-nanako tsuba
3 in. (7.6 cm.) and
$2\frac{7}{8}$ in. (7.2 cm.)
Each inscribed Goshu
Hikone ju Soheishi
Soten sei
Sold 11.3.75 for
£714 ($1724)

Japanese works of art

Top left: Wood netsuke of the
Badger Tea Kettle
19th century
Sold 24.6.75 for £504 ($1159)

Top right: Wood netsuke of a seated
tanuki
Signed Hogen Tadayoshi in ukibori
Early 19th century
Sold 24.6.75 for £945 ($2173)

Centre left: Ivory netsuke of the ghost
of a woman
Signed Seishu
Late 19th century
Sold 24.6.75 for £2100 ($4830)

Centre right: Wood netsuke of an owl
19th century
Sold 24.6.75 for £1680 ($3864)

Bottom left: Ivory netsuke of a
reclining hound
Signed, in a rectangular reserve
Okatomo (of Higashiyama, Kyoto)
18th century
Sold 24.2.75 for £1680 ($4032)

Bottom right: Ivory netsuke of a seated
dog
Signed Tomotada, Kyoto school
Sold 24.6.75 for £5040 ($11,592)

Tibetan thanka
showing the mandala
of Dorje Phurpa
Silk brocade mount
and veil
31 × 22½ in.
(79 × 57 cm.)
Early 17th century
Sold 9.12.74 for
£5040 ($12,100)

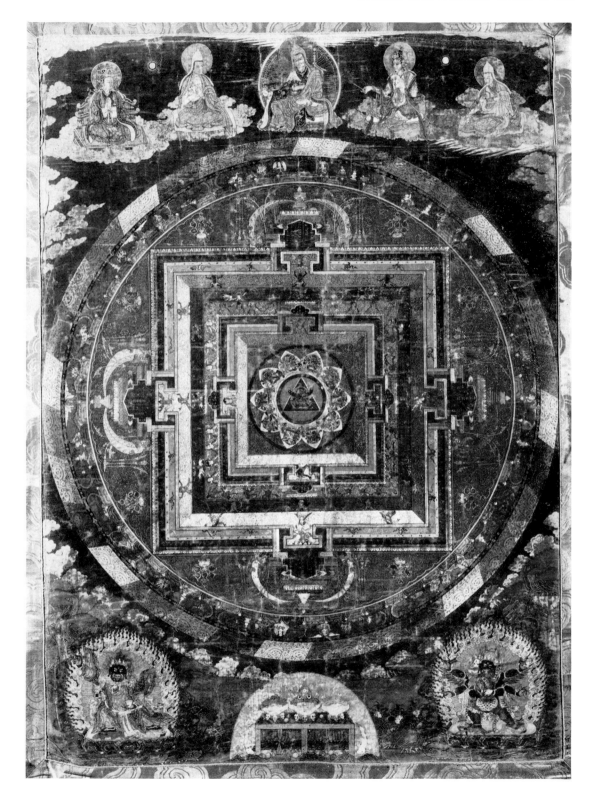

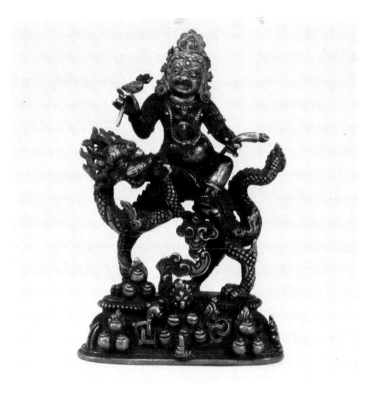

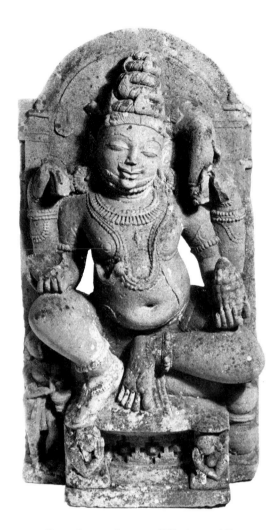

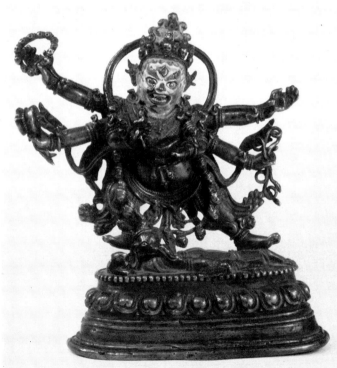

Central Indian buff sandstone figure of Bhairava (?)
30 in. (76 cm.) high
11th century
Sold 6.5.75 for £1680 ($3864)
From the collection of Mrs J. V. Ratcliffe

Top left: Tibetan bronze figure of Sitajambhala
5¾ in. (14.5 cm.) high
16th century
Sold 9.12.74 for £1260 ($3024)

Bottom left: Tibetan bronze figure of Mahakala as
Paldan Gon-po Char Drug-pa
6 in. (15 cm.) high
16th century
Sold 9.12.74 for £1050 ($2520)

Chinese gilt bronze
figure of Mahakala
7½ in. (19 cm.) high
incised with six
character dedicatory
Yung lo marks
Sold 6.5.75 for
£6825 ($15,697)
From the collection of
Michael de Laszlo

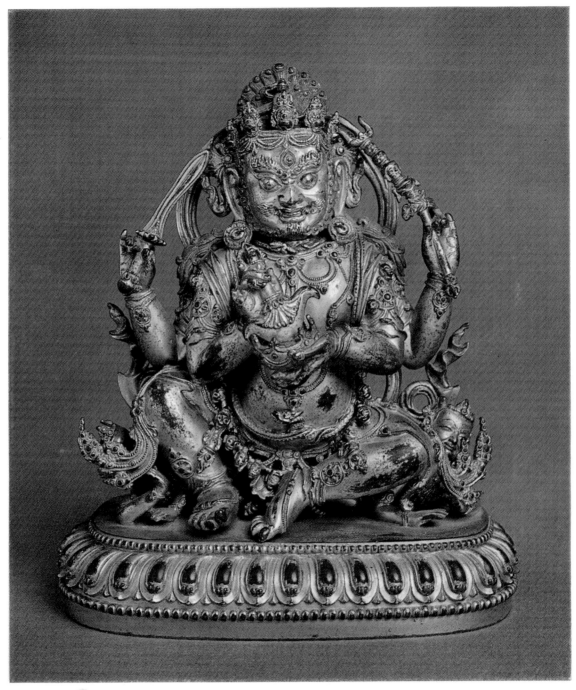

Mamluke glass vase
12 in. (30.5 cm.) high
Late 14th century
Sold 14.7.75 for £5460
($12,012)

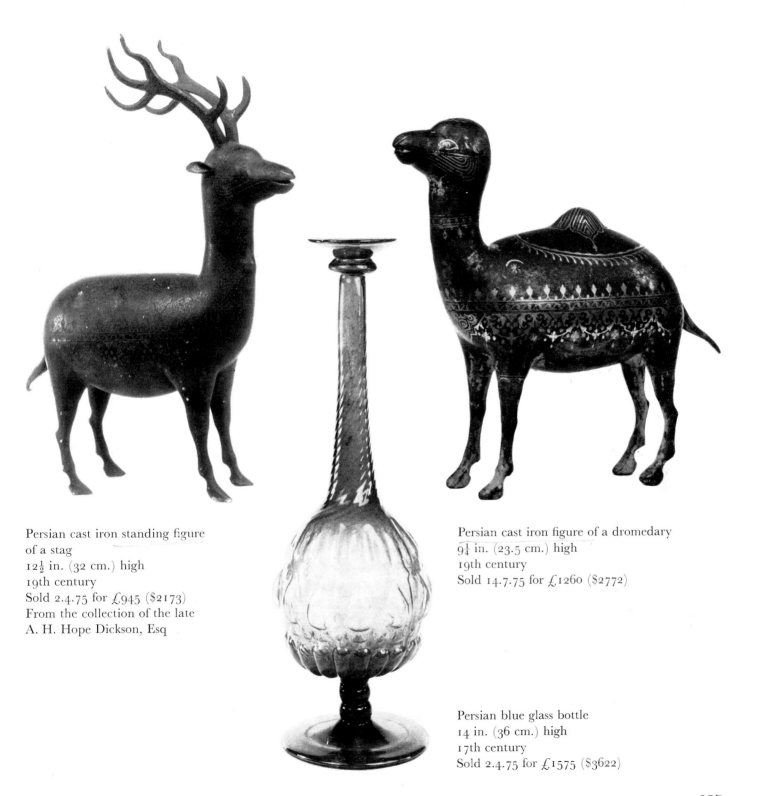

Persian cast iron standing figure
of a stag
12½ in. (32 cm.) high
19th century
Sold 2.4.75 for £945 ($2173)
From the collection of the late
A. H. Hope Dickson, Esq

Persian cast iron figure of a dromedary
9¼ in. (23.5 cm.) high
19th century
Sold 14.7.75 for £1260 ($2772)

Persian blue glass bottle
14 in. (36 cm.) high
17th century
Sold 2.4.75 for £1575 ($3622)

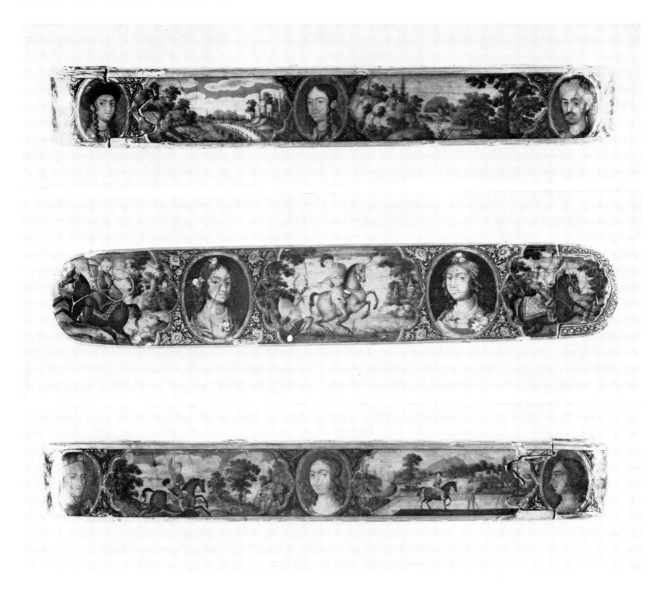

Qalamdan
8¾ in. (22.2 cm.) long
Inscribed Ya Sahib as Zaman (Mohamed Zaman)
Early 18th century
Sold 14.7.75 for £8925 ($19,635)

FURNITURE,
WORKS OF ART,
SCULPTURE,
RUGS, TAPESTRIES,
MUSICAL INSTRUMENTS,
CLOCKS AND WATCHES

Documented George III mahogany breakfront library bookcase
By Thomas Chippendale
85 in. (216 cm.) high
131 in. (333 cm.) wide
Sold 15.5.75 for
£23,100 ($53,130)

This bookcase was supplied by the firm of Chippendale and Rannie for Sir Lawrence Dundas's library at Arlington Street and the account dated 20th January, 1764, reads: 'To a very large Mahogany Bookcase of fine Wood with a Scrol pediment top & Rich folding doors glaz'd with plate glass in the upper & Cupboards with folding doors of very fine Wood in the under part'. Another bookcase, identical to the present example, was supplied for Aske Hall, Sir Lawrence's house in Yorkshire, the same year at a cost of £73. The account being dated 16th August, 1764

George III giltwood side table with D-shaped scagliola and marble top inlaid in the Etruscan style
48¾ in. (124 cm.) wide
Sold 26.6.75 for £1260 ($2898)

One of a pair of George III
giltwood side tables
Attributed to John Linnell with
scagliola tops attributed to Bossi,
the tops inlaid in the style Etrusque
48 in (122 cm.) wide
Sold 13.2.75 for £7875 ($18,900)
These tables formed part of the
original furnishings of the Long
Gallery at Castletown, the tops
designed to echo and complement
the Etruscan painted decorations
executed by Thomas Riley
(c. 1752–98), a former pupil of
Reynolds, in lavender blue, red
and green

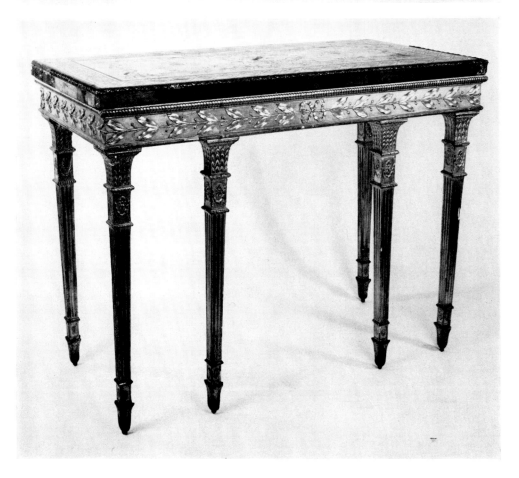

George III satinwood, rosewood and
marquetry writing-table in the French style
30¼ in. (77 cm.) wide
Sold 13.2.75 for £2415 ($5796)

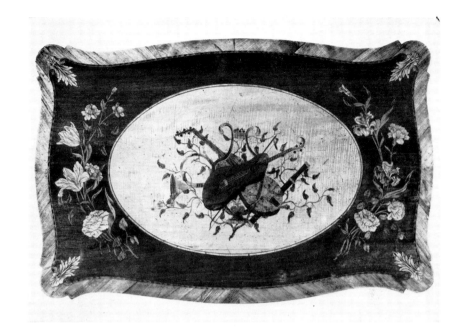

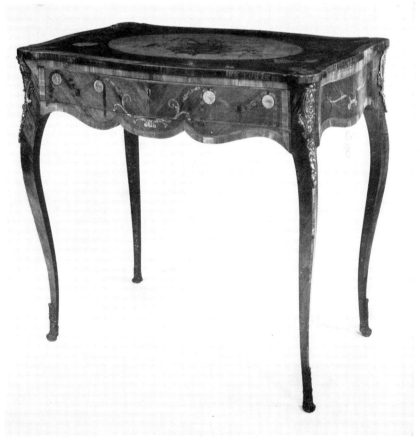

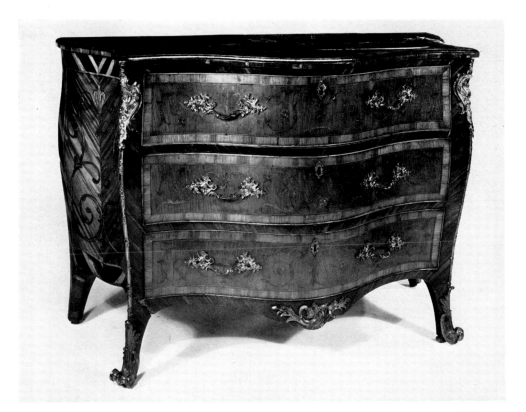

George III marquetry commode
Attributed to Pierre Langlois
46¾ in. (119 cm.) wide
Sold 10.4.75 for £5880 ($1352)

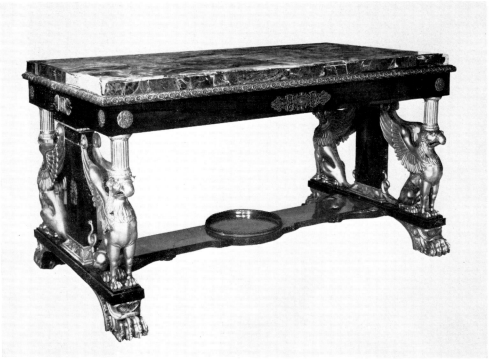

Regency rosewood and giltwood
centre table
In the Hope style
72½ × 39¾ in. (184 × 101 cm.)
Sold 15.5.75 for £4200 ($9660)
From the collection of
Sir Ian Macdonald of Sleat, Bt

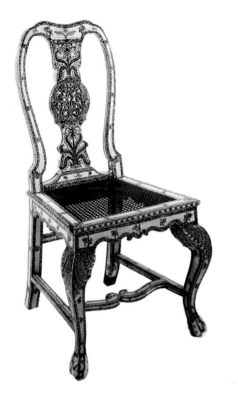

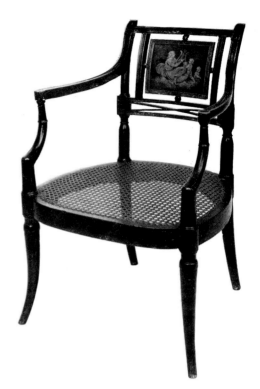

Left: Indian ivory-veneered chair
18th century
Sold 13.2.75 for £1785
($4285)

Right: One of a set of eight late George III painted open armchairs
Sold 15.5.75 for £1575
($3622)
From the collection of the late Dowager Lady Loch

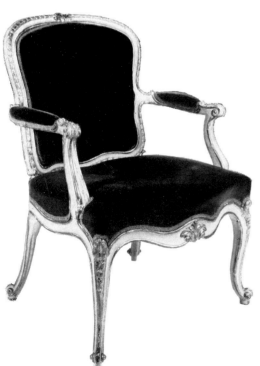

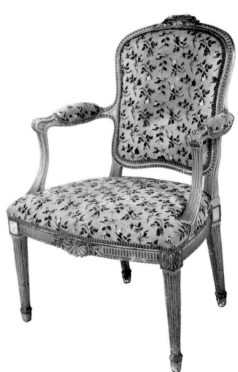

Left: One of a set of four George III white and gold painted armchairs
In the style of
Thomas Chippendale
Sold 26.6.75 for £3150
($7245)

Right: One of a pair of George III white-painted gilded open armchairs
In the style of
Thomas Chippendale
Sold 21.11.74 for £998
($2394)
From the collection of Mrs Nancy Lancaster

Left: One of a pair of
Regency chinoiserie
bedside cupboards
18 in. (46 cm.) wide
Sold 21.11.74 for £3150
($7560)
From the collection of
Mrs Nancy Lancaster

Right: One of a pair of
Regency bronze
candlesticks, with Sphinx
bodies
20½ in. (53 cm.) high
Sold 15.5.75 for £420
($966)
From the collection of
Sir Ian Macdonald of
Sleat, Bt

Left: Indian (Vizagapatam)
ivory miniature
secretaire-cabinet
37½ in. (95 cm.) high
25 in. (63.5 cm.) wide
Late 18th century
Sold 13.2.75 for £840
($2016)
From the collection of
Lady Norie-Miller

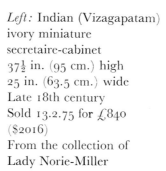

Right: Queen Anne black
and gold lacquer
'union suit'
24½ in. (62 cm.) wide
Sold 15.5.75 for £2625
($6037)

Victorian walnut and marquetry centre table
Attributed to A. W. N. Pugin
55 in. (140 cm) diam.
c. 1850
Sold 24.7.75 for £2520 ($5544)

Three comparable tables designed by Pugin and made by John Webb of Bond Street survive in the Prince's Chamber of the House of Lords, and another with a comparable top, designed for Abney Hall, Cheshire, c. 1847 is in the Victoria & Albert Museum

Shrine of the Art Style

HUGH ROBERTS

Two sales last season shed a pleasingly informative light on one of the seminal collections of English 19th-century art, long since sadly dispersed, and until now thought to be rather poorly documented. Alexander Alexander Ionides (1840–98), a patron and connoisseur of discernment, assembled over twenty years at his white stuccoed classical house, 1 Holland Park (now demolished), an unusually rich and eclectic collection: Burne-Jones and Whistler, Tanagra figures, de Morgan ceramics and furniture by leading experts of the Art Style, among them E. W. Godwin, George Jack and William Morris. The table illustrated below was designed by Jack and made by Morris & Co. in 1880 for £38 os. od. It can be seen in the contemporary photograph of the dining room (opposite), shrouded by a brocaded cloth, with its de Morgan tiled fireplace, Walter Cranc frieze and set of 18th-century chairs, re-upholstered by Morris & Co. for £20 6s. 8d., two of which we sold here on 13th February (see page 370). Both these Lots, together with a sideboard, came for sale

Documented mahogany dining table
Designed by George Jack and made by Morris & Company
78½ in. (199 cm.) wide
Sold 23.1.75 for £1102.50 ($2536)

from the estate of A. A. Ionides' daughter and by a happy chance it transpired that the family still possessed two unrecorded volumes of photographs by Bedford Lemere of 1 Holland Park, one of which had belonged to the architect and designer Philip Webb. Through the medium of Lemere's richly atmospheric photogravure, one can easily step back into these momentarily vacated, clustered and draped 'eighties interiors, the day-light filtering across the furniture carefully arranged to impede all direct movement; the sense of time stopped is particularly vivid in the nurseries where dolls and toys line up by the beds, and in the bathroom where a dressing gown lies casually draped and Julia Margaret Cameron prints line the walls. (Copies of these photographs have now been lodged, by courtesy of the owners, with the National Monuments Board.)

The dining room at 1 Holland Park

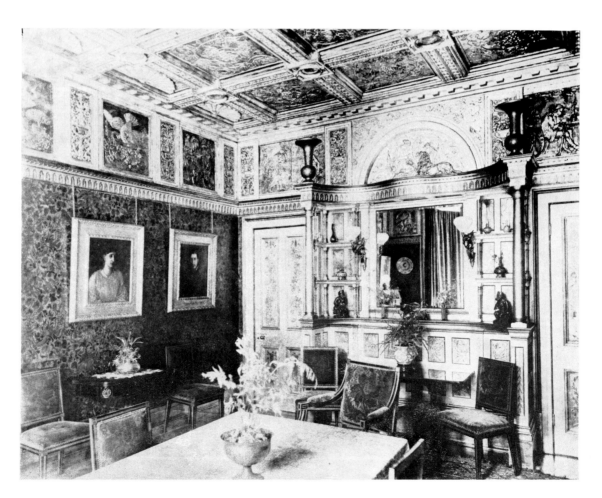

A. A. Ionides Esq. Mch 18**

26, QUEEN SQUARE, BLOOMSBURY, W.C.

PAINTED GLASS.
EMBROIDERY.
PAINTED TILES.
WALL PAPERS.
CHINTZES.

Dr. to MORRIS & COMPANY.

FURNITURE SILKS.
VELVETS, SERGES, &c.
MOROCCOS.
CARPETS.

18 Copy. *The Prices are for Cash without discount.* Folio

		£	s	d
Rectifying Stuffing of 12 single & 2 Arm chairs & covering in Red stamped Velvet finished with fringe		20	6	8
Do Do 2 Ebony Chairs recaning seat, repairing & repolishing frames making 2 new cushions, putting on new castors & covering in Red Velvet finished with nails		10	6	0
2 Red Velvet Hassocks	18/	1	16	0
Supplying 4 Muslin Curtains for Dining room and 4 do for Antiquity Room		12	3	0
4 prs Loop	3/6		14	0
Supplying 1 pair of Red Stamped velvet Curtains for Dining room lined with merino & finished with fringe also valance for same, do 1 pr of portière curtains & valance		81	8	6
2 prs Double holders		1	7	6
Mahogany Dining Table inlaid with Ebony		38	0	0
Supplying 3 best white holland blinds on spring rollers with lines, tassels &c		3	15	9
2 Blue velvet Hassocks	18/	1	16	0
Amount		171	13	5

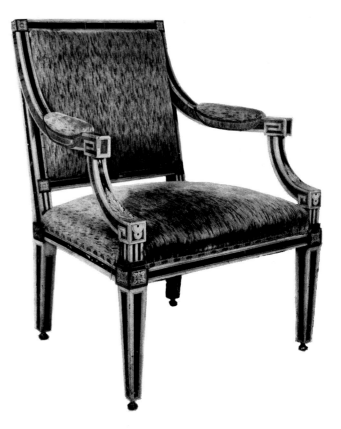

One of a pair of George III rose and satinwood marquetry armchairs
Sold 13.2.75 for £892.50 ($2143)
From the collection of the late Mrs P. Hotchkis, sold by order of the Executors

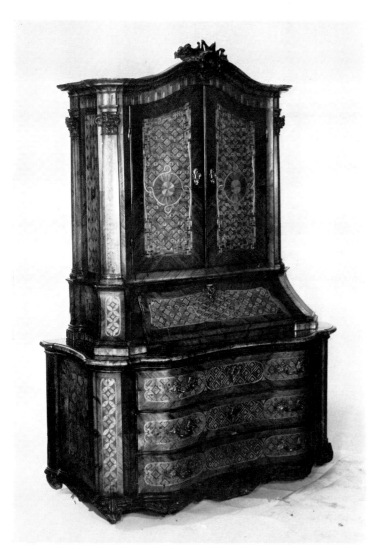

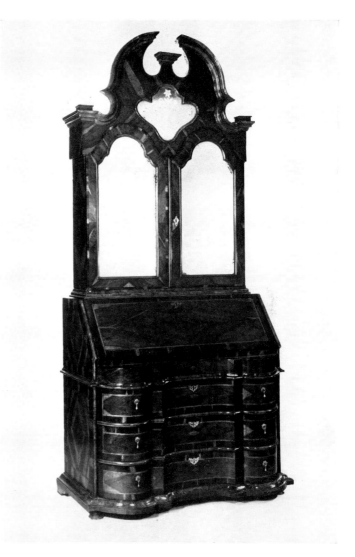

German (Mainz) rococo walnut marquetry bureau-cabinet
89¼ in. (227 cm.) high, 59½ in. (151 cm.) wide
Mid-18th century
Sold 6.3.75 for £8925 ($20,527)

Venetian walnut and fruitwood bureau bookcase
101 in. (257 cm.) high, 45½ in. (116 cm.) wide
Early 18th century
Sold 3.4.75 for £7875 ($18,112)

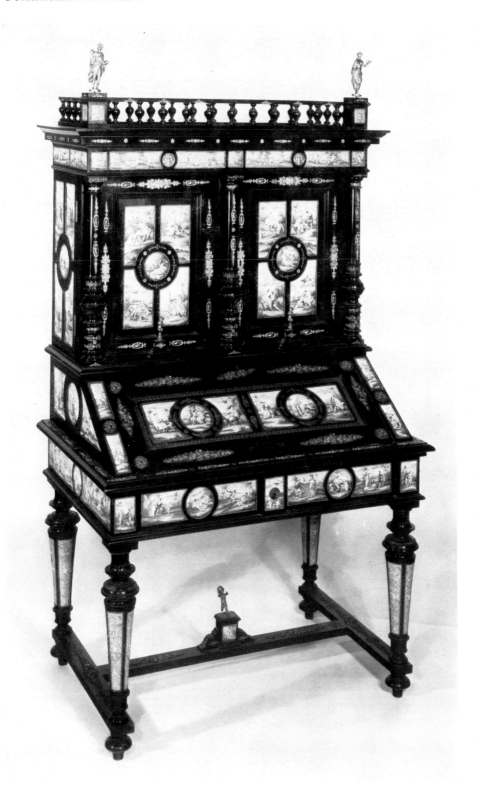

Viennese enamel-mounted
bureau-cabinet
70 in. (178 cm.) high
42½ in. (108 cm.) wide
19th century
Sold 6.3.75 for £17,325 ($39,847)

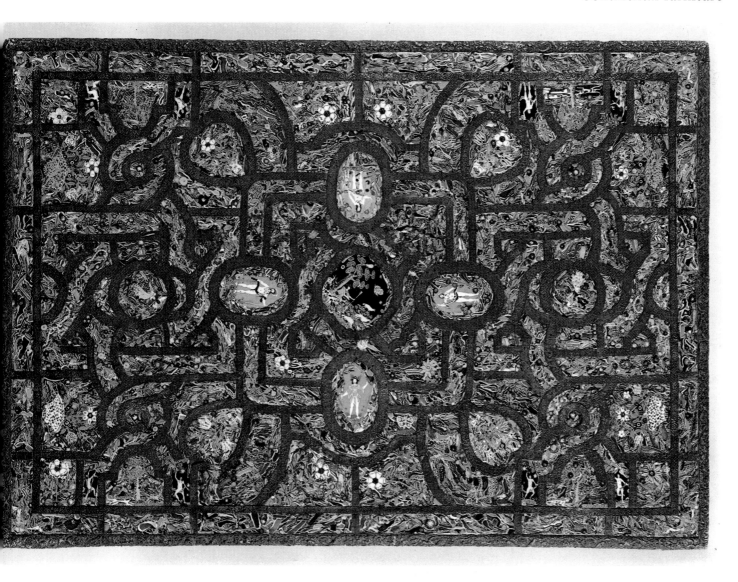

Millefiori glass table-top on giltwood base
$45\frac{1}{2} \times 32$ in. (116×81 cm.)
c.1700
Sold 26.6.75 for £7140 ($16,422)

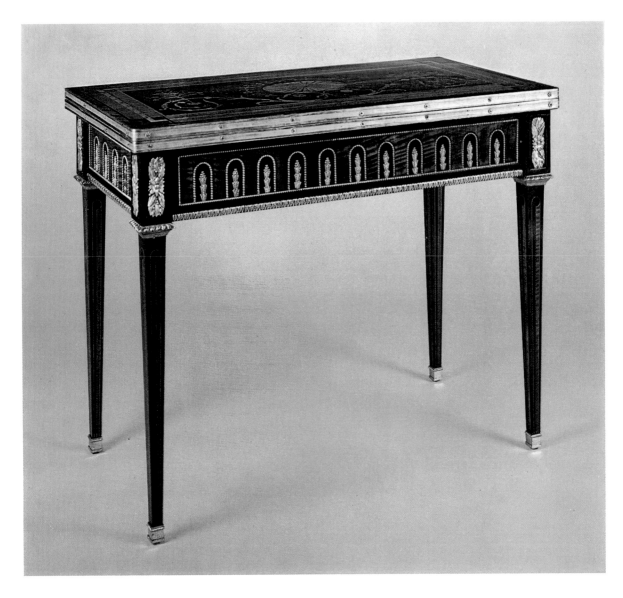

One of a pair of Russian marquetry card-tables
$38\frac{3}{4} \times 19\frac{1}{2}$ in. (98.5×49.5 cm.)
c. 1780
Sold 18.11.74 at the Hôtel Richemond, Geneva, for £11,437 (Sw. fr. 70,000)

One of a pair of German
maplewood bureau-cabinets
87 in. (221 cm.) high
40 in. (102 cm.) wide
Dresden, c. 1730
Sold 10.7.75 for £7350 ($16,170)

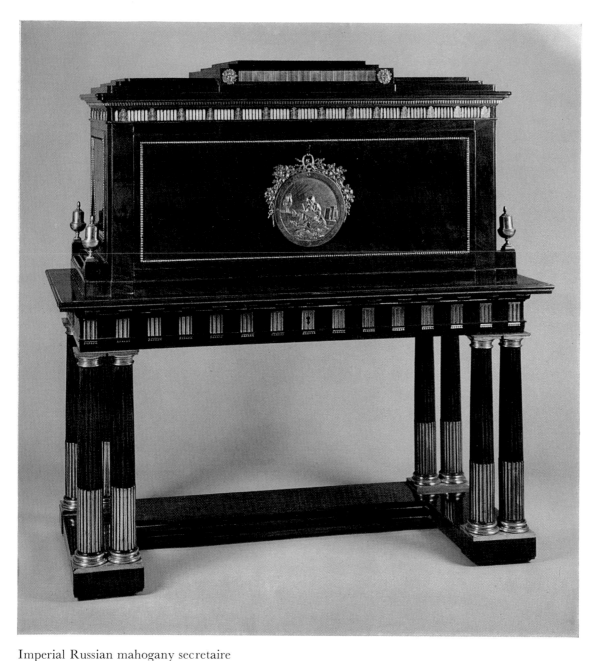

Imperial Russian mahogany secretaire
by David Roentgen
49⅝ in. (126 cm.) high, 50⅜ in. (128 cm.) wide, 22 in. (56 cm.) deep
Sold 18.11.74 at the Hôtel Richemond, Geneva, for £19,607 (Sw. fr. 120,000)

Roentgen and the Russian Court

Two Imperial Russian secretaires made by David Roentgen, the famous German *ébéniste*, for Catherine the Great and Tsar Paul I respectively were sold by Christie's in Geneva on 18th November. German by birth, like most of the great 18th-century cabinet makers, David Roentgen produced his furniture in Germany but had a shop in Paris. In spite of its high quality, Roentgen was able to organize the manufacture and distribution of his furniture on a very large scale; in his spare time, like Sheraton, he was a low church preacher. The most important of the two secretaires (illustrated opposite) was made by Roentgen in 1786 for the Palace of Pavlovsk outside St Petersburg (now Leningrad). It is similar to one in the Hermitage Museum and was part of a large quantity of furniture ordered by Catherine the Great during the years 1784–86 for the sum of 11,512 roubles; the sterling equivalent, allowing for currency devaluations over the years, would be at least £400,000 (Sw. fr. 2,800,000; $960,000). The cost alone of transporting the secretaire from Roentgen's workshop at Neuweid on the Rhine to St Petersburg was 540 roubles or at least £2000 (Sw. fr. 14,000; $4800). These details are known from the invoice which survives to this day.

The second Roentgen piece is a *secrétaire de voyage* (see illustration page 378) and was made for Tsar Paul I in 1799. The secretaire can be dated accurately because of the Russian Imperial arms on the front which include the Cross of the Order of Malta. The Order came under Russian protection in 1798 following the invasion of Malta by Napoleon and Paul I became Grand Master of the Order; the arms remained in use until his death in 1801.

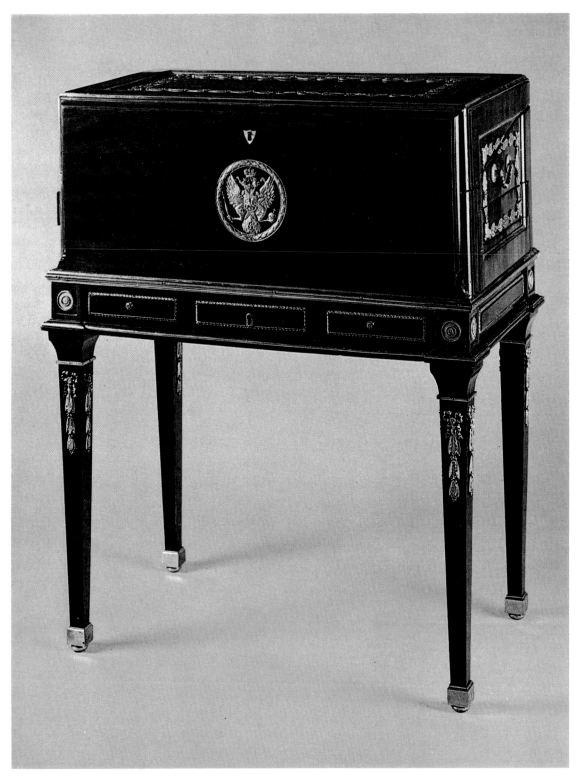

The travelling
secretaire of
Tsar Paul I
Attributed to
David Roentgen
40½ in. (103 cm.) high
32⅝ in. (83 cm.) wide
19⅝ in. (50 cm.) deep
Sold 18.11.75 at the
Hôtel Richemond,
Geneva, for £11,437
(Sw. fr. 70,000)

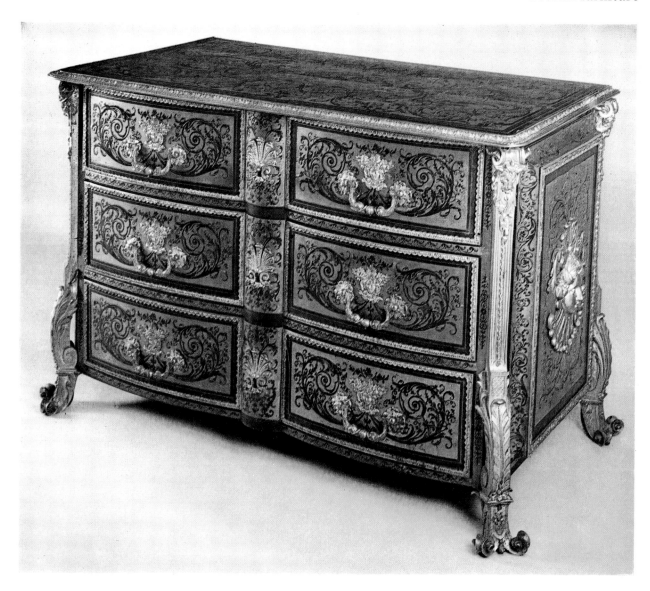

Louis XIV boulle commode
$32\frac{5}{8}$ in. (83 cm.) high, $52\frac{3}{8}$ in. (133 cm.) wide, $26\frac{3}{8}$ in. (67 cm.) deep
Sold 18.11.74 at the Hôtel Richemond, Geneva, for £16,339 (Sw. fr. 100,000)
Reputedly from the Château de Bercy, Paris

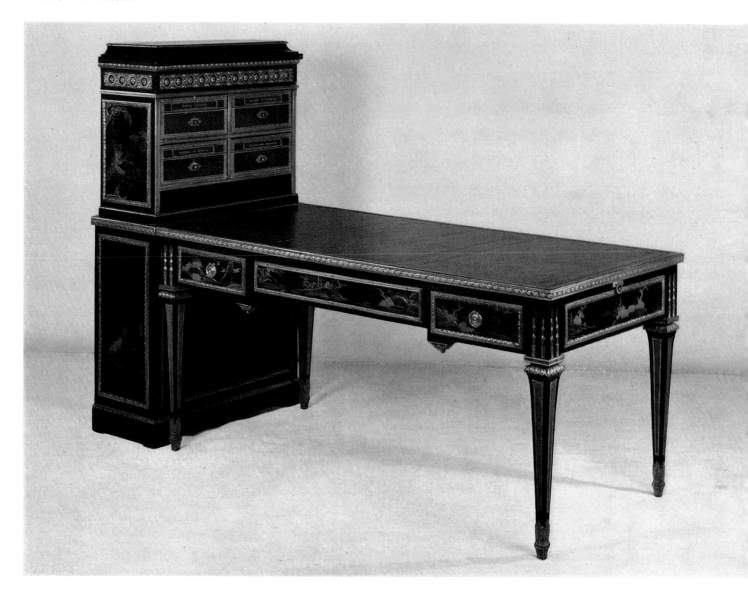

Louis XVI black lacquer and ebony bureau plat and cartonnier
By Martin Carlin
The bureau 64 × 32½ in. (163 × 82.5 cm.); the cartonnier 55½ in. (141 cm.) high, 32½ in. (82.5 cm.) wide, 13½ in. (34.4 cm.) deep
The bureau stamped once and the cartonnier twice M. CARLIN JME
Sold 3.7.75 for £157,750 ($362,825)

18th-century office furniture

Since the collecting of French 18th-century furniture became consciously antiquarian – around the beginning of the 19th century – the powerful attraction of a distinguished provenance has often equalled if not actually excelled the inherent qualities of the piece itself. The two desks illustrated here both have this attraction and furthermore constitute major additions (one previously unrecorded) to the canon of the two greatest *ébénistes* of the later 18th century.

The secretaire (see illustration page 382) represents the full flowering of Riesener's monumental style of the early 1770s with its rich combination of brilliantly executed floral marquetry and lavish sculptural ormolu mounts; the bureau plat (opposite) by contrast illustrates the sombre refinement and elegant chastity of Neo-classical taste of the mid-1780s interpreted by Carlin. Both belonged, almost certainly, to leading figures of the *ancien régime* – the secretaire to Pierre-Elisabeth de Fontanieu, *Intendant et Contrôleur-générale des meubles de la Couronne* from 1767 to 1783, delivered in 1771 at a cost of 7000 *livres*; the bureau plat to Count Nicolas-François Mollien (1758–1850), who served Louis XVI in the Treasury from the early 1780s and Napoleon as Minister from 1806. Both pieces were intended (the bureau plat more obviously than the secretaire) as office furniture – of a grandiose kind – and bear elegant testimony to the consideration given to the circumstance and practice of writing in that highly literate age.

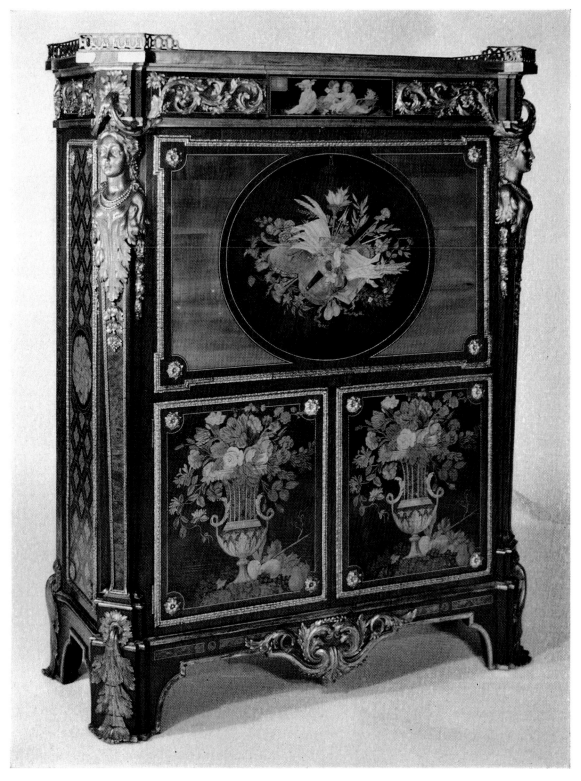

Louis XVI
secrétaire à abattant
By J. H. Riesener
56¾ in. (144 cm.) high
46¼ in. (111.5 cm.)
wide
18 in. (45.5 cm.) deep
Stamped J. H.
RIESENER four times
Sold 5.12.74 for
£47,250 ($113,400)

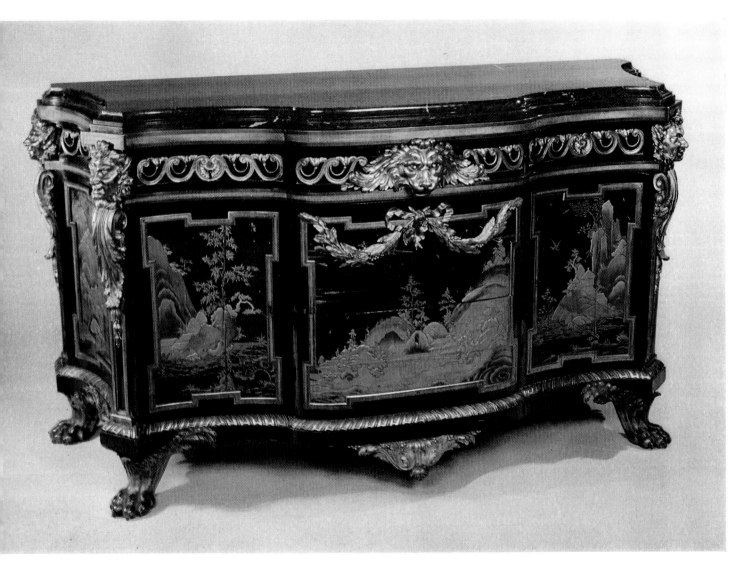

Louis XVI black lacquer and ebony commode
By J. Baumhauer, called Joseph
35½ in. (90 cm.) high, 64¼ in. (163 cm.) wide, 24¼ in. (61.5 cm.) deep
Stamped JOSEPH between fleur-de-lys four times
Sold 3.7.75 for £115,500 ($265,650)
From the collection of Edmund de Rothschild, Esq, TD

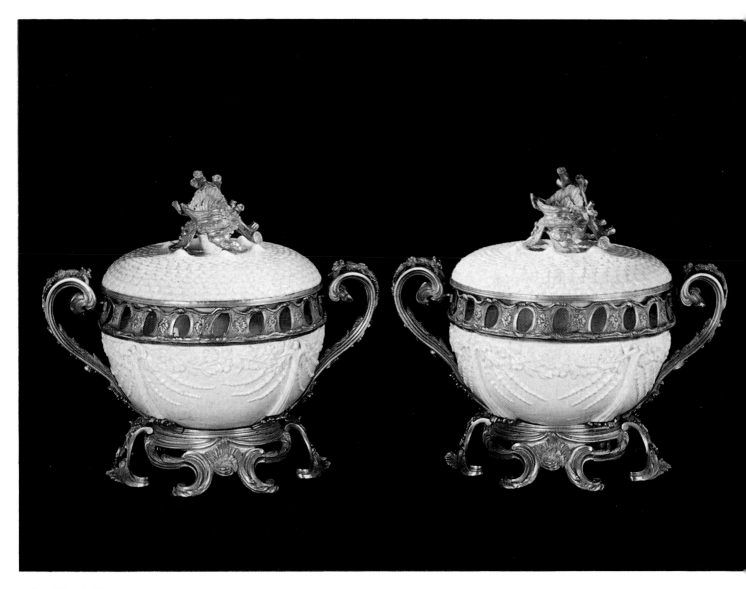

Pair of Louis XV ormolu-mounted white Meissen porcelain pot-pourri vases and covers
12½ in. (32 cm.) high, 14¼ in. (36 cm.) wide
Sold 3.7.75 for £33,600 ($77,280)
From the collection of The Lord Rothschild, GBE, GM, FRS
The porcelain appears to be an unrecorded model and may have been specially ordered for mounting in ormolu

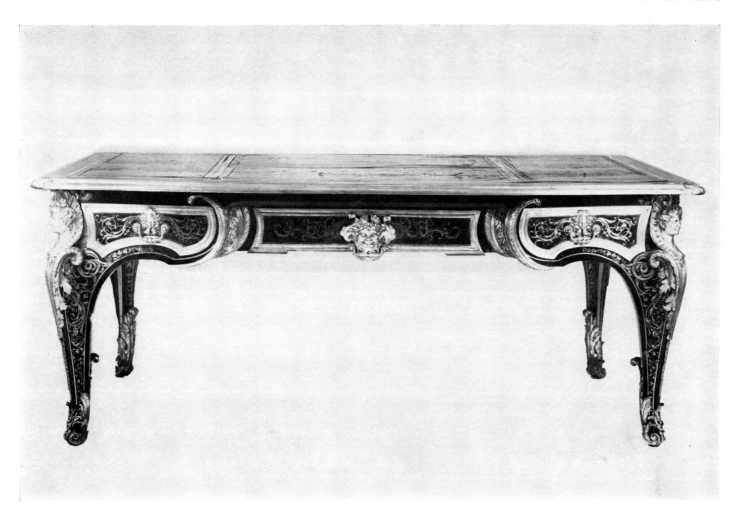

Régence boulle bureau plat
39×41 in. (99×104 cm.)
Sold 18.11.74 at the Hôtel Richemond, Geneva, for £21,242 (Sw. fr. 130,000)

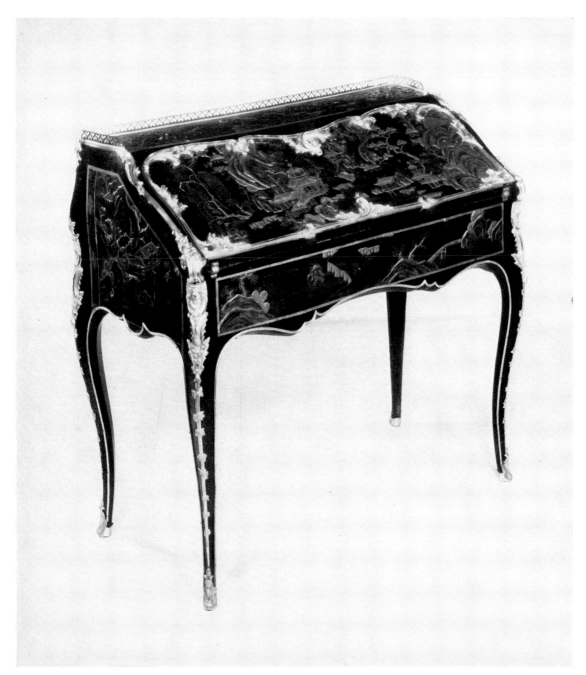

Louis XV black gold
lacquer bureau de
dame
By I. Dubois
38¼ in. (97 cm.) wide
Sold 17.4.75 for
£16,800 ($38,640)
From the collection
of The Lord
Rothschild, GBE, GM,
FRS

Louis XV kingwood and
tulipwood parquetry
commode
By P. Garnier
44 in. (112 cm.) wide
The mounts struck with the
C couronné poinçon for the
years 1745–49
Sold 3.7.75 for £14,700
($33,810)

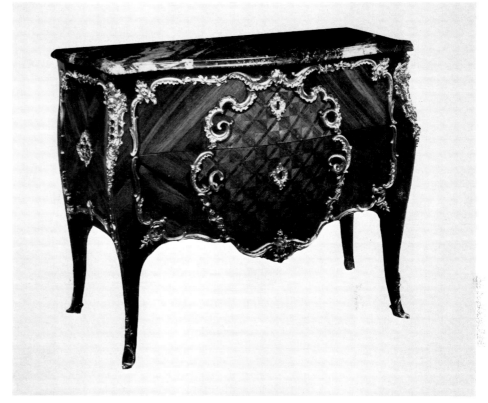

Louis XVI pictorial
marquetry commode
By C. Topino
51 in. (129 cm.) wide
23½ in. (60 cm.) deep
Sold 3.7.75 for £4725
($10,867)

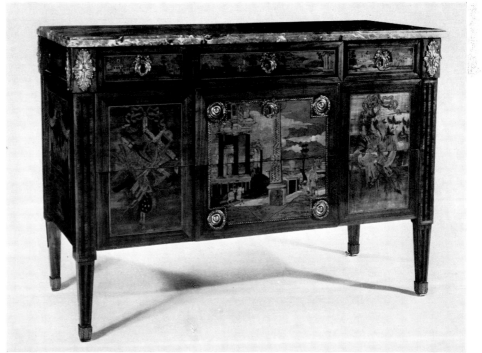

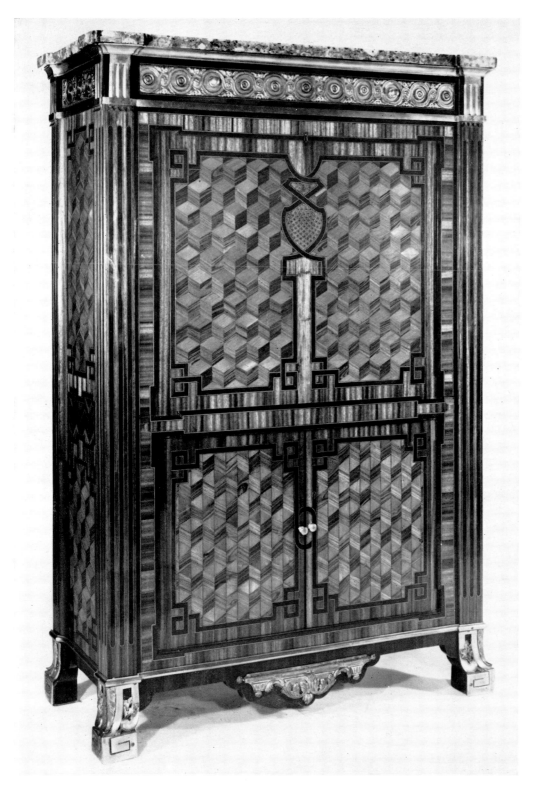

Louis XVI parquetry
secrétaire à abattant
By J. F. Oeben
57½ in. (146 cm.) high
39¼ in. (100 cm.) wide
16¾ in. (42.5 cm.) deep
Stamped J. F. OEBEN
Sold 3.7.75 for £17,850
($41,055)

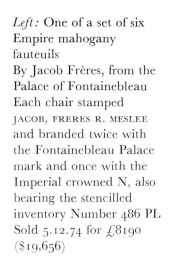

Left: One of a set of six
Empire mahogany
fauteuils
By Jacob Frères, from the
Palace of Fontainebleau
Each chair stamped
JACOB, FRERES R. MESLEE
and branded twice with
the Fontainebleau Palace
mark and once with the
Imperial crowned N, also
bearing the stencilled
inventory Number 486 PL
Sold 5.12.74 for £8190
($19,656)

Right: One of a pair of
Louis XV beechwood
fauteuils and a chair
en suite
Sold 3.7.75 for £1995
($4588)
From the collection of the
late A. V. Walker, Esq

Left: Louis XVI giltwood
fauteuil à la reine
By Delaisement
Sold 18.11.74 at the
Hôtel Richemond, Geneva,
for £3267 (Sw. fr. 20,000)

Right: One of a set of six
Austrian rococo walnut
and parcel-gilt armchairs
Formerly in the collection
of The Princess of
Liechtenstein,
Schloss Vaduz
Sold 3.4.75 for £7875
($18,112)

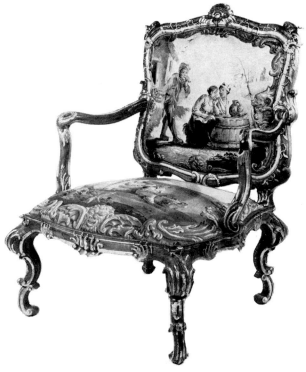

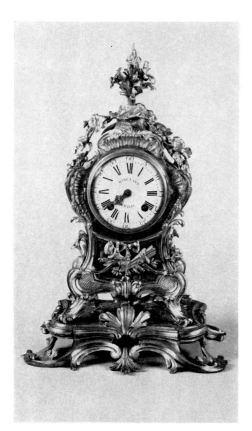

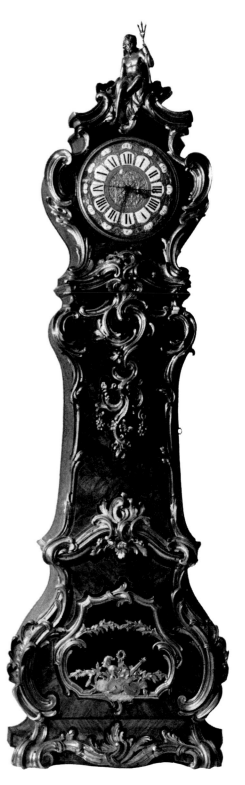

Left: Louis XV ormolu mantel clock
Signed Mangeant à Paris
17¾ in. (45 cm.) high
Sold 18.11.74 at the Hôtel Richemond,
Geneva, for £2287 (Sw. fr. 14,000)

Right: Louis XV ormolu-mounted
tulipwood and kingwood longcase
clock
90½ in. (230 cm.) high
Sold 18.11.74 at the Hôtel Richemond,
Geneva, for £4902 (Sw. fr. 30,000)

Below: Louis XV ormolu mantel
clock in the manner of J.-C. Duplessis
The movement signed Jn. Martinot
de L'Horlogerie du Palais and
J. Martinot Hgr du Roi Sept 1755
27 in. (69 cm.) high
33 in. (84 cm.) wide
Sold 3.7.75 for £6300 ($14,490)
From the collection of
Edmund de Rothschild, Esq, TD

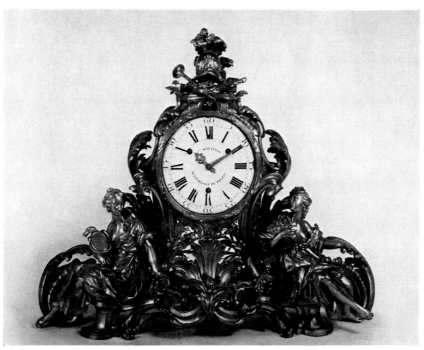

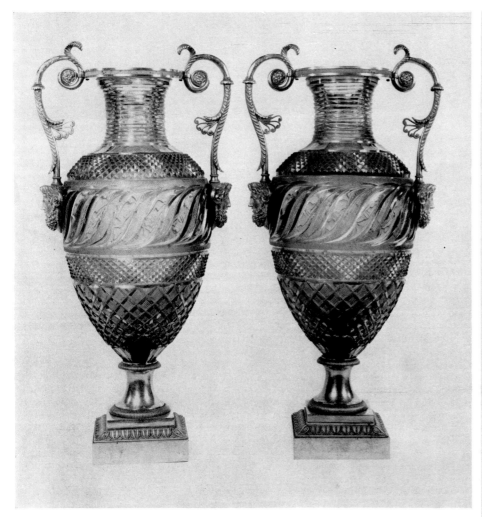

Pair of Empire ormolu-mounted glass vases
In the manner of P. P. Thomire
23½ in. (60 cm.) high
Sold 3.7.75 for £2415 ($5554)

Right: One of a pair of Louis XVI bronze and ormolu candelabra
Sold 3.7.75 for £2520 ($5796)
From the collection of Edmund de Rothschild Esq, TD

Above left: Walnut group of the Holy Family
16 in. (40.6 cm.) wide
Middle Rhine, first quarter 16th century
Sold 22.10.74 for £2730 ($6552)

Above right: Oak carving of the Agony in
the Garden
$13\frac{3}{8} \times 10\frac{5}{8}$ in. (34 × 27 cm.)
Netherlandish, late 15th century
Sold 21.7.75 for £2310 ($5082)

Left: Oak relief of the Entombment
$21 \times 24\frac{1}{2}$ in. (53.3 × 62.2 cm.)
Netherlandish, c. 1480
Sold 22.10.74 for £4725 ($11,360)

Walnut group of the Entombment
25 in. (63.5 cm.) high
Flemish, early 16th century
Sold 22.10.74 for £4410 ($10,584)

Right: Oak statue of St Mary Magdalene
31½ in. (80 cm.) high
Netherlandish, c. 1480
Sold 7.4.75 for £3990 ($9177)

Pair of South German gilt-bronze models of
mastiffs
6¾ in. (17 cm.) wide
Early 17th century
Sold 7.4.75 for £1260 ($2898)

Below: Pair of Louis XIV bronze groups of enlèvements: the
Rape of the Sabine Women after GIOVANNI BOLOGNA, and
Pluto carrying off Proserpine, with Ceres at their feet, after
FRANÇOIS GIRARDON
29¾ in. (75 cm.) and 26 in. (66 cm.) high
Sold 3.7.75 for £6510 ($14,973)

Below: WORKSHOP OF GIOVANNI BOLOGNA:
Gilt-bronze statuette of Hercules
16½ in. (42 cm.) high
Late 16th century
Sold 21.7.75 for £1995 ($4389)
From the collection of
Edmund de Rothschild Esq, TD

Carrara marble group of Ino and the
infant Bacchus
By Richard James Wyatt (1795–1850)
55 in. (140 cm.) high
Sold 17.10.74 for £6825 ($16,380)
Now in the Fitzwilliam Museum, Cambridge

Two of a set of six stained glass windows, depicting Norse gods
Designed by Sir Edward Coley Burne-Jones and made by
Morris & Company
Each in two panels, 52½ × 20 in. (133 × 51 cm.) overall
Sold 23.1.75 for £1260 ($2898)

These panels removed from No. 8 Earl's Avenue, Folkestone, were
made to designs produced by Burne-Jones in 1883 for a six-light
window for Miss Catherine Wolfe of Newport, Rhode Island. The
choice of subject was inspired by an old round tower at Newport
believed by some to be a relic of the Norse voyagers who crossed
the Atlantic c. A.D. 1000–1010

Group of mother-of-pearl objects
Sold 7.4.75 for a total of £20,680 ($47,564)
From the collection of the late Christabel, Lady Aberconway

Antique Turkish prayer rug
74 × 54 in. (188 × 137 cm.)
Late 17th century
Sold 13.1.75 for £5775 ($13,283)

Lenkoran rug
115 × 57 in. (292 × 145 cm.)
18th century
Sold 13.1.75 for £3360 ($7728)

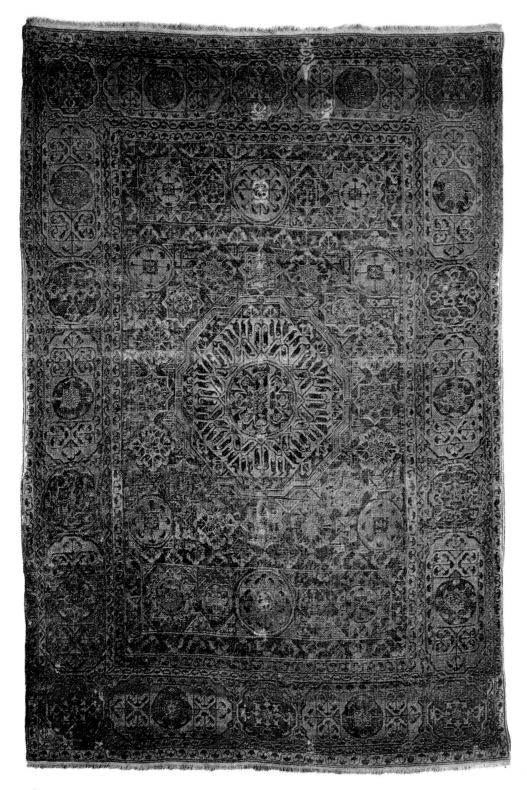

Mamluke rug
82 × 56 in. (208 × 142 cm.)
Cairo, 16th century
Sold 13.1.75 for £9450
($21,735)

'Star Ushak' carpet
159 × 86 in. (403 × 218 cm.)
First half 17th century
Sold 13.1.75 for £14,700 ($33,810)

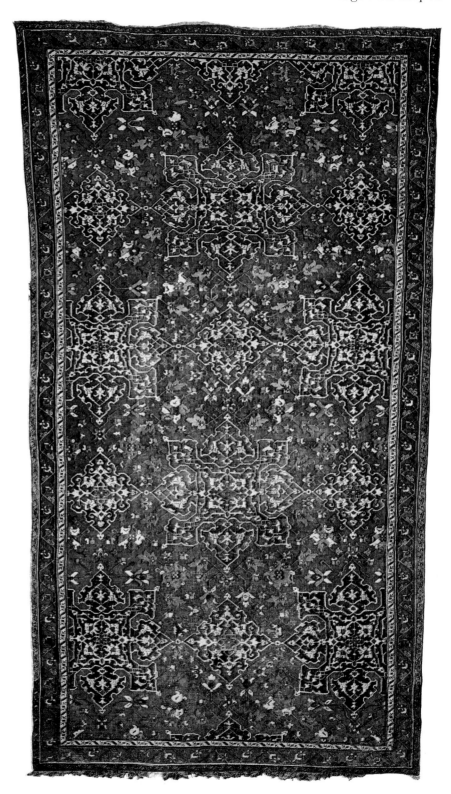

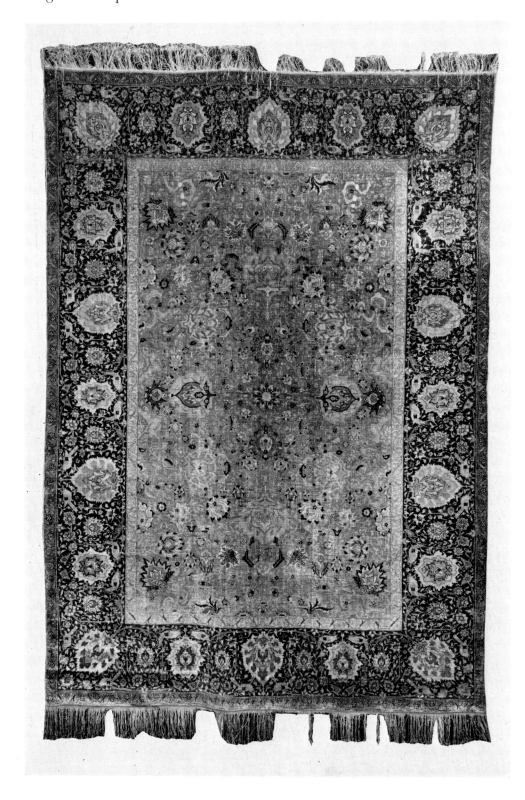

Antique silk and silver thread
embossed Koum Kapour rug
80 × 57 in. (203 × 145 cm.)
Sold 31.10.74 for £4620
($11,088)

Heriz silk rug
71 × 51 in.
(178 × 130 cm.)
Sold 17.4.75 for £4410
($10,143)

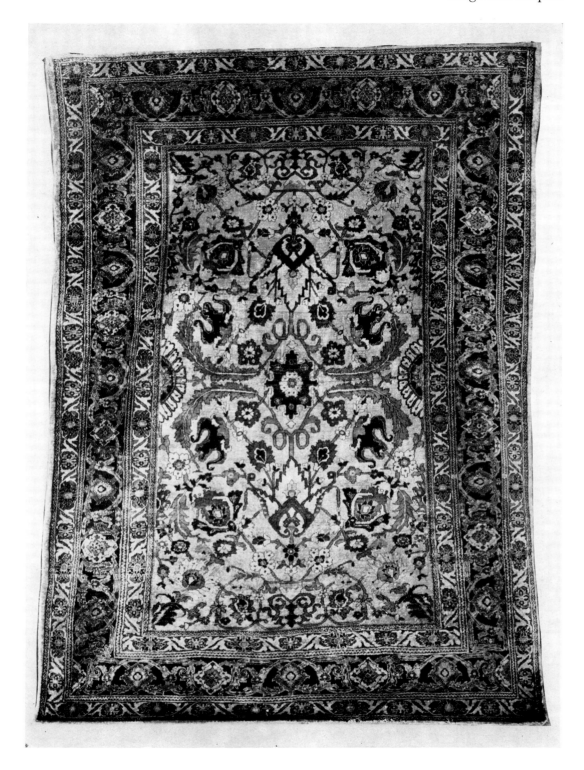

Senneh saddle cover
75 × 65 in. (191 × 165 cm.)
Kelim woven
Sold 22.5.75 for £997.50 ($2294)

Antique Verneh rug
68 × 73 in. (173 × 185 cm.)
Sold 12.6.75 for £1050 ($2415)
From the collection of the late Joseph V. McMullan

Antique Mongol saddle rug
52 × 24 in. (132 × 61 cm.)
Sold 12.6.75 for £609 ($1400)
From the collection of the late
Joseph V. McMullan

One of a set of six French
needlework grotesque panels
Four 127 × 37 in.
(322 × 94 cm.); two
128 × 84 in. (324 × 213 cm.)
Sold 10.7.75 for £4200
($9660)

Brussels tapestry from the History of Alexander, depicting the Battle of Arbela
By J. F. Van den Hecke after Le Brun
166 × 183 in. (321 × 466 cm.)
Late 17th century
Sold 17.4.75 for £4410 ($10,143)
Jean-François Van den Hecke, privileged in 1662
Probably from the collection of the Duke of Alba and Berwick

Soho arabesque tapestry
Attributed to Joshua Morris
120 × 92 in. (305 × 233 cm.)
c. 1720
Sold 10.4.75 for £4200 ($9660)
From the collection of the late W. S. Bell, Esq

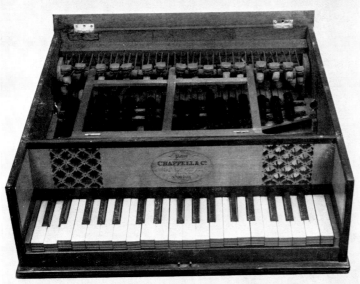

Above left: J. ZOFFANY: *Portrait of James Cervetto*
27½ × 21½ in. (69.8 × 54.6 cm.)
Sold 19.12.74 for £735 ($1691)

Above right: English keyed serpent
By Huggett
29½ in. (75 cm.) high
London, c. 1845–50
Sold 19.12.74 for £420 ($966)

Left: Pianino
By Chappel & Co
22½ in. (57 cm.) wide
c. 1830
Sold 19.12.74 for £252 ($580)
From the collection of P. N. P. Mackenzie, Esq.

Single-manual harpsichord
By Burkat Shudi and
John Broadwood
82½ in. (209 cm.) long
London, 1775
Sold 19.12.74 for £4725 ($10,868)
From the collection of
The Earl Howe, CBE

This instrument, long in the Curzon
family, is thought probably to have
descended from Elizabeth Jennens,
sister of Charles Jennens the younger,
friend and librettist of Handel.
The Jennens estates passed through
Elizabeth Jennens' grandson Penn
Assheton Curzon, to his wife Sophia
Baroness Howe, eldest daughter of
the Admiral, whose son Richard
William Penn Curzon was created
Earl Howe in 1821

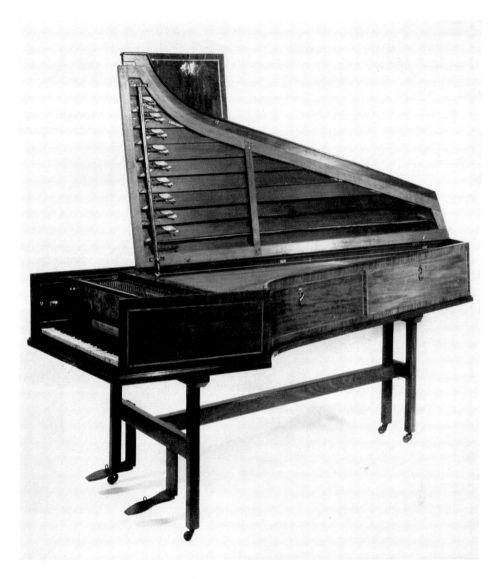

Important German
gebunden clavichord
By Georg Friedrich
Schmahl
54 in. (137.5 cm.)
wide
Ulm, 1807
Sold 19.12.74 for
£2310 ($5313)

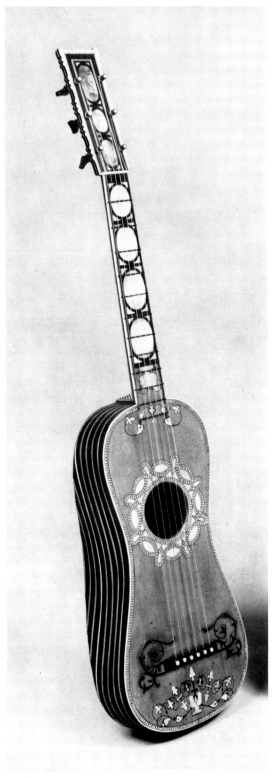

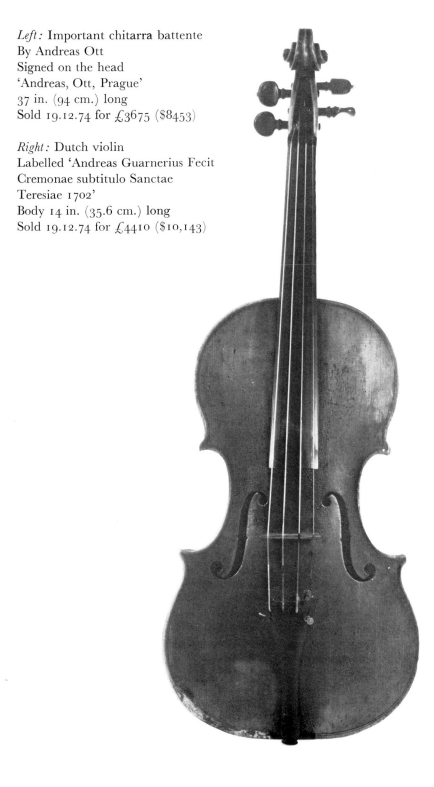

Left: Important chitarra battente
By Andreas Ott
Signed on the head
'Andreas, Ott, Prague'
37 in. (94 cm.) long
Sold 19.12.74 for £3675 ($8453)

Right: Dutch violin
Labelled 'Andreas Guarnerius Fecit
Cremonae subtitulo Sanctae
Teresiae 1702'
Body 14 in. (35.6 cm.) long
Sold 19.12.74 for £4410 ($10,143)

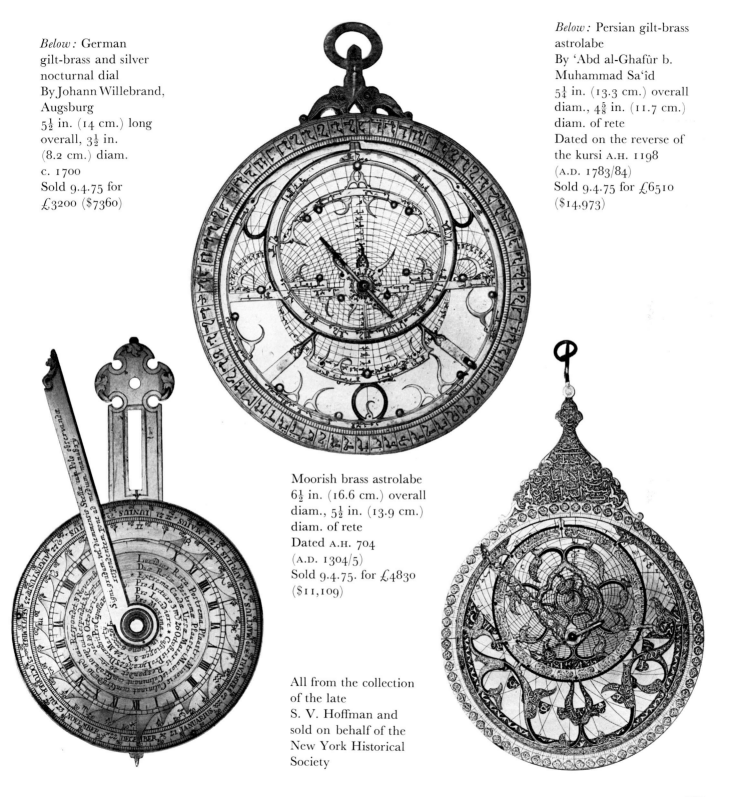

Below: German
gilt-brass and silver
nocturnal dial
By Johann Willebrand,
Augsburg
5½ in. (14 cm.) long
overall, 3¼ in.
(8.2 cm.) diam.
c. 1700
Sold 9.4.75 for
£3200 ($7360)

Below: Persian gilt-brass
astrolabe
By 'Abd al-Ghafûr b.
Muhammad Sa'îd
5¼ in. (13.3 cm.) overall
diam., 4⅝ in. (11.7 cm.)
diam. of rete
Dated on the reverse of
the kursi A.H. 1198
(A.D. 1783/84)
Sold 9.4.75 for £6510
($14,973)

Moorish brass astrolabe
6½ in. (16.6 cm.) overall
diam., 5½ in. (13.9 cm.)
diam. of rete
Dated A.H. 704
(A.D. 1304/5)
Sold 9.4.75. for £4830
($11,109)

All from the collection
of the late
S. V. Hoffman and
sold on behalf of the
New York Historical
Society

Clocks and watches

Right: Gold hunter-cased
perpetual calendar
minute-repeating keyless
lever split-seconds
chronograph watch
By Dent, 34 Cockspur Street,
London, No. 32384
Case plain (London 1922)
2⅛ in. (5.5 cm.) diam.
Sold 23.10.74 for £6300
($15,420)
From the collection of the late
M. Castel-Branco, Esq

Silver-gilt astronomical crucifix watch
By J. Troyon A. Poitiers
2½ in. (6.3 cm.) long
c. 1630
Sold 11.6.75 for £17,325 ($39,848)

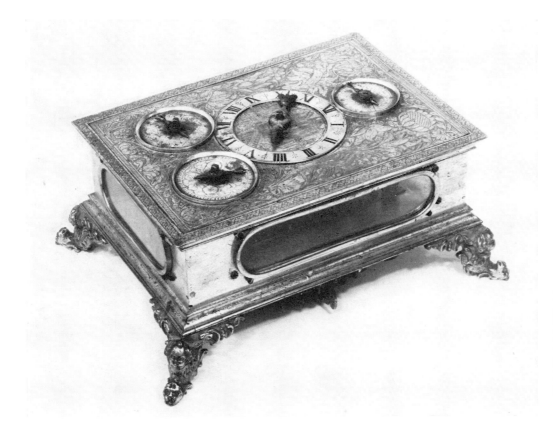

Prussian rectangular
gilt-metal table clock
By Georg. Schultz,
Königsberg
9½ in. (24.5 cm.) long overall
Mid-17th century
Sold 26.2.75 for £8400
($20,160)

Near right: German gilt-brass diptych dial 4⅛ in. (10.5 cm.) long Dated 1571 Sold 9.4.75 for £1785 ($4106)

All from the collection of the late S. V. Hoffman and sold on behalf of the New York Historical Society

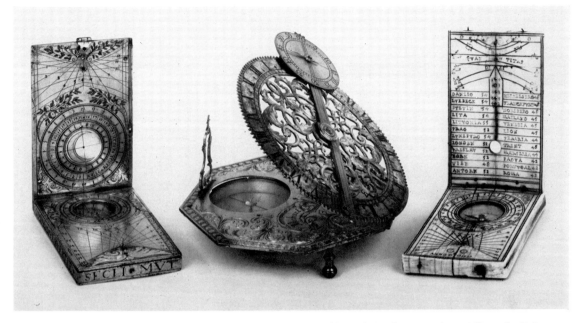

Above centre: German gilt-metal and silvered mechanical equinoctial dial 5⅛ in. (13 cm.) diam. Early 18th century Sold 9.4.75 for £1575 ($3623)

Above right: German ivory diptych dial 3½ in. (9 cm.) long Dated 1729 Sold 9.4.75 for £399 ($918)

Near right: French gilt-metal and porcelain-mounted striking carriage clock 5½ in. (14 cm.) high Sold 7.5.75 for £945 ($2173)

Centre: Large French gilt-metal striking carriage clock 7¼ in. (18.2 cm.) high Sold 7.5.75 for £714 ($1642)

Far right: French gilt-metal and porcelain-mounted striking carriage clock 6⅝ in. (16.7 cm.) high Sold 7.5.75 for £1050 ($2415)

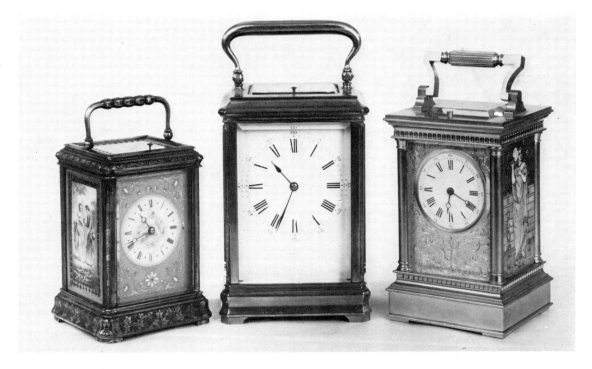

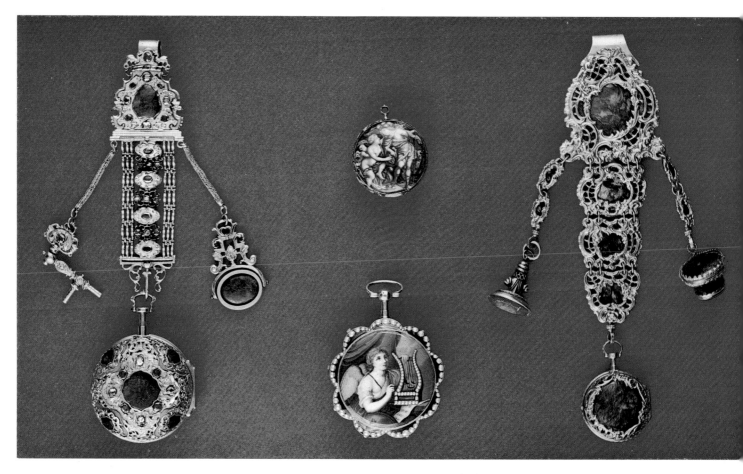

Gold and stone-set quarter-repeating
verge watch and chatelaine
The movement signed
Arned, London
2 in. (5 cm.) diam.
c. 1740
Sold 29.4.75 at the Hôtel
Richemond, Geneva, for £7000
(Sw. fr. 42,000)

Enamelled gold watch case
Signed Huaud Lepuisné fecit
1¾ in. (3.7 cm.) diam.
The case c. 1685
Sold 29.4.75 at the Hôtel
Richemond, Geneva, for £2833
(Sw. fr. 17,000)

Swiss gold and enamel
quarter-repeating verge watch
2⅛ in. (5.4 cm.) diam.
c. 1800
Sold 29.4.75 at the Hôtel
Richemond, Geneva, for £5833
(Sw. fr. 35,000)

Gold and agate-cased verge watch
and chatelaine
7¼ in. (18.5 cm.) long overall
Mid-18th century
Sold 29.4.75 at the Hôtel
Richemond, Geneva, for £2833
(Sw. fr. 17,000)

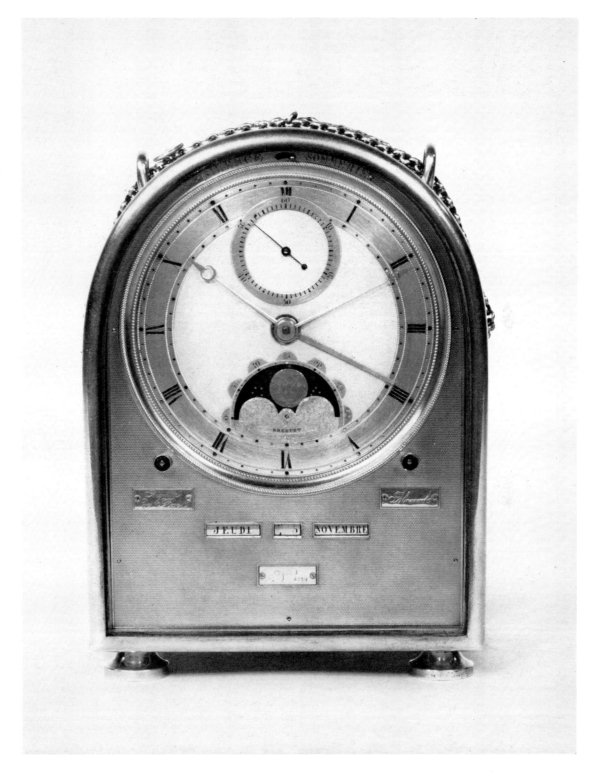

Silver cased grande
sonnerie carriage
clock with calendar
By Breguet No. 4529
Sold 26.2.76 for
£15,225 ($37,800)
From the collection
of The Lord
Ashburton, KG, KCVO
Record auction price
for a carriage clock

Louis XVI ormolu régulateur de table
By Lepaute Hger. Du Roi
20 in. (51 cm.) high
Sold 11.6.75 for £4410 ($10,143)
Sold on behalf of the Trustees of The Lord Hillingdon

French Empire pendule squelette
Signed Breguet
19¼ in. (49 cm.) high
Sold 11.6.75 for £2520 ($5796)
From the collection of The Lord Hillingdon

MODERN
SPORTING GUNS,
ARMS AND
ARMOUR

Modern sporting guns

CHRISTOPHER BRUNKER

Detail from a pair of 12-bore
sidelock ejector guns
By Boss, built in 1904
Sold 9.7.75 for £5775 ($13,282)

The engraved decoration of most British sporting guns tends towards uniformity. Makers have their individual patterns and styles, but most designs are based on scrollwork combined with formal foliate and floral motifs, usually executed in relatively shallow, fine lines. Iron and steel, unlike wood, have no apparent natural figuration and, unless decorated, the action and furniture of a gun would appear severely plain in comparison with its stock. Standard engraving is not intended to be a conspicuous feature, therefore, but a means of harmonizing contrasting materials.

The gun illustrated above, engraved with game scenes based on Thorburn drawings published in *The Encyclopaedia of Sport* (1897), shows that a more decorative effect can be produced when desired. The gun-engraver was probably Sumner, but it is frustrating that such fine workmanship can not be positively identified and that so little information is available on the engravers who worked in or for the gun trade. Very few signed their work, but an important exception in the present is K. C. Hunt, whose reputation rightly complements that of the gunmaker. A Holland gun engraved by him is included in the examples below.

As shooting is a relatively expensive sport, the market for guns is bound to be affected by the general economic climate and the past year saw some decline in demand, especially for guns in less than very good condition. In the circumstances, however, the season was most successful and the sales total slightly exceeded the record turnover of the more buoyant preceding year. The following are examples of prices obtained in 1974–75. All these guns were double-barrelled hammerless, unless otherwise noted, and barrel and chamber lengths are shown thus: '28/2½ in.'.

	\pounds	$ US
Pairs of sidelock ejector guns		
BOSS 12-bore, Nos. 7539/40, $29/2\frac{3}{4}$ in.	5250	12,075
EVANS (W) 12-bore, Nos. 14380/1, $30/2\frac{1}{2}$ in.	2625	6037
GRANT (S) 12-bore, Nos. 7778/9, with extra barrels by Boss, $28/2\frac{1}{2}$ in.	3360	7728
HOLLAND & HOLLAND 12-bore 'Royal', Nos. 27737/8, $30/2\frac{1}{2}$ in.	3360	7728
PURDEY (J) 12-bore, Nos. 27583/4, $28/2\frac{1}{2}$ in.	5775	13,282
WESTLEY RICHARDS 20-bore, Nos. T10224 & 10654, $28/2\frac{1}{2}$ in.	3990	9177
Sidelock ejector guns		
ATKIN (H) 16-bore 'Spring-Opener', No. 3303, $26\frac{3}{4}/2\frac{1}{2}$ in.	1890	4347
BOSS 12-bore, No. 6342, $29/2\frac{1}{2}$ in.	2205	5071
BOSS 12-bore over-and-under, No. 7293, $28/2\frac{3}{4}$ in.	5775	13,282
CHURCHILL (EJ) 12-bore 'Imperial XXV', No. 5523, $25/2\frac{1}{2}$ in.	1575	3622
DICKSON (J) 12-bore side-opening over-and-under, No. 7540, $28/2\frac{3}{4}$ in.	6825	15,697
HOLLAND & HOLLAND 12-bore 'Modèle de luxe', No. 36526, with game-engraving by K. C. Hunt, $28/2\frac{3}{4}$ in.	3150	7245
HOLLAND & HOLLAND 12-bore 'Royal', No. 33144, $28/2\frac{1}{2}$ in.	2730	6297
HOLLAND & HOLLAND 12-bore 'Badminton', No. 34065, $28/2\frac{1}{2}$ in.	2100	4830
POWELL (W) 12-bore, No. 15659, $26/2\frac{1}{2}$ in.	1680	3864
PURDEY (J) 12-bore, No. 25259, $28/2\frac{1}{2}$ in.	2520	5796
PURDEY (J) 12-bore, No. 17845, $30/2\frac{1}{2}$ in.	2100	4830
PURDEY (J) 20-bore under-and-over, No. 27476, $26/2\frac{3}{4}$ in.	6510	14,973
Pairs of boxlock ejector guns		
CHURCHILL (EJ) 12-bore 'Utility XXV', Nos. 4727/8, $25/2\frac{1}{2}$ in.	1680	3864
CHURCHILL (EJ) 12-bore 'Regal XXV', Nos. 8602/3, $25/2\frac{3}{4}$ in.	1365	3139
COGSWELL & HARRISON 12-bore, Nos. 41201 & 41214, $30/2\frac{1}{2}$ in.	735	1690
LANG (J) 12-bore, Nos. 18732/3, $28/2\frac{3}{4}$ in.	840	1932
Boxlock ejector guns		
CHURCHILL (EJ) 20-bore 'Utility XXV', No. 5628, $25/2\frac{3}{4}$ in.	546	1256
COGSWELL & HARRISON 12-bore 'Konor', No. 70431, $26/2\frac{3}{4}$ in.	504	1159
EVANS (W) 20-bore, No. 18532, $26/2\frac{3}{4}$ in.	462	1063
GREENER (WW) 12-bore, No. 68945, $26/2\frac{1}{2}$ in.	546	1256
HELLIS (C) 12-bore 'Featherweight', No. 3469, $28/2\frac{1}{2}$ in.	504	1159
MARTIN (A) 12-bore, No. H21065, self-opening action, $28/2\frac{1}{2}$ in.	336	773
WESTLEY RICHARDS 12-bore, No. 09665, selective single-trigger, $28/2\frac{1}{2}$ in.	651	1497
WESTLEY RICHARDS 28-bore, No. 15926, rebarrelled by Atkin, $28/2\frac{3}{4}$ in.	840	1932
Hammer and multi-barrelled guns		
DOBSON & ROSSON 8-bore hammer, No. 1445, $35\frac{1}{2}/3\frac{1}{4}$ in. (Black Powder)	504	1159
LANCASTER (C) 'Patent Four Barrel' 16-bore, No. 5089, $28/2\frac{1}{2}$ in.	1680	3864
PURDEY (J) 12-bore hammer, No. 16123, rebarrelled, $28/2\frac{1}{2}$ in.	997	2294
POWELL (W) 4-bore hammer, No. 12642, $42/4$ in.	1050	2415
WESTLEY RICHARDS 'Patent Three Barrel' 16-bore, No. 17272, $28/2\frac{1}{2}$ in.	7140	16,422
WOODWARD (J) 12-bore hammer, No. 4202, $29/2\frac{3}{4}$ in.	525	1207
Double-barrelled hammerless ejector rifles		
HOLLAND & HOLLAND .458 (Win. Mag.) 'Royal', No. 35461	5250	12,075
HOLLAND & HOLLAND .375 (Mag.) 'Modèle de luxe', No. 35325, with telescope	4725	10,867
PURDEY (J) .400 (3 in.) sidelock, No. 22074	1050	2415
RIGBY (J) .470 'Class C' boxlock, No. 17978	1470	3381

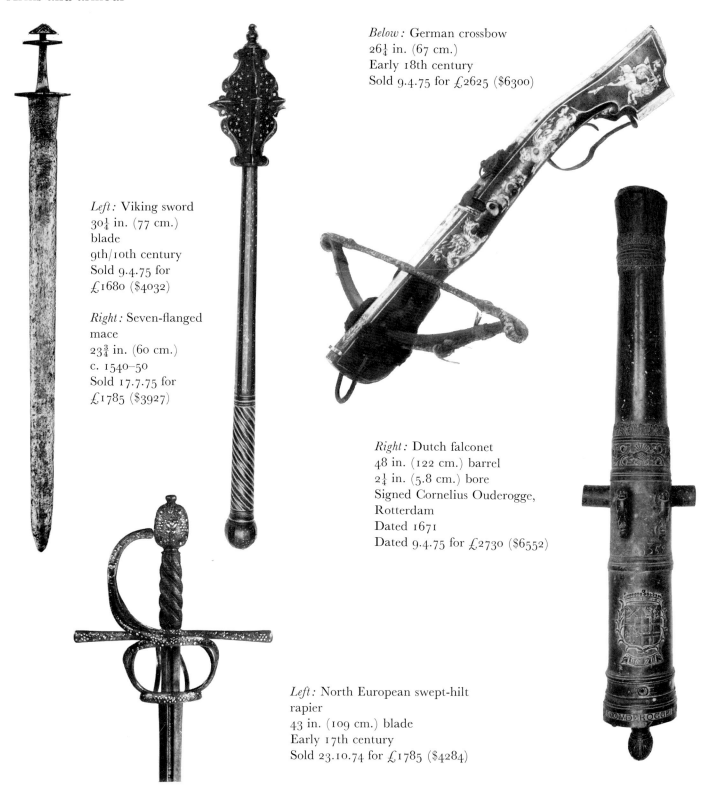

Left: Viking sword
30¼ in. (77 cm.)
blade
9th/10th century
Sold 9.4.75 for
£1680 ($4032)

Right: Seven-flanged
mace
23¾ in. (60 cm.)
c. 1540–50
Sold 17.7.75 for
£1785 ($3927)

Below: German crossbow
26¼ in. (67 cm.)
Early 18th century
Sold 9.4.75 for £2625 ($6300)

Right: Dutch falconet
48 in. (122 cm.) barrel
2¼ in. (5.8 cm.) bore
Signed Cornelius Ouderogge,
Rotterdam
Dated 1671
Dated 9.4.75 for £2730 ($6552)

Left: North European swept-hilt
rapier
43 in. (109 cm.) blade
Early 17th century
Sold 23.10.74 for £1785 ($4284)

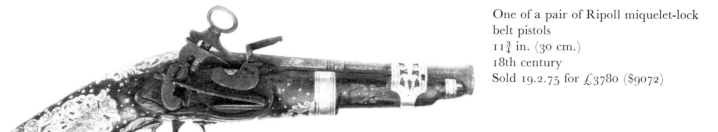

One of a pair of Ripoll miquelet-lock
belt pistols
11¾ in. (30 cm.)
18th century
Sold 19.2.75 for £3780 ($9072)

One of a pair of flintlock turn-off pistols
12 in. (30.5 cm.)
By B. Brooke, London, c. 1720
Sold 19.2.75 for £1260 ($3024)

From the collection of the late
Ian Glendenning and illustrated
in his book *British Pistols and
Guns 1640–1840*

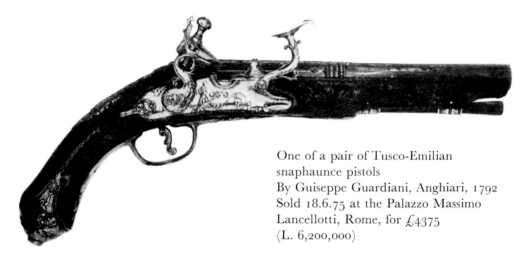

One of a pair of Tusco-Emilian
snaphaunce pistols
By Guiseppe Guardiani, Anghiari, 1792
Sold 18.6.75 at the Palazzo Massimo
Lancellotti, Rome, for £4375
(L. 6,200,000)

German self-spanning wheel-lock
mechanism
12 in. (30.5 cm.)
c. 1550
Sold 19.2.75 for £1050 ($2520)

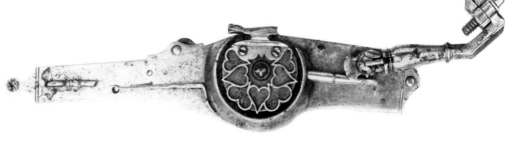

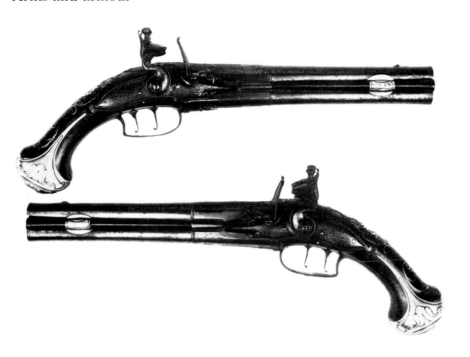

Pair of silver-mounted
over-and-under flintlock pistols
16¼ in. (41.3 cm.)
By William Turvey, London, c. 1730
Sold 23.10.74 for £10,500 ($25,200)
From the collection of
Capt. A. J. Whitehead

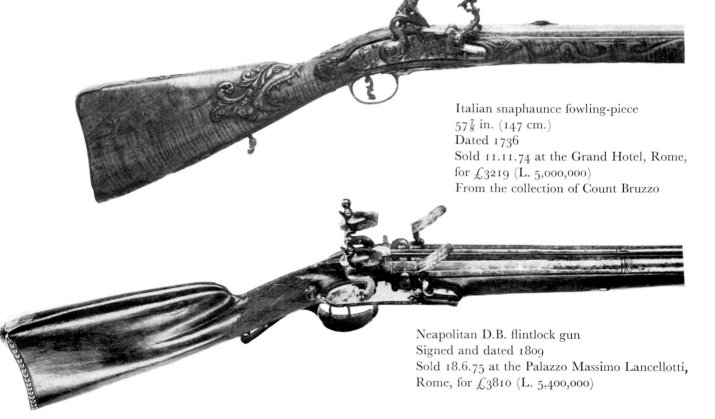

Italian snaphaunce fowling-piece
57⅞ in. (147 cm.)
Dated 1736
Sold 11.11.74 at the Grand Hotel, Rome,
for £3219 (L. 5,000,000)
From the collection of Count Bruzzo

Neapolitan D.B. flintlock gun
Signed and dated 1809
Sold 18.6.75 at the Palazzo Massimo Lancellotti,
Rome, for £3810 (L. 5,400,000)

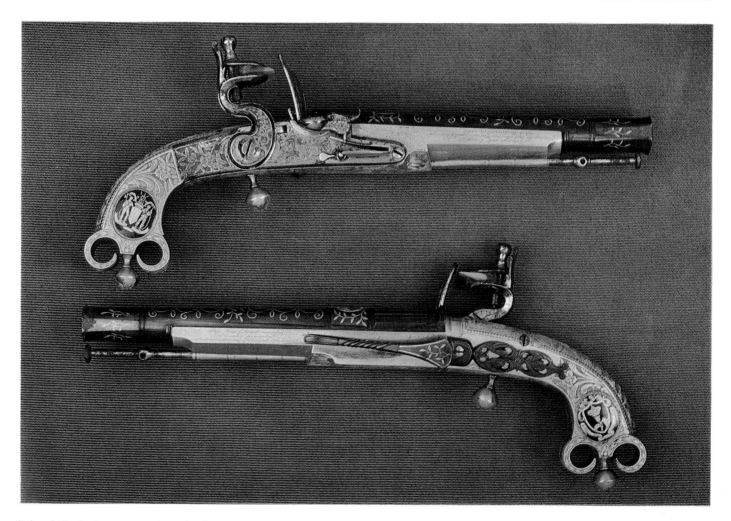

Pair of flintlock presentation pistols
12½ in. (31.8 cm.)
Signed Murdoch, London proof marks, c. 1780–85
Sold 9.4.75 for £27,300 ($65,520)

These pistols were presented to Lord Amherst by the officers of the 71st Foot (Frasers Highlanders) 'most of whom had serv'd & many of whom had bled serving their most Glorious King and Country In a Victorious Army led by his Lordship to Success & Conquest During the Last Glorious War in North America which terminated in 1763'.

Jeffrey, Baron Amherst was chosen by Pitt to command the expedition, 14,000 strong, which set sail in 1758 and succeeded in capturing French North America by September 1760. He was at once appointed Governor-General and was made Knight of the Bath in 1761. He became officiating commander-in-chief of British forces in 1772 and was created Baron Amherst in 1776.

The pistols belong to a small group of extremely elaborate weapons with copper-gilt stocks which were possibly produced in London, despite their traditional Scottish design and the Murdoch signature on the locks. Some six pairs are recorded, including a pair at Windsor Castle and another pair, undoubtedly the finest, sold at Christie's in June 1960, presented to General Sir Henry Clinton, but perhaps made originally for George III

A pair of French presentation pistols

The important pair of pistols illustrated opposite were presented to Joseph-César de Bourayne by the traders of the island of Mauritius for his capture of the frigate *Laurel* and the raising of the British blockade of the island in 1808. Bourayne subsequently manned the *Laurel* with a French crew and inflicted serious losses on British trade in the Indian and China seas before being captured in 1809 and sent as a prisoner to England, where he remained until 1814. He was one of the very few sailors to have been raised to the nobility under the *ancien régime* and he died a Major-General, Chevalier de St Louis and Commander of the Légion d'Honneur in 1817.

The pistols, which had remained in the family until their sale, are signed 'Boutet Directeur Artiste, Manufacture à Versailles' in script on the inside of the locks and under the barrels, leaving the outer surfaces free for gold decoration. They bear solid gold mounts decorated in relief with Empire and marine motifs. The stocks are inlaid with gold wire and engraved vari-coloured gold sheet, and the pre-Revolutionary form of the pistols is refreshingly different from the standardized design of most of the *armes de luxe* produced at Boutet's Versailles factory.

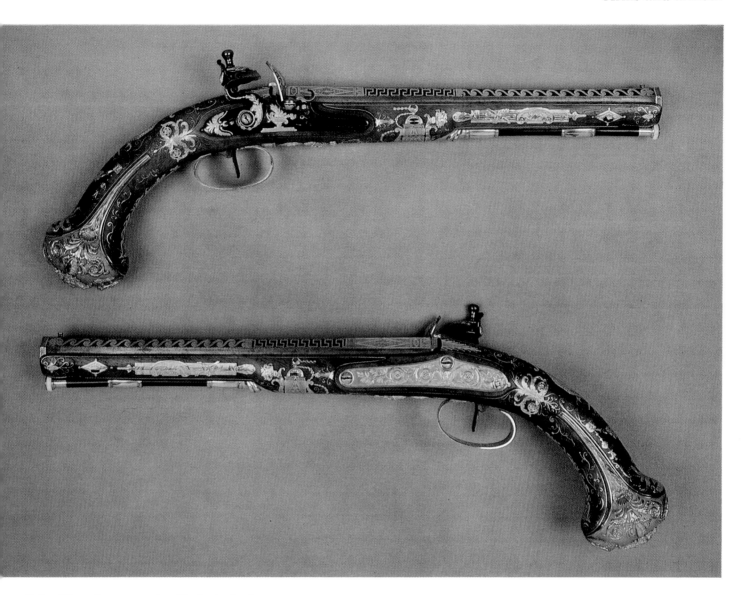

Pair of French presentation flintlock pistols
17¼ in. (43.8 cm.)
Sold 18.12.74 for £31,500 ($72,450)
From the collection of Baron de Bourayne

Napoleon's gunmaker

Cased French double-barrel flintlock gu
29½ in. (75 cm.) barrels
By Le Page, Paris, 1807
Sold 14.5.75 for £25,200 ($57,960)
Sold on behalf of the Trustees
of The Nostell Settled Estate

In the absence of complete Le Page records the exact history of this gun is unlikely to come to light, but it was acquired in Paris in the 1820s by Charles Winn, ancestor of the present 4th Baron St Oswald, and is believed, according to family tradition, to have belonged to Napoleon. The gun is dated 1807 and stamped with the serial number 946. This number falls within a series of orders executed either for Napoleon himself or for members of his entourage. Jean Le Page was appointed Arquebusier du Roi under Louis XVI and became gunmaker to Napoleon after the change of régime. According to the Versailles contract he was responsible for production of the Emperor's shoulder arms, while Boutet was responsible for pistols.

Unusually lavish for Le Page, the gun has lost none of the precision of the wood-carving or the sharpness of the neo-classical decoration of the silver mounts against their gilt ground, for it remains today in unfired state.

VETERAN AND
VINTAGE CARS
AND MODELS

1929 Rolls-Royce
40–50 h.p. Phantom I
seven-seater coupé
Coachwork by
Letourneur et
Marchand, Paris
Sold 20.3.75 at the
Palais des Expositions,
Geneva, for
£12,121
(Sw. fr. 72,000)
From the collection
of E. Suenson, Esq

1931 Alfa-Romeo
1750GS 5th series
sports two-seater
Coachwork by
Zagato, Milan
Sold 10.7.75 for
£17,500 ($40,250)

1933 Rolls-Royce
40–50 h.p. Phantom
II four-door
Continental Berlin
sport
Coachwork by
Thrupp & Maberly
London
Sold 20.3.75 at the
Palais des Expositions,
Geneva, for
£16,835
(Sw. fr. 100,000)

1937 Railton 28.8
h.p. straight eight
light sports
two-seater
Sold 10.7.75 for
£4000 ($9200)

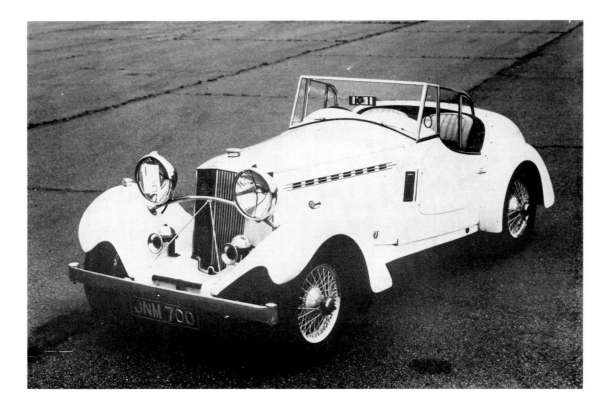

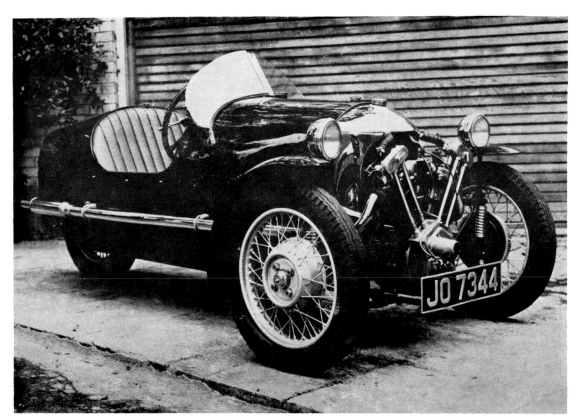

1933 Morgan
1100 c.c. super sports
two-seater
Sold 10.7.75 for
£2600 ($5980)

Below: 1948
Talbot-Lago T26C
4-litre Grand Prix
racing single-seater
Sold 20.3.75 at the
Palais des Expositions,
Geneva, for
£15,993
(Sw. fr. 95,000)

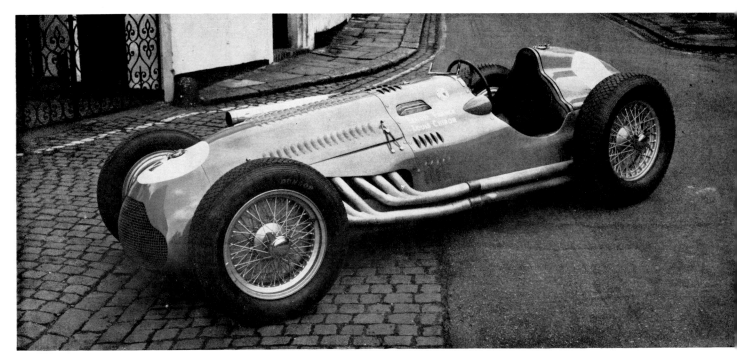

1930 Bentley
6½-litre speed six
foursome drophead
coupé
Coachwork by H. J.
Mulliner, London
Sold 10.7.75 for
£15,000 ($34,500)

Below: 1931 Bentley
8-litre replica sports
tourer
Coachwork by
Elmdown Vintage
Automobiles,
Ramsbury
Sold 10.7.75 for
£17,250 ($39,675)
From the collection
of The Lord
Cranworth

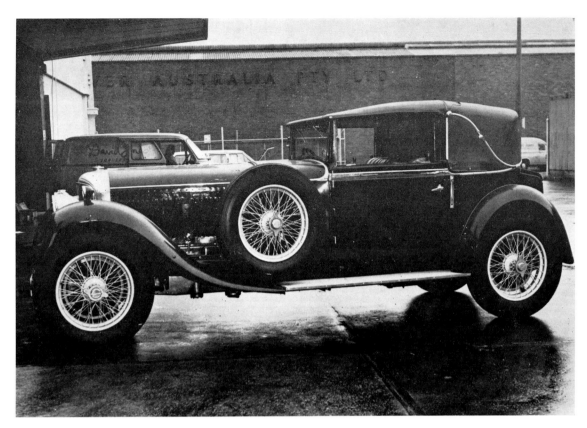

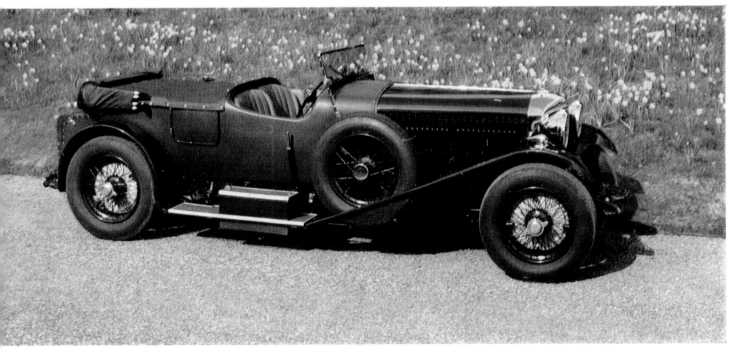

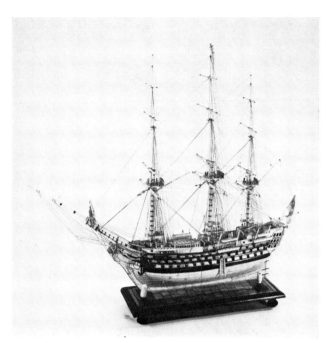

Bone, ivory and horn contemporary fully rigged French
prisoner-of-war model of a 126-gun man-o'-war
26 × 28 in. (66 × 71 cm.)
Sold 28.5.75 for £5775 ($13,282)

Below : The Royal Naval Steam Cutter No. 463
Built by J. Samuel White of Cowes in May 1899 and allocated
to the Royal Yacht *Victoria and Albert* in July 1901
Length overall 32 ft. (9.75 cm.), beam 7 ft. (2.13 m.)
Draft 2 ft. 5 in. (0.74 m.)
Displacement 4.4 tons (4470 kg.), speed 8.33 knots at 485 r.p.m.
Sold 6.11.74 for £6000 ($13,800)
Now the property of the Maritime Trust

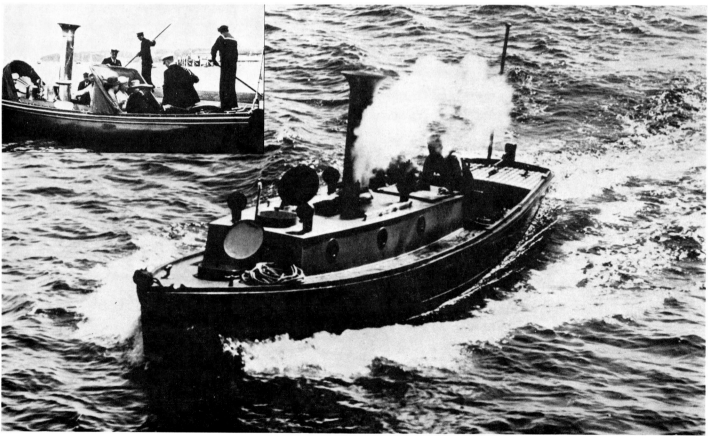

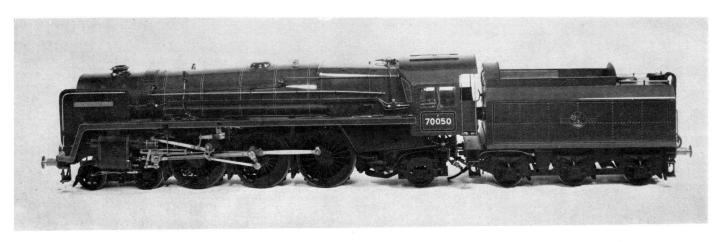

5 in. gauge model of the British Railways 'Britannia' class 4–6–2 locomotive and tender No. 70050 'Firth of Clyde'
Built by F. Barber of Poole, Dorset
13½ × 74 in. (34 × 188 cm.)
Sold 6.11.74 for £7875 ($18,900)

Below: Hand-built 1/12th scale model of the 3-litre 1926/27 Le Mans Bentley 'Old No. 7'
5 × 14 in. (12 × 36 cm.)
Sold 28.5.75 for £682.50 ($1569)

This 3-litre Bentley crashed twenty minutes before the finish of the 1926 Le Mans 24-hour Grand Prix d'Endurance when lying third. In 1927, the same car, bearing no. 3, won the Le Mans Race at an average speed of 61.35 m.p.h. after being involved in the White House Corner crash. On both occasions the drivers were Dr J. D. Benjafield and S. C. H. Davies. The car became known thereafter as 'Old No. 7'

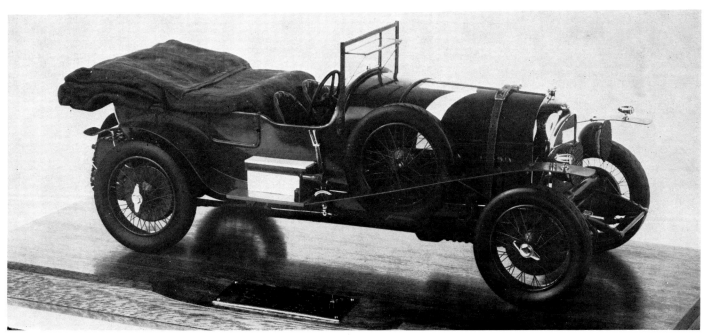

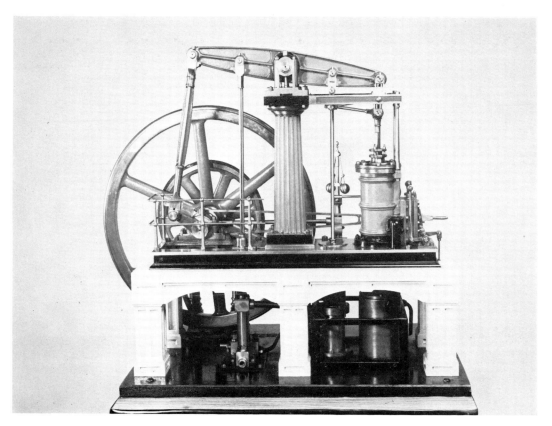

Exhibition single-cylinder centre pillar condensing rotative beam engine
By H. Booth of Bingley
19 × 22 in. (48 × 56 cm.)
Sold 6.11.74 for £1365 ($3139)

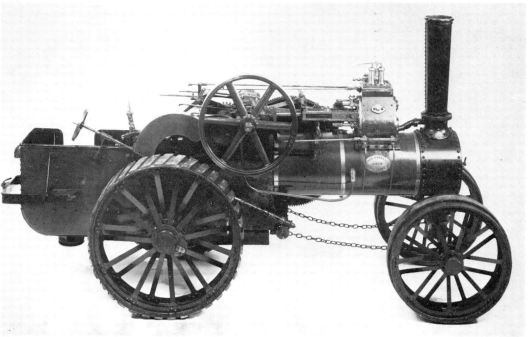

3 in. scale model of a Burrell 'Universal' single-crank compound two-speed four-shaft side-drum ploughing engine
Built by G. Woodcock
35 × 66 in. (89 × 168 cm.)
Sold 6.11.74 for £2047 ($4914)

PHOTOGRAPHICA, TOYS, DOLLS, TEXTILES AND STAMPS

Quality cameras

None of the cameras shown opposite are of particularly rare types, but they are all exceptional in terms of quality and condition. The tail-board camera at the top left was made by Henry Park for Whiteley's of Bayswater, and exhibits his penchant for figured wood. To the right is quite the finest example of the ubiquitous half plate field camera we have seen. The workmanship is that of Quaker master camera builder George Hare. Centre left, a tropical model of the long lived (1900–39) and popular Sanderson hand-and-stand camera. Below, a roll-film 'Delta', probably by Kruegener. The large camera in the centre is a fine teak tropical Contessa Nettel, still perfect after over 50 years, and much sought after. Finally, a nice example of what was probably the very first really successful pocket camera, the Shew Eclipse of 1883. This company was in the business of building cameras as early as the 1840s and its products are a collecting subject on their own.

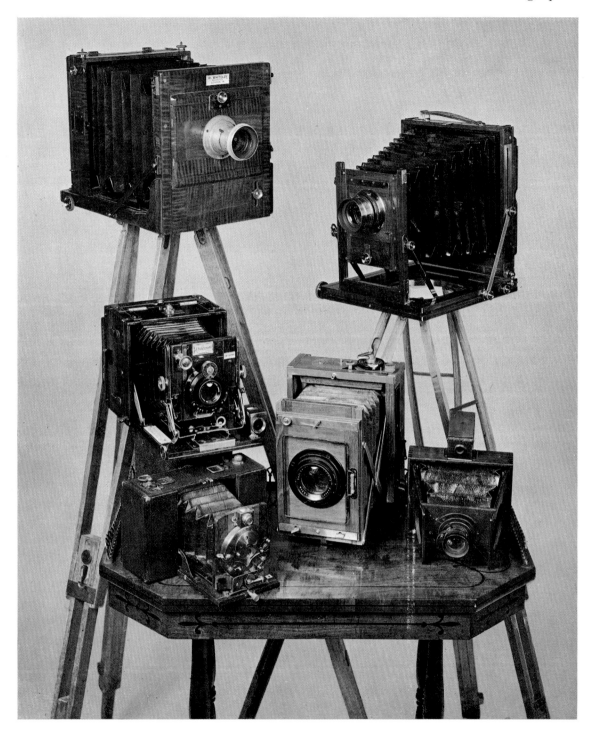

A growing new field

EDWARD HOLMES

The collection of photographica is but a recent addition to the range of subjects catered for at King Street. Now, after the first three years, it is interesting to review the way this activity has developed.

Initially the number of collectors in this country was small, and the documentation of the subject was scant, but it quickly became apparent that the potential interest was very considerable, as was evidenced by the many and searching questions that one had to answer on viewing days.

Quite the most commonplace camera to be made and sold in the 19th century is the half plate mahogany field camera. Almost every maker included his own versions of the instrument in his lists, and the variation of quality and price was very considerable. But irrespective of original price, their quality can be assessed either technically or in terms of the quality of their workmanship. Yet in the earlier sales they were bid for and bought as though there was little or nothing to choose between them, and the only factor which seemed to count was present condition. It is a healthy and encouraging sign that, as sale has followed sale, collectors have become far more discriminating and the better work of such makers as George Hare, Thomas Ross, Henry Park, Shew, and several others is now recognized and sought after, with a consequent encouraging improvement in prices.

Some collectors who started their collections with purchases at our earlier sales have specialized in the work of particular makers, and have not been slow to share the results of their researches.

What might be termed the cameras curiosa – though almost without exception they represent no more than an interesting by-way in photographic history – always excite the interest of collectors. These range from such technical tours de force as the Sigriste of 1898, and the Dubroni cameras of three decades earlier, to such oddities as the Demon – 'the wonder of the world' – and the Presto, in which the simple shutter was cocked by turning the camera on to its back. Perhaps the most elegant item of this sort to pass through Christie's hands was the delightful little Skaife metal miniature, which sold for £5250 ($12,600) in October 1974. All curiosa in the camera field are sought after, and those which come to light are often in excellent condition, mainly,

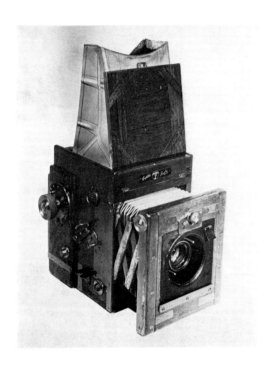

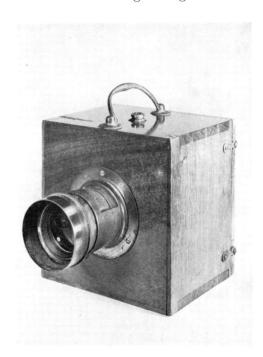

Left: Probably the finest camera ever produced by Thornton Pickard – the 'Duplex Ruby'. A tropical model, it has built-in facilities for taking pictures equal in size to the object photographed Sold 24.7.75 for £230 ($506)

Right: Fine example of the large 'Dubroni' (the name is an anagram of the maker's Bourdin). The chemistry of photography with this camera all took place within its earthenware lined body Sold 24.7.75 for £950 ($2090)

The 'Sigriste'. The inventor, Swiss artist Guido Sigriste was deeply interested in analysing the movements of horses, and perfected this instrument for the purpose. It had a top shutter speed of 1/10,000th of a second Sold 24.7.75 for £1500 ($3300)

A fine tropical 'Una' by Sinclair, in Spanish mahogany. One of the most aesthetically appealing cameras ever made Sold 24.7.75 for £320 ($704)

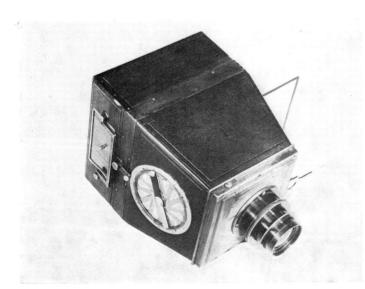

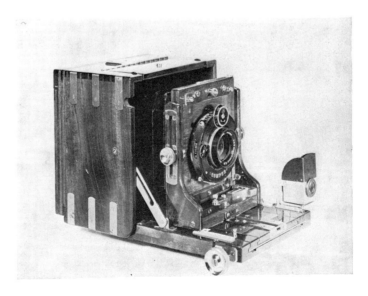

A growing new field

I suppose because they were seldom subjected to really hard use, either because they were highly specialized, or to be perfectly frank, because they were not really very practical as cameras – which does nothing to detract from their charm.

The tropical models of various very fine cameras are rightly very highly regarded, and we have had the pleasure of handling many superb examples. The leather covering of the ordinary models, and the animal glue with which it was attached to the wooden body, both suffered badly in tropical conditions of heat, damp, and insect appetites, and so the tropical models were made in polished teak or mahogany, and reinforced with neatly inlaid brass – or sometimes aluminium – insets. These handsome instruments are immediately recognizable, but less familiar to collectors are the tropical models of some Continental makers, such as Goerz, where forms of gluing were evolved, and leathers used, which resisted the ill effects of tropical use. In the case of the quite rare Goerz tropicals, the covering used was a very durable form of green Russia leather.

I am sure that much of the appeal of old cameras lies in the fact that photography makes use of many skills and technologies. At the beginning of it all are the photo-chemical processes which make the whole thing possible. To this is added the work of the optician, whose lenses create the bright image which is captured in the chemical emulsions, and then these basic elements are housed in a body – at first the work of cabinet makers, but increasingly, as the 19th century ended, the work of mechanics and instrument makers.

Apart from the events recorded in the camera's pictures, the camera itself is a fascinating record of progressing technologies.

Sinclair 'Una' tropical
quarter-plate hand and stand
camera in teak
1911
Sold 23.4.75 for £1470 ($3381)

Megalethoscope
By Charles Ponti, 1868
35½ in. (90 cm.) long, 23 in. (58 cm.) wide
(not including table), 53½ in. (136 cm.)
high overall
Sold 16.10.74 for £1890 ($4536)

This viewer, invented by Charles Ponti
in 1862, was sold with about 70 specially
prepared photographs on thin paper
mounted on curved frames. They are
viewed by reflected light to provide day-
time scenes and by transmitted light
to produce a view of the same scene
at night

Left: Skaife's patent miniature brass camera
c. 1859
Sold 22.1.75 for £5250 ($12,600)
From the collection of L. V. Williams, Esq

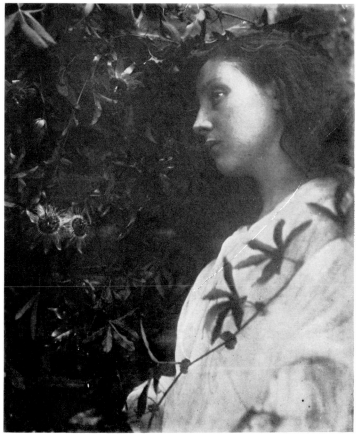

Photogenic drawing, *Two Butterflies*
Watermark 1836
Sold 24.7.75 for £100 ($200)

Right: JULIA MARGARET CAMERON: *Illustrations to Tennyson's* Idylls of the King *and other poems*
Vol. 2, published by Harry S. King and Co., 1875
Sold 24.7.75 for £2835 ($6237)

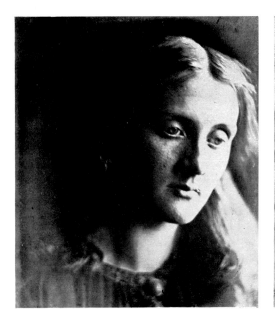

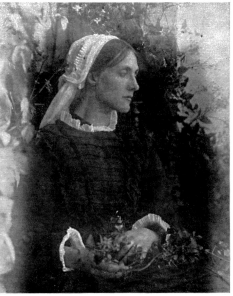

JULIA MARGARET CAMERON:
Album of photographs compiled
by Mrs Cameron herself
Sold 16.10.74 for £6825
($16,380)

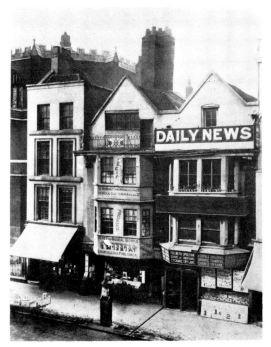

Two folders containing a total of 120 carbon prints from the series published by the Society for Photographing Relics of Old London, photographed by Henry Dixon and A. & J. Bool between 1875 and 1886 including views of the Oxford Arms, Warwick Lane, Drury Lane, Fleet Street, Holborn, Soho, Southwark, Clerkenwell, Bloomsbury, Lincoln's Inn Fields and Grays Inn
Sold 24.7.75 for £3150 ($6930)

Above: HENRY PEACH ROBINSON: *Gwysaney, North Wales*
Album of 39 photographs, all c. $10\frac{1}{2} \times 14\frac{3}{4}$ in. (27×37 cm.)
Sold 23.1.75 for £2940 ($7056)

HENRY PEACH ROBINSON: Portrait study of a *Consumptive Girl in a Chair*
Mounted on card, $7\frac{3}{8} \times 9\frac{1}{2}$ in.
(18.8×24.2 cm.)
Sold 23.4.75 for £1417.50 ($3260)

This is probably a preliminary study for *Fading Away*, Robinson's composite photograph of 1858. The model, chair and stool appear to be the same

Master Benjamin and Miss Arabella Bristol playing with toys from the Verspyck Mijnssen-Duyvis Collection of Dolls and Toys which totalled £19,621 ($47,091)

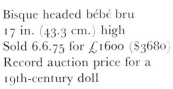

Bisque headed bébé bru
17 in. (43.3 cm.) high
Sold 6.6.75 for £1600 ($3680)
Record auction price for a
19th-century doll

Painted wooden Dutch dolls' house
69 in. (175 cm.) high overall
c. 1860
Sold 23.9.74 for £1680 ($4032)
From the Verspyck Mijnssen-Duyvis Collection of Dolls and Toys

Textiles and fan

Length of Italian lace
$6\frac{1}{2} \times 32$ in. $(16.5 \times 81$ cm.)
c. 1680
Sold 5.11.74 for £147 ($353)

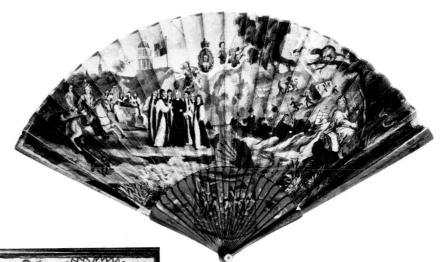

Below: Silkwork picture
18×21 in. $(45.7 \times 53.4$ cm.)
c. 1645–50
Sold 5.11.74 for £630 ($1512)

Printed fan
10 in. (25.4 cm.)
English, early 18th century
Sold 17.4.75 for £150 ($360)

Stamp sales

ROBSON LOWE

The season's total has brought another record turnover of just over £2,750,000 ($6,325,000) and the policy of taking the auctions to the right markets has contributed substantially to this increase.

Overseas

The three series of sales held in Switzerland this season proved as popular as ever, particularly the four sales held in Geneva in May. The latter were a new venture for Robson Lowe International and were held in conjunction with Christie's who were selling other works of art in the same week.

The October sales in Basle included the collection of Austria formed by Dr Immanuel Bierer which realized a total of £22,423 (Sw. fr. 149,490), and an original artist's sketch in colour of the Russian 10 kopeks from the Alex Droar Collection which made £1800 (Sw. fr. 12,000).

The March sales in Basle provided considerable excitement, the sale of Brazil realizing £51,291 (Sw. fr. 307,745), that of Guatemala £13,594 (Sw. fr. 81,505) and that of Peru etc., £22,921 (Sw. fr. 137,530). In the Brazil sale the famous used block of seventeen 90 Reis 'Bull's Eyes' went for £8000 (Sw. fr. 48,000); in the Peru, a mint block of eight of the 1857 Pacific Steam Navigation Co. 2r. was sold for £3166 (Sw. fr. 19,000).

The Italian sale saw £3500 (Sw. fr. 21,000) paid for a Lombardy-Venetia 15c. used on the first day of issue on a cover from Vicenza to Padua and the Treasure Trove Sale, which consisted largely of a family collection of envelopes which had been brought into 50 Pall Mall in a fishing basket realized £20,826 ($49,984).

The Geneva sales in May totalled £719,740 (Sw. fr. 4,318,440). This was a wonderful series of four sales, with Michael Sacher's Near East getting off to a good start with an 1873 cover with a G.B. 4d. cancelled GO6 at the British Post Office in Beyrout with a strip of four Italian 20c. alongside tied by the c.d.s. of the Italian Postal Agency soaring to £1250 (Sw. fr. 7,500). The collection of Jordan formed by the late R. T. Ledger, MBE, who was for many years a civil servant in Jordan, made up the afternoon session and totalled £25,048 (Sw. fr. 150,290). Competition for

1859 cover from Parma, with different shades of the 40c. Provisional Government issue Sold in Geneva in May 1975 for £56,667 (Sw. fr. 340,000)

this collection was fierce between the Israelis and the Kuwaitis and really opened up this field.

The Rarities Sale was held in a packed room and provided many surprises. A collection of Aden offered intact sold for £21,666 (Sw. fr. 130,000), the famous pair of 2c. cotton-reels of British Guiana on cover went for £75,000 (Sw. fr. 450,000), the unique unused block of four 1848 1d. 'Post Paid' Mauritius sold for £55,000 (Sw. fr. 330,000), and the Baltimore Postmasters' Provisional on an 1846 cover reached £41,666 (Sw. fr. 250,000). Perhaps the greatest surprises came when the 1859 and 1860 covers from Parma came up for sale. The former realized £56,667 (Sw. fr. 340,000) and the latter £36,667 (Sw. fr. 220,000) both roughly 40% more than had been expected (see illustration above).

The sale of Hawaii the next day totalled £88,904 (Sw. fr. 533,425) and that of the Papal States £159,117 (Sw. fr. 954,705), in each case all the high prices being due to bidders from these areas coming over to Geneva especially for the sales.

Our first sale in Sweden was held on 25th September, 1974, at the time of the International Exhibition in Stockholm.

Six sales were held in Melbourne bringing over £110,000, the bulk of which was for the Pacific Islands collections formed by the late John Powell of Sydney.

1873 Valentine's 'Industry of All Nations' envelope from Mitau to London bearing 1, 5 and 10 kopek values
Sold in Basle
in March 1975 for £434 (Sw. fr. 2600)

London

Among the GREAT BRITAIN auctions was the 'Max Stothert' Collection of King George V issues which was sold on 24th September, 1974. A master die proof of the Mackennal head made £550 ($1320) and a die proof in black of the 1924 Wembley 1d. realized £1000 ($2400). The top price for an issued stamp was £1800 ($4320) paid for a block of four of the 1915 ½d. in Cyprus green.

In the two 'Victoria Collection' sales of Great Britain held on 19th November, 1974, and 14th May, 1975, prices included the following:

Three covers bearing 1d. blacks used in May 1840—6th May (first day of issue) £1900 ($4560); 9th May (block of six) £7500 ($18,000); 10th May (first Sunday) £4600 ($11,040)

1840 1d. black plate III used block of ten £6750 ($16,200)

Coloured cancellations—blue Maltese Cross on 1840 2d. blue block of four £4500 ($10,800); orange-red cross on 1841 1d. on cover from Hayle £2100 ($5040); Horsham (on 1d. black) and Stratford-on-Avon (on 1d. red) datestamps in yellow £3200 ($7580) and £3000 ($7200) respectively (without these rare cancellations the stamps would have been worth £6 and 20p)

Mint block of nine of the 1841 2d. plate III £4500 ($10,800).

The Victoria Collection was the property of a lady who spent about £9000 ($21,600) on it between 1932 and 1957. She was very exacting about quality. She

hoped that her collection would sell for about £100,000 ($240,000), and in fact it fetched just over £200,000 ($480,000).

A collection of the stamps of King Edward VII made £16,303 ($39,127) on 20th November, £675 ($1620) being paid for a die proof of the unissued £5 value. The 'Max Stothert' Victoria surface-printed aroused a lot of competition on 28th January when £1050 ($2520) was paid for a set of the 1883 ½d. to 1s. essays.

BRITISH EMPIRE sales included the 'Byron Cameron' Collection of Jamaica on 5th November, when an unused 1919 1s. with inverted frame made £2600 ($6240).

In the Australian sale held on 11th March, 1975, a New Zealand 1844 entire letter from Paihia to London with a superb strike of the 'WM. CLUNIE, SHIP AGENT, BAY OF ISLANDS' forwarding agents cachet realized £1000 ($2400). The bulk of the sale was sold for the benefit of the funds of Lancing College Chapel.

In the Dominica sale on 12th March, 1975, two items of interest were an 1886 1d. on 6d. provisional used which realized £3600 ($8640) and an 1879 envelope to Antigua with a 6d. cancelled 'AO7' which realized £900 ($2160); less than twenty years ago this cover fetched £20 ($48).

The auctions of overseas stamps included a sale of Americana on 8th October, 1974, which made £30,433 ($73,040), the best items being a mint block of six 1847 5c., £1900 ($4560), and mint blocks of four 1861 10c., £1600 ($3840), 1893 $3, £1100 ($2640) and $4, £1400 ($3360). A cut round copy of Robertson's Philadelphia Despatch Post 3 cents used on an 1843 letter went for £525 ($1260).

In the Far East sale on 12th February, 1975, an 1876 registered envelope from Soochow to South Carolina which passed through the U.S. Postal Agency in Shanghai made £750 ($1800) while an 1882 cover from Tientsin to Massachusetts bearing one American and three Chinese stamps soared to £1700 ($4080).

Bournemouth

The monthly general auctions at our new premises at 39 Poole Hill have realized £682,602 ($1,570,000), a record for any provincial stamp auctioneers. At the November 1974 sale there were 684 bidders and 419 buyers.

In view of the additional accommodation, four Postal History auctions were held here and brought £115,799 ($266,337). Sales of British Ship Letters were very popular and, as examples of the prices paid for the rare items, a 1791 Lancaster at £425 ($1020), 1792 PTEERH^D (Peterhead) £360 ($864) and 1825 I.MAN (Isle of Man) £520 ($1248) were among the best.

Three sales of Revenue stamps totalling £28,329 ($65,156) have demonstrated the increasing interest taken in this long neglected subject. A block of eight British 1786 Hair Powder Tax 1d. made £300 ($720).

WINE

Wine sales 1974-75

ALAN TAYLOR-RESTELL

Overall activity

The 1974–75 season has undoubtedly been the most active the Wine Department has ever experienced. Despite miserably uncertain economic conditions, not to mention greatly increased competition, the number of sales held by Christie's has increased from 31 to 38 over the season. The number of lots catalogued is up from just over 16,000 to just under 22,000 and, despite the drop in wine prices, the overall total sold is higher than ever before: £1,600,000 ($3,680,000).

Major sales

The season opened with a very big trade sale – something of a feature of the current saleroom scene, which is witnessing a considerable run-down of stocks, and a situation which clearly benefits buyers.

However, the entire wine sales season was dominated by a 'Highly Important Sale of First-Growth Claret from the Cellars of Château Lafite-Rothschild and Château Mouton-Rothschild' on 6th June. Although not the largest wine sale, it was certainly the most prestigious and significant in our long history and merits a separate report in this Review (see page 455).

Other notable sales included the disposal of the London Wine Company stocks, and the wines of James Richards and Co., and the Company of the Connoisseurs of Claret. Totally different from the last-named sales (Christie's two centuries of sales are liberally sprinkled with such unloadings) was the attractive range of wines offered on behalf of the twin wine companies, Laurence Hayward Ltd and Laytons Wine Merchants. This sale was held at the Ritz Hotel. To brighten the occasion further, champagne was handed round at midday to toast the 208th anniversary, to the day, of James Christie's first sale.

The wine market

CLARET. By now it is common knowledge that claret prices have slumped due to world recession, over-production and a severe reaction to the speculatively forced high prices of the 1971–73 period.

Left to right:
Ch. Montrose 1870
£34 ($81)

Ch. Lafite 1874
Magnum
£62 ($148)

Believed Lafite
Vintage 1864
Tappit-hen
£140 ($336)

Ch. Lafite 1874
Magnum
£31 ($74.50)

Premier Empire
Cognac 1809
£38 ($91)

All sold 28.11.74

Certainly top-growth prices reached a level which did not make sense to the drinker and it is this quality range which has taken the greatest tumble. First growths can now be bought for £4 ($9) or so per bottle for drinking (1967s for example), other classed growths in the £2 ($4.50) range – even less for laying down.

SAUTERNES. Happily in the saleroom (but not at the château) there has been a noticeable, deserved and belated, upturn of interest in fine sauternes and barsac. Prices for Yquem of classic vintages have been high.

BURGUNDY. Good burgundy in the saleroom has ploughed a steady furrow, but it has always been below Burgundian and London merchants' prices. Romanée-Conti still fetches either side of £10 ($23) a bottle, but really good wines from other reputable domaines can be obtained for between £1.50 ($3.50) and £2.50 ($5.75) a bottle, which after all is a sensible and acceptable range for drinking at dinner parties.

HOCK AND MOSELLE. Again very steady, albeit at unexciting prices. The market is small and specialized. Inexpensive hock is one of the few cheap wines which can be recommended these days to discerning clients.

VINTAGE PORT. Prior to each of our three specialized port sales we have suggested that port, particularly of young vintages, is underpriced; and in the circumstances prevailing in Oporto, it may be scarce if not a thing of the past. The market is small, however, and the long maturing period is a deterrent for private as well as trade buyers. Nevertheless, sales have been steady and are easing to a healthier level.

Fine and Rare

From the start, the most successful and prestigious of our regular sales have been 'Fine Wines, mainly from Private Cellars'. Seven such sales were held this season, including two of our inimitable 'Finest and Rarest'.

An increase in the number of notable overseas collections coming in for sale is both a measure of our international reputation and also, less happily, of the depletion of great private cellars in this country. Last autumn a magnificent collection came from Australia; more recently from Bordeaux and Antwerp. A bevy of outstanding French cellars was shipped and offered on 12th June, including old Lafite, Margaux, and Yquem from the Marquis de Vasselot; a range of Château Latour from the Marquis de Beaumont, whose family were sole owners of that great vineyard for over two centuries; and a magnificent collection of magnums and jeroboams, vintages 1924 to 1937, from a country house near Beauvais. A single jeroboam of Mouton-Rothschild 1929 from this cellar fetched £720 ($1656), the highest individual bottle price on the London market last season.

Nevertheless, the bulk of our fine and rare wines is from private cellars in the United Kingdom. They have included 1847 vintage port from Sherborne Castle, pre-phylloxera claret, venerable madeira and old vintage cognac.

A few notable wines and prices:

Vineyard	Vintage	Price
Believed Lafite	1864	£140 ($336) per tappit-hen
Ch. Lafite	1874	£62 ($148) per magnum
Ch. Lafite	1875	£50 ($120) per bottle
Ch. Lafite	1895	£370 ($888) per dozen
Ch. Latour	1878	£80 ($192) per magnum
Ch. Latour	1899	£72 ($172) per bottle
Ch. Latour	1929	£300 ($720) per dozen
Ch. Cheval-Blanc	1947	£84 ($201) per magnum
Ch. Petrus	1947	£330 ($792) per dozen
Ch. d'Yquem	1874	£40 ($96) per bottle
Ch. d'Yquem	1937, '49 & '55	£400 ($960) per dozen
La Tâche	1961	£180 ($432) per dozen
Ch. Mouton-Rothschild	1929	£490 ($1127) per 6 magnums
Ch. Mouton-Rothschild	1929	£720 ($1728) per jeroboam
Blandy's madeira	1792	£56 ($134) per 2 bottles
Cockburn	1896	£26 ($62) per bottle
Taylor	1896	£34 ($81) per bottle
Grande Champagne Cognac 1811		£110 ($264) per imperiale

Selection of corkscrews sold 28.11.74
Top left: £58 ($140)
Top right: £46 ($110)
Centre: £74 ($177)
Bottom left: £105 ($252)
Bottom right: £60 ($144)

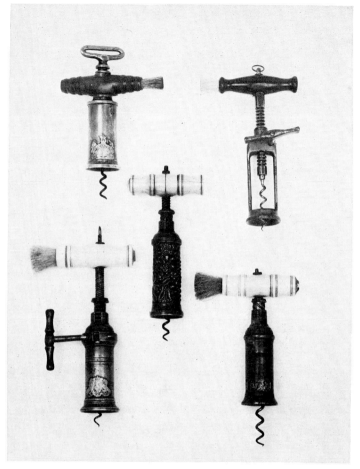

Relics and collectors' pieces

These sales continue bi-annually, usually forming the afternoon session of our Finest and Rarest wine sales.

Corkscrews still – and very appropriately – dominate the relics sales, and undoubtedly our revival of interest in these formerly humdrum artefacts was largely instrumental in the formation, last autumn, of the International Correspondence of Corkscrew Addicts. The early patented corkscrews sell effortlessly in the £20 ($48) to £60 ($144) region, £105 ($252) being paid for a Dowler at our sale last November.

Other interesting items have included a wine shipper's walking cane dip stick, £125 ($300), fine papier mâché coasters, £190 ($456) for a set of six, and semiglazed delft bin labels, £66 ($158) the pair. Particularly interesting and rare was the original cellar-book of one of Nelson's men-o'-war, H.M.S. *Bellerophon*, a manuscript account of the year 1800, which was bought by Magg's the antiquarian book dealers for £100 ($240).

Christie's South Kensington

At Christie's South Kensington, our new saleroom in the Old Brompton Road, a series of popular-priced wine sales are being organized on a monthly basis. The saleroom was packed to overflowing on the day of the first wine sale, on 20th March, and clearly the compact session, with the tasting in the morning and the sale itself over the lunchtime period, has been found attractive and convenient by a lively new clientele. A useful outlet for inexpensive trade stocks, South Kensington will probably be the future venue for all our popular End of Bin sales.

Wine publications

Scholarship and commerce are happily combined in Christie's wine publications. The annual *Wine Review* (the 1975 edition is the fourth of the series) has a distinct house style and a regular and increasing following for its market information, articles for collectors and, of course, its unique price index of fine and rare wines and cognac.

Michael Broadbent's already established *Wine Tasting* became the first of Christie's wine midway-edition monographs. The current edition has sold out and the book is being revised and reprinted for the fourth time.

The latest monograph, published last December, is *Mouton-Rothschild* by the distinguished wine writer Cyril Ray. The first edition sold out within three months of publication and was speedily revised and reprinted. Further publications are in printers' hands.

Bidding in progress during the Lafite-Rothschild and Mouton-Rothschild sale, which continued all day and totalled £438,222 ($1,008,000)

The Rothschild wine sale

MICHAEL BROADBENT, MW

The owners of the two greatest vineyards in Bordeaux, Château Lafite and Château Mouton-Rothschild, combined forces to offer for sale on 6th June an unparalleled range of claret from their own cellars.

These two great first-growth rivals sank their differences in order to shake the stagnant fine wine market into activity and to help re-establish an orderly pattern of prices to correct the severe over-reaction to excessive prices caused by the inflationary demand and speculation during the 1971–73 period. Not least, the sale was intended to – and did – provide a substantial amount of cash, as necessary to the running of a great wine estate as to any other business.

Why Christie's?

The managing director of Château Mouton-Rothschild was asked this question by the French press and the reply was: '*Nous avons choisi Londres et non pas la salle Drouot, pour cette vente aux enchères, pour profiter de la clientèle internationale de Christie's.*'

He was aware of Christie's position in the fine wine market, not through hearsay but by practical experience. Many thousands of cases belonging to Bass Charrington's were lying at the château at the time of the big Bass sale in the summer of 1974 and he was able to note that not only was the wine sold at satisfactory prices but despatched from their cellars to buyers across four continents.

The range and quantities

Twenty of the best vintages from 1945 to 1971, of both châteaux, were represented: some 6000 cases in all, lot sizes ranging from single rare bottles to 100 dozen. One of the attractive features of the sale was the never-before-seen range of *grands formats* – magnums, double-magnums, jeroboams and imperiales, also the rare marie-jeanne.

Sale attendance and results

The total value of wine sold was £438,222 ($1,008,000) (at ex-cellars prices, prior to duty and VAT). 1146 lots were catalogued, yielding an average price of roughly £80 ($189) a case.

Château Lafite – vineyard, chais and château

The great chai at Mouton-Rothschild

Thanks to a considerable amount of publicity for this unprecedented event, there was a great deal of interest: 527 bidders were registered in the saleroom and a further 320 bidders unable to attend left their commissions to bid by letter, cable and telex.

In the event there were 310 buyers, a high proportion of whom were from overseas including Australia, Belgium, Bermuda, Canada, France, Germany, Holland, Luxembourg, Switzerland and all over the U.S.A.

Prices

These were higher than anticipated, though the estimates proved a more reliable guide than we had dared hope. Both Lafite *and* Mouton '45 fetched £600 ($1380) per dozen bottles. In case the cynics think this was rigged, let us say immediately that neither wine needed a reserve price and that after fierce bidding two major buyers were left in the field, one Swiss and one American. Indeed it was brisk international bidding which set the pace though a surprising number of English buyers secured major items.

Predictably the rarer large-bottle (*grand format*) sizes realized high prices, e.g.:

Lafite '45 double-magnum £280 ($644)
Mouton '45 jeroboam £360 ($828)
Lafite '48 marie-jeannes from £64 ($147) to £80 ($184) each
Mouton '49 imperiale £360 ($828)
Lafite '53 magnums £330 ($760) per case of 6
Lafite '61 imperiales £250 ($575) each
Mouton '61 imperiale £270 ($621), jeroboam £260 ($598) (only one of each available)
Lafite '70 imperiales £125 ($287)
Mouton '70 imperiales up to £140 ($322).

Pre-sale tasting

Somewhere approaching 1000 people, trade and private, attended the two pre-sale sessions. Most were surprised to see a full range of samples (despite mentioning this in the accompanying Sale Memorandum), including the older vintages; some late-comers were equally surprised, and some annoyed, that samples had run out (despite our warning in the same Sale Memorandum). In fact the owners had supplied a very generous quantity for sampling: copious bottles of younger vintages and even three bottles of each of the 1945s despite there being only two single-case lots of each available for sale. So quite a lot of people had a sip of nectar which commanded an all-time record price the following day.

The sale of 6000 cases of first growth claret from the Châteaux Lafite-Rothschild and Mouton-Rothschild was held in the Ballroom of Quaglino's. The tasting prior to the sale, as seen here, was packed not only with members of the wine trade and wine connoisseurs, but also with those who did not wish to miss the opportunity of savouring such noble vintages

Overall results of the sale

Despite the apprehension of the established trade that the offering of a large quantity of first-growth claret would damage the market and, if low prices materialized, would severely reduce the value of their own stocks, their fears proved entirely unjustified; indeed the general market reaction was of relief and reassurance. However, their fears regarding the offering of first-growth claret on an open-to-all basis, without the usual string of middle-men, were less reassured: it became perfectly apparent that a well-mounted sale with attractive wines could achieve what the existing trade channels signally failed to do. Indeed one of the principal reasons for holding this sale at Christie's was that the brokers, shippers and importers were not performing their normal functions, not we must hasten to add because of ill-will, but because of the generally stagnant and overstocked position. However, whereas merchants can cease buying and steadily reduce their stocks, the château proprietor must necessarily add considerably to his stocks each year following the vintage.

From the point of view of the owners of Lafite and Mouton, the sale was a complete success. Immense interest was engendered, world wide, virtually all the wines on offer were sold and the prices exceeded expectations; a clouded and uncertain market was cheered and a pattern of significant prices was established by a wide spread of willing buyers, for each of the vintages, for the various bottle sizes, and for the various lot offerings. Above all the sale confirmed, if confirmation was needed, that London, and Christie's in particular, is *the* international centre for fine wine.

CHRISTIE'S
SOUTH KENSINGTON

Christie's South Kensington

PAUL WHITFIELD

The establishment of Christie's South Kensington in the New Year has broadened the service which Christie's are able to offer their clients, as a far wider range of works of art is now acceptable for sale. Moreover, those items in the lower price-ranges, most of which are offered at Christie's South Kensington, can now be sold with appropriate speed – about three to four weeks from delivery, and payment within ten days – while benefiting from expert and personal attention and the full backing of Christie's services.

Pictures, Furniture, Ceramics, Jewellery and Silver are all sold weekly at Christie's South Kensington, and in addition we also hold regular but slightly less frequent sales of Wine, Mechanical Music, Dolls and Toys, Textiles and Costume and Books, particularly those concerning Motoring, Aeronautical or Railway subjects. Specialized groups of Pot-lids, Staffordshire Portrait Figures and Goss-ware are included in the Ceramics category.

The cataloguing of all sales is supervised by experienced staff from the St James's saleroom. Works of art which would benefit from being included in sales at King Street and international bidding are, as a matter of course, sent there. A few examples of this during the first few months of operation are: an Abraham Storck harbour scene, a Webb cameo overlay vase, various items of Wedgwood, a Louis XV clock, several Renaissance bronzes and a gold flute.

Christie's South Kensington is at 85 Old Brompton Road, S.W.7 (telephone: 589-2422) and is not far from South Kensington station. Opening hours are 9 a.m. to 5 p.m. (7 p.m. on Mondays) and sales continue throughout the year with no summer recess.

R. G. WINCHESTER:
The Pantiles, Tunbridge Wells
On board
18 × 14 in. (45.7 × 35.6 cm.)
Sold 18.6.75 for £100 ($230)

JOHN ARMSTRONG, RA: *Harlequins*
Signed with initials and dated '50
Tempera
36 in. (91.4 cm.) diam.
Sold for £300 ($690)

MERVYN PEAKE:
Portrait of David Jones
Sold 28.5.75 for £85 ($195)

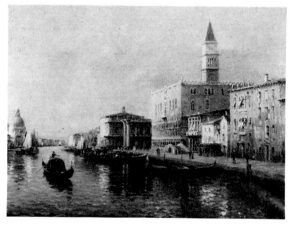

Below: HENRY M. PARKER:
On the Lea near Chingford, Essex
Sold 9.4.75 for £550 ($1320)

Below: THOMAS ALLOM:
*House of a Chinese Merchant
near Canton*
Pencil, sepia, pen, ink and
sepia wash
4¾ × 7½ in. (21.1 × 19.1 cm.)
Sold 23.4.75 for £150 ($345)
From a collection of 22
drawings by Thomas Allom
which realized a total of £4280
($9844)

Above: AUGUSTE
BOUVARD: *View of
the Bacino and the
Mouth of the Grand
Canal, Venice*
Signed
19 × 25 in.
(48.3 × 63.5 cm.)
Sold 21.5.75 for
£390 ($897)

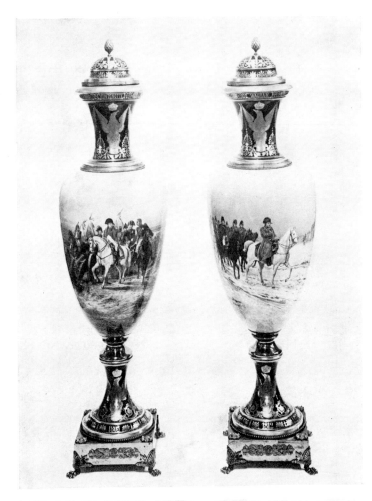

Left: Pair of Sèvres-pattern ormolu-mounted vases
By Desprez
55½ in. (141 cm.) high
Sold 10.7.75 for £7000 ($15,400)

Above centre: K'ang Hsi blue and white baluster vase
and cover
19 in. (48.3 cm.) high
Sold 22.5.75 for £400 ($920)

Above right: Chinese hanging scroll
Sold 12.6.75 for £130 ($299)

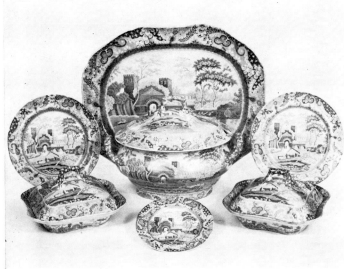

Spode blue-printed dinner service
Impressed marks (128 pieces)
Sold 12.6.75 for £450 ($1035)

Top left : Victorian silver four-piece
tea- and coffee-service
By Messrs Barnard, London, 1845–50
Sold 14.5.75 for £600 ($1380)

Top right : Victorian silver paperweight
T.W.D., London, 1862
5 in. (12.8 cm.) high
Sold 16.6.75 for £500 ($1150)

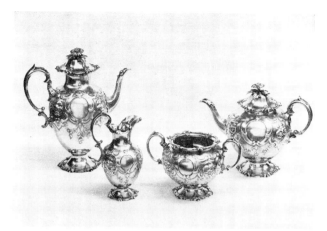

Middle left : Diamond and pearl
brooch
Sold 2.6.75 for £1325 ($3047)

Middle centre : Brilliant and navette
diamond triple cluster ring
Sold 2.6.75 for £2000 ($4600)

Middle right : Quarter-repeating gold
hunter pocket watch
Sold 23.6.75 for £285 ($655)

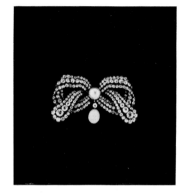
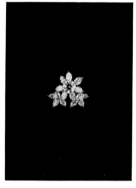
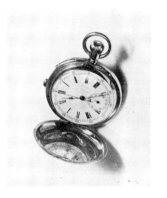

Bottom left : Brilliant and baguette
diamond necklace
Sold 2.6.75 for £4300 ($9890)

Bottom right : Silver repeating carriage
clock
Geneva Clock Company
Sold 23.6.75 for £580 ($1334)

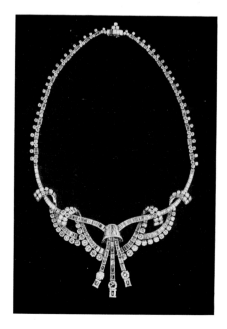
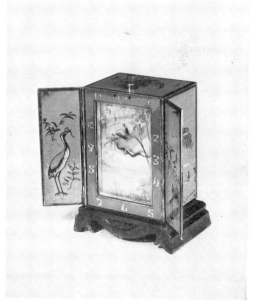

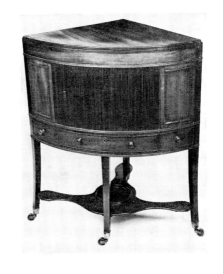

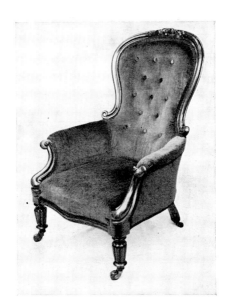

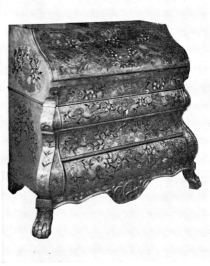

Top: One of a pair of late
Georgian mahogany library
armchairs
Sold 21.5.75 for £290 ($667)
From Lockington Hall, Derby

Dutch marquetry bureau
52 in. (132 cm.) wide
18th century
Sold 2.4.75 for £2300 ($5520)

Top: George IV mahogany
bowfront corner washstand
29 in. (74 cm.) wide
Sold 2.4.75 for £110 ($264)

Teheran rug
82 × 54 in. (208 × 137 cm.)
Sold 11.6.75 for £400 ($920)

Top: Victorian mahogany
framed easy chair
Sold 2.4.75 for £110 ($264)

George III mahogany chest
36 in. (91 cm.) wide
Sold 28.5.75 for £340 ($782)

Pair of raised-work silk portraits of emperors
English, c. 1660
7 × 6½ in. (17.8 × 16.5 cm.)
Sold 17.4.75 for £520 ($1248)

Right: Four joined gros-point borders
Mid-17th century
Sold 17.4.75 for £1300 ($3120)
Now in the National Museum of
Antiquities, Scotland

Suit of magenta and ivory ribbed
velvet, c. 1740
Sold 5.11.74 for £609 ($1462)
Now in the Royal Scottish Museum

Right: Wall panel of petit-point, c.1740
66 × 103 in. (168 × 262 cm.)
Sold 17.4.75 for £1300 ($3120)

Bottom left: Three car mascots First World War to 1930s
From a sale on 5.6.75 entirely devoted to this new
collector's field, which realized a total of £8845 ($20,343)

Bottom right: BRYAN DE GRINEAU: *The Maestro in Action,
Nuvolari The World's Greatest Driver romps home in the 1933
T.T. driving an M.G. Magnette*
Signed and dated Belfast 1933, and autographed by Nuvolari
Pencil and crayon heightened with white
19½ × 30 in. (49.6 × 76.3 cm.)
Sold 29.7.75 for £650 ($1430)

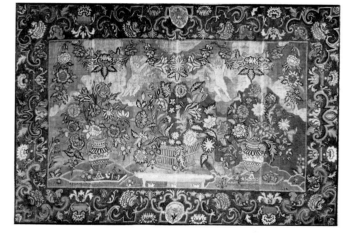

Top left: Edison opera phonograph, 1912
The horn $21\frac{1}{2}$ in. (54.7 cm.) diam.
Sold 15.5.75 for £750 ($1725)
Record auction price for a cylinder
phonograph

Top right: Key-wind overture box by
Nicole Frères, No. 32071, c. 1850
$21\frac{1}{2}$ in. (54.7 cm.) wide
Sold 4.3.35 for £1500 ($3600)
Record auction price for a single-cylinder
musical box

Bottom left: Chamber barrel-organ
By Longman, Clementi & Co., 1798–1801
Sold 15.5.75 for £500 ($1150)

Bottom right: Stella disc musical box in
kingwood-veneered case of Louis XV
design, c. 1900, 50 in. (127 cm.) wide
Sold 15.5.75 for £2530 ($5819)
Record auction price for a musical box

Christie, Manson & Woods, Ltd

LONDON
8 King Street, St James's, SW1Y 6QT
Telephone (01) 839 9060 *Telegrams* Christiart London SW1 *Telex* 916429

Agents in Scotland and Yorkshire

SCOTLAND
Michael Clayton
48 Melville Street, Edinburgh EH3 7HH
Telephone (031) 225 4757
Sir Ilay Campbell, Bt
Cumlodden Estate Office, Furnace by Inveraray, Argyll
Telephone Furnace 206

YORKSHIRE
Nicholas Brooksbank
46 Bootham, York YO3 7BZ
Telephone (0904) 30911

Companies and Agents Overseas

THE AMERICAS
United States
Christie, Manson & Woods (U.S.A.) Ltd
867 Madison Avenue, New York 10021, NY
Perry T. Rathbone
Christopher Burge
David Renwick Hall
Stephen Massey
Telephone 744 4017
Cables Chriswoods, New York *Telex* New York 620 721

Canada
Christie, Manson & Woods (Canada) Ltd
1115 Sherbrooke Street West, Suite 1805, Montreal 110, P.Q.
Mrs Laurie Lerew
Telephone 842 1527 *Cables* Chriscan Montreal

Argentina
Consultant: Cesar Feldman
Libertad 1269, Buenos Aires
Telephone 41.1616 or 42.2046 *Cables* Tweba, Buenos Aires

Mexico
Consultant: Martin Kiek, OBE
Schiller 326 – Dpto. 7, Polanco, Mexico 5 D.F.
Telephone 531–1686

AUSTRALIA
Sydney
Christie, Manson & Woods (Australia) Ltd
298 New South Head Road, Double Bay, Sydney, 2028
John Henshaw
Telephone 326 1511 *Cables* Christiart, Sydney *Telex* AA26343

Melbourne
Christie, Manson & Woods (Australia) Ltd
233/239 Collins Street, Melbourne, Victoria, 3000
Telephone 63 2631 *Cables* Christiart, Melbourne *Telex* AA32911

EUROPE
Switzerland
Christie's (International) SA
8 Place de la Taconnerie, 1204 Geneva
Anthony du Boulay
Dr Geza von Habsburg
Hans Nadelhoffer
Telephone 28 25 44 *Cables* Chrisauction, Genève *Telex* Geneva 23634

Italy
Christie, Manson & Woods (Internazionale) SA
Palazzo Massimo Lancellotti, Piazza Navona 114, Rome 00186
dott. Paolo Del Pennino
Nathalie Narischkine
dott. Victor Wiener
Telephone 654 1217 *Telex* Rome 58241
Consultant: d. ssa. Luisa Vertova Nicolson

France
Princesse Jeanne-Marie de Broglie
68 Rue de l'Université, 75, Paris VIIe
Telephone 544 16 30 *Telex* Paris 200024

Germany
Baroness Olga von Fürstenberg
Alt Pempelfort 11a, 4 Düsseldorf
Telephone 36 42 12 *Cables* Chriskunst Düsseldorf *Telex* Düsseldorf 7599

Austria
Baron Martin von Koblitz
c/o Christie's Geneva Office

Holland
Christie, Manson & Woods Ltd
91, Rokin, Amsterdam
Drs Andries Baart
Telephone 240–999 or 239–720 *Telex* Amsterdam 15758

Spain
Anthony Coleridge
Casilda Fz. - Villaverde
Carlos Porras
Casado del Alisal, 5, Madrid 14
Telephone 228 39 00 *Cables* Christiart, Madrid

Sweden
Mrs Lillemor Malmström
Hildingavagen 19, 182 62 Djursholm, Stockholm
Telephone 755 7533 *Telex* Stockholm 10936

Acknowledgements

Christie's are indebted to the following who have allowed their names to be published as purchasers of works of art illustrated on the preceding pages. The figures refer to the page numbers on which the illustrations appear

M. Abram, 188 (top)
Mansour Afshar, 187 (left centre and right centre), 192 (top right)
Thos Agnew & Sons Ltd, 87, 91, 153
Ahuan Islamic Art, 356
Albany Gallery, 96 (top)
Alexander Gallery, 209 (top), 233 (top right), 234 (bottom)
Messrs A. F. Allbrook, 288 (top left)
Mr and Mrs James Alsdorf, 244, 394 (right)
Albert Amor Ltd, 313 (bottom left)
Mrs W. R. Appleby, 202 (bottom left)
Master of the Armouries, H.M. Tower of London, 418 (top left)
Asprey & Co. Ltd, 206 (top), 234 (bottom left), 239 (bottom left and top right), 412 (right)
Monsieur Alfred Ayrton, 229 (right)

Keith Banham, 411 (bottom left), 414 (left and right)
Baskett & Day, 58, 88 (top), 92
Bentley & Co. Ltd, 189 (necklace)
D. Black Oriental Carpets, 402 (top right)
Blaise Preston Ltd, 67
A. B. Bloomstein, 207 (bottom)
Bluett & Sons Ltd, 331
A. Brieux, 409 (all), 411 (top centre)
Tan Bunzl, 83, 85 (bottom)
C. Burden Esq, 270 (top)
Tom Burnside, 441 (bottom)

H. M. Calman Esq, 84 (bottom)
Philippe Carlier, 266
Jean-Claude Caveng, 428 (bottom)
Mr Kenneth S. M. Chan, 338 (top)
William Clayton Ltd 337
Mrs W. Graham Claytor, 443 (right)
Sibyl Colefax and John Fowler, 365 (bottom right)
Collector's (Sam Someya), 351 (top)
P. & D. Colnaghi & Co., 79 (top), 82 (bottom centre), 84 (top), 104 (left and right), 112, 113, 115 (bottom left)
Gene Corman, 146
Craddock & Barnard, 98, 100

P. Dale Ltd, 159 (bottom), 418 (bottom left)
A. Davidson Ltd, 411 (top right)
Monsieur Paul Delplace, 324 (top)
Kate de Rothschild, 85 (top)
Alexandre de Villiers, 403
His Grace the Duke of Devonshire, 235 (top)
Maison Diagen S.A., 7 (bottom right)
D. Drager, 232 (top left, centre and right), 239 (top left)
Spencer Drummond Ltd, 75 (bottom)
D. W. Dunphy Esq, 60 (bottom)

Mr Elghanayan, 238 (bottom)
Eskenazi Ltd, 326, 328, 352 (top right)

B. Fabre et Fils, 390 (right)
Ditta Fallani, 252 (top)

Lew David Feldman, House of El Dieff, Inc., 279, 280, 281 (left and right), 282
Fernandez & Marsh, 363
The Fine Art Society Ltd, 151
Mr John Fleming, 272 (bottom right)
Kate Foster Ltd, 297 (left), 299 (bottom right)
Monsieur Jean P. François, 219
Carl Franklyn, 348 (bottom)
Gary A. Friedland, 419 (top right)
Frost & Reed, 154 (bottom)

Garrard & Co. Ltd, 186 (necklace)
Gay Antiques, 372
Thomas Gibson Fine Art Ltd, 136
Glasgow Museums & Art Galleries (with grant-in-aid from Royal Scottish Museum), 288 (bottom)
Graff, 172 (bottom right), 174 (bottom right)
Richard Green Fine Paintings, 23 (top and bottom), 27, 33, 59, 60 (top), 62 (top), 65 (right), 156 (top), 162 (bottom)
Messrs A. V. Gumuchdjian S.A., 182 (centre)

Otto Haas, 406 (top left)
Stephen Hahn, 119
W. F. Hammond Esq, 270 (bottom)
H. R. Hancock & Sons, 322 (bottom)
Messrs S. H. Harris & Son, 179 (necklace)
Hartman Rare Art Ltd, 341
Haslam & Whiteway Ltd, 368
Hazlitt, Gooden & Fox Ltd, 63
Heim Gallery, 395 (left)
Heirloom & Howard Ltd, 322 (top right)
A. K. Henderson Esq, 115 (bottom right)
Hilton Jewellers, 171 (bottom left), 174 (top right), 175, 179 (bottom centre)
M. Hogg Esq, 335 (bottom)
Paul Hottlet, 143
How of Edinburgh, 203 (bottom)
Heide Hübner, 375
D. J. Hudson, 411 (bottom right)

Jansy-Joaillerie-Orfèvrerie, 216, 223 (top)
G. P. Jenkinson, Geneva, 418 (top right)
C. John Ltd, 405
Seine Durchlaucht Franz Josef II Regierender Fürst von und zu Liechtenstein, 389 (bottom right)

Paul Kantor Gallery, 140
Société Kilmarnoc, 383
J. Kirkman Esq, 155, 288 (top right)
Oscar Klein & Jan Klein Inc., 61 (top)
Baron Martin Koblitz, 427 (bottom)
David M. Koetser Gallery, Zurich, Switzerland, 37, 47
E. & C. T. Koopman & Son Ltd, 202 (bottom right), 205 (top right) 206 (bottom left), 209 (bottom), 225 (top), 228 (right)
Mr H. P. Kraus, 274
Monsieur J. Kugel, 226

Monsieur V. Laloux, 218
August Laube, Zurich, 109 (top)
D. S. Lavender (South Molton Antiques Ltd) 240 (top left)
Ronald A. Lee, 254 (left)
Alex Reid & Lefevre Gallery Ltd, 137
Leger Gallery, 51, 54, 55, 56 (left), 61 (bottom), 90, 93, 94
Leggatt Bros, 29
L. P. Lemos, 191 (left and centre)
Lennox-Money, 365 (top left), 366 (bottom left)
Leva Art, 154 (top)
The late Herbert List, 82 (bottom left)
T. Lumley Ltd, 204
H. D. Lyon Esq, 106

K. J. McKinnon Esq, 161 (top)
Manheim Galleries, 339 (right)
E. Mannheimer Galerie, 410 (top left and bottom), 411 (top left),
 413
Mansfield Book Mart, 159 (top)
Mansour Gallery, 253 (top), 357 (bottom)
S. Marchant & Son, 324 (bottom)
Antiquariat Hans Marcus, 267
Dan Margulies, 426 (top)
The Maritime Trust, 430 (bottom)
Chas Mathews & Sons Ltd, 188 (bottom), 190 (top left)
Matsuoka Museum of Art, 325
The Mayor Gallery, 144
C. Michailidis, 74
Roy Miles Gallery, 40
W. Minns Esq, 96 (bottom)
Hans Mischell, 295 (bottom)
Mr Mischell, 214
Modarco S.A., 138
E. H. Morgan Esq, 101
John Morley Esq, 407 (top
Morton Morris & Co., 95 (left)
Hugh Moss Ltd, 342 (top left, centre left and right)
Musashiya Co. Ltd, 351 (bottom)
G. Music & Sons Ltd, 189 (centre), 190 (right centre)

David Newbon, 284, 292 (bottom right), 294 (left)
Newhouse Galleries, 44
Nissei Trading Co., 346, 347
Mr John Norris, 429 (top)

Galerie Ostler, 399
S. Ovsievsky, 223 (bottom)

E. Grosvenor Paine, 236 (bottom left)
Partridge Fine Art Ltd, 82 (bottom right), 245, 334, 362, 364 (bottom),
 366 (bottom right)
Perls Galleries, New York, 126
Mr S. R. Perren, 190 (bottom right)
Howard Phillips, 314 (top left and bottom)

S. J. Phillips Ltd, 173 (necklace), 184 (top), 202 (top), 208 (bottom
 right), 225 (bottom), 228 (left), 229 (left), 232 (top, second from right),
 240 (right)
Piccadilly Gallery, 127
Pickering & Chatto, 269 (right)
Mr Henry Prager, 342 (centre and bottom right)

Bernard Quaritch Ltd, 272 (left), 273
J. A. Quilter Esq, 7 (top). 234 (top right)

F. Ragazzoni, 39
Dr Ewald Rathke, 114 (top)
Dr R. Rosenbaum, 406 (top right)
Mrs Edward F. Rosenberg, 208 (top)
Helmut H. Rumbler, 103

Frank T. Sabin Ltd, 162 (top)
Mr & Mrs Max Sacher, 121
Maison Samourai S.A. 179 (top centre)
Manfred Seymour Ltd, 173 (top centre and bottom right), 176
 (necklace), 177, 185, 187 (top left and bottom right)
S. J. Shrubsole Ltd, 206 (bottom right)
Sir Raymond Smith, KBE, 46
Somerville & Simpson Ltd, 89, 110 (right), 115 (top), 125
His Excellency John N. Sossidi, 389 (top left)
E. Speelman Ltd, 36
Mr S. F. Speira. 439 (right)
Spink & Son Ltd, 7 (bottom left), 57, 321 (right), 323 (right),
 327, 336 (top)
Vigo Sternberg Galleries, 397 (left), 401
R. Symes Esq, 254 (right)

Galerie Tamenaga, 120
Temple Gallery, 247
Messrs J. R. Thomas Inc., 2, 332
Mrs Maureen Thompson, 313 (right), 314 (top right)
Tilley & Co, Antiques, 291
Alan Tillman (Antiques) Ltd, 316
Mr Charles Traylen, 271, 272 (top right)
Mr D. Tunick, 124

Earle Vandekar, 335 (top)
C. J. Vander Ltd, 205 (top left)
Vintage Cameras, 438

Wartski Ltd, 238 (top right), 240 (bottom), 242 (left)
Julius Weitzner Esq, 34. 48
P. Wenning Gallery, 160 (left)
Winifred Williams, 285 (top), 293 (left and right), 304
H. Woods Wilson, 345 (top), 348 (top)
Douglas J. K. Wright Ltd, 352 (centre left and bottom left), 353
 (bottom right)

R. Zietz, 309. 310, 312, 314 (top centre)
Mrs Begona Zunzunegui de Aranguren, 142

Index

Index

The currency equivalents given throughout the book are based on the rate of exchange ruling at the time of the sale. Any apparent contradictions are due to fluctuations in the exchange rates during the course of the season.